Lockdown Cultures

Lockdown Cultures
The arts and humanities in the year of the pandemic, 2020–21

Edited by Stella Bruzzi and Maurice Biriotti
With Sam Caleb and Harvey Wiltshire

First published in 2022 by
UCL Press
University College London
Gower Street
London WC1E 6BT

Available to download free: www.uclpress.co.uk

Collection © Editors, 2022
Text © Contributors, 2022
Images © Contributors and copyright holders named in captions, 2022

The authors have asserted their rights under the Copyright, Designs and Patents Act 1988 to be identified as the authors of this work.

A CIP catalogue record for this book is available from The British Library.

This book contains third-party copyright material that is not covered by the book's Creative Commons licence. Details of the copyright ownership and permitted use of third-party material is given in the image (or extract) credit lines. If you would like to reuse any third-party material not covered by the book's Creative Commons licence, you will need to obtain permission directly from the copyright owner.

This book is published under a Creative Commons Attribution Non-commercial Non-derivative 4.0 International licence (CC BY-NC-ND 4.0), https://creativecommons.org/licenses/by-nc-nd/4.0/. This licence allows you to share, copy, distribute and transmit the work for personal and non-commercial use providing author and publisher attribution is clearly stated. If you wish to use the work commercially, use extracts or undertake translation you must seek permission from the authors. Attribution should include the following information:

Bruzzi, S. and Biriotti, M. (eds). 2022. *Lockdown Cultures The arts and humanities in the year of the pandemic, 2020–21*. London: UCL Press. https://doi.org/10.14324/111.9781800083394

Further details about Creative Commons licences are available at http://creativecommons.org/licenses/by-nc-nd/4.0/

ISBN: 978-1-80008-342-4 (Hbk.)
ISBN: 978-1-80008-343-1 (Pbk.)
ISBN: 978-1-80008-339-4 (PDF)
ISBN: 978-1-80008-340-0 (epub)
DOI: https://doi.org/10.14324/111.9781800083394

Contents

List of figures ix

List of contributors xi

Foreword xxiii

Acknowledgements xxv

Introduction 1
Maurice Biriotti

Part 1: Politics

1 'Give me liberty or give me death' 12
 Lee Grieveson

2 Translating Covid-19 information into Yiddish for the Montreal-area Hasidic community 22
 Zoë Belk, Lily Kahn, Kriszta Eszter Szendrői and Sonya Yampolskaya

3 Shakespeare and the plague of productivity 30
 Harvey Wiltshire

4 The decolonial option and the end of the world 38
 Izabella Wódzka

5 Distant together: creative community in UK DIY music during Covid-19 49
 Kirsty Fife

6 Now are we cyborgs? Affinities and technology in the Covid-19 lockdowns 58
 Emily Baker and Annie Ring

Part 2: History

7 Reflections on Covid-like pathogens in ancient Mesopotamia 68
 Markham J. Geller

8 Handwashing saves lives: producing and accepting new knowledge in Jens Bjørneboe's *Semmelweis* (1968) and the Covid-19 pandemic 79
 Elettra Carbone

9 Experiencing and coping with isolation: what we can see from ethnic Germans in Britain 1914–18 89
 Mathis J. Gronau

10 Unexpectedly withdrawn and still engaged: reflections on the experiences of the Roman writer and politician Marcus Tullius Cicero 97
 Gesine Manuwald

11 The Gallic sack of Rome: an exemplum for our times 103
 Elizabeth McKnight

12 On Spinalonga 111
 Panayiota Christodoulidou

Part 3: Performance, identity and the screen

13 The thing itself 115
 Alexander Samson

14 Towards a new history: the corona-seminar and the drag king virus 123
 Helena Fallstrom

15 'In spite of the tennis': Beckett's sporting apocalypse 137
 Sam Caleb

16 Screening dislocated despair: projecting the neoliberal left-behinds in *100 Flowers Hidden Deep* 145
 Nashuyuan Serenity Wang

17 A digital film for digital times: some lockdown thoughts on *Gravity* 154
 Stephen M. Hart

| 18 | The Great Plague: London's dreaded visitation, 1665
Justin Hardy | 163 |

Part 4: Literature and writing

19	Lessons for lockdown from Thomas Mann's *The Magic Mountain* *Jennifer Rushworth*	170
20	The locked room: on reading crime fiction during the Covid-19 pandemic *Jakob Stougaard-Nielsen*	179
21	The weight of a shrinking world *Florian Mussgnug*	188
22	A voice-mail lyric for a discipline in crisis: on Ben Lerner's 'The Media' *Matthew James Holman*	198
23	20,000 leagues under confinement *Patrick M. Bray*	205
24	Reflections on *Guixiu/Kaishu* literary cultures in East Asia *Tzu-Yu Lin*	211

Part 5: Personal reflections

25	At home: Vaughan Williams' 'The Water Mill' and new meanings of 'quotidian' *Annika Lindskog*	222
26	The habit of freedom *Naomi Siderfin*	230
27	Pandemic dreaming *Adelais Mills*	240
28	In pursuit of blandness: on re-reading Jullien's *In Praise of Blandness* during lockdown *Emily Furnell*	249
29	Blinded lights: going viral during the Covid-19 pandemic *Sarah Moore*	254

Part 6: Visual responses

30 Morphologies of agents of the pandemic 258
 SMRU (The Social Morphologies Research Unit: David Burrows, Martin Holbraad, John Cussans, Kelly Fagan Robinson, Melanie Jackson, Dean Kenning, Lucy Sames, Mary Yacoob)

31 Wildfire 272
 Jon Thomson and Alison Craighead

32 Poems from *Gospel Oak* 274
 Sharon Morris

33 I have a studio (visit) therefore I exist 281
 Alice Channer, Anne Hardy, Karin Ruggaber and Carey Young

34 Inventory 292
 Jayne Parker

35 After a long time or a short time 300
 Elisabeth S. Clark

36 When the roof blew off 302
 Joe Cain

Index 313

List of figures

1.1 Jamie Lee Taete, photograph of an anti-lockdown protestor outside a Baskin Robbins 'ice cream speciality shop', April 2020, Huntington Beach, California. Reproduced courtesy of the photographer. 13

4.1 Wojtek Rodak, still from *Rok, w którym porzuciłem sztukę* (2020, YouTube). The subject is a young person in theatrical makeup. 42

4.2 Wojtek Rodak, still from *Rok, w którym porzuciłem sztukę* (2020, YouTube). The subject now is a young woman, caught in a close-up with a hand-held camera. 44

4.3 Wojtek Rodak, still from *Rok, w którym porzuciłem sztukę* (2020, YouTube). Another artist interprets a set of passages using distorted shapes and colours. 44

4.4 Wojtek Rodak, still from *Rok, w którym porzuciłem sztukę* (2020, YouTube). The final scene from the video, with a tripled subject. 47

6.1 Brigitte Helm plays cyborg Maria as an anti-essentialist double-agent, between virginity and jouissance, in Lang and von Harbou's *Metropolis* (1927). 60

14.1 The title slide of Preciado's seminar *Une nouvelle histoire de la sexualité* (*A New History of Sexuality*). Photo: Helena Fallstrom. 124

14.2 Paul Preciado presenting the first session of his seminar. Projected on the screen to his right is the front cover of *La volonté de savoir*, the first volume of Michel Foucault's *History of Sexuality*, first published by Gallimard in 1976. Photo: Helena Fallstrom. 125

14.3 The coronation of Judas La Vidange at the Dragkingathon, the first formal drag king competition to be held in France. Photo: Helena Fallstrom. 131

17.1 Comparison of brainprints of *Birdman*, *Gravity* and *Are You Smarter than a Fifth Grader?* Jeremy Skipper and Stephen Hart, 2017. 158

25.1	Bars 1–3 from 'The Water Mill' by Ralph Vaughan Williams (1872–1958), words by Fredegond Shove (1889–1949), from 'Four Poems by Fredegond Shove'. © Oxford University Press 1925. Reproduced by permission. All rights reserved.	224
26.1	Simon Tyszko and A.D. Crawforth, *B_T1 Freedom of the Mind* (2020). Screen grab ('a ghost of an image').	234
26.2	Anne Bean, 'Peace in Rest', installation view. *Disorders*, St Thomas' Hospital, London, 15–16 August 1996, produced by Beaconsfield. Photo Robin Chaphekar.	235
30.1	'Pandemic Stack: Agents Visible & Invisible to the Eye'. David Burrows, 2020.	259
30.2	'Pandemic Timeline: Covid-19 UK From First Case to Lockdown'. Dean Kenning, 2020.	260
30.3	'Covid-State Triangle'. Dean Kenning, 2020.	261
30.4	'Social Distance Diagram'. Martin Holbraad, 2020.	262
30.5	'Semiotics of Covid-19'. Kelly Fagan Robinson, 2020.	263
30.6	'Breach & Clear: Pandemic'. David Burrows, made in discussion with John Cussans, 2020.	265
30.7	'Aspirational Horror'. Text and image by Lucy A. Sames and Melanie Jackson, 2020.	268
30.8	'Aurora 01'. Mary Yacoob, 2020.	269
31.1	Photo by Jon Thomson and Alison Craighead.	273
33.1	Two-by-two grid view of the authors on a video call, December 2020.	281
34.1a and 34.1b	Inventory 1–2', photograms from series, 2017 to the 'present, Jayne Parker.	293
34.2	'Haphazard', photogram from series, 2017 to the present, Jayne Parker.	295
34.3a	'Magnolia Petals', photograph from series, 2017 to the present, Jayne Parker.	296
34.3b	'Magnolia Petals', photograph from series, 2017 to the present, Jayne Parker.	297
34.3c	'Magnolia Petals', photograph from series, 2017 to the present, Jayne Parker.	298
34.3d	'Magnolia Petals', photograph from series, 2017 to the present, Jayne Parker.	299
35.1	Elisabeth S. Clark, *After a long time or a short time*, 2020. Reproduced courtesy of the artist and Galerie Dohyang Lee.	300
36.1–18	All images by Joe Cain, Hove, UK, 2020.	302

List of contributors

Emily Baker researches and teaches in the areas of Comparative Literature and Latin American Cultural Studies at University College London (UCL). Her first monograph, *Nazism, the Second World War and the Holocaust in Latin American Fiction*, was published in June 2022 by Cambridge University Press. She has also published peer-reviewed articles on Mexican, Colombian, Argentine and Brazilian literature and Cuban film. She is currently working on a project related to the politics of aesthetics and revolution in screen media and culture (including the work of Adam Curtis), and another on contemporary eco-fictions. Before coming to UCL she completed a PhD at Jesus College, University of Cambridge, and held lecturer posts at Robinson College, Cambridge and at Birkbeck College, University of London.

Zoë Belk completed her PhD in the UCL Department of Linguistics and is currently conducting research at UCL on Hasidic Yiddish globally. Her main specialisations are determiner phrase (DP) syntax, particularly adjectival modifiers of nouns; linearity and adjacency constraints; and ordering restrictions.

Maurice Biriotti is Chief Executive of SHM and Professor of Applied Humanities at UCL. Before co-founding SHM in 1996, Maurice was a full-time academic and held posts at the Universities of Cambridge, Birmingham and Zurich. His published work covers literature, philosophy, anthropology and the dynamics of cultural change. SHM was built on the insight that human motivation is at the root of all business success and is critical to business innovation and the delivery of competitive advantage. Maurice has applied this insight successfully across both the public and private sectors and it remains at the heart of all of the work the company carries out. Maurice is a Visiting Professor in the department of Psychiatry, Yale University and a member of the advisory board for the Faculty of Arts, Aarhus University.

Patrick M. Bray teaches French Literature at UCL, serves as Editor-in-Chief of the journal *H-France Salon*, and is the author of *The Novel Map* and *The Price of Literature* (Northwestern University Press).

Stella Bruzzi FBA has been Executive Dean of the Faculty of Arts and Humanities and Professor of Film at UCL since 2017. Her first academic post was at the University of Manchester, followed by periods at Royal Holloway, University of London and the University of Warwick, where she also served as Chair of the Faculty of Arts from 2008 to 2011. She has published widely in the areas of costume and cinema, documentary, gender and masculinity in Hollywood and representations of history, and has, to date, published eight monographs, the last of which was *Approximation: Documentary, history and the staging of reality* (Routledge, 2020). In 2013 she was elected Fellow of the British Academy.

Joe Cain is Professor of History and Philosophy of Biology in the UCL Department of Science and Technology Studies. He is a specialist on Darwin and Darwinism, the history of eugenics and history of paleoart.

Sam Caleb is a London Arts and Humanities Partnership-funded PhD candidate in English Literature at UCL. Provisionally titled *Ludic Late Modernism: Play, games and sport in British experimental fiction of the long 1960s*, his research explores the ludic turn in postwar experimentalist writing by Christine Brooke-Rose, B. S. Johnson, George Lamming and Alexander Trocchi. He was the co-editor (with Niall Ó Cuileagáin) of the UCL graduate journal *Moveable Type* special issue on nostalgia (2020).

Elettra Carbone is Associate Professor in Norwegian Studies in the UCL Department of Scandinavian Studies (School of European Languages, Culture and Society). Her main areas of research and teaching are nineteenth-century Norwegian and Nordic literatures, cultural mobility, sculpture, print culture and archival studies. She is the author of *Nordic Italies: Representations of Italy in Nordic literature from the 1830s to the 1910s* (Nuova Cultura, 2016) and has co-edited volumes such as *The Public Sphere and Freedom of Expression in Northern Europe, 1814–1914* (Norvik, 2020), *Sculpture and the Nordic Region* (Routledge, 2017) and *The Norwegian Constitution and Independence of 1814* (Norvik, 2015). She is currently working on her next monograph, *British Representations of Modern Scandinavia: An object-based investigation* (UCL Press, forthcoming).

Alice Channer is an artist working with sculpture. Her forms and materials are found in the social and sensual and worlds of industrial and

organic processes. Over long periods of time, she immerses herself in industrial and natural materials and production processes to find forms within them that she develops as sculpture. Her method is both experimental and precise, collaborating with people, machines and materials to bring multiple bodies and voices into her polyphonic works. Channer lives and works in the edges of London. She has exhibited widely during the last 15 years, including institutional exhibitions at the Liverpool Biennial, Marta Herford, Yorkshire Sculpture Park and New Art Gallery Walsall (2021); the Tate Britain and Towner Gallery (2019); Museum Morsbroich, Whitechapel Gallery, Kettles Yard and La Panacée MoCo (2018); Aspen Art Museum and Kunsthaus Hamburg (2017); Museum Kurhaus Kleve and Whitworth Art Gallery (2016); Aïshti Foundation, Public Art Fund, New York and Aspen Art Museum (2015); Fridericianum, Kassel, and Kestnergesellschaft Künstlerhaus Graz (2014); The Hepworth, the 55th Venice Biennale and Kunstverein Freiburg, Germany (2013); and the South London Gallery and Tate Britain (2012). She is represented by Konrad Fischer Galerie, Berlin and Düsseldorf, Germany.

Panayiota Christodoulidou has recently been awarded her PhD in the field of Inclusive Education (UCL, Institute of Education). She is a Senior Postgraduate Tutor for the BA Arts and Sciences, UCL, and an adjunct lecturer at the School of Education and the School of Humanities and Social Sciences of the University of Nicosia (Cyprus) and in the Department of Psychology and Education of the Neapolis University Paphos (Cyprus). She is also an Associate Teaching Fellow at the Advance Higher Education Academy. Her research interests are related to inclusive and special needs education, theories of disabilities, pedagogical models of teaching and learning, and innovative educational policies and practices.

Elisabeth S. Clark is an artist who lives and works between London and Mayenne, France. She recently completed a practice-based Fine Art PhD (2012–2020) at the Slade School of Fine Art, UCL, where she also received her MA (2008), and she earned a BA in Fine Art and Art History (2005) from Goldsmiths University. Artist residencies include the Fondation d'entreprise Hermès (2010) and Le Pavillon, Laboratoire de Création du Palais de Tokyo (2011), as well as residencies in New York, Colombia, Germany, Ireland, Russia, and South Korea (2012–16). Her work has been included in the 2017 Lyon Biennale *Floating Worlds* (Lyon, France), Palais de Tokyo (Paris), FIAC Hors les Murs, Jardin des Plantes (Paris), FRAC Franche-Comté (Besançon), Dallas Contemporary (Dallas, USA), Roaming Room (London), and Site Gallery (Sheffield, UK). Awards

include the honorary Clare Winsten Research Fellowship Grant and a travel scholarship in South America. She is represented by Galerie Dohyang Lee (Paris).

Helena Fallstrom is an Arts and Humanities Research Council-funded PhD candidate in Anthropology at King's College London and is currently completing an ethnography of the emergent Parisian drag king scene. Her thesis is based on fieldwork conducted between 2016 and 2021 and draws extensively on her own performance practice. She is a creative associate and founding member of the Pecs drag king theatre company, who have been creating critically acclaimed shows for the LGBTQ+ community since 2013.

Kirsty Fife is a Lecturer in Digital Information and Curatorial Practice at Manchester Metropolitan University and a PhD student in the Department of Information Studies at UCL. They have previously taught at Leeds Conservatoire and the University of Dundee. Prior to returning to academia, they worked as an archivist in public sector organisations including the National Science and Media Museum and the UK Parliamentary Archives. Alongside research, they are also active as a cultural producer and community organiser in UK-based DIY cultures.

Emily Furnell studied Fine Art at Bath School of Art and Design. Her practice plays on misinformation and an excess of arbitrary information. Through diagrams, casts, texts, objects and gifs she pits present-ness and blandness against phrases and imagery lent from popular culture to explore the strange mood of our time. Emily is currently the Studio Coordinator at the Slade School of Fine Art.

Markham J. Geller received his degrees from Princeton University and Brandeis University. He was invited to London for a postdoctoral fellowship in 1973, and in 1976 was appointed to a Lectureship at UCL, where he has been teaching ever since. He became Director of the Institute of Jewish Studies at UCL in 1983. Markham was an Alexander von Humboldt-Fellow and was twice invited as a Fellow to the Netherlands Institute of Advanced Studies in Wassenaar (NIAS). Between 2007 and 2009, he was regularly invited as Visiting Fellow at the Max-Planck-Institut für Wissenschaftsgeschichte in Berlin. Between 2010 and 2018, Markham served as Professor für Wissensgeschichte at the Freie Universität Berlin, on secondment from UCL. During this period, he became PI of a European Research Council (ERC) Advanced Grant for *BabMed*, on ancient Babylonian medicine. Since 2018, he has returned to UCL as Jewish Chronicle Professor. He was a Fellow at the Paris Institute for Advanced Study (IEA) for 2020/1.

Lee Grieveson is Professor of Media History in the Faculty of Arts and Humanities at UCL. Most recently he is the author of *Cinema and the Wealth of Nations: Media, capital, and the liberal world system* (University of California Press, 2018); as well as co-editor of *Empire and Film* and *Film and the End of Empire* (both British Film Institute, 2011, with Colin MacCabe); and *Cinema's Military Industrial Complex* (University of California Press, 2018, with Haidee Wasson). Grieveson is currently at work on a book called *Prediction Machines* and a collaborative project (with Priya Jaikumar) entitled *On Extraction and Media*.

Mathis J. Gronau is a PhD student at the UCL Centre for Multidisciplinary and Intercultural Inquiry in European Studies. His doctoral study focuses on the comparative experiences and emotional history of the German diaspora in Great Britain and France during and after the First World War. In a broader sense, he is interested in international German cultural history of the late nineteenth and early twentieth century, as well as German linguistics. The most recent presentation of his work was at the migration history lecture series at London Metropolitan University in 2021. He has also organised an interdisciplinary postgraduate conference with the Early Research Academic group.

Anne Hardy is an artist working with immersive installations, photography and sound. Her work derives from places she calls 'pockets of wild space' – gaps in the urban space where materials, atmospheres and emotions gather – using what she finds there to manifest sensory works that immerse you and that she calls FIELDworks. Solo exhibitions include Tate Britain, Towner Art Gallery, Museum Boijmans Van Beuningen, Leeds Art Gallery, Modern Art Oxford, Kunstverein Freiburg and The Common Guild. Group exhibitions include Merz Foundation, The Hayward Gallery, Barbican Art Gallery, V&A Museum, Marta Herford, and British Art Show 9 (2021/2). In 2022 she is Artist in Residence at the Chinati Foundation, Marfa. She is represented by Maureen Paley, London.

Justin Hardy is a practising historian-filmmaker whose films have won a BAFTA and four Royal Television Society Awards; his work has also been nominated for two EMMYs and a Grierson. He has been the recipient of three Wellcome Trust Awards for *Trafalgar Battle Surgeon*, *The Relief of Belsen* (both Channel 4) and *Spanish Flu: The forgotten fallen* (BBC). His PhD at UCL, supervised by Professors Stella Bruzzi and Melvyn Stokes, reflects on the dramatisation of British history documentary at the turn of the millennium. He leads the Moving Image pathway of the new BA in

Creative Arts and Humanities and has also designed a film pathway for the new MA in Public History, both due to start at UCL East in 2022/3.

Stephen M. Hart is Professor of Latin American Film at UCL. In the field of Film Studies he has published *A Companion to Latin American Film* (2004) and *Latin American Cinema* (2015), and co-edited the *Wiley Blackwell Companion to Latin American Cinema* (2017). He has a particular interest in neurocinematics.

Matthew James Holman is an Associate Lecturer in the English department at UCL, where he completed his PhD on the poet Frank O'Hara in 2020. With principal research interests in American modern and contemporary literature and visual culture, Matthew has received research fellowships from Yale University, the Smithsonian Institution and the Terra Foundation for American Art, and spent a year at The John F. Kennedy Institute for North American Studies in Berlin under a Leverhulme Trust studentship. He has taught modern literature and art history at UCL, the Slade School of Fine Art, Queen Mary University of London and the Courtauld.

Lily Kahn is Professor of Hebrew and Jewish Languages in the Department of Hebrew and Jewish Studies at UCL. Her main research areas are Hebrew in Eastern Europe, Yiddish and other Jewish languages. She is co-editor (with Riitta-Liisa Valijärvi) of the UCL Press series *Grammars of World and Minority Languages* and Co-Investigator of an AHRC project on Hasidic Yiddish worldwide.

Tzu-yu Lin is an associate lecturer in translation at UCL. She holds a PhD in Comparative Literature (Edinburgh University, UK) and an MA in Colonial and Postcolonial Literature (Warwick University, UK). In 2016, she was awarded a British Academy Postdoctoral Fellowship. Her research interests include comparative literary studies, literary translation, Sinophone literature in translation and memory studies.

Annika Lindskog is Lecturer in Swedish and Scandinavian Studies in the Department of Scandinavian Studies (SELCS) at UCL, where her teaching spans language, cultural studies and cultural history in the Nordic region and beyond. She has published on a variety of topics including landscape ideology, collective identity and representations of north, with a particular focus on classical music as a cultural expression in articles on Brahms, Frederick Delius, Stenhammar and others, and most recently co-edited a volume *Introduction to Nordic Cultures*, also published by UCL Press (2020). She is also a professional

language coach for singers and choirs in the UK taking on the Nordic repertoire.

Elizabeth McKnight is an associate lecturer in the Department of Greek and Latin at UCL, where she teaches a range of undergraduate modules in Latin language and literature. She completed a PhD at UCL in 2018 on conceptions of the rule of law in ancient Rome, as evidenced in the works of various Roman authors of the late republic and early empire. Before embarking on post-graduate study in Classics, Elizabeth worked as a solicitor in the City of London.

Gesine Manuwald is Professor of Latin at UCL. Her research interests cover Roman oratory (especially the speeches of Cicero), Roman drama, Roman epic and the reception of antiquity in later periods (especially in early modern Latin literature). She has published widely on all these topics.

Adelais Mills teaches English Literature at King's College, Cambridge. In 2020/1 she was a Visiting Fellow at the Rothermere American Institute. She received her AHRC-funded doctorate from UCL in 2019. She is a graduate of Pembroke College, Cambridge (2015) and St John's College, Oxford (2014). Her research interests include the novel, the connections between philosophy and literature, literary theory and criticism, and the history and theory of psychoanalysis.

Sarah Moore is a doctoral student researching how mnemonic sites in post-war Bosnia-Herzegovina are influenced by gender and childhood experiences. Her main research interests include transitional justice, memory politics and ethnopolitical studies, and past projects have included examining the United Nations' response to the Srebrenica genocide and the formation of memory narratives in Serbia since 1995.

Sharon Morris is a Professor of Fine Art at the Slade School of Fine Art, UCL. An artist and poet, her artworks, which include photography, video, film, installation and live performance-readings, have been exhibited widely and her poetry collections *False Spring* (2007) and *Gospel Oak* (2013), and her artist's book *The Moon is Shining on my Mother* (2017), were published by Enitharmon Press. Her research is interdisciplinary and her critical writing, addressing the relation between words and images, uses the semiotics of C. S. Peirce. She is currently working on macaronic poems and images and researching Welsh medieval poetry through the Slade-IES research group MiCA (Medieval in Contemporary Art).

Florian Mussgnug is Professor of Comparative Literature and Italian Studies at UCL, where he also serves as Vice Dean International in the Faculty of Arts and Humanities. He has published widely on twentieth- and twenty-first-century literature in Italian, English and German, with a particular focus on the environmental humanities, creative critical practice and narratives of risk, crisis and care. Recent publications include *Dwelling on Grief: Narratives of mourning across time and forms* (2022, with Simona Corso and Jennifer Rushworth); *Thinking Through Relation: Encounters in creative critical writing* (2021, with Mathelinda Nabugodi and Thea Petrou); *Mediating Vulnerability: Comparative approaches and questions of genre* (2021, with Anneleen Masschelein and Jennifer Rushworth); *Human Reproduction and Parental Responsibility: Theories, narratives, ethics* (2020, with Simona Corso and Virginia Sanchini); and *Rethinking the Animal-Human Relation: New perspectives in literature and theory* (2019, with Stefano Bellin and Kevin Inston). He has held visiting and honorary positions at the Universities of Rome Sapienza, Siena, Oxford and Cagliari, and at the British School at Rome, and is currently Professor of Literary Criticism and Comparative Literature at Roma Tre University, a part-time appointment that he will hold from 2021 until 2023.

Jayne Parker is an artist and film maker. Much of her recent work concerns music and its performance. A DVD compilation, *Jayne Parker: British Artists' Films*, was issued by the British Film Institute in 2009. She is Professor in Fine Art and Head of Graduate Fine Art Media at the Slade School of Fine Art, UCL. Her films are distributed by LUX (www.lux.org.uk).

Annie Ring is Associate Professor of German in the School of European Languages, Culture and Society at UCL. Her research focuses on German and comparative film and the politics of subjectivity, and she teaches German and comparative literature, film and cultural theory. Before joining UCL she was Research Fellow at Emmanuel College, Cambridge, and in 2020/1 she was a Leverhulme Research Fellow. Her publications include the monograph *After the Stasi* (Bloomsbury, 2015; second edition 2017), and *The Lives of Others* (BFI Film Classics, 2022) and articles on theories of the archive, critical data studies, documentary, complicity and pleasure in Kafka. She is contributing co-editor of *Architecture and Control* (with Henriette Steiner and Kristin Veel, Brill, 2018), *Uncertain Archives: Critical keywords for big data* (with Nanna Bonde Thylstrup, Daniela Agostinho, Catherine D'Ignazio and Kristin Veel, MIT Press, 2021) and the forthcoming *Citational Media: Counter-archives and technology in contemporary visual culture* (with Lucy Bollington, Legenda).

Karin Ruggaber makes sculpture as well as producing artists' publications. She is Professor and Head of Graduate Sculpture at the Slade School of Fine Art, UCL, and is represented by greengrassi, London. Solo exhibitions include Walter Knoll, London; PEER, London; Art Now, Tate Britain. Group exhibitions include La Casa Encendida, Madrid; CCA, Andratx; MUDAM, Luxembourg; Museo Marino Marini, Florence; Artists Space, New York; Mount Stuart Trust, Scotland; and Camden Arts Centre, London. Her work was included in the British Art Show 7 at the Hayward Gallery, London, and she was recipient of an Abbey Fellowship at the British School, Rome, Italy (2019). She recently completed a permanent commission for Selldorf Architects, New York.

Jennifer Rushworth is Associate Professor in French and Comparative Literature at UCL. She is the author of two books, *Discourses of Mourning in Dante, Petrarch, and Proust* (Oxford University Press, 2016) and *Petrarch and the Literary Culture of Nineteenth-Century France* (Boydell, 2017). She is also the co-editor of *Mediating Vulnerability: Comparative approaches and questions of genre* (UCL Press, 2021, with Anneleen Masschelein and Florian Mussgnug) and of *Dwelling on Grief: Narratives of mourning across time and forms* (Legenda, 2022, with Simona Corso and Florian Mussgnug).

Alexander Samson is a Professor of Early Modern Studies at UCL. His research interests include the early colonial history of the Americas, Anglo-Spanish intercultural interactions and early modern English and Spanish drama. His book *Mary and Philip: The marriage of Tudor England and Habsburg Spain* was published by Manchester University Press in 2020. He runs the Golden Age and Renaissance Research Seminar and is director of UCL's Centre for Early Modern Exchanges and the Centre for Editing Lives and Letters.

Naomi Siderfin is an artist and a founding director of Beaconsfield London, a national centre for the research and development of contemporary art. Recent doctoral research at UCL's Slade School of Fine Art focuses upon the role played by tacit knowledge in the work of artist-curators. Solo and collaborative artworks have been exhibited in a range of international contexts, including institutions such as Chaplaincy Projects Online UAL (2021), Helsinki Contemporary (2018), Athens Biennale (2013), Tate Britain (2011), Alta Museum (2002), Tate Modern (2001), National Gallery of Namibia (2000), Hamburger Bahnhof Museum für Gegenwart (1999), Ministry of Sound (1994) and Royal Academy of Art (1986). Anthologised texts include *Monochrome (Anchored)* (2016), *Carry on Curating* (2007) and *Occupational Hazard* (1998).

The **SMRU (Social Morphologies Research Unit)** is a collaboration between artists and social anthropologists with a shared interest in the creative, educational and transformative use of diagrams. Initially conceived under the auspices of CARP (Comparative Anthropologies of Revolution), a research project led by Professor of Social Anthropology, **Martin Holbraad**, from UCL Anthropology, SMRU was brought together by Holbraad and Professor of Fine Art **David Burrows** from the Slade, UCL in November 2017. The group includes the artists and anthropologists who have contributed to this volume: **John Cussans** (Worcester University), **Melanie Jackson** (Royal College of Art), **Dean Kenning** (Kingston University), **Lucy A. Sames** (independent curator), **Kelly Fagan Robinson** (Cambridge University) and **Mary Yacoob** (London Met University). SMRU is currently developing a new project which will apply an ethnographic-diagramming method to art schools and arts education, exploring the different forms of value they generate, question and challenge.

Jakob Stougaard-Nielsen is Professor of Scandinavian and Comparative Literature in the School of European Languages, Culture and Society at UCL. He is the author of *Scandinavian Crime Fiction* (Bloomsbury, 2017) and has co-edited the anthologies *Translating the Literatures of Small European Nations* (Liverpool University Press, 2020) and *Introduction to Nordic Cultures* (UCL Press, 2020). His research interests include authorship studies, Hans Christian Andersen, print culture, intermedial studies, world literature, welfare cultures and crime fiction.

Kriszta Eszter Szendrői is Professor of Information Structure in Language in the Linguistics Department at UCL. She specialises in the syntax, semantics and prosody of focus and quantification, and their acquisition. She is currently Principal Investigator of an AHRC project on the syntax and acquisition of Hasidic Yiddish worldwide.

Jon Thomson and Alison Craighead (Thomson & Craighead) make artworks that examine the changing socio-political structures of the Information Age. In particular they have been looking at how the digital world is ever more closely connected to the physical world, becoming a geographical layer in our collective sensorium. Time is often treated with a sculptor's mentality, as a pliable quantity that can be moulded and remodelled. Jon is Professor of Fine Art at the Slade School of Fine Art, University College London, and Alison is Reader in Contemporary Art at the University of Westminster and Lecturer in Fine Art at Goldsmiths University of London. They live and work between London and Ross-shire.

Nashuyuan Serenity Wang is a PhD candidate at UCL History department. She read Film Studies at the University of Warwick (BA) and at University College London (MA). Her research project is titled 'Cinema of dislocation: The geo-emotional journeys of women in twenty-first century Chinese cinema'. She is particularly interested in the representation of cinematic space and cultural identity, psychogeography, rural studies and women's cinema. Her work has been published in *Film Matters* and in *Film and the Chinese Medical Humanities* (Routledge, 2019). Nashuyuan is a volunteer consultant at the Chinese Information and Advice Centre, helping disadvantaged Chinese in the UK; she also serves as Deputy Secretary General at the UK Research and Development Centre for Chinese Traditional Culture

Harvey Wiltshire is a Teaching Fellow in Early Modern Literature, Shakespeare, and Inclusive Pedagogies in the Department of English at Royal Holloway (University of London), having completed his PhD at UCL, where he also taught in the Department of English and the School of European Languages, Culture and Society. His research interests include Shakespeare and early modern medicine, the history of emotion, and trauma theory; his work has been published in *Etudes Episteme* (2018), *Shakespeare Seminar Online* (2019), *English: The Journal of the English Society* (2020), and most recently *Shakespearean Criticism* (2021).

Izabella Wódzka is a PhD candidate in Film Studies at UCL, with a background in European languages and cultures; she completed her undergraduate degree in Scandinavian Studies and postgraduate degree in Translation Studies at the University of Edinburgh, and later obtained a master's degree in Film Studies from UCL. Currently, she is finishing her doctoral project titled *Spaces of exclusion, places of inclusion: Representing Roma, Gypsy, and Traveller identities in contemporary European cinema*. Her research interests include marginalised and non-hegemonic identities in visual media, postcolonial and decolonial studies in East European contexts, and the role of space and place in film.

Sonya Yampolskaya is a linguist and sociolinguist whose research interests include multilingualism, diglossia, bilingualism, minority and endangered languages, code-switching, address forms and linguistic politeness. Her main specialisations are Hasidic Yiddish and Ashkenazic Hebrew in various historical periods. She completed her PhD at St Petersburg State University and is currently conducting research at UCL on Hasidic Yiddish and Ashkenazic Hebrew globally. She is also a researcher at the University of Haifa.

Carey Young is a London-based artist whose work across video, photography, text, performance and installation explores relations between the body, language, rhetoric and systems of power. Her videos and photographic series examine law in relation to gender, performance and speculative fiction. Young's solo exhibitions include Kunsthal Aarhus, La Loge, Brussels, Towner Art Gallery, Eastbourne, Dallas Museum of Art, Migros Museum für Gegenwartskunst, Zurich, Eastside Projects, Birmingham, Contemporary Art Museum, St Louis, and the Power Plant, Toronto. Group exhibitions include Walker Art Center, Minneapolis, Centre Pompidou (Paris and Brussels), the New Museum, New York, MoMA/PS1, New York, Tate Britain and the Busan, Sharjah, Moscow and Venice Biennials. In 2023 she will have a solo exhibition at Modern Art Oxford. She is represented by Paula Cooper Gallery, New York and her works are held in the collections of Tate, Centre Pompidou and Dallas Museum of Art, amongst others. She is Associate Professor in Fine Art at the Slade School of Fine Art, UCL.

Foreword

In all its destructive power, the Covid-19 pandemic has also brought enormous creativity in many sectors, including that of higher education. Within weeks we were teaching online and experimenting with new forms of pedagogy; our students and staff were on the front line in the health services and elsewhere; we were developing new forms of digital student life and finding new ways of looking after one another; our research was pivoted to finding practical solutions to a global emergency unfolding at breakneck speed. In the arts and humanities, both inside and outside the academy, we saw a new intensity of both reflection and expression; a drawing on the depths of ancient and modern cultures to make sense of our experience.

This volume represents a brilliant snapshot of the arts and humanities while memory of the early stages of the pandemic is still visceral. The work draws on a wide range of disciplines and of responses both analytical and creative. But the important thing is that the responses are all offered while the experience of the pandemic is fresh. In time we will come to argue about the significance and legacy of this period, but – both as a source of insight about those issues, and as an artefact of the period itself – this collection will remain invaluable. In that it evinces a deep desire to make sense of the world with, and for, the communities we serve, it is UCL at our very best.

Dr Michael Spence AC, President and Provost, UCL

Acknowledgements

Many people have contributed to the creation of this book. First and foremost, the editors would like to thank members of UCL's Faculty of Arts and Humanities – not just those whose contributions feature here, but all of our community who made the pandemic years of 2020–2 as good as they possibly could have been. We were immensely grateful for the work and commitment of Maurice Biriotti's two research assistants, Helena Fallstrom and Celine Lowenthal, who provided invaluable editorial assistance. A huge thanks also to Dania Herrera, Stella Bruzzi's executive assistant, for her support through the copy-editing process. Thank you to Florian Mussgnug, Tim Mathews and all the others who believed in this project and who helped bring it to fruition.

Introduction
Maurice Biriotti

Covid-19

April 2020. It had begun as little more than a flicker on a news feed, a tiny spark in a media agenda that was already crackling with the electric charge of a world increasingly divided. But as the Covid-19 crisis began to take hold, with every new outbreak confirming its deadly horror, two opposing phenomena very quickly began to emerge. The first was a kind of global solidarity in helplessness. Across the world, as never before in our lifetimes, we would come to feel bound by a bewildering and terrifying common experience. Simultaneously, an opposing force pulled us in the other direction – as lockdowns were announced country by country, we all began to feel in a very tangible sense disconnected from one another, isolated, alone. For many people, this was a contradiction of enormous intensity; we were bound by a common humanity and yet utterly cut off from others.

One year on (at the time of writing), this description may seem like hyperbole. But it is still fresh enough in the collective memory that one can feel its veracity at a visceral level. The pandemic ushered in a period of intense destabilisation and uncertainty. What would become of our way of life, or our jobs, or our relationships? How would our institutions survive the cataclysm? Especially in those early days, who, we wondered, would die and who would be spared? And above all, what was to be done?

This project was born in the atmosphere – sometimes febrile, sometimes abject – of the early days and weeks of the first UK Covid-19

lockdown. As such, its most important theme is a moment in time. What was happening was not merely concerning, it was overwhelming. Everyone was talking about it constantly and academics were no exception. Our context had become our text.

Academia in (a) crisis

Universities have had a very particular experience of Covid-19. Again, this has manifested in a number of contradictions. On the one hand, for many universities, Covid-19 has signalled a series of existential threats. Could the model of the university simply pick up as before after the enforced hiatus? For many British universities, UCL included, many aspects of the 'model' for the university suddenly came into sharp focus. From the concept of 'student experience' to the collaborative endeavour of the laboratory, from the dream of interdisciplinarity enabled by physical proximity to the welcoming of students and scholars from around the world, Covid-19 raised an uncomfortable set of questions. Would life – and would funds – ever return to dispel the eerie silence of campuses in lockdown?

But set against those profound anxieties, it also felt as though academia had never been more in demand. News media that had only recently been sneering disparagingly at 'experts' developed a seemingly insatiable hunger for academic opinion. And this hunger was not just an artefact of the media; there was, and remains, a great deal of work to be done by universities. Leading figures across many disciplines have been called upon to help steer us through this challenge: the medics and the sociologists, the engineers and the chemists, the mathematicians and the economists. And in most cases, they have done so with dignity and with aplomb.

But what of the arts and humanities?

Arts and humanities in a pandemic

A large part of the impetus for this project has been an exploration of this last question. The arts and humanities may not be called upon to develop vaccines, to build breathing apparatus or to create algorithms that can predict the progress of pathogens. But outside the university, the themes and questions that have historically occupied the arts and humanities took on a new life under lockdown. People that had barely touched a book

for 20 years began to take up reading again – not out of boredom, but out of a profound quest for a deeper sense of meaning in a time of bewilderment. Debates about ethics or culture suddenly took centre stage in social media feeds that had previously been dedicated to the vagaries of fashion or celebrity. Fundamental questions started to be addressed and, even though those questions had existed long before the pandemic, somehow the Covid-19 crisis created a space in which such thinking was not only possible but necessary. These were questions of representation, of inequality, of collective interdependency and individual responsibility, questions about what we can or should care about.

Meanwhile, in my own work, I have been applying humanities thinking to the worlds of business and public institutions for the last 25 years. My team has never been busier. Before Covid-19, even in the wake of the 2008 crash, the momentum of global commerce often meant one had to fight hard to get people to engage in enquiry. Everyone was too busy making or chasing money. Covid-19 halted the juggernaut, and even if that pause was short lived, it opened up a space certainly unprecedented in all of my years doing this kind of work. Corporations started to seriously consider a number of long-neglected questions. What do we mean by value? Who benefits from what we do? What good or harm can we do through the language that we use? Who do we include and who do we exclude, deliberately or inadvertently? What is our responsibility towards the planet? What is the true meaning of that elusive thing we call culture?

The articulation of these questions may seem naïve from the viewpoint of people within the academy who grapple with such issues day to day. But the fact is that they are being raised today at the highest levels of industry, public service and politics. That in itself represents a kind of triumph for generations of arts and humanities scholars whose efforts in research, publishing, teaching and outreach have worked to expand, nuance and – in some cases – truly transform the way we understand these issues. In the unfolding debates, one can perceive the traces of academic framing, stored away in the collective consciousness of leaders who might once have taken courses on emerging ideas about identity or gender in the 1970s or 1980s. Or who drew on the powerful memories and insights born of serious engagement with works of art or literature over the course of a lifetime. At some stage, no doubt, someone will trace these various intellectual genealogies. And when those histories have been written, I am certain that the impact of the arts and humanities will be just as evident as those of other, more urgently engaged disciplines in shaping responses to the Covid-19 pandemic and its manifold repercussions.

Culture and lockdown

The significance of the processes I have just described, of the work of arts and humanities scholars in shaping and framing the way we see the world, is one I am convinced of. But it can be hard to grasp, and this is partly due to the fact that these processes of changing the way people see the world can be desperately slow. In addition, academia is not a monolith: there is not one collective movement or current of 'progress' that arts and humanities scholars are engaged in. Instead, we might define these processes as a collective endeavour on the one hand, bound by disciplines, departments, faculties and institutions, but carried out on the other often alone and in the silence of reflection, of interrogation, and of close and tireless engagement with the objects of study.

But what if we had a snapshot of these processes in a moment of time? What if we could make visible the emergent nexus of questioning amongst humanities scholars as they grapple with the dichotomies we all find ourselves in, caught between the solitary world of our interior lives and the collective experience that binds us?

With this view in mind, the project has proceeded rather differently from that of a typical academic collection. The principles of engagement were quite simple. My co-editor, Stella Bruzzi, and I set out some ground rules for an invitation to submit expressions of interest. First of all, the invitation was to be as broad as possible: we did not want to specify or select a set of disciplines, nor limit contributors to working within their respective disciplinary boundaries. We wanted contributors to engage with Covid-19 and lockdown without prescribing the form this engagement would take. The link could be explicit, or it could be entirely tangential. And, critically, we wanted people to write brief pieces, unencumbered by the usual anxieties about academic apparatus. We were interested in gathering contributions that would reflect a multitude of emerging responses, that would be more about process and context than the objects or fields of enquiry. The contributions in this collection are here to serve as an insight into the minds and aspirations of a community grappling like everybody else with the perils of the pandemic, but doing so with the tools at their disposal: art, words, text, writing.

It has to be said that, from the outset, Stella and I were unsure whether our call would be met with much enthusiasm. People were (and remain) stressed and busy. There is barely enough time in the normal run of things for most people to put pen to paper and write about their research, let alone in the maelstrom of the breaking Covid-19 crisis. And

in an era that is increasingly concerned with academic advancement and with research assessment exercises and evaluation, we offered little apparent benefit. This was not to be an academic project in a traditional sense. So why respond?

That is a question better directed, perhaps, to the individual contributors. But they did respond. In surprisingly large numbers, as you can see. And as the prospective size of the volume grew, so did our editorial team. Stella and I took on Sam Caleb, Helena Fallstrom and Harvey Wiltshire to help prepare the multitude of diverse responses we received for print. If there is one thing that emerges both from the willingness of our contributors and from the nature of their responses, it is their profound interest in exploring why what we do matters. Readers will, of course, judge for themselves. But the editors make no apology for the heterogeneity of this volume. It is, in part, the point of the endeavour. There are pieces here that clearly represent the culmination of years of research, reflection and debate. There are others that feel more like the first steps in a long process of developing an argument, whose full weight cannot yet be measured. Some pieces read like a howl of anguish, others like cool pauses for reflection amongst minds sheltering from the storm. There are contributions that have all the architecture of published academia, and others that come in the form of poems, autofiction or visual art. You will find articles here that overtly grapple with political themes, and others that are more suggestive in their engagement with current political challenges. We wanted the book to be a celebration of the diversity of themes, of styles, of objects of study in the humanities. However, there is no attempt to be comprehensive; if we received no responses from a particular discipline, we did not seek out further contributions. Neither did we wish to compel authors to engage in debates with one another, as you would in a collection born out of an academic conference, for instance. We believe that the value of this volume, for anybody who wants to read it in its entirety or in part, is precisely its varied and almost aleatory nature.

Besides some form of association with the Faculty of Arts and Humanities at UCL and a requirement to engage with the pandemic in a succinct manner, no other mechanism was put in place to impose any kind of coherence on the collection.

The collection

Despite the fact that the brief was so open, we as editors were interested in whether patterns or directions would emerge naturally from the contributions. We felt that this in itself threw up an interesting question: across all the disciplines in the arts and humanities, can we identify a common set of approaches to a phenomenon as overwhelming as the Covid-19 crisis? In turn, could such an exercise help us shed light on the state of these disciplines and their relationship to the wider world?

We can make no pretence to speak on behalf of the entire field of arts and humanities scholarship and creativity. However, as we look at the responses six kinds of engagement emerge:

Politics

The first major theme to emerge is political. For many of us, the pandemic has thrown up a range of urgent questions. First of all, there is the matter of how politics has evolved during this period itself as well as the sociopolitical phenomena that have come to the fore during the crisis. For instance, **Lee Grieveson**'s chapter examines protests across the US (in mid-April 2020) against 'excessive quarantine' and the 'lockdown' of public life, orchestrated on Facebook by a complex bloc of libertarian, radical right and white nationalist groups. The pandemic has caused many of us to wonder whether there is another way to organise societies or rethink relationships to each other and to technology. **Emily Baker** and **Annie Ring**'s re-reading of Donna Haraway's classic 'A Cyborg Manifesto' (1985) considers how the act of re-imagining ourselves through Haraway's vocabulary could offer new ways of challenging late capitalist logics and social inequalities deepened by the Covid-19 fallout. Others consider the needs of specific groups, taking the opportunity to look at our social and political reality through the lens of an alternative or marginal point of view. Where **Zoë Belk**, **Lily Kahn**, **Kriszta Eszter Szendrői** and **Sonya Yampolskaya**'s chapter discusses an ongoing project of the translation of Covid-19 information into Yiddish for the Hasidic Jewish communities of London and the Montreal region, examining the sociolinguistic context underpinning the process, **Kirsty Fife** takes a close look at the profound and devastating impact of the lockdowns on those working in the creative and cultural industries. Similarly, **Harvey Wiltshire** explores online discussions around productivity during the first lockdown, and particularly the notion that

Shakespeare composed *King Lear* during the 1604 plague. But there is also a great deal of optimism shown amongst the contributions, too; **Izabella Wódzka** looks to the Polish writer Olga Tokarczuk and the decolonial option to argue that this moment of crisis represents an inevitable transformation which proffers the hope of beginning something anew.

History

Some contributors sought out historical analogues, parallels or comparisons and again demonstrated the ways in which academic work and the context in which it is being carried out can create resonances, eerie or profound, terrifying or illuminating. In certain cases, this is a matter of understanding how other eras may have conceptualised and managed disease and contagion. These contributions serve to contextualise and historicise elements of our contemporary experience, as does, for example, **Markham J. Geller**'s investigation of the main medical issues of diagnosis, prognosis and treatment of fevers in ancient Mesopotamia. In other instances, our contributors have homed in on a particular theme of the pandemic experience to illuminate historical paradigms. **Elizabeth McKnight**'s revisiting of a society on the brink of crisis at the Gallic sack of Rome finds disconcerting echoes with our collective experience in the twenty-first-century United Kingdom, whilst **Mathis J. Gronau**'s piece on German civilians living in Britain during the First World War draws unsettling parallels between previous experiences of isolation and our own. **Panayiota Christodoulidou** reflects on disease as a vector for stigma and marginalisation by focusing on the leper community of Spinalonga, Crete, while **Gesine Manuwald**'s supremely classical reading of Cicero in light of current events reflects on how these texts may illuminate public discourse. **Elettra Carbone**'s piece, meanwhile, provides a fascinating insight into handwashing through the lens of Ignaz Semmelweis, the nineteenth-century Hungarian physician who discovered that the spread of disease could be prevented if doctors scrubbed their hands, as depicted in Jens Bjørneboe's 1968 play *Semmelweis*.

Performance, identity and the screen

The next theme to emerge is that of performance and identity, as mirror images of the self were found in the most unlikely of places, from film or sport to social media, allowing contributors to process their lockdown

experiences in unexpected ways. In some cases, a particular film or artefact opened up a means of reflecting on the conditions we found ourselves in. **Nashuyuan Serenity Wang** finds a fresh reading of dislocation and the loss of 'home' in a rapidly developing China through Chen Kaige's *100 Flowers Hidden Deep* (2002), while **Stephen M. Hart** reflects on new understandings of art during lockdown through his re-watching and re-reading of Alfonso Cuarón's *Gravity* (2013). Others found insight into the way the pandemic drastically shifted their relationship to 'normal life'. **Alexander Samson** offers reflections on the social and embodied nature of learning in the university, considering the challenges that digital substitutes pose to the communal nature of knowledge production. **Sam Caleb**'s chapter unravels the perplexing return of organised sport in the first lockdown through a reading of the games played out in apocalyptic circumstances in Samuel Beckett's *Waiting for Godot* (1952). **Helena Fallstrom** discovers alternative parallels on the virus through the perspective of the emergent Parisian drag king scene and the figure of queer theorist Paul B. Preciado. And **Justin Hardy** shares insights from *London's Dreaded Visitation* (1995) by Justin Champion, the primary historical source used by the author in the making of a drama documentary film on the Great Plague of London.

Literature and writing

Many of our authors naturally gravitated towards reading or re-reading texts. The collective power of these readings is striking. Here, the act of interpretation provides a series of lenses through which we can reconceive the current moment. In **Jennifer Rushworth**'s reading of Thomas Mann's *The Magic Mountain* (1924), there is a sense of a profound insight into illness and isolation that can come from reading an acknowledged twentieth-century classic. Then there are examples of textual readings that might seem only obliquely related to our experience but unexpectedly bring into sharp focus an aspect of how lockdown has affected us. **Jakob Stougaard-Nielsen**'s investigation into the classic genre motif of the locked-room mystery is a case in point, or indeed **Florian Mussgnug**'s contribution on the dystopian novels of British author and comic artist M. R. Carey. In some cases, the interactive dimension of reading – as an act of communication, teaching and care – is the focus, as in **Patrick M. Bray**'s account of his experience reading Jules Verne's *20,000 Leagues under the Sea* (1869–70) to his young son over video chat during lockdown. **Tzu-yu Lin**'s chapter juxtaposes *Guixiu/Kaishiu* literature of East Asia (women's or domestic writing)

with lockdown conditions and the attendant restructuring of private space, while **Matthew James Holman** offers a reading of Ben Lerner's prose poem 'The Media', published in the *New Yorker* shortly after New York City went into lockdown. Varied as they are, these pieces together show the power of the concept of reading in its broadest sense, and they demonstrate the way in which text and context play with and against each other to profound effect.

Personal reflections

Freed from some of the usual expectations about their subject matter, many contributors found fresh expression through reflections on memoir, autofiction and writings of the self. For many of us, the domestic world was brought to the fore during the first lockdown, and **Annika Lindskog**'s 'At Home' illuminates our domestic experiences through Ralph Vaughan Williams' 'The Water Mill' (c.1922), a song which evokes and celebrates daily life in the mill house. **Emily Furnell**'s contribution explores the usefulness and advantages of 'blandness' in the pandemic by re-visiting François Jullien's *In Praise of Blandness* (1991). Others found inspiration in the personal writings or expressions of others, as we see in **Naomi Siderfin**'s reflections on the particular challenges facing visual artists in lockdown as informed by Virginia Woolf's 'A Room of One's Own' (1929), while **Sarah Moore**'s essay unpacks the strange phenomenon of viral Tiktok dances in lockdown, and what they tell us about the human motivations for documenting experience. By contrast, **Adelais Mills** turned inwards, inspired by the slew of reports on pandemic-inflected dreams, by exploring the possibility of dreaming as a way of engaging with unfolding socio-historical events through Charlotte Beradt's *The Third Reich of Dreams* (1966).

Visual responses

Finally, many of the pieces directly took up the editors' offer to think beyond the normal academic frame and to consider a very different kind of submission. Of course, every kind of academic writing is already a creative act and the line between these different approaches is often quite blurred. But in many cases, the departure from the academic endeavour is even more sharply defined, and for these contributors the visual and image-rich came to the fore. **Sharon Morris** has contributed six extracts from her poetry collection *Gospel Oak* (2013). Although already published in a different form, in this context the poems selected take on a new

meaning. **Jayne Parker** from the Slade has submitted an image-based contribution from her ongoing project on magnolia tree buds, entitled 'Inventory', begun in 2017, while **Elisabeth S. Clark** has shared a photo of a 'time-tangle' sculpture, her own work, as part of her practice exploring translation processes of a physical and linguistic nature. **Carey Young** meanwhile contributes a discussion between herself, **Alice Channer**, **Anne Hardy** and **Karin Ruggaber** on their relationship with their studios, sharpened by the distances felt during lockdown. Where **Jon Thomson** and **Alison Craighead**'s piece of autofiction is illustrated with an image of a landscape, the **Social Morphologies Research Unit (SMRU)** contributes a set of diagrams and texts resulting from discussions held during the first lockdown. And **Joe Cain** provides a photo essay of shop closure signs in Hove from the first lockdown with accompanying text, a register of forms of communication during a time of absence. We are glad to reproduce these images, stories and poems here, as they represent a different way of engaging with the pandemic and its varied effects.

Coming to terms

We, the editors, wanted a snapshot and our contributors delivered just that. We wanted to see the process of arts and humanities scholars tackling the extraordinary events of 2020 as their thoughts emerged. We are left with three major impressions. The first is a sense of hope: while we have spaces in which people can apply their minds and their creative energies to thinking about what is happening, to engage with text, politics, history and art, there is the possibility that we will somehow make sense of our distress. The second impression we are left with is that, in time, we will need to resolve what the Covid-19 crisis and its aftermath mean for us. How we tell the story, how we explain what happened, how we contextualise our experiences – these things matter now and will continue to matter. This volume represents a kind of trace of our first attempts to engage with this crisis of making meaning. Just as debates in the arts and humanities have always eventually found their way into the mainstream, so too will some of these diverse ideas and opinions.

One day, I believe they will play a role in shaping the way we think about a world after Covid-19. And finally, we come full circle to the dichotomy this introduction opened with. Covid-19 has brought us together; Covid-19 has forced us apart. Each of these pieces represents an individual's way of grappling with the private isolation of one's thoughts on the one hand and the collective experience that has united us all on the

other. The struggle is not over yet but reading these pieces, in all their unevenness and variety, somehow helps orientate us towards beginning to come to terms with the enormity of lockdown and the pandemic.

1
'Give me liberty or give me death'
Lee Grieveson

In mid-April 2020, about a month after the coronavirus pandemic began to spread in the US, a wave of protests 'against excessive quarantine' and the 'lockdown' of public life were orchestrated on Facebook by a complex bloc of libertarian, radical right and white nationalist groups.[1] The protests migrated from virtual to public space. Pictures circulated of anti-government militias surrounding state capitol buildings. In one of the protests, in a small wealthy city in California (named after a famous railroad magnate), a woman was photographed outside a Baskin-Robbins ice-cream parlour holding a sign saying 'Give Me Liberty or Give Me Death', as well as a small American flag and a large drink (Figure 1.1).[2] (The drink is probably a 'Big Gulp', leading to some meme fun when the photograph went viral on social media: 'Give Me a Mango Temptation Big Gulp, or Give Me Death', and so on.) My short essay is an experiment in unpacking some of the complex vectors of this image. Specifically, it puzzles over the history of both the idealisation of 'liberty' in contradistinction to government (and its biopolitical investment in protecting populations during a global emergency) and the orchestration of media, spectacle and information to foster such a conception of liberty beyond and against government. By this measure the image is but one minor node in a complex history of a radically liberal project of mediation to degrade government ostensibly in the interests of individual liberty.

'Give me liberty, or give me death' is, of course, a cherished phrase in American history. It is attributed to 'founding father' Patrick Henry, the first governor of Virginia, and was articulated in 1775, in the midst of the

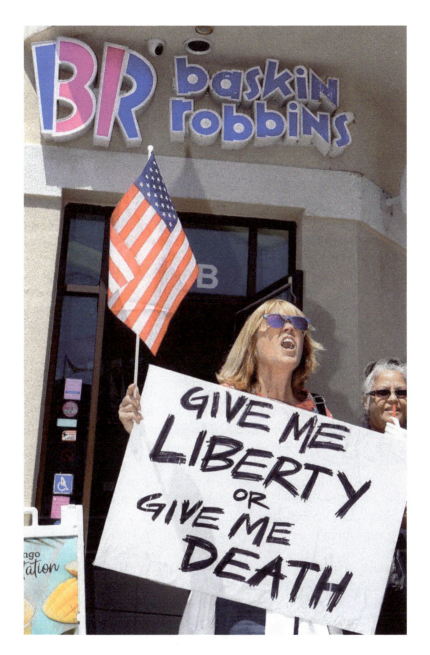

Figure 1.1 Jamie Lee Taete, photograph of an anti-lockdown protestor outside a Baskin Robbins 'ice cream speciality shop', April 2020, Huntington Beach, California. Photograph reproduced courtesy of the photographer. https://www.jlctjlct.com.

revolutionary war against the British to establish a new political sovereignty. It bears emphasising (not least because I am a media historian) that the revolutionary ferment in the US (and Henry's activism) began after the Stamp Act of 1765, when the British proposed to tax US newspapers and information to pay for colonial war and further entrench political control.[3] I shall return to questions about the control of information to shape political realities below. Often Henry's speech is invoked as a marker for the establishment of a liberal constitutional democracy that prioritised individual liberty beyond the reach of despotic government. But, of course, the historical record is murkier than that, and certainly there was little 'liberty' afforded racialised subjects in a white settler colony established out of the genocide of indigenous populations and growing wealthy from the enslavement of Africans. (Henry was himself a slave-owner.[4]) As is well known, the constitutional system in the US was designed to structurally limit the possibility of democracy in order to entrench white minority rule and control over land and resources. Put simply, the US was constituted as a liberal capitalist state in which democracy – as popular sovereignty and shared rule – was radically circumscribed. I shall take this as the furthest reaches of my genealogical unravelling of the meanings of this image of our near-present. 'Give me liberty, or give me death' speaks to a *continuum* of ideas and institutional structures that prioritise 'liberty' as the absence of government and that license the exercise of 'freedom' (to amass capital from slavery, say, or drink a Big Gulp) without care for others, society, civility or social bonds. Give me liberty, even though it requires your enslavement or proximity to a deadly virus.

The anti-lockdown protests, then, were part of a complex and sprawling libertarian, radical right and white nationalist protest movement that grew on Facebook before materialising in physical space. It traces its origins back to the radicalisation of liberalism gathering pace in the early 1970s in opposition to the social democratic liberalism established from the New Deal and its expansion in the Great Society.[5] One strand of this is the history of neo-liberalism and its licensing of capital, its encasement beyond the reach of democracy, and its demonising of the social state.[6] More directly germane to the image under scrutiny here is the birth and expansion of a libertarian praxis that ferociously opposed government and the ideals of equality essential to democracy and the operation of popular sovereignty. It grew (as historian Nancy MacLean explains) in direct opposition to the civil rights movements and school desegregation in the 1960s organised by government to facilitate racial equality.[7] Put simply, the libertarians oppose the ideal of equality

and its political form of democracy and work to disable government projects to foster egalitarianism (like public schooling or health care) and to 'protect capitalism from government'.[8] Beginning in the 1970s (and ongoing), wealthy libertarian oligarchs and groups began funding think-tanks, foundations, fellowships and media praxis to realise liberty by degrading government. Together, they made a concerted effort to use capital to batter the idea and practice of government to better serve the liberty of capital and further entrench elite rule. The radical liberal attack on government and democracy assumes freedom is the right to be left alone, and that any efforts to realise liberty by lessening inequality through the funding of public goods (such as education, health care and welfare) constitute an illegitimate and ultimately tyrannical practice.[9] One of the most powerful symbols for this demonisation of the social state in the era of neo-liberalism became that of the Black female 'welfare queen', but the idea of racialised others benefiting from government largesse is usefully polysemic and has recently been redeployed with respect to refugees and migrants.[10] Again, liberty is counterposed to equality and comes from the absence of government. Or, in the terms of the ice-cream protest's invocation of Henry, in a city named after a wealthy oligarch, government is death and liberty requires its dissolution.

In the aftermath of the financial crash of 2008, a newly radicalised bloc of libertarian oligarchs broke rank with the neoliberals (after the bailout to banks and insurance companies) and began more actively financing political groups and new media entities to reshape political reality. In the soil of economic immiseration, and on new digital networks (particularly after Facebook developed as a platform from 2007), grew a sprawling libertarian, radical right and ethno-nationalist movement.[11] In 2010, in response to the Affordable Care Act, colloquially known as Obamacare, and its plans to extend health care to impoverished citizens, a group of wealthy libertarians secretly funded an insurgent radical-right protest movement to shape and control public attention.[12] The Tea Party movement (its name also referencing the revolutionary revolt against taxation) was in this sense partly a so-called astroturf exercise, whereby protest is orchestrated by particular groups to appear organic and real. Parts of the lockdown protests were astroturf exercises also and both were complex 'pseudo-realities' orchestrated to garner media attention and virality for a position that opposed government ostensibly in the interests of liberty.[13] Our reality now is often an astroturfed reality, jumbled together with fictions and mediation and marshalled by wealthy elites or commercial technology and media oligopolies profiting from the circulation and virality of information.

Broadly, a radically liberal bloc began making use of the new affordances of a digital communication and media system that had radically disrupted the way information was produced and circulated. One of the better-known recent examples of these practices is Cambridge Analytica, a company created in 2014 by Robert Mercer, a wealthy radical libertarian, to use information and persuasive media to influence the way people think and vote.[14] (Predictably, he was a hedge-fund billionaire waging war on taxation, as Henry had, keeping the continuum alive in the contingent descent into a radical liberalism opposed to democracy.[15]) In 2016, Cambridge Analytica worked together with Facebook (whose data it was mostly built from), the Trump campaign and the Republican Party, to use information and media to *dissuade* Black citizens from voting.[16] The history from 1765 to 2016 is a dizzying one, spanning the Stamp Acts imposed to control information to Cambridge Analytica using information to control people and degrade democracy. Or, from the orchestration of a political system built to circumscribe democracy (because of the fiction of racial difference and the control of land-owning elites) to a digital praxis wielded to distort and bypass democracy. One can spin that history forwards, too, to early 2021, when the consequences of the fusion of radical libertarianism and the new digital architecture for the orchestration of information and media (as exemplified by Facebook) spilled over into the Capitol Building in an effort to directly stop the democratic transfer of power.

Curiously, the Tea Party and the anti-lockdown protests were both in opposition to government measures to protect the health of its populations. In simple terms, this presents what we might term a 'public relations challenge' because it required an argument that ensuring health care is *opposed* to liberty and that the degradation of government *produced* liberty. Hence the astroturfing and the amplification of disinformation and misinformation and 'alternative facts' and conspiracy (often initially about China's supposed purposeful creation of the virus) and spectacle and pseudo-events – all ferociously opposed to government and amplified despite the inescapable reality of a deadly pandemic that *requires* government. Covid-19 presents a difficult limit case for the libertarians because logic dictates that the emergency compels a pausing of liberty to foster the possibility of its continuance. As is now well-known, the ravages of Covid-19 hit a racialised and gendered front-line of essential workers hardest and have amplified the divisions between the propertied and the dispossessed. In the US (as elsewhere) those divisions are often racialised. Defying this reality, the anti-lockdown protests were often simultaneously in favour of white nationalism and against the remnants of social democratic liberalism embodied especially in civil rights. Gun-toting

militias and white nationalist groups surfaced in the protests and one of the signs circulating on digital networks said, simply, 'Liberty or Boogaloo' – that is, give me liberty from government, or racialised violence and civil war will ensue. Certainly, it was less eloquent than Henry, yet it is the continuation across a quarter-millennium of the racist logic that liberty is in opposition to racial equality that is more striking. It reminds us that the histories of slavery, settler colonialism, and territorial dispossessions 'constitute not a singular event but a structure'.[17]

One doleful conclusion to be drawn from these examples and the anti-lockdown protests in particular is that they mark a mutation of the liberal biopolitics that (Michel Foucault taught us) were orchestrated to ensure the utility of populations to a 'necropolitics' unconcerned with the wellbeing of disposable populations. Achille Mbembe's powerful exploration of this necropolitical logic, of a 'political order … reconstituting itself as a form of organization for death', was written before the virus changed our world, but reads as prophetic.[18] Of particular significance has been the 'vaccine apartheid' that has seen the intellectual property of vaccine manufacturers privileged over the health of populations in the myriad states impoverished by the legacies of imperialism and the realities of global capitalism. One can say simply that property and shareholder value necessitate the necropolitical organisation of death. Other states governed by libertarians proselytising for 'herd immunity' and the sanctity of economy over life suffered too. In the so-called 'United Kingdom', for example, the libertarian bloc that pushed for Brexit (as a project of deregulation and white nationalism), and which purposely broke laws to degrade democracy, refused to publish and act upon the results of a pandemic stress test in 2016 and cancelled a parliamentary inquiry into biological security in 2019 because of the escalating costs of the efforts to ensure our 'liberty' from refugees and migrants and pesky regulations on the mobility of capital.[19] As the pandemic hit, the corrupt ruling elite doled out billions to ineffective companies run by relatives and friends.[20] As the saying goes, never let a good crisis go to waste. Racialised capitalism, the deep histories of slavery across the 'black Atlantic', of colonialism, all manifested this necropolitical logic, Mbembe reminds us, and it spreads now from the space of the plantation and colony to become 'the ordeal of the world'.[21]

Our ordeals in recent years – in this descent into a radical liberalism opposed to democracy and mutating into new forms of 'post-fascism' – have been enabled by the control and use of media.[22] The image I have been exploring is one minor node in this broader history. In my own country, the Brexit referendum was won by libertarian groups illegally

controlling and sharing information.[23] Cambridge Analytica (and the Russian Internet Research Agency) became scandalous for controlling and using information in ways that are routine for Facebook. Put simply, these consist of gathering information, mining it for what it reveals, and using this data to make predictions about what people will likely do or think. On Facebook, human sociality is turned into data and capital, and mined to produce influence and control. It is close to the opposite of liberty. In the years since Facebook became popular, in 2007, catalysing too with the breakdown of the neoliberal order from 2008, a newly radicalised libertarian/post-fascist formation has grown globally. Collectively, this formation calls for liberty by building walls and creating 'hostile environments' to keep out desperate refugees and migrants and for the liberty from taxation that contributes to the public good. In the process, our world has descended into the violent nihilism glimpsed in these images celebrating the liberty to bring death to others.

One final and even hopeful conclusion. The reality of imperialising necropolitical violence has historically mostly been kept off screens. I once spent three years watching films made by the British colonial state in pursuit of its imperialising agendas and glimpsed the reality of this violence only once.[24] (In amateur films made by a British soldier in colonial Malaya.) In the disruption of the digital, though, and its reordering of information and reality, the truth of this violence is made newly visible. In May 2020, a month after the protests outside the ice-cream parlour, footage of a racist police officer killing a man named George Floyd in Minneapolis circulated online and sparked further waves of protests against the structural violence of policing that insisted on the revolutionary idea that Black Lives Matter. One can see the spontaneous communal protests as the flipside of the astroturfed media spectacles and pseudo-realities calling for the death of others to realise my liberty. They offer instead glimpses into the possibility of an alternative future. One that breaks the continuum of elite rule, that insists on the importance of social infrastructure beyond markets, and that learns from our younger generations fighting against entrenched racism and accelerating planetary emergencies. One that re-learns from the pandemic the inescapable interconnected fragility of people and of the necessity of generosity and care to live together. Give me liberty (to breathe and exist), not death; defund the institutions that bring death (police forces, border regimes, militaries) and enable those that make possible human flourishing (schools, hospitals); break up a media system parasitic on enmity and division and profiting from informational control; disrupt an economic and political system that directly prioritises profit and property

over people and degrades our shared environments; and let us together imagine and enact a liberty rooted in equality and the in-common.

In memory of my friend and colleague Roland-Francois Lack. With thanks to Jamie Lee Taete; and my lockdown comrades, Lora Brill and Cooper Grieveson-Brill.

Notes

1. Stanley-Becker and Romm, 'Pro-gun activists using Facebook groups'; Mathias, 'The extremists and grifters'.
2. The first of the wealthy Henries significant to this short essay: Huntington Beach, California, was named after Henry Edwards Huntington, owner of the interurban Pacific Electric Railway, built in 1901, as well as substantial real estate holdings.
3. Starr, *The Creation of the Media*, 65–7.
4. Joyce, 'Give me liberty'. In the words of Nikhil Pal Singh, the 'slave-holding regime constructed blackness by way of a biopolitics oriented toward the management of capital and the depletion (and depreciation) of the lives of people whose bodies and labor were essential to its accumulation'. Singh, *Race and America's Long War*, 44.
5. See Slobodian, 'Anti-'68ers and the racist-libertarian alliance', and Doherty, *Radicals for Capitalism*, particularly 339–87.
6. The scholarship on neo-liberalism is (rightly) voluminous, but see here Brown, *Undoing the Demos*.
7. See MacLean, *Democracy in Chains*.
8. Dwight R. Lee, 'The *Calculus of Consent* and the constitution of capitalism', *Cato Journal* 7 (Fall 1987): 331–6; 332, cited in MacLean, *Democracy in Chains*, 81.
9. See also Brown, *In the Ruins of Neoliberalism*.
10. See Wang, *Carceral Capitalism*.
11. See also Grieveson, 'On data, media, and the deconstruction of the administrative state'.
12. Fang, *The Machine*, 83–124; Mayer, *Dark Money*, 165–97, 240–67. I focus here (and throughout) on elite practices – such as the top-down direction of libertarian groups who had long worked to roll back state regulation – but it bears stating that the Tea Party was also part of the bottom-up revolt against governmental elites that became central to the political revolutions of 2016. On the Tea Party from this latter perspective, see Skocpol and Williamson, *The Tea Party*.
13. The term 'pseudo realities' comes from Lippmann, *Public Opinion*, 18. (See the discussion in Grieveson, *Cinema and the Wealth of Nations*, 224–7.) See also Boorstin, *The Image*.
14. Cadwalladr, 'The great British Brexit robbery'; Cadwalladr, 'Follow the data'; Grassegger and Krogerus, 'The data that turned the world upside down'.
15. Cadwalladr, 'Robert Mercer'; and Green, *Devil's Bargain*, 119–36.
16. Green and Issenberg, 'Inside the Trump bunker'.
17. Singh, *Race and America's Long War*, 24–5.
18. Mbembe, *Necropolitics*, 7. See also Foucault, *The Birth of Biopolitics*.
19. Pegg, 'What was Exercise Cygnus'; Carrington, 'UK strategy to address pandemic threat'.
20. See (for example), Byline Times Team, 'Prime Minister Boris Johnson confronted'; Conn and Geoghegan, 'Firm with links to Gove and Cummings'; Busby, 'UK government under growing pressure'; Bradley, Gebrekidan, and McCann, 'Waste, negligence and cronyism: Inside Britain's pandemic spending'. Transparency International UK, an independent anti-corruption organisation, released a report in March 2021 that observed that around 20 per cent of the billions spent by the British state on Covid response contracts 'were allocated in seemingly partisan and systematically biased ways, raising red flags for corruption'.
21. Mbembe, *Necropolitics*, 1. My reference is to my colleague Paul Gilroy's foundational book *The Black Atlantic*.
22. Traverso, *The New Faces of Fascism*.

23 On the Leave.EU and Vote Leave groups' law-breaking, see, for example, Electoral Commission, UK, 'Report on an Investigation'; Elgot, 'Vote Leave fined'; Pegg, 'Vote Leave drops appeal'.
24 The results of the project are available here: http://www.colonialfilm.org.uk.

Bibliography

Boorstin, Daniel J. *The Image: A guide to pseudo-events in America*. New York: Atheneum, 1962.

Bradley, Jane, Selam Gebrekidan and Allison McCann, 'Waste, negligence and cronyism: Inside Britain's pandemic spending', *The New York Times*, 17 December 2020. Accessed 23 May 2022.

Brown, Wendy. *In the Ruins of Neoliberalism: The rise of antidemocratic politics in the West*. New York: Columbia University Press, 2019.

Brown, Wendy. *Undoing the Demos: Neoliberalism's stealth revolution*. New York: Zone Books, 2015.

Busby, Mattha. 'UK government under growing pressure over Covid procurement', *Guardian*, 20 February 2021. Accessed 24 August 2021. https://www.theguardian.com/politics/2021/feb/20/uk-government-under-growing-pressure-over-covid-procurement.

Byline Times Team. 'Prime Minister Boris Johnson confronted about the great procurement scandal', *Byline Times*, 11 November 2020. Accessed 24 August 2021. https://bylinetimes.com/2020/11/11/prime-minister-boris-johnson-confronted-about-the-great-procurement-scandal/.

Cadwalladr, Carole. 'Follow the data: Does a legal document link Brexit campaigns to US billionaire?', *Guardian*, 14 May 2017. Accessed 24 August 2021. https://www.theguardian.com/technology/2017/may/14/robert-mercer-cambridge-analytica-leave-eu-referendum-brexit-campaigns.

Cadwalladr, Carole. 'The great British Brexit robbery: How our democracy was hijacked', *Guardian*, 7 May 2017. Accessed 24 August 2021. https://www.theguardian.com/technology/2017/may/07/the-great-british-brexit-robbery-hijacked-democracy.

Cadwalladr, Carole. 'Robert Mercer: The big data billionaire waging war on mainstream media', *Observer*, 26 February 2017. Accessed 24 August 2021. https://www.theguardian.com/politics/2017/feb/26/robert-mercer-breitbart-war-on-media-steve-bannon-donald-trump-nigel-farage.

Carrington, Damian. 'UK strategy to address pandemic threat "not properly implemented"', *Guardian*, 29 March 2020. Accessed 24 August 2021. https://www.theguardian.com/politics/2020/mar/29/uk-strategy-to-address-pandemic-threat-not-properly-implemented.

Conn, David, and Peter Geoghegan. 'Firm with links to Gove and Cummings given Covid-19 contract without open tender', *Guardian*, 10 July 2020. Accessed 24 August 2021. https://www.theguardian.com/politics/2020/jul/10/firm-with-links-to-gove-and-cummings-given-covid-19-contract-without-open-tender.

Doherty, Brian. *Radicals for Capitalism: A Freewheeling History of the Modern American Libertarian Movement*. New York: PublicAffairs, 2007.

Electoral Commission, UK. 'Report on an investigation in respect of the Leave.EU Group Limited', 11 May 2018. Accessed 9 August 2018, https://publications.parliament.uk/pa/cm201719/cmselect/cmcumeds/363/36302.htm.

Elgot, Jessica. 'Vote Leave fined and reported to police by Electoral Commission', *Guardian*, 17 July 2017. Accessed 24 August 2021. https://www.theguardian.com/politics/2018/jul/17/vote-leave-fined-and-reported-to-police-by-electoral-commission-brexit.

Fang, Lee. *The Machine: A field guide to the resurgent right*. New York: The New Press, 2013.

Foucault, Michel. *The Birth of Biopolitics: Lectures at the Collège de France, 1978–1979*, translated by Graham Burchell and edited by Michel Senellart. New York: Palgrave Macmillan, 2008.

Gilroy, Paul. *The Black Atlantic: Modernity and double consciousness*. London: Verso, 1993.

Grassegger, Hannes, and Mikael Krogerus. 'The data that turned the world upside down', *Motherboard*, 28 January 2017. Accessed 24 August 2021. https://www.vice.com/en/article/mg9vvn/how-our-likes-helped-trump-win.

Green, Joshua. *Devil's Bargain: Steve Bannon, Donald Trump, and the storming of the presidency*. New York: Penguin, 2017.

Green, Joshua, and Sasha Issenberg. 'Inside the Trump bunker, with days to go', *Bloomberg*, 27 October 2016. Accessed 24 August 2021. https://www.bloomberg.com/news/articles/2016-10-27/inside-the-trump-bunker-with-12-days-to-go.

Grieveson, Lee. *Cinema and the Wealth of Nations: Media, capital, and the liberal world system.* Berkeley, CA: University of California Press, 2018.

Grieveson, Lee. 'On data, media, and the deconstruction of the administrative state', *Critical Quarterly* 63, no. 2 (July 2021): 102–19. https://doi.org/10.1111/criq.12613.

Joyce, Frank. 'Give me liberty, give you death', *Counterpunch*, 3 July 2020. Accessed 24 August 2021. https://www.counterpunch.org/2020/07/03/give-me-liberty-give-you-death/.

Lippmann, Walter. *Public Opinion*. London: George Unwin, 1922.

MacLean, Nancy. *Democracy in Chains: The deep history of the radical right's stealth plan for America.* New York: Viking, 2017.

Mathias, Christopher. 'The extremists and grifters behind many of the anti-lockdown protests', *HuffPost*, 22 April 2020. Accessed 24 August 2021. https://www.huffingtonpost.co.uk/entry/extremists-anti-shutdown-protests_n_5ea057f6c5b6b2e5b83b55cd?ri18n=true.

Mayer, Jane. *Dark Money: How a secretive group of billionaires is trying to buy political control in the US*. London: Scribe, 2016.

Mbembe, Achille. *Necropolitics*, translated by Steven Corcoran. Durham, NC: Duke University Press, 2019.

Pegg, David. 'Vote Leave drops appeal against fine for electoral offences', *Guardian*, 29 March 2019. Accessed 24 August 2021. https://www.theguardian.com/politics/2019/mar/29/vote-leave-drops-appeal-against-fine-for-electoral-offences.

Pegg, David. 'What was Exercise Cygnus and what did it find?' *Guardian*, 7 May 2020. Accessed 24 August 2021. https://www.theguardian.com/world/2020/may/07/what-was-exercise-cygnus-and-what-did-it-find.

Singh, Nikhil P. *Race and America's Long War*. Berkeley, CA: University of California Press, 2017.

Skocpol, Theda, and Vanessa Williamson. *The Tea Party and the Remaking of Republican Conservatism*, Oxford: Oxford University Press, 2012.

Slobodian, Quinn. 'Anti-'68ers and the racist-libertarian alliance: How a schism among Austrian School neoliberals helped spawn the Alt Right', *Cultural Politics* 15, no. 3 (November 2019): 372–86. https://doi.org/10.1215/17432197-7725521.

Stanley-Becker, Isaac, and Tony Romm. 'Pro-gun activists using Facebook groups to push anti-quarantine protests', *Washington Post*, 20 April 2020. Accessed 24 August 2021. https://www.washingtonpost.com/technology/2020/04/19/pro-gun-activists-using-facebook-groups-push-anti-quarantine-protests/.

Starr, Paul. *The Creation of the Media: Political origins of modern communications*. New York: Basic Books, 2004.

Transparency International, 'Track and trace: Identifying corruption risks in UK public procurement for the Covid-19 pandemic', March 2021. Accessed 23 May 2022. https://www.transparency.org.uk/sites/default/files/pdf/publications/Track%20and%20Trace%20-%20Transparency%20International%20UK.pdf.

Traverso, Enzo. *The New Faces of Fascism: Populism and the far right*, translated by David Broder. London: Verso, 2019.

Wang, Jackie. *Carceral Capitalism*. South Pasadena, CA: Semiotext(e), 2018.

2
Translating Covid-19 information into Yiddish for the Montreal-area Hasidic community

Zoë Belk, Lily Kahn, Kriszta Eszter Szendrői and Sonya Yampolskaya[1]

In this chapter we will discuss our ongoing work translating Covid-19 information into Yiddish for the Hasidic Jewish[2] communities of London and the Montreal region, with a focus on the latter. We will first examine the sociolinguistic context underpinning the need for these translations and then discuss the actual translation process itself, which necessitated careful consideration of linguistic and cultural issues particular to the needs of the Yiddish-speaking Hasidic community. It is hoped that our documentation of this translation project will draw attention to the ways in which the humanities disciplines of translation studies and linguistics can be harnessed directly in an attempt to mitigate the current Covid-19 emergency, and will provide a case study of how arts and humanities scholarship can contribute to broader society in ways that might not be immediately obvious or predictable.

For the past year we have been working on an AHRC-funded research project on contemporary Hasidic Yiddish based in UCL's departments of Linguistics and Hebrew & Jewish Studies. Yiddish, the traditional language of Eastern European Jews, had around ten to twelve million speakers before the Second World War, but is today considered an endangered language. However, among many of the world's estimated

700 thousand to 750 thousand Hasidic Jews it remains a daily language,[3] with major Yiddish-speaking Hasidic communities in New York, London, Antwerp, Jerusalem, Bnei Brak and Montreal.[4] Present-day Hasidic Yiddish exhibits striking linguistic differences from the traditional pre-war Eastern European dialects of the language as well as from its standardised variety.[5] Nevertheless, despite the intriguing differences in its structure and its central role in the contemporary Yiddish world, very few studies exist on Hasidic Yiddish grammar or language use. Our main aim is to change this situation by providing the first in-depth description of the grammatical and sociolinguistic features characteristic of the Yiddish used by Hasidic communities worldwide, and an analysis of their implications for linguistic theory. Our research team consists of four UCL-based linguists and three research assistants who are native speakers of Hasidic Yiddish from Stamford Hill and Israel.

Since the project began, we have been focusing on collecting linguistic and sociolinguistic data from Yiddish speakers in the main Hasidic centres worldwide, with extended fieldwork conducted in London's Stamford Hill, the New York area and Israel. The Covid-19 pandemic put an abrupt stop to our work as we suddenly found ourselves unable to conduct interviews. Moreover, two of our team members were unexpectedly stranded in Canada at the beginning of the pandemic. We expected that we would spend the lockdown working on written materials and analysing data that we had already collected. However, like everything with this pandemic, things moved very quickly, and we soon found ourselves with an unexpected role to play during the crisis.

All around the globe, Covid-19 has affected various groups of people unequally, even within one country. Especially during the early stages of the pandemic, Hasidic communities appeared to be quite vulnerable when compared to the average incidence of Covid-19 among populations in the UK, USA, Israel and Canada.[6] Hasidic communities are generally extremely tight-knit and members frequently avoid secular sources of information, especially online media. Given the fast-moving situation, health and police guidance started to appear in several waves on online forums, which many in the Hasidic community do not have access to. In any community, it is natural that restrictive and (for some) inconvenient rules can be better adhered to if the authorities provide clear and transparent guidance as to why they have been put in place. We thus decided that we had a role to play in making such advice available in an accessible format, and immediately contacted the NHS, the Metropolitan Police and Hackney Council with an offer to provide them with a Yiddish translation of their Covid-19 guidance for the Stamford

Hill Hasidic community. All three institutions were enthusiastically supportive of our endeavours.

Our team members in Canada were uniquely placed to provide similar assistance to Hasidic communities there. They heard that, due to an acute outbreak of Covid-19, a Hasidic community in the Montreal area was to be subject to a lockdown order, closing the neighbourhood off from the surrounding region.[7] This extreme and unprecedented situation understandably caused concern among the residents of the community in question, and these team members contacted public health authorities in the area, offering their assistance in translating relevant guidance.

The Hasidic community of Kiryas Tosh, near Montreal, Quebec, Canada, comprises approximately three thousand people, the majority of whom are Yiddish-speaking. It is geographically separated from its neighbours, with only one road in and out. Moreover, many in the community find written Yiddish more comfortable and accessible than written English. It is clear that a strong flow of information is a key means for all of us to shift our daily routines drastically to this new emergency mode of living, and that communication between public health authorities and the Hasidic community in Kiryas Tosh would gain clarity if it were conducted in Yiddish.

We decided to translate the official guidance into colloquial Hasidic Yiddish, a generally spoken variant of the language employing vocabulary, grammar and expressions that are perhaps surprising to the eyes of a trained Yiddishist accustomed to the literary version of the written language. Our translation process was a team effort, with one native speaker of Israeli Hasidic Yiddish and one linguist producing the first draft, which was then checked with the other members of the team. Two of these are native speakers of Stamford Hill Hasidic Yiddish, who scrutinised the text to make sure that it reflected vocabulary and usage characteristic of Hasidic Yiddish in an English-language-majority setting rather than that of Israel.

Although there is a high degree of linguistic similarity between the various Hasidic Yiddish-speaking communities around the world, there are also a number of noteworthy differences. Some of these raised interesting questions during the translation process. For example, although Hasidim in Stamford Hill are exposed to English on a regular basis, the linguistic context in Kiryas Tosh is more complicated. Yiddish is used as a lingua franca throughout the Hasidic world, and for many North American speakers (particularly men) Yiddish is the primary language. Hasidim in the Montreal area tend to be educated in Yiddish for religious subjects and in French for secular subjects, particularly at the primary

school level. However, there is a lot of community contact between Hasidim in the Montreal and New York areas, so many people acquire Hasidic English as an additional language. Notably, Montreal does not have any Yiddish-language publications of its own, so Yiddish media used in Montreal tend to be published in the New York area, reflecting linguistic trends of those communities.

Although Yiddish has a rich literary tradition, today it is largely used as a spoken or colloquial medium in Hasidic communities. Technical and medical vocabulary tends to be borrowed from English in English-majority countries, and from Hebrew in Israel. Thus, our Israeli team member sometimes employed Hebrew-derived vocabulary, while our Stamford Hill team members were often unfamiliar with these and would instead use a Germanic equivalent, or in certain cases an English loanword. However, we were wary of reflecting contemporary Hasidic usage in this respect, because English loan words are not necessarily accessible for all Hasidic Yiddish speakers: some speakers speak very little English, either because they have moved to Kiryas Tosh from a non-English-majority country (typically Israel or Belgium), or because their education has not exposed them to very much English. We therefore needed to strike a balance between using words derived from historical and non-Hasidic varieties of Yiddish, which might not be used very often if they relate to technical or medical terminology, and using English or Hebrew borrowings, which might be more precise but might equally exclude a number of potential readers. One way we tried to solve this problem was by providing a translation of technical and medical vocabulary in Yiddish and its equivalent in English in parentheses. This approach was informed by our field research, in which we found that the use of chains of synonyms is a typical discourse tool for oral and especially written forms of modern Hasidic Yiddish. Thus, in our translations we provided Yiddish terms such as עפּירג *gripe* (flu) and רעביפּ *fiber* (fever) alongside their English equivalents in parentheses. Hasidic speakers use both traditional Yiddish words and English borrowings for these concepts (often depending on sociolinguistic factors such as speaker gender and linguistic history), and providing bilingual synonyms increased the much-needed clarity of the instructions.

As with any translation, we sometimes had difficulty finding an appropriate Yiddish translation for certain English or French words. One example is the word *community*, which has several possible translations in Yiddish. In English, this word can be used as an abstract noun denoting a group sharing certain social, religious, ethnic or other characteristics, or in the more concrete sense of the locality inhabited by such a group. In

Yiddish, *community* is most readily translated as קהילה *kehile,* a word from the Hebrew-Aramaic component of the language. However, this word is strongly associated with the Haredi (strictly Orthodox) Jewish religious community, rather than a social group in general. Thus, it is inappropriate to translate a sentence such as 'movement into and out of your community is restricted' using קהילה *kehile,* as it suggests that entry into the (conceptual) Haredi religious community is restricted. In such instances where the concrete meaning of *community* (in other words, 'locality') was required, we used the word דאָרף *derfl* (village) (which is the term that inhabitants of Kiryas Tosh use for their locality). An alternative, געגנט *gegnt* (area, neighbourhood), was used when a more general locality was intended, for example, Kiryas Tosh and the neighbouring secular city of Boisbriand. Additionally, קהילה *kehile* is inappropriate when talking about groups other than Haredi Jews, so another alternative was needed when referring to social groups outside of Kiryas Tosh. In such instances, we used געמיינדע *gemeynde* (community), which comes from the Germanic component of Yiddish and is less strongly associated with the Haredi community. Consequently, when referring to communities outside of Kiryas Tosh that were also affected by quarantine orders, געמיינדע *gemeynde* was preferred over קהילה *kehile.* These issues provide insight into the roles of the Hebrew-Aramaic and Germanic components of Yiddish, as well as the intricate pattern of connotations of such a high-frequency English word.

As well as these regional challenges, there were also interesting issues relating to the formulation of understandable Yiddish versions of certain key terms. For example, the phrase 'social distancing' has only recently come onto the radar of English speakers and lacks a recognised Yiddish counterpart. In this case, the team used the Yiddish phrase מענטשלעכע דערווײַטקייט *mentshlekhe dervaytkayt* (personal distancing), which conveys the sense of the original and has a relatively transparent meaning. We also favoured this term because the word מענטשלעך *mentshlekh* (personal, human, humane) has the connotation of behaving decently and considerately, which is a key concept in Hasidic society. One particularly memorable discussion involved arguably the most important word in the entire translation project, 'cough'. There are two variants of the verb 'cough' in Yiddish, הוסטן *hustn* and היסן *hisn,* both of which are in use in the Hasidic world. Different members of the research team, as well as other Hasidic Yiddish speakers with whom we consulted, had particularly strong opinions about which was the correct one to use, and it was important to come to a satisfactory solution for such a crucial word

in the context of the information we were trying to convey! In the end, we adopted וטסוה‎ *hustn* due to the impression that it was more widely recognised, and also employed the strategy of providing the English equivalent in parentheses.

In addition to the linguistic issues concerning the translation, there were also cultural factors to be taken into account. One of the main priorities for our translation process was to ensure that the Yiddish text we produced was culturally appropriate to the Hasidic community in question and did not contain any renderings which might be insensitive to the concerns of the target audience.[8] Translating an order sealing off a whole community was intimidating, especially since Hasidim often feel threatened by the secular communities surrounding them. Additionally, for Hasidic Jews the ghettoes of the Holocaust are a very real and recent cultural memory. We were therefore acutely aware that we needed to be very careful with the tone of the quarantine notice. We worked hard to find ways of expressing the guidance and rules contained in the health authority's communications that were clear and easy to understand without frightening community members or straining relations between Kiryas Tosh and their secular neighbours. In our translation, we emphasised that Kiryas Tosh was one of several communities experiencing such an acute outbreak of Covid-19 and therefore subject to strict orders controlling movement into and out of the area. Additionally, while words like *contrôles policières* might sound concerning in French but understandable in the context of a global pandemic, for a Hasidic community being told that entry and exit to their community would be controlled by police checkpoints is downright terrifying. Therefore, instead of translating 'police checkpoints', we warned that police officers would be positioned at the entrance to the community to make sure that public health orders were being followed. During and after the translation process, we were also in contact with members of the Kiryas Tosh community and with public health officials to explain each group's concerns. We found that both groups were keen to work together and were understanding of the issues at hand.

It has been a very moving experience producing these translations, and even more so to finalise the translation of the notice opening the community at the end of their quarantine.[9] We were truly honoured to be able to help during such a difficult time, and we hope that the translations not only helped keep people safe, but also served as a bridge for communication between Kiryas Tosh and their secular neighbours.

Notes

1. We thank Eli Benedict, Izzy Posen and Noah Ley for help with the translations and for discussions. We gratefully acknowledge the financial support of the UKRI Arts and Humanities Research Council and the Leverhulme Trust.
2. This term refers to adherents of the Hasidic spiritual movement, which is a Haredi (strictly Orthodox) Jewish group following specific rabbinic dynasties which trace themselves back to various geographic locations in eastern Europe.
3. Biale et al., *Hasidism*; Isaacs, 'Contentious partners', 58; Comenetz, 'Census-based estimation', 13.
4. See Wodziński, *Historical Atlas of Hasidism*.
5. See, for example, Krogh, 'How Satmarish is Haredi Satmar Yiddish?'; Krogh, 'How Yiddish is Haredi Satmar Yiddish?'; Assouline, *Contact and Ideology*; Sadock and Masor, 'Bobover Yiddish'; Belk et al., 'Complete loss of case and gender'.
6. See, for instance, Bateman, 'Coronavirus: Israel's Ultra-Orthodox lockdown'; Baxter, 'How New York's Hasidic Jewish community'; Goldstein, 'Data shows which New York City neighborhoods'; Hutton, 'How a Haredi community in London'; Stack, '"Plague on a biblical scale"'.
7. See Shingler, 'Hasidic community in Boisbriand under quarantine'.
8. See Nida, 'Principles of correspondence'; Nida and Taber, *The Theory and Practice of Translation*; Vermeer, 'Skopos and commission in translational activity'; Bassnett and Lefevere, *Translation, History and Culture*; Pym, *Exploring Translation Theories*; Toury, *Descriptive Translation Studies*, 17–34, for discussion of cultural considerations in translation.
9. Laframboise, 'Coronavirus: Quarantine lifted'.

Bibliography

Assouline, Dalit. *Contact and Ideology in a Multilingual Community: Yiddish and Hebrew among the Ultra-Orthodox*. Berlin: Mouton De Gruyter, 2017.

Bassnett, Susan and Andre Lefevere, (eds). *Translation, History and Culture*. London: Pinter, 1990.

Bateman, Tom. 'Coronavirus: Israel's Ultra-Orthodox lockdown challenge'. *BBC News*, 7 April 2020. Accessed 12 August 2021. https://www.bbc.co.uk/news/av/world-middle-east-52189059.

Baxter, Holly. 'How New York's Hasidic Jewish community was completely changed by coronavirus', *Independent*, 5 June 2020. Accessed 12 August 2021. https://www.independent.co.uk/independentpremium/long-reads/ultra-orthodox-coronavirus-new-york-brooklyn-hasidic-antibodies-lockdown-a9537556.html.

Belk, Zoë, Lily Kahn and Kriszta Eszter Szendrői. 'Complete loss of case and gender within two generations: Evidence from Stamford Hill Hasidic Yiddish', *Journal of Comparative Germanic Linguistics* 23 (2020): 271–326. https://doi.org/10.1007/s10828-020-09119-9.

Biale, David, David Assaf, Benjamin Brown, Uriel Gellman, Samuel Heilman, Moshe Rosman, Gadi Sagiv and Marcin Wodziński. *Hasidism: A new history*. Princeton, NJ: Princeton University Press, 2018.

Comenetz, Joshua. 'Census-Based estimation of the Hasidic Jewish population', *Contemporary Jewry* 26 (2006): 35–74. https://doi.org/10.1007/BF02965507.

Goldstein, Joseph. 'Data shows which New York City neighborhoods were hit the hardest'. *New York Times*, 21 August 2020, p. A5.

Hutton, Grey. 'How a Haredi community in London is coping with coronavirus – photo essay'. *Guardian*, 26 May 2020. Accessed 12 August 2021. https://www.theguardian.com/world/2020/may/26/how-a-haredi-community-in-london-is-coping-with-coronavirus-photo-essay.

Isaacs, Miriam. 'Contentious partners: Yiddish and Hebrew in Haredi Israel', *International Journal of the Sociology of Language* 138 (1999): 101–21.

Krogh, Steffen. 'How Satmarish is Haredi Satmar Yiddish?' In *Leket: Yiddish studies today*, edited by Marion Aptroot, Efrat Gal-Ed, Roland Gruschka and Simon Neuberg, 483–506. Düsseldorf: Düsseldorf University Press, 2012.

Krogh, Steffen. 'How Yiddish is Haredi Satmar Yiddish?' *Journal of Jewish Languages* 6, no. 1 (Spring 2018): 5–42. https://doi.org/10.1163/22134638-06011143.

Laframboise, Kalina. 'Coronavirus: Quarantine lifted for Boisbriand's Hasidic Jewish community', *Global News,* 22 April 2020. Accessed 12 August 2021. https://globalnews.ca/news/6851887/boisbriand-tosh-quarantine-end-coronavirus/.

Nida, Eugene A. 'Principles of correspondence'. In *The Translation Studies Reader,* edited by Lawrence Venuti, 3rd ed., 141–55. London: Routledge, 2012.

Nida, Eugene A. and Charles R. Taber. *The Theory and Practice of Translation.* Leiden: Brill, 2003.

Nove, Chaya. 'The erasure of Hasidic Yiddish from 20th-century Yiddish linguistics', *Journal of Jewish Languages* 6, no. 1 (Spring 2018): 111–43. https://doi.org/10.1163/22134638-06011142.

Pym, Anthony. *Exploring Translation Theories.* London: Routledge, 2010.

Sadock, Benjamin, and Alyssa Masor. 'Bobover Yiddish: "Polish" or "Hungarian?"' *Journal of Jewish Languages* 6, no. 1 (Spring 2018): 89–110. https://doi.org/10.1163/22134638-06011133.

Shingler, Benjamin. 'Hasidic community in Boisbriand under quarantine after COVID-19 outbreak', *CBC News,* 30 March 2020. Accessed 12 August 2021. https://www.cbc.ca/news/canada/montreal/tash-boisbriand-covid-19-1.5514517.

Stack, Liam. '"Plague on a biblical scale": Hasidic families hit hard by virus', *New York Times,* 21 April 2020. Accessed 12 August 2021. https://www.nytimes.com/2020/04/21/nyregion/coronavirus-jews-hasidic-ny.html.

Vermeer, Hans. 'Skopos and commission in translational activity'. In *The Translation Studies Reader,* edited by Lawrence Venuti, 3rd ed., 191–202. London: Routledge, 2012.

Toury, Gideon. *Descriptive Translation Studies – and Beyond,* 2nd ed. Amsterdam: John Benjamins, 2012.

Wodziński, Marcin. *Historical Atlas of Hasidism.* Princeton, NJ: Princeton University Press, 2018.

3
Shakespeare and the plague of productivity

Harvey Wiltshire

Even before Boris Johnson declared that the United Kingdom was entering a period of lockdown, on 23 March 2020, claims that Shakespeare penned *King Lear* during the plague of 1606 were beginning to be deployed as a call to arms for our own quarantine-time productivity. On 14 March, for example, *The Atlantic* published Daniel Pollack-Pelzner's article 'Shakespeare wrote his best works during a plague', in which an expected period of social isolation attending Covid-19 is prospectively framed as an opportunity for creativity, innovation and productivity.[1] Either side of the Atlantic, enforced social distancing and 'Stay-at-home' directives appeared to herald a rare chance to rebalance the work–life equation and to embrace a period of more personal and pleasurable forms of productivity; for example, Bonnie McCarthy, of the *Los Angeles Times*, remarked that whilst 'Shakespeare wrote "King Lear" while quarantined during the plague', she was alternatively considering that 'a sourdough starter' might be her own 'magnum opus (with a happier ending)'.[2] And yet, at the same time that Shakespeare's plague-time output was being co-opted into calls to capitalise on the expected free time afforded by lockdown, this feat of resourcefulness began to be ironised online, giving voice to a palpable backlash against the fetishisation of labour and productivity.

As illustrated in Nick Martin's article, 'Against productivity in a pandemic', in *The New Republic,* and Dan Falk's *Scientific American* article

'Must we all become more creative because of the pandemic?' – both of which make reference to Shakespeare's plague-time writing – the expectation that lockdown would and should incite individual hyperproductivity was met with mocking resistance:

> ... *you can actually get a lot done in home isolation*! Did you know Shakespeare wrote *King Lear* while he was quarantined during the plague? Have you tried baking as a form of corona therapy? How about turning your living room into a home gym using soup cans for hand weights?[3]

As Martin goes on to suggest, the expectation that we all capitalise on coronavirus represents 'the natural endpoint of ... hustle culture – the idea that every nanosecond of our lives must be commodified and pointed toward profit and self-improvement'.[4] Experienced in real time, the realities of and responses to coronavirus can be seen precipitating and hardening the individualising forces of neo-liberalism, both against which and in support of which declarations of Shakespeare's plague-time output have been deployed.

As an early career scholar, several years of precarious employment within British academia – during which the University and College Union has waged repeated strikes against the marketisation of higher and further education, and sought to secure a new settlement for increasingly overworked and often underpaid educationalists – has entirely skewed my own relationship to academic productivity, engraining a fraught awareness of the value of my labour and the almost ubiquitous necessity of various forms of privilege to bridge the gulf between graduate studies and professional academia. With my own research falling into the field of Shakespeare and renaissance studies, that *King Lear* was being cited online as a reason to exploit lockdown as a period of intense, individual productivity felt as potent as it did discouraging.

At the moment that lockdown appeared to promise those living in relative financial comfort and secure employment a welcome gear change from the daily grind, references to Shakespeare's own modes of production gave people an opportunity to both promote and contest societal expectations and the late-capitalist amplification of the Protestant work ethic:

> Isaac Newton discovered gravity. Shakespeare had nothing better to do and wrote 'King Lear' and 'Macbeth'. Those guys didn't even have Wi-Fi. You do, plus extra time. Be productive[5]

> If this pandemic is a golden opportunity for you to write the next King Lear, congratulations! But lots of us are just trying to get through the day without the added pressure of having to be creatively productive :)[6]

Sitting in the middle of these two contrasting takes on what Shakespeare's labour means for our own historical moment, some took direct aim at both ends of the spectrum:

> The prescriptive self help feelgood bullshit of 'You Don't Need To Be Productive' pieces is reaching a volume that makes them as loathsome as the 'King Lear' hustle culture assclowns. How about, just: You really Don't Need To Tell People How To Live[7]

In a fundamental way, these tweets have absolutely nothing to do with Shakespeare; the memeification of *King Lear*'s plague-time context and Shakespeare's quarantine labour is entirely secondary to their role as vehicles for commenting on twenty-first-century productivity. And yet, these comments have coalesced around Shakespeare, unavoidably drawing him and his work into dialogue with our own cultural moment. As such, this phenomenon gives rise to a series of questions that speak to the specific exigencies of this global pandemic and the forces of individualisation, as well as public interest in and the reception of Shakespeare as a cultural figure. How and why does Shakespeare enable us to reflect on our experience of productivity during a pandemic, and what does this tell us about Shakespeare's role in contemporary online discourse?

Foremost amongst these social media references to the circumstances in which Shakespeare wrote *King Lear*, Rosanne Cash – daughter of country music legend Johnny Cash – tweeted 'Just a reminder that when Shakespeare was quarantined because of plague, he wrote King Lear' (@rosannecash, 14 March 2020). Since then, Cash's tweet has been liked nearly a quarter of a million times and has been quoted or retweeted over fifty-nine thousand times, making it both the most liked and the most retweeted Twitter post referring to *King Lear* in the history of the platform. In fact, whilst delving into the murky depths of Twitter analytics is far from straightforward, it also appears that Cash's *King Lear* tweet may well be the most liked tweet referring to any single play by Shakespeare and the third most acknowledged tweet referring to Shakespeare in any capacity. Whilst this factoid had begun to circulate some days earlier, such as in Chris Jones's *Chicago Tribune* article

published on 11 March, Cash's tweet certainly brought this idea to its widest audience.[8] What is striking about this tweet is that attention was drawn to both the circumstances and the mode of production of one of Shakespeare's plays, rather than a concentrated sense of what the play is about governing its cultural significance. Which is to say, in 2020, *King Lear* has become the play written by Shakespeare during a period of plague-enforced theatre closure, rather than it being the play about an ageing king, inheritance, unruly daughters or filial ingratitude.

Of course, such statements are more a comment on our own attitudes towards productivity than Shakespeare's, but this moment of transhistorical recognition has inevitably brought the literary processes of writing and the circumstances of textual production into focus; the specific material and cultural conditions in which Shakespeare's plays were not only conceived but also those in which they would have been written became temporarily more important than the play's plot. At the same time that Shakespeare's labour prompted a brief moment of twenty-first-century self-scrutiny, a small aspect of his experience as a writer appeared to become tangible through our own lockdown battles with motivation and the circumstances and precariousness of our work.

The picture created, of Shakespeare hunkering down to both avoid contracting the plague and exploit the pressures created by the closure of the London theatres, has proved to be as powerful as it is partial. But this has, in turn, prompted important questions relating to how both Shakespeare and Shakespeare's plays are consumed and conceptualised during a global pandemic and in an internet age.

It can be roughly estimated that between 1603 and 1613, which essentially marks the last decade of Shakespeare's writing career, London's theatres would have been closed for significantly over 50 per cent of the time, which suggests that writing during some degree of restriction on public performance was a routine circumstance for Shakespeare. Much has also been written about Shakespeare's turn to penning narrative poetry during the extremely deadly plague of 1592/3, and certainly *Venus and Adonis* and *The Rape of Lucrece* bear linguistic traces of the contagious circumstances in which they were written. In *Venus and Adonis*, for example, Venus's amorous advances on the unwilling Adonis are depicted as a form of plague therapy:

> Long may they kiss each other, for this cure!
> O, never let their crimson liveries wear!
> And as they last, their verdure still endure,
> To drive infection from the dangerous year!

That the star-gazers, having writ on death,
May say, the plague is banish'd by thy breath.⁹

However, when we begin to see that urban epidemics were far more routine during Shakespeare's lifetime than they are now, one might be led to reframe the importance of specific periods of plague to individual plays. Undoubtedly, the forced closure of the theatres during the early 1590s afforded Shakespeare both time and financial motivation to set his pen to writing long, Ovidian-inspired poetry, but that should not obscure how likely it is that his primary concern was to exhibit his skill in writing genre poetry in response to fairly public criticism of his ability as a writer. Early in his writing career, the dedication of poetry to a significant literary patron – Henry Wriothesley, 3rd Earl of Southampton – feeds into our sense of Shakespeare's desire to solidify his reputation and, possibly, his financial position; however, ten years later, during the period in which Shakespeare wrote his great tragedies, including *King Lear*, the need for this kind of patronage will have been far less acute. By 1606, Shakespeare was a shareholder in the acting company The King's Men and joint owner of the Globe Theatre, and will have derived significant income from both writing plays and performance revenue. We know, also, that he was wealthy enough to purchase New Place, in Stratford, in 1597, to share in a 107-acre land investment in 1602, and to purchase a tithe share in 1605. By the time Shakespeare wrote *King Lear*, he was a wealthy man. However, even this information paints a slightly misleading image, as significant investments during Shakespeare's lifetime will not have necessarily meant ready access to cash during the closure of the theatres.

So too, we have very little insight into Shakespeare's practice as a writer. Give or take some lost plays and collaborations with contemporary playwrights, we know that Shakespeare penned roughly 38 plays in around two decades. During the 1630s, the dramatist Richard Brome was unable to fulfil his contract to write three plays a year for the Salisbury Court Theatre in London, which casts Shakespeare's own output in a positive light. As for how Shakespeare wrote his plays, even less evidence survives. None of Shakespeare's working papers for his canonical plays have endured. In the observation by John Heminge and Henry Condell – the editors of the first folio, the first collection of Shakespeare's plays, printed in 1623 – that Shakespeare's 'mind and hand went together', that 'what he thought, he uttered with that easiness, that we have scarce received from him a blot in his papers', the likely realities of Shakespeare's writing process are obscured by a more appealing, if ultimately specious, sense of the effortlessness and conviction with which he wrote.¹⁰ Such

statements speak more to the mythology of Shakespeare's genius than they do the actual exigencies of his writerly craft. Likewise, when, in the epilogue chorus to *Henry V*, we are offered an image of the 'bending author', hunched and straining to capture his story with a 'rough and all-unable pen', an enticing image of Shakespeare uncomfortably labouring to set his thoughts on paper jars against the clear false humility, downplaying the author's achievements, that is so common in the dedications and invocations of this period.[11]

That so many tweets and retweets have perpetuated the idea that Shakespeare made productive use of Jacobean plague restrictions in writing *King Lear* is fascinating because it solidifies a sense of how and when the play was written that is only partially supported by scholarly evidence. So little in the play itself gestures to the contagious circumstances in which it may have been penned that it is hard to say if the plague was simply so ubiquitous it was not worth mentioning or if this was, in fact, not the context of its conception and production at all. In these tweets we see, therefore, a slippage between fact and fiction, between biography and mythology. But the tweets also go some way in reminding us which of these categories wields the most influence. In the context of promoting a sense of Shakespeare's output, even if in order to critique the pressures placed on our own productivity, the coalescing of content and form conveyed in these tweets adds another complicating layer to what they say about our current culture's relationship to productivity, as Shakespeare's playwriting becomes tied to the endless and accumulating micro-productivities that Twitter allows. As Stephen O'Neill observes, when it comes to social media, 'participation is not reducible to production but can entail such activities as liking, favouriting, evaluation, and recirculation'.[12] If Shakespeare did indeed write *King Lear* during a lockdown, perhaps tweeting or retweeting marks the new limit of our own creative output in a time of widespread overwork and burnout. Shakespeare's cultural cachet and the seemingly endless iterability of quotations from his plays and pithy facts about his life appear to offer an enticing hook on which to hang our own sentiments about the world we experience.

During this period of restriction on the movement of individuals, both locally and internationally, and the hardening of geopolitical identities and borders relating to ideological and practical differences in responses to the pandemic, our current cultural moment offers perhaps a more fitting and timely reminder that *King Lear* is also a play that examines both national partition – 'the division of the kingdom' – and social division – 'brothers divide' (1.2.107); 'division betwixt the Dukes'

(3.3.8–9).¹³ At the same time, it depicts – through the ravings of Lear – the consequences of baring one's body and mind to the world around us: 'unaccommodated man is no more but such a poor, bare, forked | animal as thou art' (3.4.105–6). The American literary critic Frederic Jameson frames both late capitalist spatiality and postmodern subjecthood as a condition of being 'exposed to a perceptual barrage of immediacy from which all sheltering layers and intervening mediations have been removed'.¹⁴ Both vulnerable and 'exposed', but also isolated and protected by limitations on movements, the postmodern lockdown subject seems to be simultaneously defined by previously unimaginable levels of separation but also degrees of technological connectivity that camouflage the forces of individualisation and alienation that increasingly define the age in which we live.

Notes

1. Pollack-Pelzner, 'Shakespeare wrote his best works during a plague'.
2. McCarthy, 'In these trying times'.
3. Martin, 'Against productivity'.
4. Martin, 'Against productivity'.
5. @WSJopinion, 30 March 2020.
6. @michelleruiz, 9 April 2020.
7. @weareyourfek, 4 April 2020.
8. Jones, 'The AIDS era. 1606 London'.
9. Shakespeare, 'Venus and Adonis', 505–10.
10. John Heminge and Henry Condell, 'To the Great Variety of Readers'.
11. Shakespeare, *Henry V*, 5.Epilogue.1–2.
12. O'Neill, 'Shakespeare and Social Media', 275–6.
13. Shakespeare, *King Lear*, 1.1.4–5. All references are to this edition and will be provided in parentheses.
14. Jameson, *Postmodernism*, 413.

Bibliography

Falk, Dan. 'Must we all become more creative because of the pandemic?'. *Scientific American*, 29 March 2020. Accessed 29 July 2022. https://blogs.scientificamerican.com/observations/must-we-all-become-more-creative-because-of-the-pandemic.

Jameson, Frederic. *Postmodernism; Or, the cultural logic of late capitalism*. London: Verso, 1991.

Jones, Chris. 'The AIDS era. 1606 London. A crisis can reshape the arts. Will the coronavirus change our current artistic moment?', *Chicago Tribune*, 11 March 2020. Accessed 16 November 2020. https://www.chicagotribune.com/coronavirus/ct-ent-coronavirus-change-arts-0315-20200311-nfmvrjngdjctlcpvhh5atfzv6y-story.html.

Martin, Nick. 'Against productivity in a pandemic', *The New Republic*, 17 March 2020. Accessed 16 November 2020. https://newrepublic.com/article/156929/work-home-productivity-coronavirus-pandemic.

McCarthy, Bonnie. 'In these trying times, my sourdough starter is a mundane miracle', *Los Angeles Times*, 15 April 2020. Accessed 16 November 2020. https://www.latimes.com/lifestyle/story/2020-04-15/this-sourdough-starter-is-a-symbol-of-hope.

O'Neill, Stephen. 'Shakespeare and social media', *Literature Compass*, 12 (2015): 274–85.

Pollack-Pelzner, Daniel. 'Shakespeare wrote his best works during a plague', *The Atlantic*, 14 March 2020. Accessed 16 November 2020. https://www.theatlantic.com/culture/archive/2020/03/broadway-shutdown-could-be-good-theater-coronavirus/607993/.
Shakespeare, William. *Henry V*. Edited by T. W. Craik. London: The Arden Shakespeare, 1995.
Shakespeare, William. *King Lear*. Edited by R. A. Foakes. London: The Arden Shakespeare, 1997.
Shakespeare, William. 'Venus and Adonis'. In *Shakespeare's Poems*, edited by Katherine Duncan-Jones and H. R. Woudhuysen, 505–10. London: The Arden Shakespeare, 2007.

4
The decolonial option and the end of the world
Izabella Wódzka

Eurocentrism is a question not of geography but of epistemology.[1]

Is this the end?

The outbreak of Covid-19 in early 2020 brought with it an array of feelings, attitudes and new challenges. We have witnessed a great deal of uncertainty, with a pinch of dark humour, as people are trying to make sense of this new situation in which we are left drifting in isolation from other human beings. Some prophesy that the pandemic, hand in hand with an economic crisis, stands for the end of the world as we know it; that the neoliberal capitalist system will be replaced by something else, but what exactly that would be remains unknown. Personally, I do not believe that this is the end – Francis Fukuyama had already declared the end of history in 1992 with the fall of the Soviet Union, yet we are still facing crises of liberal democracy across the globe. Rather like the Polish writer Olga Tokarczuk, I see the current situation as an inevitable transformation that was bound to happen, and above all, a beginning of something new.[2] Thus, I do not think that we live in the end times, but instead I would argue that we live in transformation times. What kind of a new world and new modes of living will emerge from this is largely up to us, humans.

In what follows, I would like to consider new, radical modes of being, those that dwelled before the crisis at the borders of the vast ocean of human thought. The humanities (and arts), with their fluidity, flexibility and ever-expanding horizon of definitions and categories, represent the perfect sea of intellectual ferment in which to fish for epistemologies that can help us make sense of the tumultuous times of transformation. While scientists are tirelessly testing and improving the existing Covid-19 vaccines, humanists, and not only them, are here to offer a more spiritual relief. They offer visions of what could be built on the ruins of the old system, a selection of concepts, ideas and narratives to ponder on, and perhaps, implement. In my own research I have encountered many such notions but the one that stood out to me most was a set of ideas termed the decolonial option. Building on previous knowledge, both Western and non-Western, the decolonial option is not a theory; it is not a single way of doing and understanding the world; rather it is exactly what it calls itself. It is an option, among many other possible ones, that invites us to imagine a world of interconnected communities, a world of pluriversal possibilities, non-linear timelines and non-hegemonic heterarchies. I like to visualise the decolonial option as a rhizomatic network of intertwined and intersectional approaches to reality. To better illustrate how this set of ideas can be applied in practice, I look at a short video by a group of Polish artists, reading it as a contextualised embodiment of the decolonial option at work, and an example of how intercultural and intersectional alliances can be forged in order to create more inclusive, diverse spaces and timelines. I argue that the video performance is a short but important contribution not only to the decolonial option, but also to border thinking which occupies liminal spaces between the centre and the margins, and between various cultures, nations and epistemologies. What is more, I use the decolonial option as my main analytic tool, taking the concept as both an object of my study and a methodological lens. Walking in the footsteps of such scholars as Anibal Quijano, Walter Mignolo and Madina Tlostnova, I infuse decolonial thought with a specific post-Soviet context to bring into the discussion a second-world perspective. But above all, I propose this short video to be a starting point for an alternative dialogue between the humanities and the human beings.

'The year I stopped making art'

On one particularly gloomy London day during lockdown I came across a short video on YouTube, posted by Wojtek Rodak.[3] I had never heard of him, neither was I familiar with the text which he used for his project, 'The year I stopped making art' (Figures 4.1–4.4). Soon enough, I was informed by my friend who works in the field of art history, that the video had generated some noise in the Polish cultural scene and several newspapers had written about Rodak's project. I decided to watch it and I was instantly struck by its uncompromising qualities. It is a video project which does not bow to political correctness or the newest trends, it is simple yet powerful, and it blends various formal techniques experimenting with textures, sounds and voices, filters and other digital resources. In short, the video is a compilation of home-recorded footage, lasting around 15 minutes, presenting young Polish artists reciting 53 lines (for 53 weeks of the year, as 2020 had) of a text written originally by the French artist Paul Maheke.[4] The video performance, available in Polish with English subtitles, as well as the original text, were both prompted by the pandemic and the ensuing global crisis. They are not, however, directly commenting on the health emergency itself, but instead turn our attention to the underlying roots of global inequalities, the failures of the current (and previous) systems to address this, and the resultant matrix of the pandemic combined with the structural and systemic issues. The rough, home-made quality of the video, its simplicity combined with the almost-lyrical text, give a powerful testimony to the possibilities we are afforded even during the pandemic, and ultimately, the power of humanities and arts, and their impact on the world.

Making use of the available digital technology, Rodak asked several Polish artists to send over recordings of themselves, each reciting one or two lines of the text. He then edited and combined them to create the final video performance. Every sequence is different and deeply personal: some participants recorded themselves casually lying on the bed or smoking a cigarette. Others staged micro performances making use of daily objects or using filters to change their faces. Some opted for extreme close-ups on their faces and moving lips while speaking, others used voice over while lying or sitting still with the camera firmly positioned on a tripod. Yet another person decided to literally play their line on a synthesiser while another dressed up as a zombie construction-site worker. Others decided on abstract collages, surprising costumes, video installations or small performances.

The textual levels are as rich and varied as their visual interpretations. The text pertains to an array of issues that prevented the subject from becoming an artist. Its timeline is non-linear, and its spatial anchoring spans the entire globe, cutting across different historical events, regions, traditions, cultures, sexualities and genders. The subject always speaks in the first person, eliciting an emotional response from the viewer.

> One day, it felt like the ground went missing and there was nothing below to prevent the fall from happening. This was the year I came out as trans. This was the year I had to pay for my gender-affirming surgery. This was the year I got scapegoated and shit-talked.

The subject matter jumps freely between various personas and problems, but always focusing on things that prevented them from being an artist or pursuing an artistic career path. It lays bare the banality of it, the obstacles invisible to those who come from privileged backgrounds, those lucky to have a 'safety net or support structure' to help them cope with unpredicted crises such as the recent pandemic. The artists draw our attention to things like unpaid taxes, mounting bills, childcare, mental health issues, unpaid work, slavery and sexual harassment, to mention just a few, and they range from mundane, seemingly unimportant details ('The year I stopped making art is the year my secondary school teacher decided I would make a good factory technician') to ones that refer to larger historical events ('It was 1578, I was thrown into a river, my hands tied to my feet. This was the year they thought I was a witch'). The juxtaposition of the everyday with well-known, historical events creates a cognitive dissonance, reminding us that it is sometimes the small things we take for granted that possess a life-changing potential. It is indeed a powerful text, masterfully translated into Polish by the poet Natalia Malek, and similarly masterfully adapted to a visual medium. But what makes it special and what makes it an example of the decolonial option at work?

Visual encounters: where the postcolonial meets the post-Soviet

As one might expect from the decolonial option, it is not one singular characteristic that makes any given subject, or object, decolonial. It is several factors that meet in a nexus of trajectories which result in a uniquely decolonial perspective. Hybridisation, bordering and

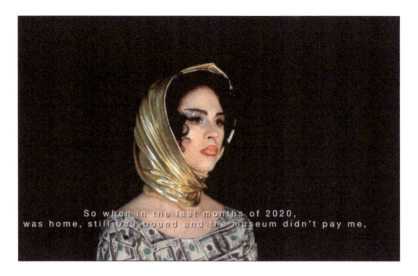

Figure 4.1 Wojtek Rodak, still from *Rok, w którym porzuciłem sztukę* (2020, YouTube). The subject is a young person in theatrical makeup.

cross-pollination of ideas and visions is what constitutes the core idea of the decolonial approach. I believe that Rodak's video project is one example of how a visual medium can serve as a platform for, sometimes, very disparate ideas to intermingle and give rise to new possibilities. I also believe that such marrying of postcolonial theories, from which partially the decolonial was born, with the post-Soviet and second-world optic is only achievable under specific conditions. This is where the decolonial option comes in, allowing for two seemingly different historical timelines and experiences to merge, and generating a fertile ground for hybridised forms of thought. Let us now consider what is special about this video, and in what ways it ushers in the decolonial thinking.

Firstly, the original text was written by a West European (French) artist, and as such it is steeped in postcolonial references as well as discourses characteristic for contemporary Anglo-Western social debate. This is important as the decolonial option does not try to erase or get rid of Western culture and history (as many would have it); it simply asks us to consider the existence of Others and other options that have long been ignored by the universalist global tendencies.[5] The ability to peacefully co-exist is at the heart of the decolonial option, and exclusion of anyone is not the intended outcome. However, as Madina Tlostanova notices on several occasions, the decolonial option, at least in its beginnings, largely ignored the existence of the post-Soviet erstwhile 'Second World' and its inhabitants. In a way similar to postcolonial thought, the decolonial

option got entangled in binary oppositions of First vs. Third World, postcolonial vs. colonial, Western vs. non-Western. In turning our attention to the semi-periphery of the Western civilisation, the post-communist countries, we encounter a new symbolic space that allows us to depart from binary thinking. Thus, the fact that a Polish artist decided to ask other Polish artists to collaborate on a text written by a French artist, a text pertaining to various planetary issues, is already interesting and signals an openness to the Other. By incorporating and extrapolating from the original text, the Polish culture, still considered marginal in the West, enters the global art scene while at the same time bringing home debates often omitted or ignored in the ex-communist regions (for example on slavery or postcolonialism). This exchange of ideas, a sort of cross-fertilisation of thought, is mutually beneficial, non-exclusionary and non-hegemonic, akin to the rhizomatic networks I have mentioned above. The use of Polish translation, rather than one of the hegemonic languages of the West, adds to the piece's multi-layered dimension in which various experiences, histories, stories and ideas converge and inhabit the virtual space of the video in a pluriversal way as imagined by Walter Mignolo.[6] Here, different narratives coexist and work together, manifesting themselves through the collaborative nature of the project as well as its diverse and hybrid formal aspects. This multiplicity of subjectivity is further reflected in the complex narrative of the text, and the layering of identities, histories and timelines.

The a-chronological, ostensibly confusing temporality of the video goes against the established notions of linear progress that follow the historic timelines constructed in Western Europe, especially that of modernity. The simultaneous pluri-existence of various narratives mirrors the multiple, inclusive global timelines proposed by Mignolo and Tlostanova.[7] As Mignolo rightly points out, 'Once you control (the idea of) "time," you can control subjectivity and make the many march to the rhythm of your own time'.[8] By decolonising time, by re-ordering it and detaching it from the colonial matrix of modernity, progress and one-way linearity, the video begins to construct a decolonial space-time (even if still virtual). Similarly, the broken, cut-up and seemingly unconnected stories and narratives present a hybrid metanarrative of those who have been marginalised, denied access to the hegemonic centre of knowledge, creation and subjectivity, and positioned – in accordance with colonial thought – somewhere in grey zones of liminal existence.[9] Where one tries to shift the epistemological, chronological and geopolitical modes of categorising the world from their presumed centre to the peripheries, the decolonial option is at work. Looking from the borders, here understood

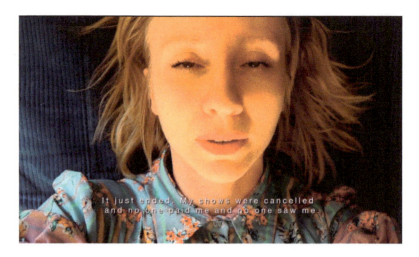

Figure 4.2 Wojtek Rodak, still from *Rok, w którym porzuciłem sztukę* (2020, YouTube). The subject now is a young woman, caught in a close-up with a hand-held camera.

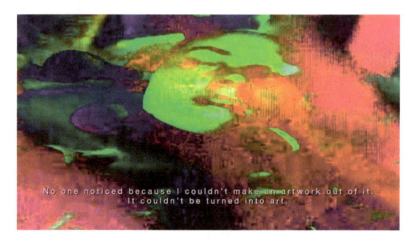

Figure 4.3 Wojtek Rodak, still from *Rok, w którym porzuciłem sztukę* (2020, YouTube). Another artist interprets a set of passages using distorted shapes and colours.

as frontiers of civilisation as demarcated by the colonial and imperial powers, new perspectives become visible, ones that can perhaps push against the prevailing Eurocentric categories of thought and being, and make space for other, non-Western and non-European ones.[10]

While the original text by Paul Maheke, as well as the video, were made in response to the precarity of artists and creators through the pandemic, often left unable to support themselves, it reveals much deeper structural problems in our contemporary societies. The underlying message in both texts is profoundly human, but even more importantly, what both texts offer is a critical lens through which we can approach issues and dilemmas stemming from various global crises and emergencies. Just try to imagine a more united and open world in which countries and regions work together, instead of closing borders and mounting restrictions; a world in which a deadly pandemic is contained by mutual efforts and sharing resources, rather than spread further by bickering politicians and incoherent, divided responses from global agents. If this sounds utopian, think that the idea of having a vaccine (and eradicating several fatal diseases) was similarly utopian only a couple of hundred years ago. This is not to say that post-Soviet, decolonial thinking can save the planet, but to merely recognise its potential to introduce meaningful changes and question the existing systems of governance and domination.

Decolonial as anti-capitalist

The question of inequalities and hegemonic power is closely linked with the rapid diffusion of neoliberal capitalism, which sped up notably following the fall of the Berlin Wall. While there are undoubtedly positive aspects to this development, there are, increasingly, equally many concerns, not least about sustainability and ecology. The very origins of the SARS-CoV-2 virus are believed to stem from human mishandling of wildlife, and the rapid dissemination of the disease can be partially attributed to our hyperconnected societies with frequent air travel.[11] Once again, the decolonial option, as evidenced in the video, offers alternative modes of resistance to the global capital and asymmetrical distribution of power and resources. The ready availability of the video online, as well as the original text, means that access to them is not restricted by price, geographical location or other obstacles. They can be freely accessed by anyone with an internet connection (which, of course, still leaves many people out) – but, unlike colonial knowledge or art, they are not commodities. Making art, science and knowledge widely accessible should be one of the main tools in fighting the inequalities left behind by the colonial and capitalist systems. The decolonial option is a way of seeing and shaping a reality in which 'many trajectories and options will

be available'.[12] Thus, making an art project, a video installation, a text or any other form of the human mind's production accessible to as wide a public as possible should be an underlying principle of decolonial activity.

> It was 1957 and my husband had to endorse every single spending made. It was 1578, I was thrown into a river, my hands tied to my feet. This was the year they thought I was a witch. It was 2008 when I became homeless because my benefits were cut, and you didn't pay me.

The text, and the video based on it, do exactly this, proving that epistemic disobedience, alliances across borders, and meetings in liminal spaces of both peripheral and central actors can produce meaningful results, available to wide audiences. In bringing together elements from seemingly disparate, unconnected narratives, a new narrative emerges, built on what we have in common as humans rather than what differences divide us. In the transnational space of the internet, somewhere among millions and trillions of other films and clips from around the world, this visual project opens a dialogue that is at the same time historically and geographically specific (conceived in Western Europe, produced in the East) and global (pertaining to issues that are time- and space-distant yet still relevant).

Working towards a new future

Obviously, the above is a description of an ideal world, a utopia that might take place on a microlevel in the virtual space but which, perhaps, might never fully realise itself on a larger planetary scale. But the uncertainty of the future does not prevent us from imagining it, shaping visions, constructing possibilities and enacting change. The power of the humanities lies in its capacity to offer an idea upon which something new can be built: an ideological foundation to bring people together in times of metamorphosis and change, a thought that can guide us in these seemingly dark times. I am not saying the humanities can offer hope or salvation, but at least they give us an opportunity to reflect, ponder on and open new spaces and times. It is timely to recall that if you are reading this text, you are most probably a very privileged person, as am I. Safely tucked away in our cocoons of clean, sanitised homes working remote jobs we often forget we are in fact a minority. Most of this world's population does not have the same access to resources as you, an academic, a West European or American, and the growing discontent

with the current system is increasingly visible in the political choices of the so-called masses. The miracle of economic growth, the promised cornucopia of wealth and success did not materialise for most of us, at least not in such a way as was described. This is nowhere better visible than in the liminal spaces of semi-peripheries, such as the post-Soviet space, where the disillusioned people who lost, rather than won, during the transformation to capitalism have been recently electing populist, authoritarian governments.[13] The extended pandemic and the economic shutdown it caused only exacerbated existing inequalities, driving inflation up and making the poor even poorer. But it was exactly the collision of the pandemic and post-communist economy (where no support was offered by the government to those left without employment) that prompted Rodak to embark on the journey to produce his video and highlight the plight of the struggling artists. From an ostensibly tragic situation emerges creative ferment, inspired by a Western text, which in turn spawns a hybrid, contingent response to the crisis.

The humanities alone cannot cure the world of its ailments, but we need them more than ever to envision and construct a new future forged in the flames of transformative events. Humanities and arts can teach us not only how to endure and survive but to thrive even in difficult times of darkness and hardship. They can give voice to those who were previously denied it and allow for unexpected, original hybrid thinking to materialise. Without the arts and humanities there would be no post-Soviet decolonial

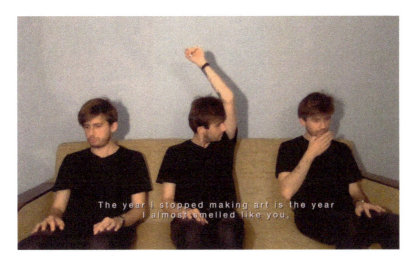

Figure 4.4 Wojtek Rodak, still from *Rok, w którym porzuciłem sztukę* (2020, YouTube). The final scene from the video with a tripled subject.

option, and perhaps there would be no video titled 'The year I stopped making art'. You would not be reading this essay and I would not be imaging a new world in which peripheries enter the centre stage, in which the marginalised become the main players and in which inequalities are, if not erased, at least acknowledged, and actively worked against.

Notes

1. Anibal Quijano, 'Coloniality of power'.
2. Tokarczuk, 'The humanity at the end'.
3. You can watch the video here: https://www.youtube.com/watch?v=YLNZGL4HOig&t=713s.
4. You can find the full text in English here: https://documentations.art/The-year-I-stopped-making-art.
5. Mignolo, *The Darker Side*.
6. Mignolo, 'On pluriversality and multipolar world order'.
7. Mignolo *The Darker Side*, 149–80; see Mignolo, 'Theorizing from the borders'.
8. Mignolo, *The Darker Side*, 177.
9. See Frederiksen, *Ethnographies*.
10. See Mignolo, 'Theorizing from the borders'.
11. For more, see the WHO's website: https://www.who.int/health-topics/coronavirus/origins-of-the-virus.
12. Mignolo, *The Darker Side*, 21.
13. While this is not a topic for this essay, it is an interesting trend which Madina Tlostanova has described in terms of 'living backward' and travelling from the future to the past, against the stream of the Western chronology of progress: see Tlostanova, *What Does It Mean to Be Post-Soviet*.

Bibliography

Maheke, Paul. 'The year I stopped making art'. *DOCUMENTATIONS*, 18 March 2020. Accessed 3 November 2021. http://www.documentations.art/The-year-I-stopped-making-art.

Knudsen, Harboe Ida and Martin Demant Frederiksen. *Ethnographies of Grey Zones in Eastern Europe: Relations, borders and invisibilities*. London: Anthem Press, 2015.

Mignolo, Walter. *The Darker Side of Western Modernity: Global futures, decolonial options*. Durham, NC: Duke University Press, 2011.

Mignolo, Walter. 'On pluriversality and multipolar world order: Decoloniality after decolonization; dewesternization after the cold war'. In *Constructing the Pluriverse: The geopolitics of knowledge*, edited by Berndt Reiter, 90–116. Durham, NC: Duke University Press, 2018.

Mignolo, Walter and Madina Tlostanova. 'Theorizing from the borders: Shifting to geo- and body-politics of knowledge', *European Journal of Social Theory*, 9 (2006): 205–21.

Rodak, Wojtek (dir.). 'Rok, w którym porzuciłem sztukę'. Accessed 1 May 2020. http://www.youtube.com/watch?v=YLNZGL4HOig&t=713s.

Quijano, Anibal. 'Coloniality of power, eurocentrism, and Latin America', *Nepantla: Views from South* 1, no. 3 (2000): 533–80. Accessed 29 July 2022. https://muse.jhu.edu/article/23906.

Tlostanova, Madina. *What Does it Mean to Be Post-Soviet?: Decolonial art from the ruins of the Soviet empire (On Decoloniality)*. Durham, NC: Duke University Press Books, 2018.

Tlostanova, Madina. 'Decolonial aesthesis and the post-soviet Art', *Afterall: A Journal of Art, Context, & Enquiry* 48, no. 1 (2019): 100–7.

Tokarczuk, Olga. 'Człowiek na krańcach świata [Humanity at the end of the world]', *Polityka* (1 October 2020). Accessed 19 November 2021. https://www.polityka.pl/tygodnikpolityka/spoleczenstwo/1972652,1,czlowiek-na-krancach-swiata-wyjatkowy-esej-olgi-tokarczuk-w-polityce.read.

5
Distant together: creative community in UK DIY music during Covid-19
Kirsty Fife

Those participating in DIY cultural communities (including zine makers, musicians, artists and activists) have traditionally been reliant on physical spaces to gather, perform, build connections and mobilise community. With the rapid closure of music venues, galleries, community centres and other public spaces, these already dispersed communities have been mobilised into seeking and creating alternatives. These alternatives include novel utilisation of existing digital platforms (Zoom, Houseparty and Instagram, for example) to forge temporary virtual spaces for cultural communities. Such spaces have been used to host everything from house parties, gigs and zine fairs to writing circles, enabling cultural organisers to raise money, connect isolated individuals and nurture creative practice in new and innovative ways. This article explores the motivations and politics of those creating these spaces, arguing that these virtual alternatives are significant (albeit temporary) in connecting communities in an otherwise distant time.

The outbreak and subsequent escalation of the Covid-19 pandemic has had a profound and devastating impact on those working in creative and cultural industries, both within the UK and internationally.[1] The already fragile infrastructure nurturing grassroots cultural creativity remains under threat due to a lack of support and long-term resource. As Music Venues Trust CEO Mark Davyd said in an open blog post,

the decision by the UK government to enforce social distancing through a 'lockdown' policy while fully understandable has been catastrophic for the live music sector, and hardest hit have been those grassroots venues already operating on thin margins.[2]

As well as the impact on spaces, the Arts Council has acknowledged the 'significant impact [of Covid-19] on the freelance creative practitioners on whom our sector depends, with many experiencing lost income and additional costs from cancelled and curtailed work'.[3] Not only have those earning their primary income from creative work been directly affected, but those working in hospitality industries to support creative practice have also been hit by the loss of precarious incomes. This is especially so for migrants and others without access to government support schemes.

This short essay considers the impact of the pandemic on UK DIY music communities. I begin by clarifying the cultural context I refer to as 'UK DIY music' and its connection to grassroots activism and far-left politics. Following this, I describe how DIY music spaces have developed over the last decade, focusing on the opening of a cluster of new spaces in the mid-2010s. The rest of the essay is devoted to providing an account of the impact of the pandemic on DIY music spaces, focusing on the threat of closure that many currently face without long-term government support. I then go on to reflect on the ways in which UK DIY music communities responded to the lack of access to traditional physical spaces (e.g. music venues, rehearsal rooms and autonomous spaces) and to social gatherings in person. I do this by exploring the use of livestreaming technologies and social media for performance and socialising in the early months of the lockdown. Finally, I consider what the future climate for grassroots creativity could look like over the coming years.

The term 'UK DIY music' refers to local and national communities of musicians who engage with 'do-it-yourself' as a model of praxis and political ethos within a UK geographical context. The intersection between the 'do-it-yourself' ethos and music is one that stretches over generations of music subcultures, including punk, indie, hip hop and electronic dance music.[4] 'DIY' music no longer strictly connotes a genre of music but instead refers to scenes with overlapping commitments to autonomy, mutual aid, anti-capitalist politics and learning through doing. As George McKay writes, 'even if it doesn't overtly espouse it, DiY [sic] Culture practises an intuitive liberal anarchism'.[5] Though there are no longer strict limitations to genres, those in DIY music are expected to contribute to central underpinning community networks – as Roued-Cunlife writes, 'although there are no spatial, territorial, formal or

membership boundaries of DIY culture, it exists through interaction and communication'.⁶ Thus, we can typify DIY music through a combination of creativity, activist/grassroots/left-wing politics and collaboration through networked cultures and spaces.

Recent music journalism has focused on the opening of UK-based DIY music spaces including DIY Space for London, Glasgow Autonomous Space, Partisan (based in Manchester) and others.⁷ The development of these new spaces (in addition to well-established autonomous spaces and social centres including the 1 in 12 Club in Bradford, Wharf Chambers in Leeds and the Cowley Club in Brighton) was viewed as a sign of the health of DIY music networks in the 2010s. Of Leeds' DIY spaces, Isobel Moloney writes:

> At the heart of the movement is a string of promoters and venues whose values sit at the opposite end of the spectrum to the gentrifying developers. Rather than sterilise the city in the hunt for financial profit, the DIY scene seeks to enrich the community through cultural stimulation.⁸

Similarly, Amin refers to how such spaces display 'a DIY attitude that prioritises communal support, autonomy and self-sufficiency over metrics such as popularity and capital'.⁹ The development of new spaces was seen as a form of resistance against precarious living, gentrification and austerity, all of which have a negative impact on the capacity to nurture creativity and collaboration within communities. The flourishing of UK DIY music spaces seemed to be a sign that we could create the alternative that had been collectively imagined over the preceding decades.

Although UK DIY music spaces were used to resisting and surviving against the odds, the onset of a global pandemic was a threat no one had been prepared to encounter. Within months of the announcement of the UK's lockdown period, music spaces of all sizes began to permanently close. This included larger venues including Gorilla and the Deaf Institute in Manchester (which were subsequently saved through acquisition by Tokyo Industries).¹⁰ However, grassroots and DIY music spaces are less profitable and, therefore, less appealing to investors, and without a clear way forward or government support many have already collapsed. These include DIY Space for London, which cited the instability caused by Covid-19 as their reason for closure, and CHUNK (based in Leeds).¹¹ As well as venues, many festivals and cultural events have had no choice but to cancel and postpone events globally. In reference to music festivals, Karen Davies writes that 'no risk assessment in the world could have

prepared the industry for the lock-downs and social distancing measures that we are currently experiencing'.[12]

The drastic impact of the pandemic was heightened by the socio-economic and political climate in which culture is currently produced. Theorists in other geographic contexts have highlighted how a lack of government support for the arts preceded and was exacerbated during the pandemic.[13] Music industry bodies have campaigned for more public support for music venues throughout the pandemic, utilising social media campaigns including the hashtags #letthemusicplay and #saveourvenues to raise awareness of the impact of the pandemic on music venues of all sizes. In September 2020, Music Venue Trust wrote that 'the whole grassroots music venue sector is now at critical, red alert status' due to inadequate support through the Cultural Recovery Fund, the winding down of furlough, the application of a 10pm curfew for all venues, social distancing laws and other measures.[14] As the world continues to open up again, crowds may begin to return to spaces but at a gradual pace that may not enable economic recovery as desperately needed by small venues.

The impact of job losses on musicians and music industry workers is also critical. In the lead up to the pandemic's outbreak, grassroots music spaces had already been closing rapidly under conditions of austerity.[15] As a result, work in live music was increasingly precarious, with many workers subsisting on minimum wage, seasonal work and/or irregular hours. In reference to music festivals, Davies writes that

> their success relies on the exchange value of the commodity of entertainment, as well as on the use of gig-workers and zero-hour contracted staff who have no job protection.[16]

Musicians also found a significant income stream removed by the impossibility of touring in a pandemic. As music blog *For the Rabbits* wrote, for many this touring income (and merchandise sales) had been the only remaining way to make money from music:

> A combination of minimal streaming royalties, dwindling physical sales and the increasing popularity of a wide variety of other media options have left music, and musicians, highly reliant on touring as a source of income.[17]

As such, the immediate halt of live performance, closure of music spaces and termination of festival and venue work that provided other sources

of income jeopardised the livelihoods of many involved in music communities. Researchers Shelley Brunt and Kat Nelligan, who explored the impact of the pandemic on the Australian music industry, highlighted experiences of grief, loss, anxiety and instability reported in the media through the early months of the pandemic, emphasising the impact on the mental as well as physical health of individuals in these communities.[18]

UK DIY music communities reacted to the UK's initial lockdown period by exploring alternative and virtual spaces in which to programme gigs and performances. Instagram, Facebook and Twitch figured highly within a UK context in particular, with DIY music labels and/or promoters including Music for the Isolated Generation, Specialist Subject, Divine Schism and Girl Gang Leeds programming regular curated livestreams featuring acts performing from within bedrooms and living rooms across the world. The utilisation of digital technologies for livestreaming was common across musical communities, with initial analyses conducted in the contexts of classical music and opera, dance and popular music.[19]

The title of this piece refers to one such initiative – Distant Together – which was a weekly livestreamed gig that platformed a total of 65 artists over 10 weekly shows. Reflecting on the shows, Specialist Subject wrote that 'it felt really important to have weekly connection through live music during physical distancing'.[20] Also in reference to these events, music blog *For the Rabbits* wrote:

> While these 'shows' are not quite the same as the real thing, they are a chance for people, some isolated and alone, to remember that there are people out there who care, there is a community, no matter how distant and disparate, who appreciate the same things you do. We are distant, and we are together, and we will get through this.[21]

These livestreaming initiatives happened at a national level within the community context of UK DIY music, and within many other geographical and subcultural contexts.[22] Small-scale projects sprang up alongside these: for instance, punk band Witching Waves committed to a series of regular weekend livestreams in which they played songs and communicated with peers via text chat. The embracing of livestream technologies created new opportunities, for example, line-ups that would not otherwise have happened without funding for international touring were much more commonplace. Livestreaming was also used as an opportunity to raise money to pay musicians, and to maintain interest in music projects in the absence of live performance or the traditions of UK DIY music.

Each of these projects enabled online community to develop in the absence of physical communities. The use of social media to develop online community existed prior to the pandemic: as Janice L. Waldron writes:

> Online music communities as spaces of community music manifest as either 'self-contained' online communities in and of themselves (i.e., they exist only in virtual space with no overlap with a correlating offline community), or as an active online 'place', which exists in addition to an already established offline music community.[23]

To connect to Waldron's ideas, these livestreamed gigs form alternatives to the physical 'places' we can no longer access with current social distancing measures. Vandenberg et al. propose that whilst livestreaming removes music from the embodied experience of attending a gig (closeness to others, dancing, the smell of a punk venue etc.) in a physical space, the 'liveness' of an event is instead determined by time. By aping the signifiers of a 'real life' gig (including interactions between users on chat, the utilisation of the applause emoji and live performance), these events provide users with connections to familiar and reassuring environments and social groups during this period, in which nothing otherwise felt normal or reassuring. This means that users are comforted by the replication of the 'rituals' of gig going, which recall the collective memory of preceding membership of subcultural spaces.[24]

The jump to embrace new media technologies and utilise them for creative purposes and community building is nothing new in the context of cultural activism. Researchers have identified close links between media technologies and activist movements dating back at least a hundred years. Kate Eichhorn refers to connections between feminist activists and broadcasting technologies in the 1930s.[25] The connections between video technologies and activists are explored by social movement researchers.[26] The DIY music community's use of social media is explored by Ellis Jones, and Christopher Cayari identifies connections between participatory cultural theory and DIY online music-making practices.[27] The application of social media in creative communities in the decade preceding the pandemic had, in many ways, prepared us with the tools we would need to navigate isolation in lockdown.

At the point of writing the abstract for this essay, I was excited and proud about the ways in which communities adapted: our rapid response and creative re-envisioning of what a community space was and could be

in a period of virtual networks and screen interactions. This was yet another challenge that we could overcome with creativity and community. However, as the months passed and we slowly came to realise that the pandemic was (and is) here to stay, the hope and togetherness that typified the first few months dwindled. Few DIY collectives were still regularly livestreaming, after interest dwindled and peers tired of spending their lives in front of computer screens in lieu of personal contact. The UK is, as I write this, midway through autumn 2020 and undergoing a series of tiered restrictions and local lockdowns which are primarily affecting the North of England (in which I am based, as is my local DIY music community). Nationally, there is still no advice that suggests when it will be safe for small music venues to reopen, and we face the next few months without these spaces *or* the community momentum that connected us through the national lockdown period.

What comes next for UK DIY music? In *DiY Culture: Party and protest in Nineties Britain*, George McKay writes that 'short or long term, space is a prerequisite for community'.[28] The rapid closure of grassroots cultural venues to date is no doubt an indicator of things to come: there will be more spaces that will not survive the combination of the pandemic and the climate of austerity that had rendered them precarious in the preceding years. This combination of factors has made community members aware of the fragility of the infrastructure of UK DIY music: when spaces and communities form outside of the sturdier but more confining structures of the mainstream music industry, they also form outside of support structures that can ensure financial sustainability in the longer term. What took decades to build can crumble at a moment's notice. Our creative thinking and collective working cannot hold us afloat through a global pandemic, and although many of our networks remain, we do not yet know whether the spaces that nurtured them will continue to exist.

Notes

1. See Botstein, 'The future of music'.
2. Davyd, cited in Music Business Worldwide, 'Two years ago'.
3. Arts Council, 'Arts Council England emergency response fund'.
4. See Harrison, 'Cheaper than a CD'; Jones, 'Platform DIY'; Chrysagis, *Becoming Ethical Subjects*; Griffin, 'Understanding DIY punk as activism'; Moloney, 'Community spirit'.
5. McKay, 'DiY culture', 3.
6. See Roued-Cunlife, 'The digital future of humanities'.
7. See Amin, 'DIY in 2017'; Welsh, 'How DIY culture is thriving in the U.K.'; Phillips and Mokoena, 'All the places musicians move'; Moloney, 'Community spirit'.
8. See Moloney, 'Community spirit'.
9. See Amin, 'DIY in 2017'.

10 See Beaumont-Thomas, 'Manchester music venues'; Heward, 'The Deaf Institute and Gorilla'.
11 See DIY Space for London, 'Goodbye Ormside Street'.
12 Davies, 'Festivals post covid-19', 3.
13 Botstein, 'The future of music', 353.
14 See Music Venue Trust, 'The whole grassroots music venue sector'.
15 See The Mayor of London's Music Venues Taskforce, 'London grassroots venues rescue plan'.
16 Davies, 'Festivals post covid-19', 2020, 3.
17 See *For the Rabbits*, 'Distant together'.
18 Brunt and Nelligan, 'The Australian music industry's mental health crisis', 2.
19 See Botstein, 'The future of music'; Parsons, 'Music and the internet'; Vandenberg et al., 'The "lonely raver"'; Parivudhiphongs, 'Covid-19 – You can't stop the beat'; Howard et al., 'It's turned me from a professional'.
20 See Specialist Subject, 'DISTANT TOGETHER'.
21 See *For the Rabbits*, 'Distant together'.
22 See Brunt and Nelligan, 'The Australian music industry's mental health crisis'.
23 Waldron, 'Online music', 110
24 Vandenberg et al., 'The 'lonely raver'', 5144.
25 Eichhorn, *The Archival Turn*, 41–2.
26 See Harding, 'Viva camcordistas!'.
27 See Jones, 'Platform DIY'; Cayari, 'Expanding online popular music education research', 5.
28 McKay, 'DiY Culture', 28.

Bibliography

Amin, Tayyab. 'DIY in 2017: How Leeds, Bristol and London's scenes are striving to survive', *FACT Magazine* (2017). Accessed 30 October 2018. http://www.factmag.com/2017/06/15/uk-diy-venues/.

Arts Council. 'Arts Council England emergency response fund: for individuals' (2020). Accessed 29 July 2022. https://www.artscouncil.org.uk/covid-19/emergency-response-funds

Beaumont-Thomas, Den. 'Manchester music venues Gorilla and the Deaf Institute to permanently close', *The Guardian*, 16 July 2020. Accessed 28 September 2020. https://www.theguardian.com/music/2020/jul/16/manchester-music-venues-gorilla-deaf-institute-close-welly-polar-bear-hull.

Botstein, Leon. 'The future of music in America: The challenge of the COVID-19 pandemic', *The Musical Quarterly* 102, no. 4 (2020): 351–60.

Brunt, Shelly and Kat Nelligan. 'The Australian music industry's mental health crisis: Media narratives during the coronavirus pandemic', *Media International Australia* 178 (2020). Accessed 2 November 2021. https://doi.org/10.1177/1329878X20948957.

Cayari, Christopher. 'Expanding online popular music education research', *Journal of Popular Music Education* 4 (2020): 131–4. Accessed 2 November 2021. https://doi.org/10.1386/jpme_00021_2.

Chrysagis, Evangelos. *Becoming Ethical Subjects: An êthography of Do-it-Yourself music practices in Glasgow*. Unpublished thesis, University of Edinburgh, 2014.

Davies, Karen. 'Festivals post Covid-19', *Leisure Sciences* 43, no. 1–2 (2021): 184–9. Accessed 2 November 2021. https://doi.org/10.1080/01490400.2020.1774000.

DIY Space for London. 'Goodbye Ormside Street – DIY Space is looking for a new home', *DIY SPACE FOR LONDON*, 2020. Accessed 28 September 2020. https://diyspaceforlondon.org/goodbye-ormside-street-diy-space-is-looking-for-a-new-home/.

Eichhorn, Kate. *The Archival Turn in Feminism: Outrage in order*. Philadelphia, PA: Temple University Press, 2013.

For The Rabbits. 'Distant together – a mixtape by Specialist Subject', *For The Rabbits*, 14 May 2020. Accessed 29 September 2020. https://fortherabbits.net/2020/05/14/distant-together-a-mixtape-by-specialist-subject/.

Griffin, Naomi. *Understanding DIY Punk as Activism: Realising DIY ethics through cultural production, community and everyday negotiations*. Unpublished thesis, Northumbria University, 2015.

Harding, Thomas. 'Viva camcordistas! Video activism and the protest'. In *DiY Culture: Party And protest in Nineties Britain*, edited by George McKay, 79–99. London and New York: Verso, 1998.

Heward, Emily. 'Deaf Institute and Gorilla saved from closure as buyer snaps up both venues', *Manchester Evening News*, 21 July 2020. Accessed 29 September 2020. https://www.manchestereveningnews.co.uk/whats-on/music-nightlife-news/deaf-institute-gorilla-saved-closure-18630674.

Howard, Frances, Andy Bennett, Ben Green, Paula Guerra, Sofia Sousa and Ernesta Sofija. "It's turned me from a professional to a 'bedroom DJ' once again': COVID-19 and new forms of inequality for young music-makers', *YOUNG* 29, no. 4 (2021). Accessed 2 November 2021. https://doi.org/10.1177/1103308821998542.

Jones, Ellis Nathaniel. *Platform DIY: Examining the impact of social media on cultural resistance in contemporary DIY music*. Unpublished thesis, University of Leeds, 2018.

Harrison, Anthony Kwame. '"Cheaper than a CD, plus we really mean it": Bay Area underground hip hop tapes as subcultural artefacts', *Popular Music* 25 (2006): 283–301.

McKay, George. 'DiY culture: notes towards an intro'. In *DiY Culture: Party and protest in Nineties Britain*, edited by George McKay, 1–53. London and New York: Verso, 1998.

McKay, George (ed.) *DiY Culture: Party and protest in Nineties Britain*. London and New York: Verso, 1998.

Moloney, Isobel. 'Community spirit: How DIY culture is transforming Leeds' music scene', *Mixmag*, 14 May 2019. Accessed 2 November 2021. https://mixmag.net/feature/leeds-diy-wharf-chambers-chunk-scene-report.

Music Business Worldwide. 'Two years ago, things were bad for grassroots music venues. Now, we are at the cliff edge', *Music Business Worldwide*, 6 April 2020. Accessed 25 August 2020. https://www.musicbusinessworldwide.com/two-years-ago-things-were-bad-for-music-venues-now-we-are-at-the-cliff-edge/.

Music Venue Trust, 'The whole grassroots music venue sector is now at critical, red alert status', *Music Venue Trust* (2020). Accessed 2 October 2020. http://musicvenuetrust.com/2020/09/the-whole-grassroots-music-venue-sector-is-now-at-critical-red-alert-status/.

Parivudhiphongs, Alongkorn. 'COVID-19 – You can't stop the beat!', *Journal of Urban Culture Research* 20 (2020): 3–9.

Parsons, Chris. 'Music and the internet in the age of covid-19', *Early Music* 48, no. 3 (2020): 403–5.

Phillips, Stephanie, and T. Mokoena. 'All the places musicians move to when London gets too expensive', *Noisey: Music by Vice*, 28 March 2018. Accessed 30 October 2020. https://noisey.vice.com/en_uk/article/evqzb4/london-expensive-city-musicians-arrows-love-petrol-girls.

Roued-Cunlife, Henriette. 'The digital future of humanities through the lens of DIY culture', *Digital Humanities Quarterly* 10, no. 4 (2016). Accessed 2 November 2020. http://www.digitalhumanities.org/dhq/vol/10/4/000277/000277.html.

Specialist Subject. 'DISTANT TOGETHER', Specialist Subject Records, 2020. Accessed 29 September 2020. https://quarantunes.crd.co.

The Mayor of London's Music Venues Taskforce. *London Grassroots Venues Rescue Plan: A report*. London: Greater London Authority, 2015.

Vandenberg, Femke, Michaël Berghman and Julian Schaap. 'The "lonely raver": Music livestreams during COVID-19 as a hotline to collective consciousness?', *European Societies* 23 (2021): 141–52.

Waldron, Janice L. 'Online music communities and social media'. In *The Oxford Handbook of Community Music*, edited by Brydie-Leigh Bartleet and Lee Higgins. Oxford: Oxford University Press, 2018. https://doi.org/10.1093/oxfordhb/9780190219505.013.34.

Welsh, April Clare. 'How DIY culture is thriving in the U.K.', *The FADER*, 23 December 2015. Accessed 20 October 2018. https://www.thefader.com/2015/12/23/how-diy-culture-is-thriving-in-the-uk.

6
Now are we cyborgs? Affinities and technology in the Covid-19 lockdowns

Emily Baker and Annie Ring

In this chapter we make the case for revisiting and learning from Donna Haraway's 'A cyborg manifesto' in the light of Covid-19 and the 2020 lockdowns around the world. First published in 1983, the manifesto argues that due to the ubiquitous hybridity between organism and machine in all areas of life, from modern medicine to industrial production and even in the realm of sexuality, 'The Cyborg is our ontology; it gives us our politics'.[1] In seeking, therefore, to shape this politics, Haraway proposed a feminism unafraid of the affordances of technology, and in so doing mobilised the figure of the cyborg as an ideal of human agency in concert with new technological gestures and designs. The cyborg, that retro phantasm of the human implanted with technological features, offered Haraway a way of thinking through a series of tensions then at play within the realms of feminism, science, technology and socialism. Many of these tensions still exist. As such, we return to the cyborg, claiming that she remains an ally in challenging the ongoing 'dominations of "race," "gender," "sexuality," and "class"'[2] that hold sway in our current phase of technological modernity. More than ever before, the vocabulary of Haraway's manifesto is needed if we are to attend to who is disproportionately at risk from the fallout of Covid-19, both physically and economically, due to their place in the current intersectional matrix. Ultimately, we argue that cyborg 'affinities' open up new ways of challenging the deadly atomisation and inhuman exploitations that

define neoliberal capitalism and make living with the deadly novel coronavirus and in lockdown even more difficult. These affinities, moreover, invite more connection and more consciously critical play into today's at-times locked-down, newly cyborgised lives.

What are cyborgs, and what can they/we do? Cybourgeoisie, keyworker, sister outsider

The cyborg, defined as a 'hybrid of machine and organism',[3] has been with us since the 1980s, representing at once a fictional being, and, at the same time, a cipher for the real advances in technology that have been changing people's lives and bodies as we live and work with – and through – technologies as prostheses. If we believe Haraway, the cybourgeoisie of white-collar workers who during lockdowns spend their time safely at home, interacting and working via video-conferencing platforms, is actually a newcomer class, coming after the working women of colour to whom Haraway originally attributed the cyborg identity. These 'sister outsiders' had replaced men in so-called 'developed' countries as 'the preferred labour-force for the science based industries'.[4] Thus, the first cyborgs were those workers whose work was systemically devalued or constructed as unskilled, for instance the 'computers', the first coders, who were women kept on low pay because of their gender until Mary Jackson questioned this injustice;[5] or think, nowadays, of the *maquiladora* workers at the Mexico–US border. In this moment of the Covid-19 pandemic, cyborgs include the keyworkers (medics, cleaners, retail-workers, porters and others, many of them people of colour) who currently move around in PPE space-suits, on suppressed pay, keeping societies going. Counter to anti-mask protestors, we see the protective equipment these keyworkers wear as a prosthesis that enables, rather than blocks, human connection by saving life from the virus.

We write about the cyborg under the pronoun 'she', and there are precedents for this gendering of the figure in sci-fi films since Fritz Lang and Thea von Harbou's sci-fi expressionist *Metropolis* (1927), whose cyborg heroine Maria (see Figure 6.1) moves in anti-essentialist fashion between virginity and sex-positive *jouissance*. Haraway, in turn, writes against an essentialist feminism that construes women as existing outside of the machine, as having skill only in mothering and belonging in nature. The cyborg celebrates the 'wayward identities' of women who have challenged such essentialist constructions, for instance, those Black women and queers on the East Coast of the US at the end of the Victorian

era, about whose radically unruly lives Saidiya Hartman writes. Hartman muses on the dual meanings of 'Manual: as of a weapon, tool, implement, etc.', which women might brandish, despite '[t]he use of the body as tool or instrument' and being used, 'handled as if owned, annexed, branded, invaded, ingested, not autonomous'.[6] This radically disempowering handling had happened, for instance, in the form of the slavery from which the people in Hartman's books had only recently been freed.

Following the model of these queer women of colour, who resisted essentialist femininity and conservative views about the household, the contemporary cyborg's mode of operation is one of dual agency. She uses her technological tools to overthrow the use of the body as tool. In this way, the cyborg represents a high-tech embodiment, and demonstrates how 'There is nothing "female" that naturally binds women. There is not even such a state as "being" female, itself a highly complex constructed category'.[7] In the light of the Covid-19 lockdowns, we celebrate the anti-essentialist lives already being lived by cyborg-beings in our time, and we still look forward to the wonderfully 'monstrous world without gender' that Haraway conceives.[8]

Figure 6.1 Brigitte Helm plays cyborg Maria as an anti-essentialist double-agent, between virginity and *jouissance*, in Lang and von Harbou's *Metropolis* (1927).

Cyborgs are machine-women, who take up the empowered stance of being-technological, and so are able to highlight the ways in which there never have been, and never can be, natural women without relation of some kind to the *techne*: to the tools we have used to heat food over fires, or those tools and now apps we use to craft the bodies we most identify with, and can most tolerably live in, despite the constraints of patriarchy around and within us. In a recent article, Giuliana Ferri takes up the cyborg as one amongst a constellation of referents used to harness 'critical interculturalism embedded in outsider narratives and engaged with the world in its multiplicity of assemblages' and as a means of 'recognizing the challenges we all face at this historical moment'.[9] In the following section we address some of the further particularities of this moment, and acknowledge the partiality of our perspective.

The informatics of domination in the lockdown 'household'

Haraway's vision of a cyborg future had room for both optimism and pessimism, as she envisioned the dual possibilities of 'the final imposition of a grid of control over the planet …, the final appropriation of women's bodies in a masculinist orgy of war', or, 'lived social and bodily realities in which people are not afraid of their joint kinship with animals and machine'.[10] There are indeed reasons for pessimism now that, through the Covid-19 lockdowns, 'the household' has 'landed back on us with such an almighty conservative thump'.[11] Aside from the 'household' traditionally being a patriarchal and conservative unit, it is now, for the privileged, a space highly mediated by technology, and as such threatens to facilitate increased surveillance and control. Haraway memorably dismissed Foucault's biopolitics as a 'flaccid premonition of cyborg politics'.[12] However, we find, with Paul B. Preciado (who is a more excited Foucauldian), that their analyses have important similarities: 'For Foucault, the techniques of biopolitical government spread as a network of power that goes beyond the juridical spheres to become a horizontal, tentacular force, traversing the entire territory of lived experience and penetrating each individual body'.[13] In 'Learning from the virus', Preciado is concerned with the possible modes by which biopolitical government (in its marriage with multinational capitalism) has used the pandemic as the new frontier for disciplinary infiltration of homes, lives and minds.

The prior 'organic industrial' societal order that Haraway described was indeed characterised by 'scientific management in home/factory';[14]

in other words, biopolitics through disciplinary institutions, whilst maintaining a nominal distinction between the different spaces (home/office; playground/factory). In our own limited world of the bourgeois office worker class, recent times have seen attempts to entice workers to be more healthy (on-site gym), spend longer at work (canteen networking, after-work drinks), bring your puppy to work, even bring your child (albeit in the minority of cases). We had already witnessed the transition to the 'global factory' in which Amazon could source and deliver products from all over the world, to those parts of the world where people could afford the goods on offer. Only in lockdown did we, the lucky ones, find ourselves confined to our 'electronic cottages', reliant on these technologically optimised delivery networks and home-gyms, while carrying out DIY cleaning, DIY cooking and DIY childcare. The ability to outsource these activities was always a privilege. In lockdown, with reduced possibilities for outsourcing, a return to conservative praxes was the norm.

One of the dual threats and possibilities we see in this situation is the way in which lockdown pressure-cooked households, breaking down bonds in some cases (as we saw in the skyrocketing figures for domestic violence in various countries), or otherwise positively re-configuring or strengthening relationships in other circumstances. In an ideal scenario, a work from home or 'home-work' economy could facilitate people of all genders to contribute equally to care duties in ways that do not suspend or delay the careers of any. Yet, statistics show that men are only contributing somewhat more to household chores, which have dramatically increased as homes become – even more explicitly – workplaces, without coming close to a balance of domestic labour,[15] while submissions of single-authored journal articles by male academics skyrocketed in the first lockdown of Spring 2020.[16] In our view, 'career' is just 'carer' with a supplementary 'e'; why should everyone not be able to have – and be – both?

As academics, it was easy to feel that we became cyborgs in lockdown, as we found ourselves working online instead of going to the library. It is still new to be discussing theories and texts with colleagues and students over video conferencing apps instead of being in the room with one another, lacking a presence that is so crucial to pedagogy and intellectual exchange as embodied encounters,[17] and at the same time permitting more access for colleagues with disabilities or caring responsibilities. While we, in the new cybourgeoisie, adjusted to these new ways of working, we were concerned about our students: where were they locked down and under what conditions? Young LGBT people who

did not have an internet connection or smartphones risked sinking deeper into isolation and psychological distress. There are households and communities where computers are shared, families that have suffered sudden bereavement or deepening poverty. To go 'home' to struggling families was not easy for students who had been enjoying reading Nietzsche or bell hooks in the library just weeks before.

The risk in all these areas is that lockdown intensified isolation in 'electronic cottages' and physically separated us from those whom we choose as our community, only to find ourselves further divided and individualised by the designs and aesthetics of high-tech capitalism, focused as it is on individual self-promotion rather than genuine connection. Meanwhile, Preciado's concern about 'infiltration'[18] by power in the time of the virus suggests we should be worried about technology's surveillant role growing in the home-working hybrid spaces of lockdown. But for her part, and for all her writing on the 'informatics of domination', Haraway ultimately rejects technophobia and advocates 'embracing the skilful task of reconstructing the boundaries of daily life, in partial connection with others, in communication with all of our parts'.[19] 'Science and technology,' she adds, 'are possible means of great human satisfaction as well as a matrix of complex dominations'.[20] But how can these means be activated?

Resistance and community through affinity, with technology

The new online connections that have been forming, both within UCL's communities and around the world, reveal the possibilities of shifting constellations of *affinities*, a category invoked by Haraway that can go beyond bounded *identities* (such as student, permanently or precariously employed staff member, teacher or researcher, administrator, cleaner, security guard). Haraway's definition of 'affinity' is a relation established 'not by blood but by choice, the appeal of one chemical nuclear group for another'[21] and she enjoins us to take on 'the task to build effective affinities'.[22] By invoking 'effective affinities', and linking them to nuclear chemistry, Haraway is indirectly quoting Goethe's *Elective Affinities* (1809), whose title was taken from an archaic chemistry term used to analyse how materials such as oil and water would combine with, or separate from, other substances according to what appeared to be natural preference. Hearing about the chemical affinities, in which 'one relation [is] deliberately chosen in preference to another',[23] Goethe's heroine

Charlotte ponders the chemical examples and challenges her male interlocutors, saying 'I cannot see any choice in this; I see a natural necessity' or 'merely a case of opportunity'.[24] In the novel, married couple Eduard and Charlotte approach their life and their homemaking projects experimentally, inviting other parties to stay in their home, reshape their landscaping and architectural designs and, ultimately, disrupt their comfortable but rather too insular marriage. Likewise, for the cyborg, under the sign of elective affinities, the household is subject to experimentation and, ultimately, to taking new shape. Identities at work, which divide, can give way to affinities built across the classes created by the neoliberal university, and cyborgs can commit to unionisation with outsourced workers and students, as well as with one another.

Such a dissolving of identities into affinities, whether in homes, the community or workplaces, needs to be done carefully and with love, picturing the fluid flexibility and, of course, the vulnerability of a *bubble*, rather than the hoped-for solidity of a wall. Given the vulnerability both the virus and the lockdowns have highlighted, and the urgent need to put community above individual identity, we echo Haraway's 'argument for *pleasure* in the confusion of boundaries and for *responsibility*'[25] in approaching the task of building sustainably effective affinities in which we are kindred by choice and act together, and are not divided into the violent units of our patriarchal pasts.

In our view, cyborgs can only build resistance to the 'informatics of domination' if we use our networked-togetherness to keep developing the cyborg myth. One of the ways of doing this is through reading, writing and other arts: the very 'lockdown cultures' this volume is interested in. In Haraway's vision, 'Intense pleasure in skill, machine skill, ceases to be a sin, but an aspect of embodiment'.[26] Accordingly, as cyborgs we take pleasure in our techne, crafts and skills and see opportunities for connection and play in poetry, philosophy, art, life-writing and hybrids thereof, as well as in our developing skills for interactive use of technology. At times we create in a locked-down room of one's own, and at other times we participate in outdoor art collectives and virtual coffee mornings that enable 'exposure', 'sharing' and 'presentation of the self',[27] acts which can contribute to what Jean-Luc Nancy would term an 'Inoperative Community' of cyborgs. In this way, the cyborg as writer co-constructs her, our, fractured identities in relation to other people, through texts, hypertexts and fictions, and via our lovely prostheses: the least-worst, least-surveillant platform; the webcam and mousepad; the pen on a scrap of colourful paper.

By resisting the conservatism of the household, and developing the cyborg myth further, we hope to respond to what Haraway described as 'the need for unity of people trying to resist worldwide intensification of domination' and trying to find 'other forms of power and pleasure in technologically mediated societies'.[28] The forms of power and pleasure we develop in this context need to unfold under the aegis of knowledge, acknowledging that play is always co-optable to reproduce capital; in fact it is always already co-opted: in Haraway's words, 'All work and all play is a dangerous game'.[29] Balancing between power and pleasure, work and play, the cyborg treads a knowing path between work for a politically preferable future and play that is only a function of gamified capitalism. To be clear, we eschew the one-way communication feeds of influencers, advertisers and their everyday imitators; instead, we tentatively (and critically) embrace the two-way channels that facilitate meaningful dialogue, interface and sharing, not just mediated by 'like' buttons.

The resulting play-work will, ideally, create its own dividends that are not paid out to wholly unconnected shareholders. We are thinking here about a 'prosperity without growth':[30] a growth mindset without competition. Linked to this mindset, we wonder whether that privileged form of play-work, writing, is still a way of fighting invisibility, as with Cixous's confrontation of the 'mystery of the there-not-there',[31] or does it create new forms of invisibility for those without access? We see it as the cyborg's duty to continue to fight, as she plays, for the structural possibility for every 'sister outsider' to have her voice heard.

Haraway's cyborg knew both 'the dream of communicating experience; and the necessity of limitation, partiality'.[32] Communication as a cyborg, therefore, implies partial, not total knowledge; it means contributing to a collective resource of shared experience, exposure and unbinding knots of connectivity: 'This is a dream not of a common language, but of a powerful infidel heteroglossia'.[33] Indeed, we refuse to further entrench conservative ways of creating profit and relating in closed, fixed ways through saturated *identities*; we would rather adapt in ways that are playful, creative and that co-construct community based on shared affinities, spoken and embodied together.

Outlook: cyborgs, robots and writing

The Covid-19 pandemic precipitated one of the greatest and rapidest shifts in human behaviour in recent times, from the mobility of globalisation to the stasis of locked-down households. It is up to the cyborgs who have

been (re)born in this time to orientate the momentum of this ongoing change, towards greener, happier, healthier and more connected futures. Following Haraway's lead, we hope that this chapter has offered one example of cyborg writing: the real result of an empathic connectivity with one another, with – and through – (other) machines. Writing, like other artforms, is a means of connecting, one that helped so many people around the world to make our way through lockdown, and to understand it. Let us hope the practices of connecting, and affinities, we developed then will remain with us when the lockdowns are finally over.

Notes

1. Haraway, 'A cyborg manifesto', 150.
2. Haraway, 'A cyborg manifesto', 157.
3. Haraway, 'A cyborg manifesto', 149.
4. Haraway, 'A cyborg manifesto', 174.
5. D'Ignazio, *Data Feminism*.
6. Hartman, *Wayward Lives*, 77.
7. Haraway, 'A cyborg manifesto', 172.
8. Haraway, 'A cyborg manifesto', 181.
9. Ferri, 'Difference', 412.
10. Haraway, 'A cyborg manifesto', 154.
11. Hemmings, 'Resisting virality'.
12. Haraway, 'A cyborg manifesto', 150.
13. Preciado, 'Learning from the virus'.
14. Haraway, 'A cyborg manifesto', 162.
15. Miller, 'Nearly half of men'.
16. Flaherty, 'No room of one's own'.
17. Berg & Seeber, *The Slow Professor*, 35–6.
18. Preciado, 'Learning from the virus'.
19. Haraway, 'A cyborg manifesto', 181.
20. Haraway, 'A cyborg manifesto', 181.
21. Haraway, 'A cyborg manifesto', 155.
22. Haraway, 'A cyborg manifesto', 157.
23. Goethe, *Elective Affinities*, 57.
24. Goethe, *Elective Affinities*, 57.
25. Haraway, 'A cyborg manifesto', 150; original italics.
26. Haraway, 'A cyborg manifesto', 180.
27. Nancy, *The Inoperative Community*, 66.
28. Haraway, 'A cyborg manifesto', 154.
29. Haraway, 'A cyborg manifesto', 161.
30. Jackson, *Prosperity Without Growth*.
31. Cixous, 'Coming to Writing', 3.
32. Haraway, 'A cyborg manifesto', 179.
33. Haraway, 'A cyborg manifesto', 181.

Bibliography

Berg, Maggie and Barbara K. Seeber. *The Slow Professor: Challenging the culture of speed in the academy*. Toronto, ON: University of Toronto Press, 2016.

Cixous, Hélène. *'Coming to Writing' and Other Essays,* edited by Deborah Jenson; translated by Sarah Cornell. Cambridge, MA: Harvard University Press, 1991.

D'Ignazio, Catherine and Lauren Klein. *Data Feminism*. Cambridge, MA: MIT Press, 2020.

Ferri, Giuliana. 'Difference, becoming and rhizomatic subjectivities beyond "otherness": a posthuman framework for intercultural communication', *Language and Intercultural Communication*, 20 no. 5 (2020): 408–18.

Flaherty, Colleen. 'No room of one's own', *Inside Higher Ed*, 21 April 2020. Accessed 17 May 2021. https://www.insidehighered.com/news/2020/04/21/early-journal-submission-data-suggest-covid-19-tanking-womens-research-productivity.

Goethe, Johann Wolfgang von. *Elective Affinities*. New York: Collier, 1809.

Haraway, Donna. 'A cyborg manifesto: Science, technology, and socialist-feminism in the late twentieth century'. In *Simians, Cyborgs and Women: The reinvention of nature*, 149–81. New York: Routledge, 1991.

Haraway, Donna. 'Situated knowledges: The science question in feminism and the privilege of partial perspective', *Feminist Studies* 14, no. 3 (1988): 575–99.

Hartman, Saidiya. *Wayward Lives, Beautiful Experiments: Intimate histories of social upheaval*. New York: Norton, 2019.

Hemmings, Claire. 'Resisting virality (after Eve Sedgwick)'. Blog series: confronting the household, *Feminist Review,* 26 May 2020. Accessed 2 July 2021. https://femrev.wordpress.com/2020/05/26/revisiting-virality-after-eve-sedgwick/.

Jackson, Tim. *Prosperity Without Growth: Foundations for the economy of tomorrow*. London: Routledge, 2017.

Miller, Claire Cain. 'Nearly half of men say they do most of the home schooling. 3 percent of women agree', *The New York Times,* 6 May 2020. Accessed 12 July 2021. https://www.nytimes.com/2020/05/06/upshot/pandemic-chores-homeschooling-gender.html.

Nancy, Jean-Luc. *The Inoperative Community*, edited by Peter Connor; translated by Peter Connor, Lisa Garbus, Michael Holland, and Simona Sawhney. Minneapolis, MN: University of Minnesota Press, 1991.

Preciado, Paul B. 'Learning from the virus', *Artforum* 58, no. 9 (2020). Accessed 12 July 2021. https://www.artforum.com/print/202005/paul-b-preciado-82823.

7
Reflections on Covid-like pathogens in ancient Mesopotamia
Markham J. Geller

Benjamin Franklin is credited with the proverbial statement that 'an ounce of prevention is worth a pound of cure'. The statement applied as much in the ancient world BCE as in the eighteenth century CE when Franklin purportedly made the observation. It is also especially apposite at the time of writing (late summer 2020), during a pandemic of a disease for which there is neither vaccine nor effective treatment. Ironically, we now fall back upon preventive measures of hygiene and social distancing, which were commonly applied in the ancient world. At the same time, we need to recognise that drugs in antiquity were prized and prescribed on the basis of trial and error but without the authority of the clinical trials which underpin modern debate. While the presence of influenza-like disease within ancient texts cannot be determined with certainty, viruses were clearly present in ancient Mesopotamia, judging from numerous references to epidemics as well as to symptoms associated with fevers,[1] although ancient physicians could not make modern clinical distinctions between bacterial and viral infections. Knowledge of past experience of disease and infection and the measures taken to alleviate these threats allows us to reflect on the history of pandemics in the light of modern experience, and, at the same time, consider how these same ancient sources can also affect our view of the Covid-19 virus today.

The approach taken here will avoid the common error of assuming that ancients had a notion of 'contagion', meaning the process by which

an illness is physically transferred from one person to another via pathogens. In classical antiquity, the modern concept of contagion did not exist,[2] but ancient physicians relied upon other explanations for the spread of disease, such as a miasma or an infectious cloud spreading disease.[3] Even as late as the nineteenth century CE, epidemics were mostly attributed to overcrowding, poor hygiene or lack of personal morality and, surprisingly, a theory of miasma still persisted.[4] The most notable contribution to counteracting these traditional notions was the discovery made by Ignaz Semmelweis, a Hungarian obstetrician who worked in the Vienna Allgemeine Krankenhaus between 1844 and 1848. Semmelweis noticed that maternity wards where women were treated by midwives had fewer fatalities than those wards where patients were treated by male doctors, who performed autopsies without washing their hands before examining patients. Although Semmelweis's reasoning was faulty regarding the actual causes of puerperal ('childbed') fever, the results of his observations nevertheless led to rigorous handwashing regimes in hospitals and medical environments, thereby saving countless lives. One of the arguments against Semmelweis's ideas at the time is also instructive: that puerperal fever was more common in winter than in summer months. Semmelweis's reply to this conundrum was that fewer women died in summer because medical students spent the warmer months enjoying Vienna's delights rather than working with cadavers or in hospital wards, resulting in a diminished number of infections.[5]

Further to the east and millennia earlier, in Mesopotamia, as noted in numerous cuneiform tablets, doctors had a different idea, best conveyed by the term 'contamination', which became a key mechanism for explaining epidemics and infections spreading from one person to another. The essential idea in preventing contagion involved totally avoiding contact with anything considered to be unclean or impure, in either a ritual or physical sense. 'Contagion' was a broad category which could implicate carrion, cadavers, menstruating women, utensils, furniture, clothing, or even houses, or any item perceived to be hexed; physical contact with any such thing was to be assiduously avoided. In fact, this idea of 'contamination' in antiquity might in some instances come closer to the modern concept of a virus, which is not a living organism but a particle comprising protein molecules and its own genetic materials.[6] A clear example of 'contagion' occurs in a Mesopotamian magical text called *Shurpu*, which seeks to identify the particular taboo that a patient or victim may have violated, thereby earning divine anger and punishment; one such improper act was that '(the patient) slept in the bed of an accursed person, he sat in the chair of an accursed person,

he ate at the table of an accursed person'.[7] The issue is fear of 'contamination' via simple contact with someone who may have suffered an ominous fate. The avoidance of contact with an accursed or ill person was driven, to a certain extent, by the common-sense observation that disease can spread, but one must not confuse this with the modern clinical concept of pathogenic 'contagion'.

Examples of the idea of 'contamination' can be found in ancient cuneiform medical recipes, as in the following example:

> If a man trod on (an object of) witchcraft or into (polluted) bathwater: in order to undo the (contamination caused by) the witchcraft or bathwater, he should look up at the 'Kidney of Ea' (a star) in the morning, on an empty stomach, and he should be pure.[8]

This mysterious 'Kidney of Ea' is a star that offered astrological protection against the fear of being contaminated by witchcraft through contact with polluted water. This is hardly a rational remedy from our modern perspective, except that it draws attention to the obligation to observe ritual purity, which meant washing or bathing. The assumption that these hygiene measures were deemed requisite derives from a procedure enumerated immediately before the diagnostic reference to treading in unclean water:

> Its procedure: You take juniper, over which you recite an incantation three times, you wash your feet and your hands and you rub on cypress-oil and everything should be favourable.[9]

The idea of thorough cleansing not only of one's person but also of the house can also be seen in other popular rituals aimed at counteracting the effects of a bad omen, which was thought to introduce impurity into the domestic environment. Richard Caplice summarises the procedures in graphic terms:

> The threatened man may be enjoined to wash, to bathe with pure water, to remove his garments and put on clean ones, to shave; in what appears to us a more 'cultic' vein, he may be purified (*ullulu*) with tamarisk and *tullal*-plant, or incensed with censer and torch. The site too is often subjected to purification rites, both physically (it is swept and pure water sprinkled on it, it is 'wiped clean,' it is 'set in order') and cultically (it is incensed with censer and torch).[10]

From a modern clinical standpoint, we cannot be sure whether the 'contamination' mentioned in these ancient texts corresponded to viral or bacterial infection events, but remedies were probably effective to an extent, in terms of washing, bathing and general attention to hygiene, in addition to 'social distancing'.[11]

One of the earliest references to quarantine was recently discovered by Irving Finkel on a cuneiform tablet in the British Museum, dating from c.500 BCE.[12] Here is a taste of this interesting text, describing first the symptoms of a feverish patient:

> O Fate, vizier of the Underworld! So-and-so, whom a witch has affected despite your protection, and upon whom mountain fever has fallen – you have struck him in his brain, made him delirious, had fever attack his body, wasted his flesh, paralysed his sinews, snatched the food and drink from his mouth; at the command of Asalluḫi, Lord of magic, let go! Be off! Spell.

The important point about this particular treatment is that the patient is to be isolated and subject to social distancing, as can be seen from instructions for strict quarantine to treat this form of fever:

> You draw [his bed on] the gate; he should remove the *wood shavings* from the door of the gate.
> You wrap a ... in wool from a virgin she-goat and place it around his neck.
> [In the morning] at sunrise, you make him enter a dark room where neither fire nor light is visible,
> [as for that man], you cover (him) with either an *azamillu*-sack or a black cloth, or you stretch out a cloth at the gate of his house.
> No-one may enter [the house], his name is not to be mentioned.
> You keep rubbing many plants on him [in ... oil] for 3? days and you enclose his bed and he must reside in the house for three days.[13]

The first requirement was for a warning, that a sign representing the patient's bed was to be put on the door, indicating illness within. This was accompanied by tidying up the entrance to the house by removing any detritus which may have collected there. Since the patient suffered from fever, he had to be kept warm by placing some ritual object wrapped in soft wool around his neck. At sunrise the patient was transferred to a dark room and covered with a dark cloth to keep out light, and a cloth placed on the house gate was a further indication of pestilence, perhaps

indicating a more advanced state of the disease. Not only could no-one enter the house, one could not even mention the patient by name, to reinforce the imposed isolation. Although the physician was still supposed to offer massage therapy, the patient was locked in a bedroom and remained there for a period of three days. Presumably, after this time the symptoms were checked again, to see if the procedure was to be repeated.

Besides the bathing and washing referred to above,[14] this document offers fresh insights into how ancient physicians coped with infectious disease. One measure, in an extreme case, was to relocate the patient to a special place, where he or she could be remotely treated with fumigation therapy.[15] The infected patient was to be secluded in a dark space, with no visitors or interlocutors,[16] hence a drastic form of 'social distancing'.[17] Why the physician kept treating the patient (as we assume was happening) and what kind of drugs were employed for massage therapy remain unanswered questions. But it would be helpful, nevertheless, to know something more about the diagnosis of fever in Mesopotamia. There are some clues which might help us detect something about the nature of infections mentioned in texts such as these.

There are two independent systems of diagnosis and prognosis within Babylonian medicine, and although they may at first seem similar, in fact the descriptions of symptoms are quite different. One set of symptoms was recorded and addressed by the *āšipu* or exorcist, a priest who was tasked with visiting the patient at home to arrive at a prognosis or diagnosis;[18] his symptom notations were collected in the *Diagnostic Handbook,* which contained some 15,000 separate entries of symptom notations. A second independent description of patient symptoms, however, appears in medical prescriptions, and these symptoms were drawn up by the *asû*-physician, who was not a priest and also acted as an apothecary; the *asû*-physician rarely offered a prognosis but could venture a diagnosis after listing symptoms. Whereas the prognoses provided by the *āšipu*-exorcist were often negative, predicting early death or chronic illness, the *asû*-physician usually ended his prescription on a positive note, advising that the patient was likely to improve.

The question is whether the recording of symptoms in either the *Diagnostic Handbook* or medical prescriptions might indicate a distinction among approaches to epidemiology. Given that ancient Mesopotamian physicians had no diagnostic means beyond physical examination of a patient, perceived causes of disease often appear to be completely arbitrary, and (often infectious) diseases were attributed to a specific god or goddess (for example, Ishtar and Marduk among others), demon (for example, Lilith) or various types of ghost. When references to these

presumed disease vectors first appeared in texts from the early second millennium BCE, the illnesses were literally understood as the outcome of personal involvement by deities and demons in the affairs of mankind. But, as time went on and medical techniques developed over the next thousand years, terms such as 'hand of a god' or 'hand of a ghost' became metaphorical, becoming used as labels to identify specific types of pathologies. These popular labels were gradually replaced in medical vocabularies by technical disease terminology which remains difficult for us to decipher, such as when referring to a variety of dermatological conditions.

In terms of ancient epidemiology, the idea that disease resulted from the 'hand' of a god, demon or ghost progressively came to reflect the *arena* within which one was understood to have come into contact with the specific 'agent', such as in an army camp, a brothel, law courts, the family or temple. For instance, within this more sophisticated system of diagnosis, the 'hand' of the toilet demon, Shulak, was likely invoked to refer to an illness associated with unsanitary or polluted or stinking conditions, rather than connoting a personal attack by the demon as such.[19] The 'hand' of the warlike god Nergal no doubt referred to this god's frequent appearance in omens portending epidemic or plague,[20] since an army encampment was a dangerous environment for sitting out an epidemic. By the same logic, the 'hand' of the love goddess Ishtar might reference another potentially dangerous location for the spread of disease, the brothel.[21] Similarly, the 'hand' of the storm god Adad could imply disease attributed to inclement weather, rather than a specific location. The 'hand' of the chief god Marduk could refer to the royal palace or administration as a potentially dangerous place for contracting illnesses, because of a lack of social distancing, and the same applies to the sun god Shamash, patron god of justice and courts of law. It is important to note that Mesopotamian urban centres did not have theatres (until late in the Hellenistic period) or public arenas, apart from the marketplaces (at the city gate) which would have been open-air. The only other major gathering place would have been temples, but these premises insisted on stringent standards of personal hygiene and cleanliness, which may have reduced opportunities for epidemic disease to spread within these precincts.

Bearing all this in mind, in later periods in the first millennium BCE the most frequent of such designations of disease vectors was 'hand of a ghost', often alluding to departed members of the same family, and often in connection with what may look like the symptoms of an infectious illness. The chief symptoms in the *Diagnostic Handbook* associated with

this label, 'hand of a ghost', indicate that this condition attacks the head, temples, eyes, neck, throat and chest, combined with paralysis of hands and feet, ringing in the ears and blood in the mouth.[22] The cluster or combination of such symptoms might possibly indicate an influenza-type virus (perceived as spreading via 'contamination'), a possibility strongly suggested by the fact that medical diagnoses make frequent reference to 'ghosts' as the disease vectors. Infectious diseases were likely to have been rampant in families, and as members of the family died from disease further infections were subsequently attributed to them. Arguably, the most dangerous arena for the spread of epidemics was likely to have been the extended family household, especially in a predominantly urban society like Mesopotamia, which was chiefly supported by irrigation agriculture; cities like Babylon and Nineveh were much larger than ancient Athens and were only later eclipsed in size by Rome. The attribution of a disease to the 'hand' of a ghost could conceivably have referred to members of the same family succumbing to an epidemic, and this notation then became used as a characterisation for sudden death within a family unit during an epidemic or seasonal virus.

However, the theoretical 'hand of a ghost' symptoms noted in the *Diagnostic Handbook* were not the same symptoms listed by physicians in their practical prescriptions.[23] In fact, the *asû*-physician was normally reluctant to attribute disease to the hand of a ghost or gods or demons. Exceptionally, a cluster of references to the 'hand of a ghost' symptoms occurs in a physician's recipe for diseases of the ear, the indications of which are ears 'roaring' or being hot and exuding pus (indicating infection).[24] Another highly atypical recipe from a Babylonian medical prescription (for an unspecified pathology) recommends an exotic magico-medical ritual (in other words, manufacturing, attending to and then burying a figurine of a ghost,[25] referring specifically to a patient's father or mother).[26] The psychological effect of such procedures on the patient is obvious, but with specific emphasis on the family ghost or ghosts of parents and siblings.

Conclusion

Even if ancients might have referred to a disease vector as a 'demon' or 'ghost', the persistent 'microbe' analogy may turn out to be only partially correct.[27] The treatments recommended by ancient medicine in Mesopotamia to prevent or treat outbreaks involved both strict hygiene measures and social distancing, as well as palliative drug treatments,

which are the standard well-recognised measures recommended for dealing with the Covid-19 virus today. The current experience of a pandemic somewhat alters our perception of pre-modern or even ancient medicine, since it allows us to appreciate the persistent nature of epidemics and disease, and to consider the extent to which protection against infectious viruses was achievable.

Notes

1. See Geller, *Ancient Babylonian Medicine,* 68–9; details regarding epidemics are not evenly distributed chronologically and come mostly from second-millennium BCE letter archives. This survey of ancient Babylonian medicine describes the respective roles of the *asû*-physician and *āšipu*-exorcist/priest in a highly systematised and complex system of medicine with an impressive pharmacopeia, extensively documented some two centuries before Hippocrates; see Steinert, *Assyrian and Babylonian Scholarly Text Catalogues,* for an overview of the medical corpus.
2. For a discussion of the classical terminology for 'contagion' and what it means, see Nutton, 'To kill or not to kill?' 233, and Nutton, 'Did the Greeks have a word for it?' 151, as well as other contributions in Conrad and Wujastyk, *Contagion,* indicating a general lack of understanding of contagion in pre-modern societies.
3. The idea of a miasma (literally, 'pollution') appears not entirely incorrect in the light of modern warnings about exposure to aerosols of Covid virus which can linger within a closed room.
4. Tulodziecki, 'Shattering the myth', 1068, also explaining an alternative 'contagion theory' which assumed that a disease like smallpox could be transferred as smallpox to another person, rather than through antigens or bacteria.
5. Tulodziecki, 'Shattering the myth', 1073–4.
6. This contrasts with the idea of a living organism or bacterium represented in antiquity as a sentient demon which could be addressed and exorcised.
7. Reiner, *Šurpu,* 16 and 23. These lines from the incantation series *Shurpu* (Tablet 2, lines 100–2, Tablet 3, lines 131–3) also mentioned eating and drinking with an 'accursed' person. *Shurpu* identifies a large number of violated taboos which made the patient liable to divine wrath, for which the cleansing ritual was to wipe the patient down with flour, which was then burned. The Babylonian term for this ritual is cognate to the Hebrew term for the atonement ritual in the annual festival of Yom Kippur. Other entries in *Shurpu* are of interest but have never been adequately explained, such as the patient seeking a 'sign' or 'omen' (*šā'il*) from ordinary household objects such as a bed, chair, table, stove, torch or bellows, etcetera; this is considered to be illicit behaviour which makes the patient culpable and ultimately responsible for his own misfortune. The danger in this activity is probably related to some form of contamination as well, since a bad omen is itself a form of impurity and the act of divination without proper ritual preparation may make one vulnerable to disease.
8. Schwemer, 'Prescriptions and rituals', 191.
9. Schwemer, 'Prescriptions and rituals', 191.
10. Caplice, *The Akkadian Namburbu Texts,* 10, referring to sequestration and purification rituals. See also Maul, *Zukunftsbewältigung,* for a comprehensive discussion of this ritual genre.
11. See Robson, 'Mesopotamian medicine and religion', 475–6, emphasising the role of rituals of purification and cleansing as a major part of the role of the Babylonian healer-exorcist-priest (*āšipu*).
12. The text is published in Finkel, 'Amulets against fever', in connection with a number of amulets from the same period designed to protect a patient from fevers. The same text was also edited independently in Stadhouders, 'The unfortunate frog', 166.
13. From another text edited for the first time, in Finkel, 'Amulets against fever', dating from c.700 BCE. The difference in age between the two texts is not significant.

14 Handwashing is specifically mentioned in ritual texts as a required procedure. Compare *šuluhhu*, s.v., *Chicago Assyrian Dictionary*, Š/3 260–1, referring to handwashing rituals.
15 Fumigation was commonly used as a treatment, since drugs which are inhaled can be rapidly absorbed into the system.
16 Another text from the same group of anti-fever rituals (Finkel, 'Amulets against fever', 263–4) advocates treating the patient similarly in isolation, but also by changing the usual household utensils which would normally come into contact with him:

> You change the *utensils* (reading Á.KÁR = *unūtu*) for him,
> cover him with a woollen *azamillu*-sack,
> fumigate him with the fumigants;
> he must not see the bright sunlight;
> no one may speak with him,
> and where he was set down no-one may enter.

A somewhat different translation of this text appears in Stadhouders, 'The unfortunate frog', 166.
17 Caplice, *The Akkadian Namburbu Texts*, 10, also refers to rituals being carried out in a secluded place or a 'place barred from access'.
18 There is no firm evidence for clinics or other treatment centres comparable to an Asklepion temple in more Western medicine.
19 A late Seleucid period commentary from Uruk provides a revealing insight into the effects of the toilet or latrine (from Hunger, *Spätbabylonische Texte*, 57, no. 47):

> **If a man's tongue is swollen** (commentary: swollen = inflamed, swollen = grows large), **(it is) the demon of the latrine** (commentary = Šulak). **One should not enter into a latrine** (commentary: Šulak can strike him. As it is said about [the name] Šulak, ŠU = hand, LA = not, KÙ = pure = he enters the latrine with unclean hands.).

See the Yale Cuneiform Commentary Project comment on this text: Philippe Clancier, (creator), 'SpTU 1, 047 [If a person's skull suffers from fever commentary]', *Yale Cuneiform Commentary Project*, 2009. Accessed 19 August 2021. http://oracc.museum.upenn.edu/cams/gkab/P348468.
20 Compare Rochberg-Halton, *Aspects of Babylonian Celestial Divination*, 132, 257: 'if an eclipse falls (on a certain day), Nergal will ravage, there will be plague'.
21 The existence of sacred prostitution in Mesopotamia remains an open question, for which see Westenholz, 'Tamar, Qedeša, Qadištu', 263. However, sexual relations with a woman could be designated as causing a 'sexual disease', as in the following symptoms from the *Diagnostic Handbook*, which refer to a patient's penis and testicles being hot and swollen with blood dripping from the penis, also attributed to the 'hand of Venus (Ishtar)'; see Geller, *Renal and Rectal Disease*, 251. Similarly, loss of potency and other symptoms were perceived as caused by extramarital sex; see Scurlock, *Sourcebook*, 24, 175, 189 (although 'venereal disease' is not provable).
22 Of particular interest is the specific 'hand of the ghost' label for a disease, rather than alternative formulations such as *ṣibit eṭemmi* ('attack of a ghost'). The reason for this is that the former is often associated with members of the family. For example, a series of 'hand of the ghost'-attributions from the *Diagnostic Handbook* (see Scurlock, *Sourcebook*, 29, 34) may all refer to the same pathology:

> If (a patient's) temple affects him and he continually calls out (and) blood runs out of his nose, **hand of a ghost**.
> If his temple affects him and ditto, his temple-blood vessels are pulsating greatly (and) the upper part of his head (feels) separated, **hand of a ghost**; he will die.
> If his temple affects him and ditto, his temple-blood vessels are pulsating greatly (and) the upper part of his head (feels) crushed, he will die.
> If his temple affects him and he continually calls out: 'my belly, my belly,' **hand of a ghost**, deputy of Ishtar; he will die; variant: **hand of a ghost**; if (the condition) is prolonged, he will die.
> If his temple affects him and ditto, he vomits a lot and cannot take up his pallet, **hand of a ghost**; he will die.

If his temple affects him and lasts from sunset till the third night watch (var. it keeps him awake at night), he will die.
If his temple affects him and from sunrise to sunset it hurts him (var. it does not let up, it will let up); **hand of a ghost**.
If his temple affects him and blood flows from his nose, **hand of a ghost**.
If his temple affects him and his neck sinews continually hurt him, **hand of a ghost**.
If his temple affects him and his eye sinews continually hurt, **hand of a ghost**.
If his temple affects him and he becomes hot (and) chilled and his eyes are inflamed, **hand of a ghost**.
If his temple affects him and has vertigo (his face spins); he gets up but falls down, **hand of a ghost**.
If his temple affects him and paralysis grips his body, but he does not sweat, **hand of a ghost**.

It is not possible to offer a modern diagnosis based upon these symptoms, although the anatomical location most affected appears to be the cranium, eyes and or nose, with the patient's condition indicated by a rapid pulse, abdominal pain and vomiting, as well as feeling feverish, dizzy and numbness. The 'hand of the ghost' was a convenient label to identify symptoms which might have been able to spread to others within close proximity, such as family members, and could possibly have been indicated by some type of virus.

23 See Bácskay, *Therapeutic Prescriptions*, 164–9, 172–3, for references to ghosts in medical prescriptions, but these do not refer to the 'hand' of a ghost, but to a variety of other ghosts attributed with causing diseases, which include 'ghosts of the family' (lines 38, 110), the 'roaming' or 'wandering' ghost (lines 41–2, 112–13, 128), or simply the 'evil' ghost (line 115). Only the family ghost mentioned here is relevant to the idea that this is an arena that could easily foster the spread of a virus in an ancient urban setting. References to a wandering or roaming ghost as a disease vector may assume illness contracted while the patient had been travelling.
24 Scurlock, *Sourcebook*, 367–87, for the text known as BAM 503, which mostly deals with ear problems.
25 Scurlock, *Sourcebook*, 692–703, for the text known as BAM 323. The recipe provides little in the way of symptoms, while suggesting that those associated with the 'hand of a ghost' syndrome were easily identifiable. In the latter part of the tablet, some conditions are mentioned which appear to reflect an unsettled mental state (lines 65–9), but despite the magical tenor of this text for the modern reader, the text specifically stipulates that the *āšipu*-exorcist-healer is not able to solve the patient's problems (line 75). The ritual for making a ghost-figurine gives pause for thought, since the raw materials for the figurine consisted of dirt from various abandoned sites, including an abandoned city, house, temple, grave, foundation, canal, or crossroads. The description of being 'abandoned' might reflect on the nature of ghosts as departed ones, to reinforce the psychological impact on the patient of the effective power of the figurine, but it might also reflect on the perceived nature of contamination from ghosts from an unhealthy or unhygienic environment.
26 See Finkel, 'Necromancy in ancient Mesopotamia', 1983/4, 11, a necromancy text which conjures up 'the ghost who has cried out in my house, whether of (my) father or mother, whether (my) brother or sister, whether a forgotten son of someone, whether a vagrant ghost who has no-one to care for it'.
27 See Wright, 'Demonology and bacteriology', 1917, 494–5, 498, referring to belief in evil spirits as cause of disease, also in Mesopotamia (505–6).

Bibliography

Bácskay, Andras. *Therapeutic Prescriptions against Fever in Ancient Mesopotamia*. Münster: Ugarit Verlag, 2018.
Caplice, Richard. *The Akkadian Namburbu Texts: An introduction*. Malibu, CA: Undena, 1974.
Chicago Assyrian Dictionary. Chicago: Oriental Institute, 1956–.

Conrad, Lawrence, and Dominik Wujastyk (eds). *Contagion: Perspectives from pre-modern societies*. Aldershot: Ashgate, 2000.

Finkel, Irving. 'Amulets against fever'. In *Mesopotamian Medicine and Magic. Studies in honor of Markham J. Geller*, edited by Strahil V. Panayotov and Luděk Vacín, 232–71. Leiden and Boston: Brill, 2018.

Finkel, Irving. 'Necromancy in ancient Mesopotamia', *Archiv für Orientforschung* 29/30, (1983/4): 1–17.

Geller, Markham J. *Ancient Babylonian Medicine in Theory and Practice*. Colchester: Wiley-Blackwell, 2010.

Geller, Markham J. *Renal and Rectal Disease Texts (Die babylonisch-assyrische Medizin in Texten und Untersuchungen* vol. 7). Berlin: de Gruyter, 2005.

Hunger, Hermann. *Spätbabylonische Texte aus Uruk* vol. 1, Berlin: Gebr. Mann Verlag, 1976.

Maul, Stefan. *Zukunftsbewältigung, Eine Untersuchung altorientalischen Denkens anhand der babylonisch-assyrischen Löserituale (Namburbi)*. Mainz: Philipp von Zabern, 1994.

Nutton, Vivian. 'Did the Greeks have a word for it? Contagion and contagion theory in classical antiquity'. In *Contagion: Perspectives from pre-modern societies*, edited by Lawrence Conrad and Dominik Wujastyk, 136–62. Aldershot: Ashgate, 2000.

Nutton, Vivian. 'To kill or not to kill? Caelius Aurelianus on contagion'. In *Text and Tradition: Studies in ancient medicine and its transmission*, edited by Klaus-Dietrich Fischer, Diethard Nickel and Paul Potter, 233–42. Leiden: Brill, 1998.

Reiner, Erica. *Šurpu, A Collection of Sumerian and Akkadian Incantations*. Graz: Erica Reiner, 1958.

Robson, Eleanor. 'Mesopotamian medicine and religion: Current debates, new perspectives', *Religion Compass* 2, no. 4 (Summer 2008): 455–83. https://doi.org/10.1111/j.1749-8171.2008.00082.x.

Rochberg-Halton, Francesca. *Aspects of Babylonian Celestial Divination: The lunar eclipse tablets of Enūma Anu Enlil*. Horn: F. Berger and Sons, 1988.

Schwemer, Daniel. 'Prescriptions and rituals for happiness, success, and divine favor: The compilation A 522 (*BAM* 318)', *Journal of Cuneiform Studies* 65 (2013): 181–200. https://doi.org/10.5615/jcunestud.65.2013.0181.

Scurlock, JoAnn. *Sourcebook for Ancient Mesopotamian Medicine*. Atlanta, GA: SBL Press, 2014.

Stadhouders, Henry. 'The unfortunate frog: On animal and human bondage in K 2581 and related fragments with excursuses on BM 64526 and *YOS* XI, 3', *Revue d'assyriologie* 112 (2018): 159–76. https://doi.org/10.3917/assy.112.0159.

Steinert, Ulrike (ed.). *Assyrian and Babylonian Scholarly Text Catalogues (Die babylonisch-assyrische Medizin in Texten und Untersuchungen* vol. 9). Berlin: de Gruyter, 2018.

Tulodziecki, Dana. 'Shattering the myth of Semmelweis', *Philosophy of Science* 80, no. 5 (December 2013): 1065–75. https://doi.org/10.1086/673935.

Westenholz, Joan. 'Tamar, *Qedeša, Qadištu*, and sacred prostitution in Mesopotamia', *Harvard Theological Review* 82 (1989): 245–65.

Wright, Jonathan. 'Demonology and bacteriology in medicine', *The Scientific Monthly* 4 (1917), 494–508.

8
Handwashing saves lives: producing and accepting new knowledge in Jens Bjørneboe's *Semmelweis* (1968) and the Covid-19 pandemic

Elettra Carbone

Since Covid-19 cases started to rise in early 2020 and national and international campaigns on the importance of handwashing became increasingly visible, I have found myself repeatedly thinking of the play *Semmelweis* (1968) by Norwegian author Jens Bjørneboe (1920–1976). The play follows the life and work of Hungarian physician Ignaz Philipp Semmelweis (1818–1865), who discovered that the spread of childbed fever could be prevented if doctors and medical students scrubbed their hands. During his time Semmelweis's theories were unpopular, and his work was not acknowledged until after his death. In the play Semmelweis is seen battling to be heard as he tries in vain to change his colleagues' routines and practices.

Semmelweis has often been regarded as a prime example of Bjørneboe's critique of authoritarian systems.[1] It is in this context that it has so far featured in research as well as teaching. In our modern times, when the importance of good hygiene for disease prevention and control is considered a given, the play's handwashing scenes have seemed relevant only if placed within a broader political and philosophical context. Having used these same scenes in my fourth-year Norwegian-language course since 2013 to practise discussion and debate, I thought

this approach was the only way of making this text relevant particularly to modern audiences. This was the case, at least, until 2020.

In this article, I wish to consider the past, present and future relevance of Bjørneboe's play. How can Semmelweis's handwashing scenes help us to understand the handwashing campaigns so crucial in the fight against the Covid-19 pandemic? To what extent do they also allow us to reflect on the socio-political and medical dynamics that shaped practices and debates around the pandemic? I will answer these questions while reflecting on what the play tells us about the production of new medical knowledge crucial to disease prevention and control and its reception by a given community.

The discovery and rediscovery of handwashing

As the Covid-19 pandemic spread rapidly across the world, the World Health Organisation (WHO) continued to stress the importance of hand hygiene to prevent the spread of the virus. In a document published on 1 April 2020 and containing a series of recommendations to member states 'to improve hand hygiene practices widely to help prevent the transmission of the COVID-19 virus', we are reminded that 'hand hygiene is the most effective single measure to reduce the spread of infections' – a fact at the centre of the 'SAVE LIVES: Clean your hands' global campaign launched in 2009 and, since then, marked yearly by World Hand Hygiene Day on 15 October.[2] According to Wang and Hong, the largest element of research on Covid-19 by the end of 2020 had fallen under the category of 'epidemiology and public health intervention', which includes 'transmission dynamics, prevention and control measures and effect dynamics at different regional levels'.[3] This is the kind of research that informs public information campaigns such as the 'Hands. Face. Space' UK government campaign launched in September 2020, which highlights the effect of 'droplets that come out of our nose and mouth' in the spread of the virus and thus the importance of handwashing, face coverings and social distancing.[4]

While the world was rediscovering the importance of handwashing, the name of Ignaz Semmelweis, the Hungarian doctor credited with this invention, kept appearing in both research and popular articles.[5] Half a century earlier, Bjørneboe had sought to remind his audiences of the historical significance of Semmelweis's discoveries, as well as his relevance as a model for critiquing authoritarianism. Primarily, *Semmelweis* is a play about the importance of understanding how illnesses

are transmitted and how, if they cannot be cured, they need to be prevented. It is about the research, observations and somewhat fortuitous circumstances that led Semmelweis to the realisation that childbed fever is indeed contagious and was spread by doctors and medical students who did not wash their hands when caring for women in maternity wards after dissecting cadavers. Yet, what makes *Semmelweis* all the more pertinent to our contemporary moment, and the miasma of denialism, misinformation and disinformation that has inflected discussion of Covid-19, is how it stages Semmelweis's attempts to save lives by fighting the resistance that met his suggested changes to routines from most of the medical community. Bjørneboe conceived of his play as anti-authoritarian in nature, one that would chart 'oppdagelsen, den videre kamp og autoritetenes senile og diktatoriske motstand mot nye tanker' ('the discovery, the ensuing fight and the authorities' senile and dictatorial opposition against new thoughts').[6]

The study of the transmission of childbed fever was the first step in Semmelweis's attempt to understand the disease. In the play's second scene, Semmelweis discusses the issue at a medical conference in the Vienna Allgemeine Krankenhaus where he works. Childbed fever – also called puerperal fever, and today known as a form of sepsis referred to as maternal sepsis [7] – was believed, as echoed in Bjørneboe's play, to be an illness that affected only certain categories of women: 'prostituerte, arbeiderhustruer, omstreifersker og tjenestepiker' ('prostitutes, working class wives, wanderers and maids').[8] While, in reality, these women were most affected as they more often gave birth in hospitals (compared to the majority of upper-class women who gave birth at home), the medical community maintained that childbed fever was a punishment from God for their 'lystfølelsen' ('feeling of sexual pleasure'), a feeling which, according to Professor Klein – one of Semmelweis's superiors – no upper-class woman ever experienced.[9] Other causes believed to be responsible for this illness were equally intangible forces: miasma, 'an emanation or an atmosphere that hovers in the surroundings and causes sickness to those exposed to it by the pervasiveness of its malignant presence', as well as 'local cosmotelluric forces, hygrometric forces, polar currents, or radiation from the constellations'.[10] In the play, Semmelweis refuses to accept that the illness has anything to do with gender, social class or the country of origin of the medical students treating the pregnant women. He looks for concrete answers through continuous observation of the world around him before looking for proof in numbers and behavioural patterns in order to challenge established routines and beliefs.

The first time Semmelweis is convinced of the contagiousness of childbed fever is through his conversation with Sofia, a prostitute in Vienna. Through her experience Sofia contests the doctors' knowledge as she insists on using the verb 'smitte' ('infect') in connection with childbed fever while also revealing that, as a prostitute, her only protections against syphilis and other illnesses are water and soap.[11] It is during their encounter that Semmelweis starts to formulate his theory and concludes: 'Studentene skal vaske hendene før de går over fra likene til de fødende. ... Feberen er smittsom.' ('The students have to wash their hands before they move from the corpses to the expecting mothers. ... The fever is contagious.')[12]

Countering perceptible and imperceptible threats

Semmelweis's second key discovery is the association between smell and infection, which leads him to suppose that cadaverous particles adhering to hands cause the same diseases among maternity patients and any other patient coming into contact with them.[13] In Bjørneboe's rendering, bad smells make the risk of infection and death more tangible as illness and death become a presence on stage. This is emphasised early on when, even before Semmelweis's discovery of the importance of handwashing to halt the spread of the infection, Semmelweis and Professor Klein consider the role of smell. As Semmelweis smells his hands, he remarks '[l]ukten av kadaverene ... som sykdommen, herr professor ... følger oss' ('the smell of the cadavers ... like the illness, Professor ... follows us'), while Klein insists: '[d]e skal betrakte lukten som soldatens sår, som offiserenes medaljer' ('you should regard the smell like the soldier's wound, like the officers' medals').[14] Klein encourages Semmelweis to embrace the smell of cadavers on his hands as an honour, a perceptible proof of his work as a doctor and one that, he bizarrely claims, will allow him to progress in his medical career to professor. Semmelweis, however, seems to instinctively realise that the smell *is* the illness. Bjørneboe's figuration of illness as smell lingers throughout the play: first when the latrine cleaner (the so-called 'nightman', 'Nattmannen') teaches Semmelweis to clean his hands with chloride of lime to get rid of the smell (and thus the infection); then in the scene showing Semmelweis's home experiments with excrement and carcasses; and finally, when Semmelweis discovers smelly sheets in the wards and realises the hospital is spreading the infection and sabotaging his clinical trials by attempting to save money on the washing of bedlinen.

The focus on smell, which allows Semmelweis to perceive and detect the infection causing childbed fever, contrasts with the 'invisible' threat of Covid-19, particularly as the role of asymptomatic carriers in spreading the virus has been progressively emphasised in medical research.[15] In addition to the challenge of identifying and isolating asymptomatic cases, the medical community has also stressed the difficulty of detecting symptomatic cases due to the very wide range of symptoms (major and minor) progressively recorded since the spring of 2020.[16] Not only is there no smell perceivable by human beings that can warn us of the presence of Covid-19,[17] but being infected with the virus can lead to the (normally temporary) loss of smell (anosmia) and taste (hyposmia), both of which were added to the UK list of official symptoms in May 2020.[18] It is precisely this ability of the virus to circulate undetected by our senses that has reinforced the importance of reducing the viral spread through preventative measures.

Despite the tension between perceptible and imperceptible threats, on the whole *Semmelweis* hinges on the same principle that has given handwashing campaigns – and, for that matter, mask-wearing, social distancing and diagnostic testing campaigns – a key significance worldwide in the fight against Covid-19: the importance of preventing, containing and mitigating transmission as we try to understand and find a cure for an illness.[19] While medical knowledge which predates Covid-19 has proved essential in responding to the pandemic (in terms of repurposing treatments and vaccine development, for instance), Covid-19 still remained for several months 'a disease with no proven pharmaceutical intervention and no proven vaccine'.[20] A year and a half after the start of the pandemic, with several approved vaccines and effective treatments, studies continue to emphasise the complex nature of this disease and the constant need to analyse the efficacy and safety of these measures through real-life observations in order to produce new knowledge that, in turn, can inform our response to this medical emergency.[21] In Semmelweis's time there was no proven cure for childbed fever – in fact, in the play the first symptoms of the illness are clearly presented as a death sentence. This is the main reason Semmelweis sees his handwashing campaign as essential to lowering the death rate: through destroying the so-called cadaverous particles, the spread of the disease will be reduced.[22] During his first attempt in the play to introduce mandatory handwashing, he responds to the protests of the majority of medical students by stating that handwashing is more important than Latin and books, thus rejecting the notion that existing

medical knowledge is comprehensive, and that so-called learned people have clean hands by nature.[23]

Science and anti-science

Semmelweis's handwashing campaign is based not on existing sources but on the new knowledge he has acquired through the numbers and statistics he has gathered. Yet, his insistence on the importance of these numbers and statistics makes him a laughing stock in the play.[24] When Semmelweis first raises the issue of the higher mortality of pregnant women (28 per cent) in Ward 1 – the ward attended by the medical students – compared to that in the ward tended to by midwives, Klein scoffs at his claims, stating 'Disse sifferne i all ære, de er nu engang Deres kjepphest ... og, ser De: man helbreder ikke sykdommer med *tall*, men ...' ('These figures in all honesty, they are now really your fad ... and you see: illnesses aren't cured with *numbers*, but ...').[25]

Throughout the play, Semmelweis is met with the same sceptical attitude towards numbers generated by clinical trials: as one of the medical students protests when Semmelweis attempts to introduce handwashing routines: 'Vi vil ha lærebokens pensum, ikke eksperimenter!' ('We want the essential knowledge of the textbooks, not experiments!')[26] Numbers are a recurrent theme: ultimately, they demonstrate the contagiousness of childbed fever, but they also pose an insurmountable barrier that stands in the way of Semmelweis's theory being properly tested. Talking in the play about his main work (published in 1860), Semmelweis states: 'Der ligger feilen; den er *saklig*! Den vil bli oversett ... eller bare avvist ... Disse akademisk åndssvake, konservative autoritetene: de reagerer ikke på *saklighet*.' ('There's my mistake; it is *objective*! It will be ignored ... or just rejected ... These academically imbecile, conservative authorities: they do not respond to objectivity.')[27]

In addition to the importance of numbers as an essential part of a methodology based on scientific (and thus provable) grounds, Semmelweis continues to stress that '[h]vert tall er et menneskeliv' ('every number is a human life') and that, in his eyes, the refusal to listen to the data makes the medical community guilty of murder.[28] However, as Semmelweis's friend Skoda points out, this realisation is the same reason the medical community refuses to accept the validity of Semmelweis's research: through his research and discoveries, Semmelweis has made all doctors into serial killers and, each year that passes without implementing his suggestions, the tally of women they have killed continues to rise.[29]

Accepting handwashing as effective prevention against infections does not only mean finding ways to facilitate its implementation but also acknowledging that individuals and not uncontrollable forces have a responsibility in – and can thus help to stop – their spread. Future generations benefitted from the work of Semmelweis, celebrated by Bjørneboe's play as well as by its narrative frame, which involves the unveiling of a monument dedicated to him during a memorial ceremony. Semmelweis himself, however, is unable to witness the impact of his research and discoveries: in the last scene he is left dying in a psychiatric ward, knowing that his patients are still dying while doctors around the world refuse to prove his discovery right. Semmelweis's protests and insults against his colleagues have little effect, as through the play we learn with him that producing new knowledge is not enough to save lives if the medical community is not ready to accept it.

While methods of hypothesis-testing in clinical trials might be established practice in today's medical community and trust in science is still comparatively high in many countries, recent studies have pointed to the rise of science scepticism. In the context of the pandemic, anti-science attitudes have fuelled a wave of misinformation and disinformation, particularly through social media, as well as driving anti-lockdown and anti-restriction protests and vaccine hesitancy, all of which threaten the efficacy of the emergency measures to stop the spread of the virus.[30] Discussing how to address science denialism, Rosenbaum and Malina acknowledge that studies on vaccine hesitancy show that 'among people who take no solace in rigorous science, more than transparency will be needed to build trust' and ultimately stop disinformation.[31] They conclude: 'Although the scientific community's obligation will always begin with championing truth, the pandemic has shown that society's health also depends on understanding why so many people reject it.'[32] Like Semmelweis, we can rage against those who refuse to follow current medical advice, but this may be of little effect, particularly in the short term. Ultimately, Bjørneboe's *Semmelweis* reminds us not only of how far medical science has come in tackling previously incurable and unknown diseases but also that new discoveries can and often do meet resistance. In the long run, understanding the causes of this resistance – as Skoda suggests – can help us to find ways in which to address it in order to stop the devastating consequences of science denialism which, ironically, in Bjørneboe's play is represented by the medical community to which Semmelweis belongs.[33]

Conclusions

Bjørneboe's *Semmelweis* is a play not just about the importance of freedom but also about the processes that lead to and accompany medical discoveries. During the Covid-19 pandemic, this text has gained new significance as it reflects on the role of scientific research and objective observations in disease prevention and control and demonstrates in practice how new scientific knowledge is produced. Several scenes in the play echo different stages of the pandemic and public debates about how best to tackle it: the race against the spread of infections; the importance of prevention – through measures such as handwashing – to reduce infection while buying the medical community essential time to understand an illness; the difficulty that new knowledge can encounter in being accepted by a given community. As we become overwhelmed by news items on the pandemic's unfolding – news items in which, according to a 2020 study on global media coverage, fear and scaremongering dominated – texts like *Semmelweis* can be crucial in helping us process and understand our current reality while also providing a break from it.[34]

As Norway celebrated the hundredth anniversary of Jens Bjørneboe's birth on 9 October 2020, a second wave of the Covid-19 pandemic continued to rage, thus disrupting some of the planned initiatives. The exhibition on his life and work at the National Library of Norway, for instance, had to be closed on 7 November in line with government guidelines. The website of the exhibition reminds us, however, that one of the main overarching themes in his writing is that of the fragile life of human beings in this world and their attempts to live in it and take care of it while also destroying it through war, greed, egoism and ignorance.[35] *Semmelweis* focuses in particular on the consequences of the latter, in other words, ignorance, while giving us insight into how research and willingness to learn and listen to the results can help us overcome our lack of knowledge in order to save lives.

Notes

1. Garton, *Jens Bjørneboe*, 82.
2. WHO, 'Recommendation to member states'.
3. Wang and Hong, 'The COVID-19 research landscape', 4.
4. Department of Health and Social Care, 'New campaign to prevent spread'.
5. Bhattacharya, 'Ignaz Semmelweis'; Ritschel, 'Ignaz Semmelweis'.
6. Bjørneboe, *Semmelweis*, 153. All translations from Norwegian are my own.
7. Today sepsis is defined as a dysfunction caused by a dysregulated host response to infection caused by any type of pathogen; it can be acquired either in the community or in healthcare settings. It should be noted that sepsis is not a single disease but an umbrella term for a set of

symptoms that accompany an infection (Cavaillon and Chretien, 'From septicemia to sepsis 3.0', 215).
8 Bjørneboe, *Semmelweis*, 171.
9 Bjørneboe, *Semmelweis*, 170.
10 Pittet and Allegranzi, 'Preventing sepsis in healthcare', 1.
11 Bjørneboe, *Semmelweis*, 176.
12 Bjørneboe, *Semmelweis*, 176.
13 Semmelweis, *The Etiology, Concept, and Prophylaxis of Childbed Fever*, 91.
14 Bjørneboe, *Semmelweis*, 163.
15 Petersen and Phillips, 'Three quarters of people'; Kault, 'Superspreaders, asymptomatics'.
16 Lippi et al., 'Searching for a clinically validated definition'.
17 Studies seem to indicate, however, that dogs may be able to detect infection in humans through smell: see Angeletti et al., 'COVID-19 sniffer dog'.
18 Dell'Era et al., 'Smell and taste disorders'.
19 OECD, *Testing for COVID-19*.
20 Ray, 'Viewpoint – Handwashing', 1; Rosenbaum, 'No cure without care', 1464.
21 Scavone et al., 'Therapeutic strategies'.
22 Semmelweis, *The Etiology, Concept, and Prophylaxis of Childbed Fever*, 91.
23 Bjørneboe, *Semmelweis*, 178.
24 Persson, 'Semmelweis's methodology', 205.
25 Bjørneboe, *Semmelweis*, 163.
26 Bjørneboe, *Semmelweis*, 199.
27 Bjørneboe, *Semmelweis*, 226.
28 Bjørneboe, *Semmelweis*, 163.
29 Bjørneboe, *Semmelweis*, 215.
30 OECD, *Transparency, Communication and Trust*; Rosenbaum and Malina, 'Escaping Catch-22'; Rutjens et al., 'Science skepticism'.
31 Rosenbaum and Malina, 'Escaping Catch-22', 1370.
32 Rosenbaum and Malina, 'Escaping Catch-22', 1370.
33 Rosenbaum, 'No cure without care', 1463.
34 Ogbodo et al., 'Communicating health crisis', 266.
35 NB, 'Kunsten å gjøre jorden ubeboelig'.

Bibliography

Angeletti, Silvia, Francesco Travaglino, Silvia Spoto, Maria Chiara Pascarella, Giorgia Mansi, Marina De Cesaris, Silvia Sartea, Marta Giovanetti, Marta Fogolari, Davide Plescia, Massimiliano Macera, Raffaele Antonelli Incalzi and Massimo Ciccozzi. 'COVID-19 sniffer dog experimental training: Which protocol and which implications for reliable sidentification?', *Journal of Medical Virology* 93, no. 10 (October 2021): 5924–30. https://doi.org/10.1002/jmv.27147.

Bhattacharya, Kaushik. 'Ignaz Semmelweis – Handwashing invention and COVID-19', *Indian Journal of Surgery* 82 (2020): 291–2. https://doi.org/10.1007/s12262-020-02445-y.

Bjørneboe, Jens. *Semmelweis*. In *Samlede skuespill*, 151–236. Oslo: Pax Forlag, 1983.

Cavaillon, Jean-Marc and Fabrice Chrétien. 'From septicemia to sepsis 3.0 – from Ignaz Semmelweis to Louis Pasteur', *Microbes and Infection* 21 (2019): 213–21. https://doi.org/10.1038/s41435-019-0063-2.

Dell'Era, Valeria, Filippo Farri, Giacomo Garzaro, Miriam Gatto, Paolo Aluffi Valletti and Massimiliano Garzaro. 'Smell and taste disorders during COVID-19 outbreak: Cross-sectional study on 355 patients', *Head & Neck* 42, no. 7 (July 2020): 1591–6.

Department of Health and Social Care. 'New campaign to prevent spread of coronavirus indoors this winter', 9 September 2020. Accessed 13 September 2021. https://www.gov.uk/government/news/new-campaign-to-prevent-spread-of-coronavirus-indoors-this-winter.

Garton, Janet. *Jens Bjørneboe: Prophet without honor*. Westport, CT: Greenwood Press, 1985.

Kault, David. 'Superspreaders, asymptomatics and COVID-19 elimination', *Medical Journal of Australia* 215, no. 3 (August 2021): 140. https://doi.org/10.5694/mja2.51177.

Lippi, Giuseppe, Brandon M. Henry, Fabian Sanchis-Gomar and Camilla Mattiuzzi. 'Searching for a clinically validated definition of "asymptomatic" COVID-19 infection', *International Journal of Clinical Practice* 75, no. 9 (September 2021). https://doi.org/10.1111/ijcp.14085.

Minari, Jusaku, Go Yoshizawa and Nariyoshi Shinomiya. 'COVID-19 and the boundaries of open science and innovation: Lessons of traceability from genomic data sharing and biosecurity', *Embo Reports* 21 (2020). https://doi.org/10.15252/embr.202051773.

NB (Nasjonalbibliotek). 'Kunsten å gjøre jorden ubeboelig. Jens Bjørneboe 100 år', 2020. Accessed 13 September 2021. https://www.nb.no/utstilling/kunsten-a-gjore-jorden-ubeboelig-jens-bjorneboe-100-ar/.

NRK (Norsk rikskringkasting AS). 'Siste møte med Jens Bjørneboe', 2020. Accessed 13 September 2021. https://tv.nrk.no/serie/siste-moete-med-jens-bjoerneboe.

OECD (Organisation for Economic Co-operation and Development). *Testing for COVID-19: A way to lift confinement restrictions*. Paris: OECD Publishing, 2020.

OECD (Organisation for Economic Co-operation and Development). *Transparency, Communication and Trust: The role of public communication in responding to the wave of disinformation about the new Coronavirus*. Paris: OECD Publishing, 2020.

Ogbodo, Jude N., Emmanuel Chike Onwe, Joseph Chukwu, Chinedu Jude Nwasum, Ekwutosi Sanita Nwakpu, Simon Ugochukwu Nwankwo, Samuel Nwamini, Stephen Elem and Nelson Iroabuchi Ogbaeja. 'Communicating health crisis: A content analysis of global media framing of COVID-19', *Health Promotion Perspectives* 10, no. 3 (2020): 257–69. https://doi.org/10.34172/hpp.2020.40.

Persson, Johannes. 'Semmelweis's methodology from the modern stand-point: Intervention studies and causal ontology', *Studies in History and Philosophy of Biological and Biomedical Sciences* 40 (2009): 205. https://doi.org/10.1016/j.shpsc.2009.06.003.

Petersen, Irene and Andrew Phillips. 'Three quarters of people with SARS-CoV-2 infection are asymptomatic: Analysis of English household survey data', *Clinical Epidemiology* 12 (2020): 1039–43. https://doi.org/10.2147/CLEP.S276825.

Pittet, Didier, and Benedetta Allegranzi. 'Preventing sepsis in healthcare – 200 years after the birth of Ignaz Semmelweis', *Euro surveillance: Bulletin européen sur les maladies transmissibles* 23, no. 18 (2018): 1–5. https://doi.org/10.2807/1560-7917.ES.2018.23.18.18-00222.

Ray, Isha. 'Viewpoint – Handwashing and COVID-19: Simple, right there…?', *World Development* 135 (2020): 1. https://doi.org/10.1016/j.worlddev.2020.105086.

Ritschel, Chelsea. 'Ignaz Semmelweis: Google doodle honours doctor dubbed "father of infection control"', *Independent*, 20 March 2020. Accessed 13 September 2021. https://www.independent.co.uk/life-style/ignaz-semmelweis-google-doodle-hand-washing-time-coronavirus-doctor-who-hungary-a9411896.html.

Rosenbaum, Lisa. 'No cure without care – Soothing science skepticism', *New England Journal of Medicine* 384, no. 15 (2021), 1462–5. https://doi.org/10.1056/NEJMms2101989.

Rosenbaum, Lisa and Debra Malina. 'Escaping Catch-22 – Overcoming Covid vaccine hesitancy', *The New England Journal of Medicine* 384, no. 14 (April 2021): 1367–71. https://doi.org/10.1056/NEJMms2101220.

Rutjens, Bastiaan T., Sander van der Linden and Romy van der Lee. 'Science skepticism in times of COVID-19', *Group Processes & Intergroup Relations* 24, no. 2 (February 2021): 276–83. https://doi.org/10.1177/1368430220981415.

Scavone, Cristina, Annamaria Mascolo, Concetta Rafaniello, Liberata Sportiello, Ugo Trama, Alice Zoccoli, Francesca Futura Bernardi, Giorgio Racagni, Liberato Berrino, Giuseppe Castaldo, Enrico Coscioni, Francesco Rossi and Annalisa Capuano. 'Therapeutic strategies to fight COVID-19: Which is the *status artis*?', *British Journal of Pharmacology* (May 2021). https://doi.org/10.1111/bph.15452.

Semmelweis, Ignaz. *The Etiology, Concept, and Prophylaxis of Childbed Fever*, translated by Kay C. Carter. Madison, WI: University of Wisconsin Press, 1983.

Wang, Junhui and Na Hong. 'The COVID-19 research landscape: Measuring topics and collaborations using scientific literature', *Medicine* 99, no. 43 (2020): 1–9. https://doi.org/10.1097/MD.0000000000022849.

WHO (World Health Organisation). 'Recommendation to member states to improve hand hygiene practices widely to help prevent the transmission of the COVID-19 virus', 1 April 2020. Accessed 13 September 2021. https://www.who.int/docs/default-source/inaugural-who-partners-forum/who-interim-recommendation-on-obligatory-hand-hygiene-against-transmission-of-covid-19.pdf.

9
Experiencing and coping with isolation: what we can see from ethnic Germans in Britain 1914–18

Mathis J. Gronau

When reading the late December observation of Sir Felix Semon, a retired London laryngologist, that 'we live the life of hermits. Such are our prospects for the New Year!', one might think those lines had been written in 2020 rather than their actual year of creation, 1915.[1] With lockdown being deeply challenging and an unprecedented watershed for many, it can be helpful to look to history and learn from those who dealt with similar times of uncertainty and isolation in the past. Personally, I found being locked down bore eerie similarities to the forms of isolation imposed on the subjects of my research. My timeframe of studies, from 1914 to 1924, covers the Spanish flu pandemic. However, unlike for the many commentators who have sought to explicate the current pandemic by searching for parallels between the two, it was the experience of individuals who had been socially distanced for quite different reasons that most struck me.[2] I had recently finished a chapter in which I analysed the experience of ethnic Germans living in Britain from 1914 to 1918.[3] When the war broke out, roughly fifty-six thousand Germans, of either German nationality or heritage, were resident.[4] While some tried to repatriate to Germany, many more stayed, hoping that Britain would remain neutral. Those who had naturalised hoped that they would be protected. Once Britain entered the war, however, those hopes were

shattered, and the consequences of being an 'enemy alien', or simply ethnic German, proved bleak.

Shifting restrictions

Measures were implemented by the British government which narrowed down the social and physical sphere of all German nationals. Names and addresses were taken at police stations and police officers followed up on any suspicion, as Semon's cook experienced: 'The poor woman … had never thought about naturalisation. When the war broke out, I dutifully reported her to the police at Aylesbury … Now a denunciation has been launched against her at the War Office.'[5] Restrictive measures did not only apply to those with a German passport, as Maximillian Mügge, a naturalised author and scholar of German heritage, bitterly remarked in 1915: 'A naturalised British subject … becomes a person *capite minutus* the moment the country of his birth goes to war with the country of his adoption.'[6] Semon, himself of German origin, similarly had to deal with accusations and, while these later dissipated, his experience showcases how closely ethnic Germans were watched.[7] This was confounded by measures changing quickly and not necessarily for the better. The report of the Friends Society, a Quaker organisation that sought to help enemy aliens in distress, described it as follows:

> Most embarrassing of all our difficulties was the constant change in the regulations. No sooner had we mastered one rule and impressed it upon our workers and their protégées than it was altered, and had to be learnt anew. These changes were especially frequent and trying in the regulations for registration and for the payment of government grants.[8]

Ethnic Germans thus faced a complex and constantly developing environment, one which posed a potential threat or problem with every turn. Alongside this came the uncertainty as to how long these measures would have to be in place, dependent as they were on a war which would supposedly be over within its first four months.[9] Not to mention the fact that who exactly counted as 'German' was rather ill-defined, leading to measures not always working as intended. This is best exemplified by a story from the same report about an elderly man in Wales:

> There was the curious case of Herr P. He was an elderly man with a still more elderly wife. Very German in his accent and way of speaking, he had nevertheless lived in England from a boy [sic] and had earned his living by giving popular lectures on various abstruse subjects. He had besides supported and educated three orphan grand-children. At the outbreak of the war he and his wife were living with one of these grandsons ... Unfortunately this was at Cardiff, *a prohibited area* [italics in the original] and the Cardiff police soon hunted out Herr P. and ejected him and his wife from the district. ... [H]owever, we discovered that Herr P. had never properly been an "Alien" at all, as he had been born in Heligoland at a time when that island belonged to Great Britain. Here was a dilemma. Herr P., not being an alien was no case for us. The other societies for helping aliens would not help him for the same reason. British societies refused because he was too German – German societies refused to help because he was English.[10]

According to the report, Herr P. finally received help via private charity. It is also mentioned that his wife had a stroke in the meantime. Whether that was linked to the circumstances is unknown, yet the idea is not too far-fetched.

Social ostracism and hostility

Social interactions for ethnic Germans in Britain did not vanish completely. They had neighbours they were legally allowed to see and could leave their houses if they so wished. Yet, the increasing hostility these individuals met outside their door meant that non-interned ethnic Germans in Britain found themselves pushed into becoming ever more like 'hermits', to use Semon's words. An ethnic German on the street or attending church, for instance, could be viewed as suspicious.[11] Semon, who had become naturalised in 1901, showed understanding for such behaviour when he wrote: 'The general feeling in our neighbourhood seemed to us rather sympathetic than hostile, and it was only later, when German atrocities became frequent, that that attitude hardened and changed to one of courteous aloofness.'[12] Taking such behaviour more personally, German national Richard Noschke bitterly remarked after his internment:

> How was it possible that the English people after me being a Resident in that Country for 25 years with an English Wife ... could turn on me so bitter [sic], but the answer I have never found. I had

made many friends, but I am sorry to say, that nearly all, with very few exceptions, have turn [*sic*] against me, even my own direct family relations never even sent me as much as a postcard.[13]

The chaos of ever-changing restrictive measures from the Home Office and the uncertainty over their duration are aspects that chime with experiences of lockdown in 2020 and 2021. Wartime Britain's politically engineered xenophobia, inculcation of a hostile environment for non-British nationals, immigration restrictions and sudden border closures also speak to the circumstances of a contemporary Britain in which the pandemic has only exacerbated existing societal tensions brought to light by the Brexit referendum. Moreover, the ostracism ethnic Germans experienced in wartime Britain provides a disconcerting antecedent for our own experiences of social isolation. With the Covid-19 crisis, one aspect which is frequently brought up is the tension of dealing with individuals in person, whether on the street or in shops. The pandemic has turned everyone into a possible carrier, a potential threat. While ethnic Germans were not perceived as possibly harbouring a deadly disease, their vice was possibly harbouring an affiliation with the enemy. Few wanted to interact with them for a fear of 'contracting' suspicion and those who did 'were treated as paupers and as enemy aliens'.[14] Furthermore, ethnic Germans faced potential violence, one such instance of which Nicoletta Gullace documents when recounting the story of Annie Monnigan, 'the Irish wife of an interned German sailor [who] was in her "shack" surrounded by her six small children when she was attacked'.[15]

Social ostracism and hostility had detrimental effects. While most ethnic Germans in Britain survived, some accounts describe individuals losing their minds or withering away.[16] The experience took a toll not only on people's mental health but also on their financial status. What this meant can be seen in some Quaker case reports, especially in rural areas. The following description of a household in Durham in 1915 is representative: 'Her children looked insufficiently clad and badly nourished. She is anxious and overworked and distressed, altogether needs immediate help.'[17] This was followed by an update from 1918: 'The eldest girl, aged eleven, is consumptive, developed since the father's internment; the second girl also shows tendencies of tuberculosis of late. The grant was only raised from 20s. to 25s. in December, 1917.'[18] The psychological toll is evident from first-hand accounts as well. Returning to Semon, at the end of 1915 he wrote: 'My reflections on the last day of the most miserable year of my life are necessarily sad.'[19] Where even such a socially reputable individual as Semon suffered from isolation within

society, those without such standing faced it to an even greater degree. As the Quaker report states about a woman that had lost her home: 'Hers was not an ordinary trouble arising from ordinary poverty. What she needed was to escape from a wide-spread net-work [sic] of social hostility and ostracism to find refuge for herself and her children.'[20] As with the lockdown measures necessitated by the Covid-19 pandemic, social isolation had a greater impact on the mental health of those with lesser financial means or lower social standing.[21]

Coping with isolation

Looking at the similarities, one must then ask: how did ethnic Germans *cope* with these issues? How did they manage their isolation? There are some encouraging examples and some cautionary ones. Maximillian Mügge, for instance, joined the British army at the outbreak of the war to prove his loyalty and escape the oppressive situation back home. While volunteering was not a total success – Mügge continued to bear a grudge against the treatment of Germans in Britain – it did provide him with a social circle and made him feel as though his heritage did not obstruct him from identifying, as he desired to, as British.[22] Others made public statements about their loyalty to Britain to ease the tension. As the naturalised barrister August Cohen wrote: 'We who have not lived in Germany during the period of … reactionary changes have observed them more acutely because we had moved in the opposite direction; we had participated in and profited by the progress, the growth of political freedom in the country of which we had become citizens.'[23]

Operating under the constraints of ever-changing policies, ethnic Germans thus tried to adapt to their 'new normal'. Attempting to stay grounded by maintaining ties to close family or carrying on with pre-war routines often proved therapeutic. As Semon wrote: 'I endeavour to distract myself by working at these memoirs, by reading and by walks with my darling wife'.[24] Such everyday consolations may have helped remind ethnic Germans of the fact that there was a time before the struggle and that there would be a time after it too.

The provision of aid, whether in goods or money, became a vital lifeline for many. As Anna B. Thomas mentions: 'The German Benevolent – The Frauen-Verein [Women's Club] – The Schröder Committee … [all] of these did good work in helping their fellow countrymen'.[25] Some monetary aid was also given by the British government and numerous private institutions did their share in helping those in need. This ranged

from personal donors to massive charities such as the Quaker Friends Society. Where widespread limitations on personal freedoms predominated, the giving of aid and assistance allowed some to at least regain a sense of agency.

Yet, for others, these mechanisms either did not work, had a detrimental effect, or were simply not available. While some ethnic Germans showed the will to retain some form of normality, whether by keeping a shop open, wearing the same valuable clothing, or simply going to church, not all had the means to keep up such a façade.[26] Financial aid extended only so far. Some had to give up their homes, having to relocate from restricted areas by the coast.[27] Others simply did not have the monetary means for such an endeavour, and many simply could not cope, physically or psychologically, with the situation itself.

Parallels can be drawn between the anxieties suffered and coping mechanisms developed by ethnic Germans in wartime Britain and our own during the pandemic. During lockdown, certain traditions were altered in light of the constraints brought about by the pandemic. Social gatherings and events transitioned online; relationships were conducted digitally rather than in person. Others actively tried to fight the virus, with many volunteering to help or offering to do their part, no matter how miniscule. Sadly, unhealthy coping mechanisms also arose.

Aid and cohesion in times of crisis

However, what struck me as most salient from my research was that the importance of aid in times of uncertainty and crisis cannot be overstated. Giving some form of stability, some sense of support, can go a long way towards securing a family's survival when it has been forced into isolation. Lockdown has hit individuals with lower incomes the hardest in numerous different ways, whether financially or in terms of housing, health or education. The victims of the pandemic number many more beyond those who have died from the virus. Newspaper headlines of a disabled man starving to death in London suggest more needs to be done to protect society's most vulnerable.[28]

An atmosphere of suspicion and accusation surrounding who might be dangerous or not, just as in the First World War, further poisons social cohesion and undermines adherence to public health measures reliant on a sense of community and togetherness to work effectively. Helping each other, making each other aware of our mutual struggle and making sure that those who struggle the most get the most help is imperative. While,

as the examples given in this chapter show, private institutions *can* help, the government as a representative of the people needs to step in as well. On a social level, we must make each other aware that we are distancing ourselves from each other not out of fear or suspicion but out of respect and care. While lockdown may cut us off from each other physically, we have the technological means at hand, no matter their limitations and drawbacks, to remain an active part of our social circles and wider community. We must be careful not to point fingers at the innocent, and must help everyone that needs help and work to return to some form of normalcy. After all, ethnic Germans in Britain suffered their social isolation for the duration of the war and many still managed to return afterwards to their lives as they had previously been. If we help each other, we can ensure that this will apply to as many people as possible after this pandemic is over.

Notes

1. Semon, *The Autobiography of Sir Felix Semon*, 316.
2. See, for example, Ashton, 'COVID-19 and the "Spanish" flu'.
3. When referring to the subjects of this chapter in general, I term them ethnic Germans, by which term I try to encompass a variety of legal and cultural statuses, ranging from German nationals living in Britain to those who had assimilated and acquired English citizenship. Ethnic in this context refers to self-identification as well as identification by others in the context of the war.
4. Grant, *Migration and Inequality*, 81.
5. Semon, *The Autobiography of Sir Felix Semon*, 304.
6. Mügge, *War Diaries*, 14.
7. Mügge, *War Diaries*, 302–3.
8. Thomas, *St. Stephen's House*, 27.
9. See Hallifax, '"Over by Christmas"'.
10. Thomas, *St. Stephen's House*, 25.
11. Schroeder Archive, 'Anonymous letter'.
12. Semon, *The Autobiography of Sir Felix Semon*, 298.
13. Noschke, *Private Papers, IWM documents: 11229*, 53.
14. Thomas, *St. Stephen's House*, 86.
15. Gullace, 'Friends, aliens, and enemies', 354.
16. Thomas, *St. Stephen's House*, 91–2.
17. Thomas, *St. Stephen's House*, 96.
18. Thomas, *St. Stephen's House*, 96.
19. Semon, *The Autobiography of Sir Felix Semon*, 316.
20. Thomas, *St. Stephen's House*, 84.
21. Mucci et al., 'Lockdown and isolation', 63–4.
22. Mügge, *War Diaries*, 55.
23. Cohn, *Some Aspects of the War*, 8.
24. Semon, *The Autobiography of Sir Felix Semon*, 313.
25. Thomas, *St Stephen's House*, 23.
26. Thomas, *St Stephen's House*, 83.
27. Thomas, *St Stephen's House*, 100.
28. Stubley, 'Coronavirus: Disabled man'.

Bibliography

Ashton, John. 'COVID-19 and the "Spanish" flu', *Journal of the Royal Society of Medicine* 113, no. 5 (Spring 2020): 197–8. https://doi.org/10.1177/0141076820924241.

Cohn, August. *Some Aspects of the War, as Viewed by Naturalized British Subjects*. Oxford: Clarendon Press, 1917.

Grant, Oliver. *Migration and Inequality in Germany 1870–1913*. Oxford: Oxford University Press, 2004.

Gullace, Nicoletta. 'Friends, aliens, and enemies: Fictive communities and the Lusitania riots of 1915', *Journal of Social History* 39, no. 2 (Winter 2005): 345–67. https://doi.org/10.1353/jsh.2005.0137.

Hallifax, Stuart. '"Over by Christmas": British popular opinion and the short war in 1914', *First World War Studies* 1, no. 2 (Autumn 2010): 103– 21. https://doi.org/10.1080/19475020.2010.517429.

Mucci, Federico, Nicola Mucci and Francesca Diolaiuti, 'Lockdown and isolation: Psychological aspects of COVID-19 pandemic in the general population', *Clinical Neuropsychiatry* 17, no. 2 (Spring 2020): 63–4. https://doi.org/10.36131/CN20200205.

Mügge, Maximilian. *War Diaries of a Square Peg*. London: George Routledge & Sons, 1920.

Noschke, Richard. *Private Papers, IWN documents: 11229*.

Roberts, Richard. *Schroders: Merchants & bankers*. London: Palgrave Macmillan, 1992.

Savage, Michael, Robin McKie and Toby Helm. 'Johnson U-turn leaves nation's plans for Christmas in tatters', *Guardian*, 19 December 2020. Accessed 23 August 2021. https://www.theguardian.com/world/2020/dec/19/johnson-u-turn-leaves-nations-plans-for-christmas-in-tatters.

Schroeder Archive, London. 'Anonymous letter, from the inhabitants of Montpelier Place', 1 March 1918. [SH387] Anti-German Material JHS/Z/00004525.

Semon, Felix, *The Autobiography of Sir Felix Semon*, edited by Henry C. Semon and Thomas McIntyre. London: Jarrods, 1926.

Stubley, Peter. 'Coronavirus: Disabled man "starved to death during lockdown", says MP', *Independent*, 24 July 2020. Accessed 5 August 2020. https://www.independent.co.uk/news/uk/home-news/coronavirus-death-starved-disabled-food-lockdown-bell-ribeiro-addy-streatham-a9584286.html.

Thomas, Anna B., and others, (eds). *St. Stephen's House: Friends' emergency work in England, 1914 to 1920*. London: Emergency Committee for the Assistance of Germans, Austrians and Hungarians in Distress, 1920.

Yarrow, Stella. 'The impact of hostility on Germans in Britain 1914–1918', *Immigrants & Minorities* 8, nos. 1–2, (1989): 97–112. https://doi.org/10.1080/02619288.1989.9974709.

10
Unexpectedly withdrawn and still engaged: reflections on the experiences of the Roman writer and politician Marcus Tullius Cicero

Gesine Manuwald

Introduction

The concept of a 'global pandemic' would have been unfamiliar to people in the ancient world; yet, the situations that some of them found themselves in, their behaviour and the coping strategies they developed provide interesting points of comparison to what people have done and considered in the current crisis. An excellent example in this context is Marcus Tullius Cicero (106–43 BCE), the famous Roman politician, orator and philosopher of the late Republican period: Cicero went through a successful political career and participated in public life in Rome as much as he could, while he had clear preferences as to which elements of that activity suited him; over the course of his life he also had to deal with different kinds of periods of (enforced) withdrawal from the public arena in Rome, for which he needed to find remedies, and which reveal interesting similarities to what people have done during this pandemic.[1]

Cicero and absence from Rome

In 63 BCE Cicero had smoothly reached the consulship, the highest political office in the Roman Republic, in line with his ambitions. His actions during that year, in confronting the political unrest caused by the so-called Catilinarian Conspiracy, were, however, later questioned by his opponents, and this forced him to withdraw into 'exile' from Rome for about eighteen months in 58–57 BCE. Later, in 51–50 BCE, he was sent away to govern a province on behalf of the state.

During his absence on both occasions Cicero regretted being far from the city and could not wait to be back. Throughout these periods Cicero stayed in touch with family, friends and colleagues via letters. The more personal of these letters from 'exile' voice criticism of the lack of activity among people back in Rome to support him and arrange his recall, complaints about his fate, regrets about his absence from the city and grief at this situation.[2] Cicero's longing to be back in Rome and thus at the centre of action is particularly prominent in the messages during his provincial governorship, as carrying out an office away from Rome proved unsatisfactory for him: for instance, in one letter Cicero asks his friend Atticus to make sure that his term of office will not be prolonged, as he is burning with desire for the city and can hardly bear the boredom in the province.[3] While in the province, Cicero declares the importance of staying in Rome in another letter to someone else: 'Rome! Stick to Rome, my dear fellow, and live in the limelight! Sojourn abroad of any kind, as I have thought from my youth upwards, is squalid obscurity for those whose efforts can win lustre in the capital. I knew this well enough, and I only wish I had stayed true to my conviction.'[4] Such exclamations are obviously to be seen in the context of a time in which 'remote working' was not possible; one could have an influence only if one was physically present in the capital and thus able to take part in public life, to be seen to engage with political business and to meet peers, colleagues and clients in person.

After his return to Rome, in good oratorical and political fashion, Cicero re-interpreted his absences and gave them a different spin. With respect to the 'exile', he asserted that he had left voluntarily for the sake of the Republic in order to avoid a potential civil war and bloodshed among his fellow citizens (cf. 'stay at home to save lives').[5] He claimed that he could now enjoy Rome and its amenities all the more for having missed them, because only through absence does one realise their full value (cf. going to a restaurant after the easing of restrictions and enjoying this as something special).[6]

Cicero and Roman amenities

Even though Cicero was eager to spend time in Rome, to play a prominent role in politics and to be publicly visible, he was not so keen on some of the entertainments favoured by a majority of the population (cf. modern politicians' declared positions on certain types of sports and music that they might not particularly like themselves, but a majority of the population enjoys). On one occasion Cicero enviously notes that a friend of his was able to spend time reading in the countryside while he was in Rome during games, which, as he acknowledges, were splendid, but not to his own taste or that of the addressee. These included wild beast hunts, display of farces and dramatic performances that impressed through the volume of props on stage rather than the quality of the actors.[7] Still, when delivering public speeches to the people, Cicero was clever enough to create the impression that he shared their values: thus, in a persuasive speech he mentions games, besides liberty and the right to vote, as key elements of public life available in Rome.[8] Upon coming back from 'exile' he notes that games, just like reconnection with friends, are among the things he can now enjoy more fully after his return to Rome.[9] Thus, as regards games, Cicero would not have minded if they had been suspended during his stays in Rome (cf. people happy about not having to attend events they do not like when these are not taking place); yet he was aware that his preferences for more intellectual pursuits were not shared by everyone (cf. agreement that certain institutions and businesses should re-open even if not everyone is using them or regards them as necessary).

Cicero and limited opportunities for political activity

In any case, public life in Rome formed the basis and the context for Cicero's career planning. In line with his ambitions and his traditional understanding of the duties of a Roman citizen, Cicero aimed to be involved as much and as prominently in politics as possible and to let nothing distract him from that, as far as was in his power. Yet, in addition to the two imposed periods of physical absence from Rome and thus the centre of activity, there were two other periods in his life (in the mid-50s and the mid-40s BCE) when his whereabouts were not officially restricted, but political circumstances made active involvement in politics almost impossible for him. Again, he had to find coping strategies and opted for measures of a kind that still retained a connection to public and political business.

Having famously claimed that he could not do nothing,[10] after moving to his country estates Cicero embarked on what he saw as the next best thing to being publicly active in Rome, namely writing treatises to familiarise his fellow citizens with the essentials of Greek philosophy and the theoretical aspects of guiding a state well or being a good orator. He interpreted this activity as another type of service for the state and stressed that he spent an extended amount of time on literature and writing only when this did not distract him from fulfilling his commitments to public service.[11] He also said that, in this period of enforced withdrawal, he found consolation in literature and philosophy and did not waste time on less meaningful activities (cf. people turning to literature or mindfulness apps and similar while confined to their homes). For instance, Cicero tells his friend Atticus:[12] 'I am living here on Faustus' library – you perhaps think it's on these Puteolan and Lucrine commodities [i.e. seafood the area was famous for]. Well, I have them too. But seriously, while all other amusements and pleasures have lost their charm because of my age and the state of our country, literature relieves and refreshes me.'

Cicero expresses the healing potential of philosophy and the enhancement of such activity as a result of the circumstances even more forcefully in the introduction to a philosophical treatise:

> But for my own part (for I will speak frankly), so long as I was held entangled and fettered by the multifarious duties of ambition, office, litigation, political interests and even some political responsibility, I used to keep these studies within close bounds, and relied merely on reading, when I had the opportunity, to revive them and prevent their fading away; but now that I have been smitten by a grievously heavy blow of fortune and also released from taking part in the government of the country, I seek from philosophy a cure for my grief and I deem this to be the most honourable mode of amusing my leisure. For this occupation is the one most suited to my age; or it is the one more in harmony than any other with such praiseworthy achievements as I can claim; or else it is the most useful means of educating our fellow-citizens also; or, if these things are not the case, I see no other occupation that is within our power.[13]

On another occasion, in a more private context, Cicero claims that it is only literature that makes life worth living in difficult political circumstances:

> But let the Fortune of the commonwealth answer for what is past; the present is our own responsibility. If only we could pursue these studies together in peaceful times and a settled, if not satisfactory, state of the community! And yet, if that were so, there would be other claims upon us, calling us to honourable responsibilities and tasks. As matters stand, why should we desire life without our studies? For my part, I have little enough desire for it even with them; take them away, and I should lack even that little.[14]

From such comments it is obvious that Cicero regarded involvement in literature and philosophy highly (and he had engaged in such studies from his youth), but also that for him they came second, after political engagement, whenever the latter was possible. Thus, as he was able to look for an alternative activity when the option of directly contributing to politics was removed, since he was sufficiently wealthy not to be affected by immediate financial problems (although in some periods of his life he expressed financial worries in his letters), he found something satisfactory, productive and rewarding to do during his withdrawal (cf. activities of some people in the creative industries). Yet it is also clear that he felt that it was only the best way to fill this sudden period of leisure, not necessarily an activity that he was aiming and planning for (cf. people suddenly deciding to learn a new skill while at home). Still, Cicero found a way to productively spend this period and also to look after his 'mental health'.

Conclusion

Although Cicero lived more than two thousand years ago in a different political and social environment, and was a more prominent figure than most people who have been experiencing lockdown during the pandemic, one finds, as with many elements of modern life, that texts from the ancient world and those of Cicero in particular address issues still relevant today. They discuss important questions that people continue to confront and thus can stimulate modern readers to reflect on their own actions. While it is unlikely that many present-day people have turned to writing philosophy instead of being politically active in the current crisis, the underlying thought – that an enforced withdrawal from one's beloved surroundings or one's favourite activities can be hard, but one can deal with it if one develops personal coping strategies – is of perennial value. That Cicero, not having to worry about everyday issues, was able to choose something that he seems to have liked and could regard as

potentially useful for the community was perhaps a particular bonus for him, although he was aware that different people will prefer different things. Not all periods of unplanned withdrawal (and 'working from home') were equally productive for Cicero, but some resulted in important treatises that are still read today. If during the current pandemic some people have had the chance to produce something of relevance to future generations, there would be some positive and encouraging outcomes of the period of lockdown.

Notes

1. All English translations of excerpts from Cicero's works have been taken from the bilingual editions in the *Loeb Classical Library* (https://www.loebclassics.com).
2. See for example Cicero, *Ad Atticum* 3.1–27; *Ad familiares* 14.1; 14.2; 14.3; 14.4; *Ad Quintum fratrem* 1.3; 1.4.
3. Cicero, *Ad Atticum* 5.11.1.
4. Cicero, *Ad familiares* 2.12.2.
5. See, for example, Cicero, *Post reditum in senatu* 6; 32–34; 36; *Post reditum ad Quirites* 1; 13–14; 16; 17.
6. Cicero, *Post reditum ad Quirites* 2–4.
7. Cicero, *Ad familiares* 7.1.
8. Cicero, *De lege agraria* 2.71.
9. Cicero, *Post reditum ad Quirites* 3.
10. Cicero, *Ad Quintum fratrem* 2.13.1.
11. See, for example, Cicero, *Academica priora* 6; *De divinatione* 2.1–7; *Orator* 148.
12. Cicero, *Ad Atticum* 4.10.1.
13. Cicero, *Academica posteriora* 11.
14. Cicero, *Ad familiares* 9.8.2.

11
The Gallic sack of Rome: an exemplum for our times

Elizabeth McKnight

The Roman historian Livy (c.59 BCE–c.17 CE) provides a dramatic account of the existential crisis that confronted the city of Rome when it was unexpectedly attacked by an army of Gauls in 390 BCE. Livy's account invites comparison with the United Kingdom's response to the Covid-19 pandemic, and a comparison of the two discloses important aspects of the moral and political values that underlie Livy's narrative.

Livy's account of the Gallic siege and sack of Rome is prominently positioned at the end of book V of his history of Rome *Ab Urbe Condita* ('From the Founding of the City'). It thereby concludes the first pentad of his work, and marks the end of Livy's account of Rome's early, near-mythical, history.[1] The Gauls, previously altogether unknown to the Romans, first appear at the mid-point of book V. Livy recounts that the Roman senate (the aristocratic council that took a leading role in the government of Rome) disregarded evidence of the threat that the Gauls posed. Taking advantage of the Romans' unpreparedness, the Gauls defeated the Roman army at the River Allia, then rapidly advanced to the gates of Rome, threatening the city itself. Forced to confront the gravity of the situation, the Romans decided that, since it would not be feasible to defend the whole city, members of the senate, men of fighting age, and as many of their wives and children as might be accommodated should retreat within the walls of the better-protected Capitol, leaving the rest of the city and population to the incoming Gauls. The older senators set an

example to the rest, expressing their willingness to remain in the lower city and face death there, rather than place extra demands on the scarce resources available to those within the Capitol. Many families fled the city altogether, to seek refuge and a new life elsewhere.

Livy describes the scene as young and old went their separate ways: young men loaded carts to take their families and possessions to the Capitol; women wept and turned first one way then another, uncertain whether to stay with their elderly parents, or to join their husbands on the Capitol. The Gauls found the city gates open to receive them; in amazement, they entered deserted streets and houses. There they came upon the elderly senators, dressed in their robes of office, sitting as motionless as statues. Feeling awe at the sight of men who could await their enemy with such equanimity, the Gauls at first held back, but it was not long before they butchered first one senator, then the rest. Next, they set about burning parts of the city, while those who had retreated within the citadel could only view with horror what was happening below.

Unable to storm the Capitol, the Gauls settled in to besiege it. As the Romans' situation worsened, the prospect of help appeared from an unexpected quarter: a large body of Roman soldiers who had taken refuge in the Roman-controlled city of Veii after the defeat at the Allia now resolved to retake Rome from the Gauls. This, they concluded, could be achieved only if one M. Furius Camillus was recalled from exile and appointed to lead them. Camillus, though a fine soldier, had been driven into exile by a hostile populace before the Gauls' first appearance. Those based in Veii now undertook elaborate steps to communicate their plans to those defending the Capitol in Rome. They duly secured Camillus' recall and appointment to supreme command of the Roman forces, and Camillus set about training his troops to march on Rome.

Meanwhile, with the defence forces on the Capitol so weakened by hunger as to be almost unable to bear arms, and despairing of Camillus' arrival, the senate authorised the military tribunes to agree terms of surrender with the Gauls: the Romans' lives would be spared on payment of a ransom of 1,000 pounds of gold. The gold was being weighed when Camillus and his forces appeared. Preferring to win back the city by force of arms, Camillus intervened to prevent payment and to reject altogether the terms of surrender agreed without his authority as a duly appointed *dictator*. The Gauls were taken by surprise, driven from Rome, then altogether defeated in fighting outside the city, leaving Camillus to re-enter the city in triumph.

There are numerous parallels between the threat posed by the Gallic attack on Rome and that posed by the Covid-19 pandemic to the lives,

economy and way of life of the people of the United Kingdom. They include initial slowness on the part of relevant public authorities in recognising the threat posed by the Gauls/Covid-19; the deaths of many elderly citizens, separated from their families; the damage to the capital city (the burning of Rome; the desertion of City-based businesses/shops/restaurants and damage to the economy of London); citizens' weariness after a long siege/lockdown; and uncertainty as to the prospect of rescue (by Camillus/a new vaccine). In what follows, I examine just one aspect of Livy's account in which the Roman response appears to have differed markedly from the UK authorities' response, namely the Romans' decisiveness in quickly adopting and implementing a strategy to make the best of a situation where an attack on Rome had become inevitable.

Livy's account of events preceding the Gauls' entry into Rome emphasises the chaotic disorder that characterised the initial response to the Gallic threat. But, in the course of one day and night, with the Gauls encamped just outside the city, the Romans' panic was superseded by a new decisiveness. Livy simply records the adoption of a resolution that *senatus . . . robur* ('the strength of the senate'), along with the younger fighting men and their wives and children, should withdraw to the Capitol, whilst men too old to fight and others who could not be accommodated should be left behind.[2] In Livy's summary, the resolution is arguably ambiguous: did it contemplate that the whole senate (including older, non-combatant members) should seek protection on the Capitol, or only those able to fight? The emphasis on the importance of having men of fighting age suggests the latter. But 'the strength of the senate' lay not only in its fighting capacity, but in its collective wisdom, including the wisdom of older members, in relation to the government of the city. In the event, the older senators chose to stay behind, thereby helping the rest of the population who were to be left in the lower city more readily to accept their fate. Nor did anyone entertain false hopes that they would survive their ordeal: with no expectation of stopping the Gauls, they simply left the city gates open.

Why was it that Livy's Romans were able, seemingly without dissent, to decide who and what should be saved and who and what abandoned to the enemy? In contrast, why did the United Kingdom's response to Covid-19 – particularly at the outset of the pandemic – appear vacillating and divisive? The UK authorities had to decide what balance they should strike between, on the one hand, safeguarding those at immediate risk from the Covid-19 virus (especially the elderly or otherwise vulnerable) and, on the other, protecting the immediate and longer-term interests of those at less risk from the virus, and the interests

of future generations, all of whom would, it seemed, be better served by the avoidance of onerous interventions and their longer-term social and economic consequences.

It is informative to probe the factors that explain the Romans' decision. Books I–IV of *Ab Urbe Condita* had traced the history of the Roman people, from Romulus' founding of Rome, his imposition of laws on the diverse multitude who gathered there, and his creation of a senate of advisers who, as a mark of honour, were known as *patres* ('fathers'), and their families and descendants as *patricii* ('patricians', in contrast to the plebeians comprising the remainder of the population).[3] Romulus' immediate successor, Numa, had established religious practices in Rome and, over time, collective religious observance united citizens in shared rituals directed at securing the gods' favour for the city and its people.[4] When later kings turned to tyranny, the people ousted them.[5] Under the newly established republic, the citizens were to be ruled by laws, rather than kings.[6] It would, Livy claims, have been disastrous if this had occurred earlier: only now, some 250 years after Rome's foundation, had the people learned to love the very soil of the land in which they had established themselves, where they had raised their families; only now were they ready for the *libertas* (freedom) that the republic offered. In the past, they had observed the king's laws because they feared his supreme power; they had now gained sufficient political maturity, and a sufficient stake in society, to observe laws made by citizens themselves, and enforced by magistrates whom they had themselves elected. The inchoate republican constitution was crude, and would not achieve a sustainable balance of power among patricians and plebeians until well into the third century BC, after a long 'struggle of the orders' through which the plebeians fought for greater political and economic rights. But, in Livy's account, the republic provided, from its inception, the kernel of civic freedom and, for that reason, it was worth fighting to defend and preserve it.

By c.25 BCE, when Livy was writing book V, other authors had explicitly recognised the relationship between the republican institutions and citizens' freedom, and Livy appears to have retrojected to his account of the early republic an awareness of the idea that the institutions and values of the republic lay at the heart of what it meant to be Roman and to be free. In his treatise *De Officiis* ('On Duties') of 44 BCE, M. Tullius Cicero had advised his young son (the treatise's addressee) that every citizen should do everything possible to promote *civium coniunctio* ('the bond among citizens'), ahead of obligations to family and of any purely personal interests.[7] *Civium coniunctio* had priority because it provided the framework within which one could pursue family life, enjoy the benefits

of personal property and flourish as an individual. In *Ab Urbe Condita*, the same hierarchy of values is reflected in the actions of men who willingly executed their own sons if the wider interests of the community demanded it,[8] or who chose to die in battle to save Rome from a military defeat that would have entailed the loss of citizens' collective freedom to a foreign power.[9] The actions of such men are recalled as *exempla* (models) by future generations.

This system of values was manifested both in Roman adaptations of Greek moral theory and in distinctively Roman cultural practices. Thus, in *De Officiis*, Cicero invoked Stoic moral theory to explain why the wise man does not shrink from death if his death will promote the interests of his community; indeed, if the preservation of his own life would damage his community, then he could derive no real pleasure or benefit from prolonging his life. Conversely, a man who died to promote the interests of his community would benefit from doing so: he would know that he had acted well, and his action would bring a form of immortality, through his well-deserved fame among future generations.[10] The Greek historian Polybius, writing in the second century BCE, had regarded the funeral practices of leading Roman families as providing an incentive to younger men to commit themselves to the interests of the republic: when a male member of the family died, a funeral eulogy would both celebrate the deeds of the deceased and recall the lives of his famous forebears; participants in the funeral procession wore wax masks taken from the faces of those forebears, so that men of previous generations also appeared to be part of the procession, thereby impressing on younger generations what a tradition of achievement had preceded them and what lasting fame awaited them if they could match their ancestors' deeds.[11]

Livy's narrative suggests that similar considerations explain the Romans' decision, in the face of the Gallic attack, to concentrate on saving the younger generation and hence the republican institutions that only they could carry forward. Thus, in Livy's account, as the older senators part from those who are to defend the Capitol, they entrust to the young men the future of the city, as if it were their legacy; the Capitol is described as just a little hill that held out, on its own, as the seat of freedom; and citizens' commitment to due constitutional process, as a safeguard of that freedom, is observed in the insistence of those stranded in Veii that Camillus should neither be recalled from exile, nor appointed *dictator*, without the proper approvals of the people, duly assembled, and of the senate in Rome. Some earlier accounts had, Livy says, described the older senators as having undertaken a religious ritual of *devotio*: that is, they had vowed, by dying, to sacrifice themselves to the gods in return for a

Roman victory. Without explicitly endorsing these accounts, Livy nonetheless adopts into his narrative features that echo the ritual of *devotio*. He thereby presents the senators' decision to die as involving a willing subordination of their personal interests to those of the republic. Livy also records that the Roman senate had insisted at the outset that, despite the Gallic attack and siege, due religious observances should continue without interruption, in recognition of the people's commitment to their gods and the gods' protection of the city. Finally, *Ab Urbe Condita* itself operates as a form of literary monument commemorating the senators' selfless action. It records that, with victory secured, the Romans resolved that the women who had contributed to Rome's survival, by donating their jewellery towards meeting the city's ransom, should be commemorated in funeral eulogies, alongside their male relatives, in recognition of their actions.

With no prospect of defending Rome in its entirety, the Romans knew that many citizens would die at the hands of the Gauls. The only question was as to who should be saved. The older senators made this choice easier by volunteering to die. The United Kingdom's initial response to the Covid-19 pandemic was very different. There were inevitably disagreements among experts and the public concerning the severity of the Covid-19 virus and what measures would suppress it most effectively. But, however one answered these questions, a range of regulatory interventions was available, each likely to affect different social groups in different ways. In these circumstances, the adoption of one set of measures over others necessarily entailed making choices about whose lives should be protected, and at what cost to others.

As the pandemic developed, some older citizens made clear that, if they fell ill, they would not wish to receive scarce or expensive treatments, but would prefer to receive only appropriate palliative care. But these offers were not so numerous, co-ordinated or widely approved as to encourage the shaping of public policy interventions around them. Meanwhile, the Government found itself contemplating measures that would subordinate individual citizens' legal rights and interests (including, potentially, rights to family life, to freedom of religious expression and to peaceful assembly) to other rights or interests to which it attached greater priority. In the event, the Government appeared to prioritise the objective of minimising the total death toll, by restricting the freedoms of all citizens in order to protect the most vulnerable, even at the expense of the wider interests of younger and future generations, and at a grave cost to the economy and to many religious and cultural institutions.[12]

In a democratic society, it generally falls to parliament to decide how best to reconcile or prioritise conflicting rights and interests in a way that reflects the values of those whom they represent. But there was, it appears, no clear consensus as to what weights these various interests should carry in the choice of an appropriate policy response. The government did not wish to discuss openly whether it was contemplating measures that would cause more to die from Covid-19 than was strictly inevitable and little attempt was made to foster candid parliamentary debate or to provide a reasoned account of the government's overall strategy.

Livy's Rome may appear superficially to have been a simpler society, united in pursuit of a single objective, so that the decision as to who should have the chance to live, and who should die, was straightforward. But Roman society was far from united, and Rome's ultimate victory over the Gauls, and its aftermath, were politically, legally and practically messy: Livy records that, once the Romans had secured victory, the 'struggle of the orders' continued unabated for another century, with rancour, ill-will and intransigence on all sides. Camillus' invocation of his own superior authority to reject the terms of surrender agreed without his approval was to prove an awkward and contested precedent long into the future and, in their haste to rebuild the city, citizens gave no thought to building something better, or even to rebuilding according to an orderly plan.

If *Ab Urbe Condita* offers an enduring lesson, it is that Livy's older senators hoped, by their selflessness, to maximise the prospects of survival of the Roman republic, and, by their example, to quell the fears of others who could not be saved. In Livy's presentation, their choice was made possible, and rendered more worthwhile, by the moral, political and cultural institutions of the early Roman republic. Those institutions encouraged future generations to celebrate, commemorate and learn from their ancestors' exemplary action, and older men were, perhaps, more willing to volunteer to die in circumstances where they believed that, within a society that shared their values, their choice would be remembered, and valued as exemplary, long into the future.

Notes

1. On the structure of *Ab Urbe Condita* and its treatment of the Gallic attack on Rome at V.39.4-49.7, see Stadter, 'The structure of Livy's history'; Ogilvie, *A Commentary on Livy*, 719–752); and Oakley, *'Reading Livy's book 5'*.
2. Livy, *Ab Urbe Condita*, V.39.
3. Livy, *Ab Urbe Condita*, I.7–8.
4. Livy, *Ab Urbe Condita*, I.19.
5. Livy, *Ab Urbe Condita*, I.60.
6. Livy, *Ab Urbe Condita*, II.1.
7. Cicero, *De Officiis*, I.11–12; I.50–7.
8. Livy, *Ab Urbe Condita*, II.5.5; VIII.7.
9. Livy, *Ab Urbe Condita*, VIII.6.8–13, VIII.9.1–11.
10. Cicero, *De Officiis*, III.99–100.
11. Polybius, *Histories*, VI.53–4.
12. The success of the government's measures remains to be determined. But the deaths of many elderly residents of care homes must be recalled, along with the burden borne by members of the medical professions, and other essential workers.

Bibliography

Oakley, Stephen P. 'Reading Livy's book 5'. In *A Companion to Livy*, edited by Bernard Mineo, 230–42. Oxford: Wiley-Blackwell, 2015.

Ogilvie, Robert M. *A Commentary on Livy, Books 1 to 5*. Oxford: Clarendon Press, 1965.

Stadter, Philip A. 'The structure of Livy's history', *Historia: Zeitschrift für Alte Geschichte* 21, no. 2 (1972): 287–307.

12
On Spinalonga
Panayiota Christodoulidou

Small islands have long been favoured as sites on which to quarantine individuals believed to be infected by transmissible diseases.[1] Separated from mainland population centres by the natural barrier of the sea, their geographical advantages have routinely been exploited by nations and states to isolate, monitor and, in effect, incarcerate potential threats to the health of their citizens.

Spinalonga, situated in the Gulf of Elounda in north-eastern Crete, has a history as one such island. An uninhabited, lesion-shaped outcrop, it is home to a sixteenth-century Venetian fortress carved into its rockface, and the ruins of what was once one of Europe's last active leper colonies. Established in 1904, the Spinalonga leper colony was decommissioned only in 1957, over a decade after the first cures for the disease were discovered.[2] Originally, the island was considered a place of exile for those from mainland Greece affected by the disease.[3] From 1913 onwards, Spinalonga began to accommodate non-Greek citizens, and an international leprosy hospital was established there.[4] All that remains now to bear witness to the community of patients, doctors and Greek Orthodox priests that once lived there – and by some accounts thrived – are dilapidated houses left to collapse and crumble under the unrelenting Aegean sun.[5]

Leprosy (the name derives from the ancient Greek for 'scale')[6] is a bacterial disease that mainly affects the skin, eyes, peripheral nerves and the mucous membranes of the upper respiratory tract.[7] It generally expresses itself as an erythemal rash which leaves blotchy, discoloured

archipelagos across the skin. The belief that leprosy is a flesh-eating disease is unfounded. Leprosy patients who lose parts of their extremities do so due to the nerve damage the bacterium causes: pain sensation is numbed, and wounds or infections go unnoticed until they ulcerate, turn gangrenous and require amputation.[8]

Fears of leprosy's contagiousness and repulsion at the disfigurement it can cause have led to centuries of stigmatisation of those affected. Shunned, ostracised and scapegoated, the figure of the leprotic outcast has a long and varied cultural history. In *The Canterbury Tales* (1387–1400), Geoffrey Chaucer describes the Summoner's face as having 'whelkes white' and 'knobbes sittyng on his chekes', early signs of leprosy. Avaricious and lecherous, the Summoner is cast as someone whose leprosy is the outward expression of a moral malaise: he is a threat to both the spiritual and physical health of society.[9] In the early modern period, leprosy pervades poetic discourse on illicit sexual mores. In 'The Perfume' (c.1633), John Donne deploys the trope of the leprotic prostitute to disdain how 'the silly amorous sucks his death / By drawing in a leprous harlot's breath'. By the nineteenth century, leprosy had become firmly entrenched as a means to other and dehumanise colonial subjects of British imperial rule. Rudyard Kipling's 'The Mark of the Beast' (1890) details two white colonists' encounter with a leper named only 'The Silver Man'. With a 'slab that took [his face's] place', the leper is tortured into expurgating a curse believed to be afflicting one of the colonists. The leper here is a vehicle for the British colonists to reassert their (shaky) sense of moral and technological superiority over the wretched condition of their colonial subjects.[10]

In his founding sociological study on the subject, Erving Goffman defines stigma as the possession of an attribute that is deeply discrediting and that reduces the bearer 'from a whole and usual person to a tainted, discounted one'.[11] In Goffman's view, those stigmatised internalise the marginalisation they suffer, resulting in a 'spoiled identity' overly anxious concerning any further rejection by society at large. Subsequent writing has been more generous than Goffman in focusing on stigmatisation as a form of discriminative social segregation and not, in part or whole, the fault of the individual.[12]

For the former inhabitants of the Spinalonga leper colony, the psychological toll must have been high. Infected by a then incurable disease whose disfiguring symptoms could be severe, they were obliged to abandon their livelihoods to live in enforced confinement on a nub of land less than a kilometre in diameter. Many of them never returned, dying on the island without ever being reunited with friends and relatives.

Prior to the Covid-19 pandemic, we might have liked to simply disown such methods of quarantine as unempathetic, the cruel and antiquated diktats of imperialist powers intent on marginalising the sick and needy in favour of projecting the health and prosperity of their economic and population hubs. The emergence of a virus far more transmissible and deadly than leprosy, though one spread in similar fashion,[13] has led to a reassessment of, and often heated political debate over, the value and efficacy of differing modes of quarantine. The World Health Organization declares that early isolation and quarantine are as essential to curbing the spread of Covid-19 as they used to be for leprosy. Yet, to varying degrees depending on locality, there has been kickback against the need to re-encode signs of illness as necessitating social distancing. As Lee Grieveson has written in this volume, protests against national and local lockdowns have claimed they are an infringement on civil liberties and personal freedoms. Equally, governments have lifted, eased or failed to implement quarantine protocols against scientific consensus to boost commerce, enable international travel and resuscitate tourism. All the while, individuals' homes have been reconfigured as the small islands of self-isolation and lockdown.

If we are to emerge from the pandemic having learnt from our experience, we should look back to sites like Spinalonga as correctives to how we view infectious disease. Enforced isolation may be a crude but necessary limitation where other treatments are unavailable. However, the psychological and social costs of such do not need to be compounded by stigmatisation. Nor should we be quick to ascribe moral failings to those infected. Guilt and shame can have a detrimental effect on adherence to Covid-19 prevention and containment strategies; denialism will not curb transmission. Moreover, propagating ideologies predicated on each of us taking on personal liability for the virus will only increase the sense we have of being marooned. Instead, we should do more to inculcate compassion and community, wherever and however we can, despite any sense we may have of being cast away from one another.

Notes

1. Examples include Angel Island and Ellis Island on opposite coasts of the US; Quarantine Island (Kamau Taurua) in Otago Harbour, New Zealand; and Kamaran in the Red Sea. For an extensive cultural history of quarantine practices and their use of islands, see Bashford, *Quarantine*. For a reappraisal of the practice in light of Covid-19, see Gill, 'Islands created for quarantines'.
2. Karamanou et al., 'L'île des lépreux: Spinalonga', 1526.
3. Bardel, 'The island community of Spinalonga', 656–7.
4. Kotsiou et al., 'Devastating epidemics', 286.

5 Savvakis, 'Demarcating a state of non-illness?'
6 See the earlier 'lepra, n.', *OED Online*, for the fullest etymological entry.
7 WHO, 'Leprosy (Hansen's Disease)'.
8 Suzuki et al., 'Current states of leprosy', 127.
9 Grigsby, *Pestilence*, 84–5.
10 Both this quotation and the one above are cited in Edmond, *Leprosy and Empire*, 131, 136.
11 Goffman, *Stigma*, 3.
12 See Crocker et al., 'Social stigma', and Link and Phelan, 'Conceptualizing stigma'.
13 Both leprosy and Covid-19 are spread by airborne particles of moisture. WHO, 'Leprosy (Hansen's Disease)'; WHO, 'Coronavirus'.

Bibliography

Bardel, Michał. 'The island community of Spinalonga seen in the light of Dietrich von Hildebrand's phenomenology of community', *American Catholic Philosophical Quarterly* 91, no. 4 (Autumn 2017): 655–69. https://doi.org/10.5840/acpq2017104125.
Bashford, Alison (ed.). *Quarantine: Local and global histories*. London: Palgrave, 2016.
Crocker, Jennifer, Brenda Major and Claude Steele. 'Social stigma'. In *The Handbook of Social Psychology*, 4th edition, vol. 2, edited by Daniel T. Gilbert, Susan T. Fiske and Gardner Lindzey, 504–53. New York: McGraw Hill, 1998.
Darby, Beryl. 'Spinalonga – paradise or purgatory?' *The Star* 46, no. 1 (1986): 6–16.
Edmond, Rod. *Leprosy and Empire: A medical and cultural history*. Cambridge: Cambridge University Press, 2006.
Gill, John F. 'Islands created for quarantines', *New York Times*, 22 May 2020. Accessed 20 August 2021. https://www.nytimes.com/2020/05/22/realestate/quarantine-hoffman-island-swinburne.html.
Goffman, Erving. *Stigma: Notes on the management of spoiled identity*. New York: Simon & Schuster, 1963.
Grigsby, Bryan L. *Pestilence in Medieval and Early Modern English Literature*. New York and London: Routledge, 2004.
Karamanou, Marianna, Christina Antoniou, Kyriakos P. Kyriakis and Georges Androutsos. 'L'île des lépreux: Spinalonga', *La Presse Médicale* 42, no. 11 (November 2013): 1526–9. https://doi.org/10.1016/j.lpm.2012.11.024.
Kotsiou, Antonia, Vasiliki Michalaki and Helen N. Anagnostopoulou. 'Devastating epidemics in recent ages Greek populations', *Acta medico-historica Adriatica* 15, no. 2 (2017): 283–90. https://doi.org/10.31952/amha.15.2.6.
'lepra, n.'. *OED Online*. June 2021. Oxford: Oxford University Press. Accessed 18 August 2021. https://www.oed.com/view/Entry/107400.
Link, Bruce G. and Jo C. Phelan, 'Conceptualizing stigma', *Annual Review of Sociology* 27 (2001): 363–85. https://doi.org/10.1146/annurev.soc.27.1.363.
Savvakis, Manos. 'Demarcating a state of non-illness?: Leprosy as battlefield and as struggle of resistance', paper presented at the Life History and Biography Net Conference of ESREA, Volos, Greece, 2006.
Suzuki, Koichi, Takeshi Akama, Akira Kawashima, Aya Yoshihara, Rie R. Yotsu and Norihisa Ishii. 'Current status of leprosy: Epidemiology, basic science and clinical perspectives', *The Journal of Dermatology* 39, no. 2 (2012): 121–9. https://doi.org/10.1111/j.1346-8138.2011.01370.x.
WHO (World Health Organization). 'Coronavirus'. Accessed 18 August 2021. https://www.who.int/health-topics/coronavirus#tab=tab_1.
WHO (World Health Organization). 'Leprosy (Hansen's disease)'. Accessed 18 August 2021. https://www.who.int/news-room/fact-sheets/detail/leprosy.

13
The thing itself

Alexander Samson

The pivot online to remote teaching and home working, and the closure of campuses, libraries and archives, as well as theatres, cinemas, hospitality venues and shops, have seen academics' (and much of society's) quotidian experience of the world shrink and diminish to fit inside a luminescent screen, through which we access a once three-dimensional, spatially extensive life. While this revolutionary change has liberated us in many ways – not least from the drudgery of the daily commute – as we have come to depend on the digital avatars of sensible subjects and objects we were accustomed to experience directly, in the flesh, face to face, physically and materially, a curious pall has fallen over our everyday experience, an inescapable sense that it has somehow been diminished, impoverished and flattened out. Virtual meetings have collapsed space and time, bringing us together in a single electronic plane – the private spaces of our bedrooms, kitchens or, if we are lucky, home offices – while we teach students on the other side of the world in places whose political repressiveness casts into doubt that very connectedness. Tiled galleries of faces crowd into our displays, diminishing to pixelated unrecognisability. The sudden appearance of cats' tails, children and others, irrupting into our spaces of encounter, personalise, but also signal a darker voyeurism that reminds us of the fragility of the tissue now between our public and private lives. Social media has been a catalyst for liberation and political change. But equally, its provision of platforms for the proliferation of fake news, alternative facts, conspiracy theories and the abuse of big data has threatened to poison democracy itself.[1]

The shrinking distance between news and (personal) drama empowers and impinges. Everyone is a broadcaster as news media and journalism dwindle as going concerns. Have we just witnessed the most precipitous decline in sex in human history, with the romantic lives of the unattached curtailed by lockdowns that have confined people to family homes, halls of residence, house and flat shares, care bubbles? Affairs have become newsworthy transgressions, while casual sex teeters on the hearth of illegality. The state's intervention in the private and personal lives of citizens – drastically curtailing freedoms in the name of public health, robbing individuals (for some) of a fundamental right to decide who, when and whether it is safe to see others – has been a shock to the system in an era dominated by the neoliberal consensus.[2] The scale of the emergency powers governments have granted themselves has conjured the spectre of authoritarianism and an anxiety we are sleepwalking into the open-ended crisis that heralds the rise of a new technocratic fascism. Imprisoning us in our own homes generates a chilling echo of the draconian quarantine faced by Londoners in 1665, dramatised in Daniel Defoe's *Journal of a Plague Year* (1722), with homes where cases occurred sealed and guarded, and with frequent outbreaks of murderous violence provoked by the confined's attempts to escape their watchmen.[3]

The porosity of the digital university is a source of strength and danger. While it has potentially empowered us to reach out into, across and around the world, it also exacerbates digital divides that are already here. The perhaps surprising resistance to creating asynchronous materials – to making a permanent record – reminds us that it is the very irreproducibility and uniqueness of the teaching moment, its evanescence, the closed circle of an ideally safe, shared space of exchange, discussion, dialogue and interaction, that appears to be under threat, a danger at once political, personal and pedagogic. It is clear why teaching is often conceptualised, especially the lecture, in terms of performance. Possessed of a theatricality absent from recording, it relies on a feedback loop not just between teacher/performer and audience, but equally between those present, as emotional, cognitive responses ripple out among and between us, reinforcing or diminishing responses, reshaping and redirecting the interaction. The uniqueness of each iteration exists in the palpable space between teachers and students. If the average dropout rate of Massive Open Online Courses (or MOOCs) tells us anything, it is that the motivation and desire to learn are about peer-to-peer pressure and the group's sense of itself as much as they are about interaction with a charismatic teacher. The self-conscious embarrassment of a noisy reaction to a live performance reminds us of our place in a crowd. With the ability

to mute and sit listening unseen, the co-presence of the teacher and learner in the same space cannot be reproduced virtually.

The digital in some fundamental sense ruptures the immediacy of a learning community, a connectedness implicit for participants in the learning event. On screen, our gazes cannot meet, we cannot exchange looks, we do not feel the eyes of others upon us, their eyeballing or approval/disapprobation. In the digital world our vision is (still) mediated by the fixed point of view of the webcam. The evolution of 'smart' meeting equipment and software, far from approximating the experience of the 'real', only accentuates how far away it takes us from the three-dimensional, multi-sensory thing itself.[4] This is in part to do with the way we see, sampling parts of the visual field and imaginatively reconstructing the gaps in accordance with what we have through experience been led to expect. Electronic visual recognition's fundamental incapacity, despite AI, is underlined by the 'I am not a Robot' tests on every consumer website which ask us to identify fragmentary images of buses or traffic lights. The Kantian synthetic unity of apperception has much to recommend it as an idea given the centrality it accords to the imagination in how we experience objects, and our fundamental ability to recognise an object as such in time as it inheres in an infinite phenomenological perceptual flux. There is something about encountering others through monitors that does not trigger our preternatural ability for recognition. Not seeing individuals in three dimensions, their faces, due to lighting or unrepresentative angles, not reflecting their owners' relative stature, seems to throw off that unique aspect of our species: our massive foreheads, spawning those oversized frontal lobes related to the Dunbar number that coincides with the average number of active Facebook friends. Meeting someone digitally seems to bypass the affective component involved in knowing a face.

The paradoxical hybrid of live casting theatrical events exposes analogous contradictions to synchronous teaching. August institutions like the National Theatre began broadcasting live theatre in 2009 (NT Live), originally envisaging it as a way of broadening access to heavily state-subsidised, London-centric culture. Despite these noble aspirations, live streaming theatrical productions in cinemas reproduces some of the hierarchies it was intended to counter and is imbricated in technical limitations as well as new possibilities. The gaze is controlled by the mediating intervention of the lens, moulding the viewer's autonomy in accordance with a televisual language mixing wide shots capturing the entire stage, set design and blocking; medium shots or closeups for monologue and reverse shots for dialogue; and combining sound from

body mics for intelligibility and ambient sound to connect with audience response. The representation imposes a given understanding of the narrative by determining when and where attention is focused, despite the attempt to render the medium transparent and suggest presence and immediacy. Techniques designed to create intimacy, like the soliloquy, which theatre actors direct to particular parts of the audience but film actors deliver just off straight to camera (and with direct eye contact), can instead draw attention to remote audiences' distance. Filming live theatre attempts to reconcile a deadeningly static aesthetic with the roving motility of the camera. While broadcast theatre imposes a single shared gaze, it makes possible multiple points of view and varies distances in a way unavailable from the fixed auditorium seat. Similarly, attempts to create a sense of occasion with external views of theatres and the audience settling are undermined by partial shots during the performance of those physically present, depending on the stage and positioning of cameras or reaction shots, and can instead feed the sense of disconnection. Although still seen as a lesser experience, this new way of experiencing theatre undermines the equation of liveness and physical co-presence, simultaneity and a lack of mediation as an essential good. If broadcast emphasises simultaneity, a now, rather than a here, live streaming online loosens the fixity of place. Simulcasting on the internet breaks the problematic co-presence implicit in theatrical broadcast, moving to an entirely individualised reception. While screen size and setting change the experience, this mode can be enriched by choosing who to watch it with or participating in online communities of reception through social media. Live tweeting at academic conferences has added another element of interactivity to the experience of the keynote, again transcending the fixity of the chair.[5]

Underlying this lurks the notion of the reproduction as inferior, an idea whose roots carry us back to Walter Benjamin's influential essay on 'The work of art in the age of mechanical reproduction' (1935), which explored what new technologies had meant for art by the outset of the twentieth century. Art depended on the 'presence of the original', something beyond reproducibility, 'a unique existence' 'in time and space'. The forgery or fake merely reaffirmed the authority of the original, while technical reproduction severs and frees the copy, denying art any historicity of experience or value in a cultural heritage founded in tradition.[6] Modernity demystifies the 'aura' of the work of art, denying it unmediated, uninterrupted presence. Wrenched from its ritual context, art's magic ebbs away to be reborn in politics. Art for art's sake is the 'negative theology', Benjamin argued, born of the challenge of

photography and film. Rather than bearing within itself a history of experience, art came to resolve itself in the evidential, documentary value of the image. Benjamin's exhibition value, that which the reproduction opens up for us in terms of knowing the world, has become an obsessive exhibitionism in the digital age.[7] Despite prophesying the death of the 'aura', his argument recognised the cult value still inhering in the portraits of loved ones that make the absent present and challenge death as the haunting tokens of memory. The physical connection between the artist and the work – that access to the maker inhering in the object, its artisanal quality, exemplified by William Morris and the arts and crafts movement's nostalgic reaction to industrialisation (and now ironically eviscerated in the mass-produced wallpaper and curtains of untold bourgeois drawing rooms) – may well have evaporated. But the perception that there exists a direct connection remains and can still be seen to be challenged in the industrial art of figures like Damien Hirst, or even Antony Gormley, with authenticity recovered by the endless referencing of his own body, or Ai Weiwei's playful challenge to oppressive tradition, referenced and challenged in acts of destruction, defacement and repurposing.

Art historians and digital humanities scholars have long ruminated on how reproductions of images or objects, in resolutions that far surpass the discriminative ability of the naked eye, remain inadequate substitutes for direct experience of the object itself, unable to capture the play of light, the feel, smell, sense of place and absolute scale.[8] The 'aura', whose loss Benjamin does not lament, of the manuscript or early printed book arises from its value and rarity (often interrelated), incarnated in institutional gatekeeping that limits and controls access. Obtaining the library card, the traditional limitation of access to postgraduates and often only doctoral students, the supervisor's letter of recommendation, and travel to the specific collection, archive or museum, all form part of the mystification of the concrete object of study. But the importance of the interaction with such objects also depends on their place in the project and research being pursued, whether incidental, singular or cornerstone, and the specific moment of the researcher's encounter. Accessibility is the ease of entry somewhere, as well as the possibility of getting somewhere eventually. Access speaks to the ways in which our closeness to artefacts mediates power and history. The majority of digitised objects remain firmly locked behind the extortionate paywalls of institutional subscriptions. They are no different from the real in this sense; they too have their aura.

As before, though, the difference between the thing itself and its avatar need not be thought of in terms of hierarchy. A digital facsimile can

be thought of as an object 'in its own right' in a separate space created through image-capture, the gathering and curation of metadata and the creation of a user interface. Digital space is not simply some kind of immaterial and eternal spiritual ether. Its infrastructure is very real, from the servers and hard drives where material is stored to the cabling, routers and signals across which they travel to the screens and devices where they are viewed. The new uses (zooming, annotation, recombination) make possible an enrichment of the object itself. Used as tools, digitised objects have their own aesthetics and impart a new kind of intimacy. As Suzette van Haaren writes in a recent blog post departing from the Bury Bible, our interaction with digital objects depends on the role and value we place on them. Digital facsimiles come, for those who work on manuscripts or early printed books, to possess individualised presences.[9] The relationship between original and copy is no longer hierarchical but collateral. Following Jean Baudrillard, the 'simulacrum is never that which conceals the truth – it is the truth that conceals that there is none. The simulacrum is true'.[10] In the early modern period, ceremonial deployments of royal simulacra relied on 'understandings of the copy as an original', imbued with the divine power and authority of a distant, absent king.[11] The notable resistance to the recording of lectures and teaching springs from the anxiety that, as John Berger argued, inspired by Walter Benjamin, the (mis)use value of the reproducible being infinite renders it 'ephemeral, ubiquitous, insubstantial, available, valueless, free'.[12] What, then, is the role of the university and what could ever justify its substantial fees?

The university is a space of encounter, a concrete place, where learning and knowledge emerge from the shared spaces between us. Teaching is sensual, embodied, communal and collaborative. What happens in the webinar often underlines that our 'vision is continually active, continually moving, continually holding things in a circle around itself, constituting what is present to us as we are', and the digital remains an incredibly poor substitute for presence and presentness.[13] The moving image, in contrast to theatre, removes our free will to decide what to look at and when. It is this freedom to be attentive or not that is fundamental. The tyranny of engagement, our endless surveying and subjection to the marketisation of education, runs precisely counter to this liberty to attend or not. While the intellectual fantasy most strongly associated with the university may be one of isolation, retreat and retirement from the world embodied in the ivory tower, reading is ultimately about communication, not solitariness. The social nature of learning and intellectual practice has been made all too clear by proliferating online connection that attempts to compensate for the absence of serendipitous sociability. Perhaps there

are two fantasies whose inadequacy has been brought home by the pandemic: first, that teaching must remain ritual, performance, immanence, and that it cannot but be diminished by technical reproduction; second, that the university can be fully subjected to the exhibition value of reproducibility, implied in impact and a funding settlement founded on socio-economic benefit, without recognising that this renders all its aesthetic practices political. It is not surprising that in our febrile confinements, the natural world has become a life saver, reminding us of the richly textured, sensually layered reality from which we have been shut out. The pandemic and its attendant lockdown have forced us to reflect on how we see and look, what happens in the shared physical spaces between us and what exactly, in relation to its digital replacement, the thing itself is.

Notes

1. It seemed especially important for this chapter to retain the author's use of the present tense.
2. Monbiot, *Out of the Wreckage*, 29–41.
3. Defoe, *Journal of a Plague Year*, 68–74.
4. The Meeting Owl Pro device from Owl Labs is an example of how lucrative the market for such equipment has become. See Owl Labs, 'Meeting Owl Pro'. See also Keach, 'PS5 DualSense controller'.
5. On these issues, see Aebischer, *Shakespeare, Spectatorship*; Aebischer et al., *Shakespeare and the 'Live' Theatre*; and Barker, *Live to Your Local Cinema*. This innovation's access-broadening credentials have been criticised on a number of grounds: limited screenings (or time-limited availability of streaming) communicate a certain kind of exclusivity; programming can often reproduce cultural hierarchies, given the imperative to attract the biggest – although perhaps not widest – audiences; and productions often come from the well-established and well-resourced companies able to take advantage of new technology.
6. Benjamin, 'The work of art', 214–15. See also Orson Welles' genial exploration of the theme in *F for Fake* (1973).
7. Benjamin, 'The work of art', 219.
8. Between 2013 and 2018, the number of monthly users of *Second Life* fell from one million to half a million, while *Fortnite*, launched in 2017, has amassed 350 million players globally. *Second Life* offers individuals a virtual object world to inhabit, while *Fortnite* is a space of joint play, of connection, whose cartoonish graphics makes no attempt to reproduce the real. Dodds, 'Second Life enjoys'; Clement, 'Registered users'.
9. Haaren, 'Physical distancing from manuscripts'.
10. Jean Baudrillard, 'The precession of simulacra', 1.
11. Osorio, 'The copy as original', 704–5.
12. Berger, *Ways of Seeing*, 32. He argues crucially that '[i]nformation carries no special authority within itself', 24.
13. Berger, *Ways of Seeing*, 9.

Bibliography

Aebischer, Pascale. *Shakespeare, Spectatorship and the Technologies of Performance*. Cambridge: Cambridge University Press, 2020.

Aebischer, Pascale, Susanne Greenhalgh and Laurie Osborne (eds). *Shakespeare and the 'Live' Theatre Broadcast Experience*. London: The Arden Shakespeare, 2018.

Barker, Martin. *Live to Your Local Cinema: The remarkable rise of livecasting*. New York: Palgrave Macmillan, 2013.

Baudrillard, Jean. 'The precession of simulacra'. In *Simulations*, translated by Paul Foss, Paul Patton and Philip Beitchman, 1–30. New York: Semiotext(e), 1983.

Benjamin, Walter. 'The work of art in the age of mechanical reproduction'. In *Illuminations*, introduced by Hannah Arendt and translated by Harry Zorn, 211–44. London: Pimlico, 1999.

Berger, John. *Ways of Seeing*. London: Penguin, 2008.

Clement, J. 'Registered users of Fortnite worldwide from August 2017 to May 2020', *statistica*, 10 September 2021. Accessed 30 September 2021. https://www.statista.com/statistics/746230/fortnite-players/.

Defoe, Daniel. *Journal of a Plague Year*. London: Penguin, 2003.

Dodds, Io. 'Second Life enjoys a surprising renaissance as social distancers flock to virtual worlds', *Telegraph*, 26 March 2020. Accessed 8 December 2020. https://www.telegraph.co.uk/technology/2020/03/26/second-life-enjoys-surprising-renaissance-social-distancers/.

Harren, Suzette van, 'Physical distancing from manuscripts and the presence of the digital facsimile', *Cambridge Medieval Graduate Students,* 25 May 2020. Accessed 7 December 2020. https://camedievalists.wordpress.com/2020/05/25/physical-distancing-from-manuscripts-and-the-presence-of-the-digital-facsimile/.

Keach, Sean. 'PS5 DualSense controller lets you "feel" video games with revolutionary "haptic" tech', 20 June 2020. Accessed 1 December 2020. https://www.thesun.co.uk/tech/11849088/ps5-dualsense-controller-playstation-5-haptic-feedback/.

Monbiot, George. *Out of the Wreckage: A new politics for an age of crisis*. London: Verso, 2018.

Osorio, Alejandra. 'The copy as original: The presence of the absent Spanish Habsburg king and colonial hybridity', *Renaissance Studies* 34 (2019): 704–21. https://doi.org/10.1111/rest.12596.

Owl Labs. 'Meeting Owl Pro'. Accessed 25 August 2021. https://shop.owllabs.com/products/meeting-owl-pro.

14
Towards a new history: the corona-seminar and the drag king virus

Helena Fallstrom

He looks so small. An unremarkable, grey figure seen from afar, caught in a tight pool of light on the stage. The stage is otherwise empty but for a screen, which stretches from floor to ceiling along the back wall of the cavernous theatre. Emerging from the centre of the luminous black canvas is an arresting image: a bald man in thick, rectangular glasses and a white polo-neck, caught in a moment of animated thought over what appears to be a cake (Figure 14.1). It is a pink penis cake, swollen head caught mid-ejaculation, bulbous balls crowned with thorny flecks of icing. In the glow of this towering projection the grey man sits gingerly, hovering above his wad of notes, which cast a quivering shadow over the desk below. Through an interminable series of introductory acknowledgements his faltering voice, marked by a distinctly Hispanic rendering of the gallic nasal vowels and schwas, gains in consistency, emboldened, it seems, by the electric focus emanating from the packed sea of velour seats. He begins in earnest:

> Let's just say that I thought this seminar could be like a virus that would enter the museum, that could proliferate through the museum, propagating a new politics of gender and sexuality, but it looks like I have been taken over by the virus itself and we may soon be evicted … What seems interesting to me is that this seminar, which may just turn out to be the corona-seminar, interpellates us

directly as somatic apparatuses, as living somatic apparatuses, vulnerable and, thus, mortal. It's through this vulnerability, this mortality, that I would like to start this *New History of Sexuality* ...[1]

On 6 March 2020, just days before France went into national lockdown, Paul B. Preciado held the inaugural session of his seminar *Une nouvelle histoire de la sexualité* (*A New History of Sexuality*) in the main theatre located in the basement of the Centre Pompidou Museum (Figure 14.2). It was to be the first of an ambitious series of interventions combining theory, activism and performance, programmed throughout the spring and summer months of 2020 in the context of his tenure as intellectual of the year. This was a position, he observed mischievously, which could exist only in France, a country where the public intellectual constitutes a pillar of national mythologies of political and cultural exceptionalism, enshrined in the Pompidou Museum itself.[2]

Preciado's project was launched in the shadow or, rather, in the haunting glow of perhaps the principal exemplar of this mythic figure in French political life: Michel Foucault. Today, decades after a wave of

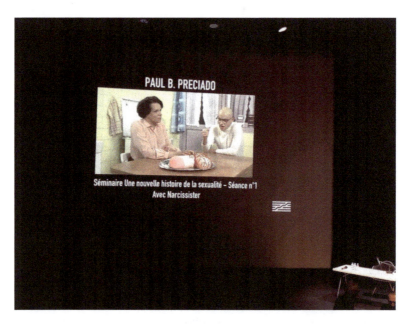

Figure 14.1 The title slide of Preciado's seminar *Une nouvelle histoire de la sexualité* (*A New History of Sexuality*). The image at its centre is a still from Su Lea Chang's film *Foucault X*, presented at the 2019 Venice Biennale for the Taiwan Pavilion. Photo: Helena Fallstrom.

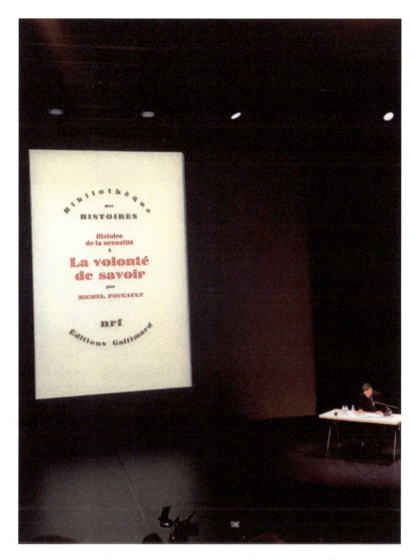

Figure 14.2 Paul Preciado presenting the first session of his seminar. Projected on the screen to his right is the front cover of *La volonté de savoir*, the first volume of Michel Foucault's *History of Sexuality*, first published by Gallimard in 1976. Photo: Helena Fallstrom.

post-structuralist thought first swept through the academy of North America, crystallising in the fetishised object of 'French Theory' and initiating a much-contested 'Theory' craze, Foucault's star power across the human and social sciences, notably in my own discipline of

anthropology, remains unparalleled.[3] Thinking after, alongside and against this monument, the seminar's stated objective was to carve out a new history of sexuality. A transfeminist, *queer*[4] and anticolonial history centred on the analysis of 'the patriarchal and colonial infrastructure of modernity' through the fissures of the Foucauldian narrative.[5] Together, in the company of his assembly of 'bodies against the norm', Preciado set out to examine the spectacular mutations in the 'technopolitics of violence and control' of the body, identified as the principal object of contemporary political life and reconceptualised through the *somathèque*. The *somathèque*, an archival apparatus made up of dense webs of signification and technologies, incorporates and extends beyond the anatomical body of modern medical discourse. It is through the *somathèque* that the philosopher identifies and seeks to intervene in contemporary regimes of sovereignty, but also to foreground the critical subjectivities constructed from within and against the political practices governing the (re)production and destruction of bodies.

The political and epistemological project of the *New History of Sexuality*, conceived upon the revolutionary battlegrounds of the minoritarian movements of the late twentieth century, did not erupt in a bolt of luminous ejaculation out of the dark underbelly of the Centre Pompidou. Rather, it represents the culmination of a philosophical career and a personal or, to use the philosopher's own language, a somatopolitical trajectory that has unfolded over the past three decades in the haunting glow of Foucauldian fandom, exegesis and critique. The conceptual crux of this unfolding trajectory is the 'pharmacopornographic era': a regime of power-knowledge defined by new forms of biochemical and technological control emerging in the post-industrial, post-war landscape.[6] It is the cyborg child of the 'necropolitical father' of the sovereign, *ancien regime* and the 'white, bourgeoise mother' of modern biopower.[7] Preciado's playful reimagining of Foucault's notoriously pervasive, intoxicatingly flexible analytics was first theorised in *Testo Junkie: Sex, drugs and biopolitics* (2013), a performance-essay based on the philosopher's own auto-experimentation with testosterone, which marked a pivotal moment in both his philosophical career and his own intimate somatopolitical trajectory.

The drag king

Nestled in the pages of the textual bedrock of the *New History of Sexuality* is the drag king. It is for the drag king that I found myself in the velvety

belly of the Centre Pompidou on the countdown to lockdown, furiously transcribing the ever more elaborate neologisms and spiralling chains of influences cited by the philosopher; straining to muffle the tapping of my laptop keys as I struggled to distill an ethnographic moment from my participation in this Theory-saturated spectacle. Drag kings might be defined as individuals who contest heteronormativity and essentialist, dimorphic understandings of gender through the critical performance of masculinities.[8] The drag king first emerged as a category of identification, a performance genre and a political praxis in the late eighties, seeping out of the interstices of the underground performance venues, lesbian bars, ephemeral activist spaces and university lecture halls of New York, San Francisco and London. His emergence coincided with a movement of radical critique operating on two fronts: a *political* critique of the assimilatory politics of consumption and capitalist-nationalist reproduction characteristic of mainstream LG(BT) activism; and an epistemological critique of the identitarian essentialism dominant in women's studies and lesbian and gay studies. The disruptive posture of this critical movement was encapsulated in the re-appropriation of the slur 'queer', transfigured into the flag of the *Queer Nation*, flown with pride by those living outside the norms of the hetero-patriarchal sex/gender system.[9] The shift in categories, methods and fields of knowledge this counter-discursive move made possible is indissociable from the deconstruction of the performative power of categories of gender and sexuality instigated by queer theorists and staged by drag kings through an array of performance practices: namely cabaret theatre, striptease, happenings and, most characteristically, the institution of the drag king workshop.

Preciado was one such king, initiated into the drag king fraternity in the 1990s whilst studying under Jacques Derrida and Agnes Heller at the New School for Social Research in New York. He was captivated by his first experience of the drag king workshop, struck by its power as a collective plan of action and its potential as a political laboratory for developing new gendered subjectivities constructed 'against the somato-semiotic norm'.[10] The process of mutation thus initiated accelerated in the early 2000s when he began running his own workshops in France, following in the pioneering footsteps of Diane Torr.[11] In the *Drag King Plan of Action* laid out in *Testo Junkie*, the philosopher identifies the drag king with the virus: he is a micropolitical technology that infects the organism of the practitioner, the hermeneutics of gender suspicion introduced into his cells contaminating his entire worldview, revealing the sexual forms decodable as male or female as 'performative products to which different frames of cultural intelligibility confer various degrees

of legitimacy'.[12] In the viral mechanisms of the drag king political technology as conceptualised by the philosopher, it is the workshop that functions as the principal site of propagation: once launched through the male-dominated spaces of the streets, bars and transport networks of the city, these urban brigades set off to spawn more laboratories of gender hacking, weaving a web of counterhegemonic, rebellious *somathèques* across the globe.

The seminar was a continuation of this viral, drag king logic. It was to be a political theatre which, the philosopher postulated, would derive a disruptive power from the corporeal presence of the public, contaminating the master *somathèque* of the museum with a collective multitude of minoritarian voices. For me, the seminar constituted an emblematic event and something of a turning point in my ongoing research on the emergent Parisian drag king scene. I began working with drag king practitioners in Paris in the late autumn of 2015. At the time, there was no drag king scene, per se, to speak of. Here, the scene designates 'particular clusters of social and cultural activity in city life',[13] which take shape in the context of specific cultural practices and in close relation to the occupation of urban space, coalescing 'on the edges of forms'.[14] Drag king scenes around the world are archetypal of this sociological definition of the scene. Emerging and collapsing on the fringes of cultural industries, the university, and the structures of formal activism, the scene's actors engage reflexively and critically with the theatricality of the modern city and the performance paradigms of social theory and cultural studies.[15] But when I began working in Paris, I was confronted with a remarkable absence of drag king clusters. Regular practitioners were limited to a dozen or so kings, gravitating around the disjointed projects of two principal protagonists. There were no stable performance spaces, only a handful of venues open to the genre, and no identifiable public to bind together the disparate projects of the few key figures active at the time. My interlocutors often framed their activities through the language of lack, notably with respect to their North American and British counterparts, a language that I identified with wider discourses of gallic inferiority in the face of 'Anglo-Saxon' dominance.[16]

In this context, my project was initially met with scepticism on the part of certain collaborators, unsure as to why a British researcher such as myself would choose to study their 'embryonic' microcosm. But for me, this apparent 'lack' was a paradoxical puzzle which invited scrutiny. I was keenly aware of the 'French Theory' underpinning the work of the pioneering drag king forefathers, an intellectual history which was foregrounded by my living and working conditions. I was, at the time, on

a studentship at the École Normale Supérieure (Ulm), the pinnacle of the French intellectual elite and Foucault's *alma mater*. Preciado came to represent something of a leitmotif of this thread running through my project and a personification of the feeling of lack which characterised my early fieldwork. No longer an active practitioner or a corporeal presence on the scene, Preciado has remained nonetheless an ineluctable point of reference for many of my drag king collaborators and in the surrounding *queer*-feminist milieu. According to a number of accounts from the field, the seeds of the French drag king movement were sown in his workshops, first held at Paris VIII University in 2001. His writings confirmed this folk genealogy and echoed a number of the unsettling elements of my own experience. Preciado had come to France 'in search of 68', following the philosophical traces of post-structuralism.[17] If Preciado believed that he was returning to his spiritual home, the origin of the antinomian instruments of thought and action at the then beating heart of *queer*, he found instead in France a void of drag king practice and a most inhospitable terrain for his micropolitics of queer critique.

Indeed, the return of '*la pensée 68*' ('the thought of '68')[18] on the dawn of the twenty-first century in the transatlantic reincarnation of queer theory was met with resistance. The matrix of this resistance, according to a number of prominent *queer* scholars in France, lies in the master discourse of French exceptionalism: the Republic.[19] French Republicanism is a political model predicated upon a universalist contract between abstract citizens, shorn of their ethnic, religious and sexual differences. The model is frequently opposed to 'Anglo-Saxon' multiculturalism, identified primarily with North America, 'the country of difference'.[20] In recent years, critics of French Republicanism have highlighted the fallacy of its universalist premise. Although ostensibly based on a universalist contract, the French Republic 'has always presumed particular ethnic, racial, religious, and kinship norms', its ideological commitment to unity belied by the reality of a composite system, which in turn polices, excludes and seeks to absorb those who deviate from national 'regimes of the normal'.[21] In these critical readings of contemporary French Republicanism, the measure of 'the normal' is not the abstract citizen of Republican universalism but the white, European, cis-heterosexual male subject. *Queer* analysis, it follows, poses a threat to this master discourse of French exceptionalism, exposing the fallacy of its very foundations.[22]

Political fictions of masculinity and governance

Despite the methodological challenges immanent to my precarious field, emerging out of this hostile terrain, I could think of no better place than Paris, the epicentre of the French Republic and the 'antihumanist'[23] philosophers of post-structuralism, to study the drag king as an anti-king. The management of power and its theatricalisation are the historical cornerstones of the drag kings' critical performances of masculinities. Although kinging is a minoritarian, micropolitical technology focused on the individual body, the practice has macropolitical aspirations and implications whose logics find echoes in recent fields of research across the social sciences and humanities. Extant scholarship in anthropology and beyond has sought to demonstrate the mutual constitution of the nation-state and gender/sexuality, and within it there is a growing body of literature on masculinities focused on the interdependence of manhood and the state.[24] But it is in what might be considered a marginal or exceptional institution in the contemporary political landscape – kingship – that these concerns around the political fictions of masculinity and governance crystallise with compelling clarity. Political anthropologists have recently drawn attention to the salience of kingship for contemporary theories of political life. In their proposal for a theory of kingship, David Graeber and Marshall Sahlins acknowledge the 'archetypically male' nature of this most diffuse form of human governance and evoke the implications of this gendered dimension for an analysis of patriarchy.[25] Their analysis highlights the endurance of kingship, a consequence (at least in part) of the exceptional elasticity of this political form. Even when the institution of 'mortal kingship' and the male head of the household is done away with, sovereign regimes persist in new, abstracted forms, most notably in 'the curious and contradictory principle of "popular sovereignty"'.[26]

Here, the work of anthropologists and social historians of kingship dovetails with Preciado's project of *Une nouvelle histoire de la sexualité*. The seminar staged the *New History* as a *libretto*, a baroque opera in three parts revolving around three *somathèques* – three political bodies or political fictions – corresponding to three historical configurations of power-knowledge: the sovereign regime, modern biopower and the pharmacopornographic era. The first character on the scene, dubbed the 'necropolitical father', is drawn from Foucault's writings on the sovereign regime, distilled in the divinified body of the king and theorised as deriving from the sovereign's right of death over his subjects. In Preciado's

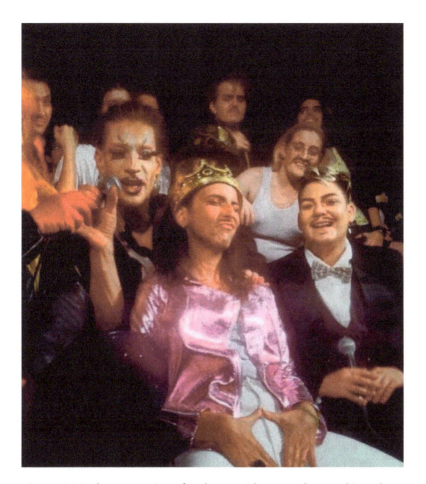

Figure 14.3 The coronation of Judas La Vidange at the Dragkingathon, the first formal drag king competition to be held in France. The event was held in October 2019 at Le Point Éphémère and hosted by Jésus la Vidange, the Parisian scene's self-proclaimed 'King of Kings' and proud drag father of Judas La Vidange. Photo: Helena Fallstrom.

reworking of the Foucauldian paradigm, the body of the king is reframed as a *masculine* body: his necropolitics can only be understood as *patriarchal* politics. Despite his archaic origins, the king occupied a central role in the plot of Preciado's opera, not as a historical prologue to the *New History* but as a live, active force in the contemporary political landscape. The king was a paradigm embedded in the here and now, informing and structuring public actions and social relations constitutive of political life.

Over the past five years, the drag king virus has taken hold in Paris, spreading through a constellation of *queer*, trans-feminist collectives and infiltrating previously untouched territories of the milieu, coalescing in an effervescent, increasingly complex scene at the nodal point of an expanding network of drag king clusters across France. The drag king virus has taken hold in France at a moment in which the necropolitics of the sovereign father – as embodied in the French Republic and analogous political bodies beyond – have come to the forefront of political consciousness: in the tragic unfolding of the so called 'migrant crisis'; in the unfurling of the #Metoo movement; and, most starkly, in the historic contestation of state-sanctioned violence enacted upon racialised bodies in the wake of the murder of George Floyd. The propagation of the drag king in France has also gone hand in hand with the accelerated diffusion and institutionalisation of queer intellectual, aesthetic and political cultures. Preciado's seminar was emblematic, in many ways, of the fraught convergence of these processes, and indexed the role of the university in the evermore apparent and uncomfortable imbrication of queer projects with both the nation-state and circuits of capital, commodities and neoliberal ideologies.[27]

The spectre of the AIDS epidemic

With the seminar brought to an abrupt halt by the announcement of a national lockdown on 14 March 2020, news of its much-anticipated return began circulating over Facebook and Twitter in October later that year. A little more than a week before the re-launch of the seminar, the number of participants registering their interest in the events shot from the tens to the thousands in a matter of days. I was lucky enough, and decidedly determined enough, to be in the room and found myself, after several hours of anxious stewing in line, back in the underbelly of the Centre Pompidou for the opening session on 15 October. This time, the seminar would coincide with the announcement of a curfew in Paris, the latest measure introduced to stem the concerning rise in Covid-19 cases and hospitalisations over the summer, sealing its fate as the corona-seminar. In the wake of the compound crises provoked by the pandemic in the six-month interval since the first launch of the *New History*, the philosopher had reworked the seminar as a 'revolutionary cluster': a 'choral narration' he would conduct alongside a host of actors engaged in 'the dismantlement of the colonial and patriarchal societal infrastructure'

in France.[28] Here, the virus as biological phenomenon, as socio-political agent and as a theoretical model definitively took centre stage. It was through the virus, he proposed, that we would together construct an anticolonial, transfeminist, revolutionary project and rethink political subjectivity beyond the limits of identity.

But the salience of the virus in the work of the philosopher predates the pandemic. Its roots lie in the cyberfeminist movement and associated viral idioms, which emerged out of the digital revolution of the 1990s.[29] We can only fully account for and comprehend the significance of Preciado's use of the virus, however, in the context of the HIV/AIDS crisis of the 1980s and 1990s, an era-defining moment in global LGBT historiography and a critical event in the emergence of *queer* thought and politics. Preciado's writings on the drag king are illustrative in this regard. Initiated in the 1990s into drag king practice in a New York ravaged by the disease, his coming to *queer* consciousness and community was defined by death. The figure of Foucault is an indelible part of this history, as the first public figure in France to die from complications related to the disease in June of 1984, just as the long-awaited final volumes of the *History of Sexuality* were published. If the *History of Sexuality* constituted the single most significant theoretical catalyst of *queer* analysis and activism, Foucault's death would underpin the *New History's* engagement with the troubled political legacy of the text and the fraught impasse of contemporary *queer*-feminist politics.

Since the first lockdown of spring 2020, my field has been transformed beyond recognition: packed bars, pokey basement clubs and throbbing performance venues – the bread and butter of my fieldwork up until this point – have been rendered largely unthinkable in the present. As I have participated in the restructuring of the scene, tracking the momentary re-surfacing of its fragments across the myriad, emergent spaces of virtual sociability and performance and the charged, all-too-fleeting 'IRL' spaces of street protests and illicit soirées, the spectre of the AIDS epidemic looms large. ACT UP's iconic, inverted pink triangle is rarely far from view. In the streets of Paris, ACT UP's 'Silence = Death' mantra collides with denunciations of white silence and comes face to face with the *collages féministes* (feminist collages) testimonials, whose graphic accounts of patriarchal violence continue to plaster the walls of the city.

Viral histories

The return of the seminar in the autumn of 2020 as the grip of the virus tightened once more foregrounded the return of another viral history, a history whose reverberations continue to shape the happenings of the present, compelling us to interrogate with renewed acuity the status of revolutions past and to scrutinise the promises of heterotopia projected into a flickering future. Whilst the virus interpellates us as vulnerable, mortal bodies it also engages us as members of the body politic, demanding that we rethink our collective lives and the regimes of the normal that have come to define our frontiers and dictate the limits of the possible. There are perhaps valuable lessons to be drawn, this chapter suggests, from drag king histories and, notably, from attempts to stage new histories at a moment in which the connections between the macropolitics of governance and the micropolitics of the body are ever more complex, their implications ever more insidious and in dire need of scrutiny.

Notes

1. Preciado, *Une nouvelle histoire*, séance 1. Translations of excerpts of the seminar and promotional material are my own.
2. The *Centre national d'art et de culture Georges-Pompidou* is a multidisciplinary arts museum, founded by Georges Pompidou, president of France between 1969 and 1974. It is widely acknowledged that one of the primary concerns motivating Pompidou's project was the perceived decline in French global influence and the stated aim to re-assert French dominance in contemporary arts and cultural industries.
3. Boyer, 'Foucault in the bush'. 'French Theory' is a term widely used to refer to a diverse body of texts produced by francophone philosophers in the second half of the twentieth century. The term is often used in parallel or conjunction with the cognate categories of post-structuralism and post-modernism, all hotly disputed. Following Eric Fassin, I find it helpful to distinguish between 'Theory' (capitalised), to refer to the 'intellectual construction from the United States', and social theory as it is more broadly understood (Fassin, 'Gender is/in French'). For an in-depth intellectual history of 'Theory' and 'French Theory', see Cusset, *French Theory*.
4. I make a distinction between two principal uses of 'queer': 1) the movement of political and epistemological critique of lesbian and gay activism and studies; and 2) the umbrella term for non-heterosexual or cis-gender minorities, increasingly synonymous with LGBT. I italicise the first use throughout.
5. Preciado, *Une nouvelle histoire*, séance 1.
6. Preciado, *Testo Junkie*, 65.
7. Preciado, *Une nouvelle histoire*, séance 1.
8. The drag king is a contested term. For a recent definition and summary of these debates, see Luca Greco's *Dans les coulisses du genre*.
9. *Queer Nation* was an LGBTQ activist collective founded in 1990 by members of ACT UP, renowned for their innovative direct-action tactics and spectacular strategies. *Queer Nation* was instrumental in the re-appropriation of the slur 'queer' and the emergence of associated (post) identity politics.
10. Preciado, *Testo Junkie*, 237.

11 Diane Torr is widely recognised as the forefather of contemporary drag king practice, pioneering the 'Man For a Day' workshop in 1990. See Bottoms and Torr, *Sex, Drag, and Male Roles*.
12 Preciado, *Testo Junkie*, 235.
13 Straw, 'Cultural scenes', 415.
14 Gaonkar and Povinelli, 'Technologies of public forms', 391.
15 Here, I refer primarily to Judith Butler's highly influential theory of gender performativity, first theorised in their field-making *Gender Trouble: Feminism and the subversion of identity* (1990).
16 '*Anglo-Saxon*' is used in French to refer to dominant English-speaking cultures, primarily the hegemonic political and economic cultures of the United States and the United Kingdom. For a critical discussion of the emergence of the French term '*Anglo-Saxon*' and its use throughout the twentieth and early twenty-first centuries, see Chabal, 'The rise of the Anglo-Saxon'.
17 Preciado, *Un appartement sur Uranus*, 6.
18 '*La pensée 68*' is a polyvalent, highly ambivalent concept in contemporary France. Here, I refer to a pejorative use popularised by Luc Ferry and Alain Renaut in their influential essay critiquing the work of francophone 'post-modernist' thinkers.
19 Sam Bourcier, a long-time collaborator of Preciado, is perhaps the most prominent of these scholars. He is the founder of *ZOO* (1996), the first French *queer* research group, which mobilised for the inclusion of gay and lesbian studies and queer studies in the French academy. The group was instrumental in introducing and translating the work of queer theorists in France.
20 Bourcier, *Sexpolitiques*, 29.
21 Fernando, *The Republic Unsettled*, 31.
22 At first limited to the academy, moral panic around queer theory entered French public discourse in the years preceding my arrival in Paris, emerging as a focal point of the opposition movement to the proposed gay marriage bill, *La Manif Pour Tous*. For discussion of the reception of queer theory in France and *La Manif Pour Tous* see Perreau, *Queer Theory*.
23 Ferry and Renaut, *La pensée 68*.
24 See Guttman, 'Trafficking in men'.
25 Graeber and Sahlins, *On Kings*, 4.
26 Graeber and Sahlins, *On Kings*, 1.
27 Weiss, 'Always after', 630.
28 Preciado, *Une nouvelle histoire*, séance 2.
29 Cyberfeminism refers to a broad spectrum of feminist approaches in the arts, activism, philosophy and criticism concerned with new technologies, the internet and cyberspace.

Bibliography

Bottoms, Stephen and Diane Torr. *Sex, Drag and Male Roles: Investigating gender as performance*. Ann Arbor, MI: University of Michigan Press, 2010.
Bourcier, Sam. *Sexpolitiques: Queer zones 2*. Paris: LaFabrique, 2005.
Boyer, Dominic C. 'Foucault in the bush. The social life of post-structuralist theory in East Berlin's Prenzlauer Berg', *Ethnos* 66, no. 2 (2001): 207–36. https://doi.org/10.1080/00141840120070949.
Butler, Judith. *Gender Trouble: Feminism and the subversion of identity*. New York: Routledge, 1999.
Chabal, Emile. 'The rise of the Anglo-Saxon. French perceptions of the Anglo-American World in the long twentieth century', *French Politics, Culture & Society* 31, no. 1 (Spring 2013): 24–46. https://doi.org/10.3167/fpcs.2013.310102.
Cusset, François. *French Theory: How Foucault, Derrida, Deleuze & co. transformed the intellectual life of the United States*, translated by Jeff Fort. Minneapolis, MN: University of Minnesota Press, 2008.
Fassin, Eric. 'Gender is/in French', *differences: A Journal of Feminist Cultural Studies* 27, no. 2 (2016): 178–97. https://doi.org/10.1215/10407391-3621771.
Fernando, Mayanthi L. *The Republic Unsettled: Muslim French and the contradictions of secularism*. Durham, NC: Duke University Press, 2014.
Ferry, Luc and Alain Renaut. *La pensée 68: Essai sur l'antihumanisme*. Paris: Gallimard, 1988.
Foucault, Michel. *Histoire de la sexualité Vol. I, La volonté de savoir*. Paris: Gallimard, 1976.

Foucault, Michel. *Histoire de la sexualité Vol. II, L'usage des plaisirs*. Paris: Gallimard, 1984.

Gaonkar, Dilip and Elizabeth A. Povinelli. 'Technologies of public forms: Circulation, transfiguration, recognition', *Public Culture* 15, no. 3 (2003): 385–97. https://doi.org/10.1215/08992363-15-3-385.

Graeber, David and Marshall Sahlins. *On Kings*. Chicago: Hau Books, 2017.

Greco, Luca. *Dans les coulisses du genre: La Fabrique de soi chez les drag kings*. Limoges: Lambert-Lucas, 2018.

Guttman, Matthew C. 'Trafficking in men: The anthropology of masculinity', *Annual Review of Anthropology* 26 (1997): 385–409. https://doi.org/10.1146/annurev.anthro.26.1.385.

Perreau, Bruno. *Queer Theory: The French response*. Stanford, CA: Stanford University Press, 2016.

Preciado, Paul B. *Un appartement sur Uranus*. Paris: Grasset, 2019.

Preciado, Paul B. *Une nouvelle histoire de la sexualité*, séance 1, 6 March 2020. Paris: Centre Pompidou.

Preciado, Paul B. *Une nouvelle histoire de la sexualité*, séance 2, 15 October 2020. Paris: Centre Pompidou.

Preciado, Paul B. *Testo Junkie: Sex, drugs and biopolitics*, translated by Bruce Benderson. New York: Feminist Press, 2013.

Straw, Will. 'Cultural scenes', *Loisir et société / Society and Leisure* 27, no. 2 (Autumn 2004): 411–22. https://doi.org/10.1080/07053436.2004.10707657.

Weiss, Margot. 'Always after: Desiring queerness, desiring anthropology', *Cultural Anthropology* 31, no. 4 (2016): 627–38. https://doi.org/10.14506/ca31.4.11.

Weiss, Margot. *Techniques of Pleasure: BDSM and the circuits of sexuality*. Durham, NC: Duke University Press, 2011.

15
'In spite of the tennis': Beckett's sporting apocalypse
Sam Caleb

In memory of Nicholas Caleb

You, like me, may have been perplexed that as we emerged in the early summer of 2020 from various national lockdowns caused by a devastating pandemic, the first mass cultural activities to return were organised sports. The obvious reason for this is money, and the billions riding on the sports industry. Another is more ideological: the belief that the citizens of late-capitalist societies need to have something to distract themselves with, in order to distract them, as a long line of neo-Marxist critique of sport has it, from any inclination to take to the streets and protest against systemic socio-economic inequalities. Jean-Marie Brohm contends that modern professional sport acts as a 'mass-political safety valve' through which the frustrations and drudgery of working life can be 'absorbed, diverted and neutralised in the sporting struggle'.[1] Guy Debord writes of sport as an 'endless series of trivial confrontations' under which hides 'a unity of misery'.[2] And Theodor Adorno argues that 'people are unwittingly trained into modes of behaviour [by sport] which . . . are required of them' by work, whether fitness, stamina, rule abidance, the completion of rote tasks or the achievement of arbitrary goals.[3] Put crudely, watching Steph Houghton or Harry Kane blast a penalty straight at the keeper

teaches us to vent our disappointments with modern existence, however misguidedly, by shouting at a screen and not at those in power.

But, is there something more existential to be construed from the fact that the 'great distraction' (as sports commentators have recently taken to calling it) has returned even as we slough through an ongoing pandemic?[4] What does it say about the human condition when we still feel the need to play games in our current state of emergency? Could we say, with 'Nothing to be done', to quote the first line of Samuel Beckett's *Waiting for Godot* (1952/1954), that, come the apocalypse, we will find ourselves turning to play, games and sport as the only things left with which to satisfactorily (or not so satisfactorily) occupy ourselves?[5]

Beckett, renowned high-art avant-gardist, was also a sports buff. As far as a biographical account goes, he played cricket, golf and rugby in his youth. Later in life, he routinely diverted himself by watching televised matches, and made sure nothing in his calendar would interrupt those hours.[6] Perhaps more peculiarly still, his interest in sport makes its way into *Waiting for Godot* and its representation of a world that appears to have suffered some form of unnamed catastrophe. Finding themselves on constant furlough, the play's motley cast of ailing and disabled characters make repeated incongruent references to games. Vladimir demands of Estragon to 'return the ball' in their verbal rallies; a stage direction orders the latter to gesture like '*a spectator encouraging a pugilist*'.[7] The cast gee themselves up for not very much at all with sporting clichés, from 'running start[s]' and 'warm . . . up[s]' to talk of being (or, more precisely, not being) 'in form'.[8]

No exploration of Beckett and sport can go without mentioning that, when asked about the 'meaning' of the play, the ever-evasive writer dropped a sporting anecdote into the equation. In 1961, Hugh Kenner reported that Beckett, when queried over the origin of Godot's curious name, referenced

> a veteran racing cyclist, bald, a 'stayer', recurrent placeman in town-to-town and national championships, Christian name elusive, surname Godeau, pronounced, of course, no differently from Godot.[9]

The absent Godot, then, might not be the 'stayer' we at first imagine. Rather than staying put where he is offstage, he could be grinding his way up a mountain pass, preferring to sweat with effort to reach the summit over fulfilling his appointments with Vladimir and Estragon.

Beckett was not the only literary writer of his time to dedicate text to cycling. Roland Barthes, writing on the Tour de France, figured the race's competitors as striving to 'conquer . . . the resistance of things'.[10]

With those words in mind, we might, then, be led to think of Beckett's *Molloy* (1951), and the logic-defying description of how its eponymous narrator precariously mounts his bicycle: 'I fastened my crutches to the cross-bar, one on either side, I propped the foot of my stiff leg ... on the projecting front axle, and I pedalled with the other.'[11] We could ask, as Ato Quayson has perceptively done, how exactly is Molloy able to push off and pedal in such a posture?[12] Not only is the bicycle resistant to Molloy's hampered efforts to mount it, its representation is also resistant to interpretation.

Sport in Beckett crops up at those junctures at which communication breaks down. Like Godot, any clarification it might give to the muddle of life remains elusive. Instead, it appears to be something to busy our bodies and minds with during periods of uncertainty. Lockdown impelled many to take to Sisyphean feats of endurance, increasingly elaborate exercise routines and punishing online fitness classes. The story of Elisha Nochomovitz stands out in particular, and the marathon he ran on his 7-metre-long balcony in Toulouse. According to my back-of-an-envelope calculation, he had to run the length 6,028 times. Asked about what motivated him, Nochomovitz stated: 'It was about launching a bit of a crazy challenge and bringing a bit of humour, to de-dramatise the confinement situation'.[13] With leisure time for many suddenly distended, yet the range of leisure activities ostensibly limited, what else is there to do than exhaust the options left to us, and ourselves in the process?

While waiting

How can we interpret Beckett's yoking of sport and the apocalypse with more assurance, then? Steven Connor, in an excellent chapter on Beckett and sport, argues that his writing presents us with not an aesthetics as such, but an 'athletics'. Vladimir, Estragon, Pozzo and Lucky are all of a sporting mindset. We can see this in how they play out a tug of war with Lucky's leash; how they exert themselves to the point of 'panting' and 'puffing like a grampus'; or urge each other or themselves to go 'on on' with words, thoughts or actions, before the inevitable slip, trip or fumbled ball.[14] To keep on trying with steely-eyed determination in the face of disability and adversity is redolently Beckettian. For Connor, forms of exercise give us tangible, achievable goals often so lacking in our everyday lives. They rush us full of endorphins and help reduce anxiety. In Connor's words, 'distraction' for Beckett equates to 'relief': 'Play seems to offer the calm or consolation – factitious but locally effective – of pattern given to

a disorderly and chaotic world'. Play is never just a pastime but an act of 'world-making' which can displace our current situation, and its ills, at least momentarily, and give some serious intent to our lives when so much of it appears meandering drift.[15]

In light of our recent experience of lockdown, I want to build on Connor's theories by exploring games in Beckett through what the former states they are not: namely pastimes. 'What do we do now . . . while waiting' is a question which occupies Vladimir and Estragon.[16] To play at something, anything that passes the time, is held as a boon. In the second act, Vladimir suggest to Estragon that they try and fit his boots on:

> VLADIMIR: It'd pass the time. [ESTRAGON *hesitates*.] I assure you, it'd be an occupation.
> ESTRAGON: A relaxation.
> VLADIMIR: A recreation.
> ESTRAGON: A relaxation.[17]

While seemingly pointless, the prospect of something with which to pass the time spurs Estragon and Vladimir into reverie. They strike up an ABCB patina of repartee ('occupation', 'relaxation', 'recreation', 'relaxation'), one that has come to pattern much of the hapless pair's dialogue throughout the play. Vladimir proffers variants to Estragon's stolid repetitions; out of the void of unstructured time in which they exist their words construct a temporary semblance of order. But Estragon's dull-witted inability to play along with the verbal association Vladimir initiates makes bathetic disappointment the punchline. Sporting games are only fleetingly satisfactory in Beckett – they descend all too quickly into farce, slapstick and pratfall. Mention of a physical exercise's 'movements' spurs related words to sprawl out unceremoniously. '[E]levations', 'relaxations' and 'elongations' might be component parts of Vladimir and Estragon's fitness regimen, but it is difficult to conceive of the characters performing such with any degree of finesse.[18] We are led to believe so by what we are presented with on stage: the pair hop about and tumble, pick themselves up and brush themselves down, and hope that no one sniggers. Of course, we, the audience, may be inclined to guffaw at the burlesque. However, the play's cast notably do not do so. They prefer to make half-hearted excuses before distracting themselves (and us) with more of the same.

Despite the failure of the games they play to live up to expectations, the cast go about them anyway. We begin to wonder if Vladimir and Estragon, Pozzo and Lucky were any more adept before whatever catastrophe has befallen the world around them. Or were they always as

bad at games as now? On the one hand, they might be attempting to claw back a semblance of normality. They play to resuscitate a time now past with their pastimes, and clutch at those activities that used to inflect life with joy in order to make it bearable in the present. On the other, the problem may be with roping the body and the mind into doing activities which never really had the desired effect to begin with. Notwithstanding the impediments of an apocalypse, games and sports are predicated on the possibility of failure, on leaving their players unsatisfied, feeling inept, starkly aware of their own corporeal limitations.

A search for relief

What Beckett plays up in *Waiting for Godot* is the absurdity of modern forms of exercise in societies where labour is ever more sedentary, where athletic instinct is sublimated to the pitter-patter of fingers on keyboards and the back-breaking task of sitting stationary at a desk. These facets of modern existence have been exacerbated by lockdown. We have been confined to rooms and, if of an athletic disposition, suffered, as Beckett writes elsewhere, 'an agony of calisthenics, surrounded by the doomed furniture'.[19] Pozzo and Lucky's punitive relationship demonstrates Beckett's sadomasochistic take on the lengths we go to when we exert ourselves. Pozzo has the air of a demented fitness instructor, one who leads Lucky through what we might now call high intensity interval training. We see this in the skit where Pozzo calls Lucky to bring him his coat, whip, stool and basket. Lucky puts down the bag he resolutely carries to traverse the stage, give Pozzo an item, then return to his place to pick up the bag again before Pozzo calls for something else.[20]

Why does Lucky go through with this punishing routine? At a point in his monologue Lucky's jabber revolves around sport:

> man . . . is seen to waste and pine waste and pine and concurrently simultaneously what is more for reasons unknown in spite of the strides of physical culture the practice of sports such as tennis football running cycling swimming flying floating riding gliding conating camogie skating tennis of all kinds dying flying sports of all sorts autumn summer winter winter tennis of all kinds hockey of all sorts penicillin and succedanea in a word I resume and concurrently simultaneously for reasons unknown to shrink and dwindle in spite of the tennis . . .[21]

Pertinent questions on modern existence are entangled in this concatenative list of sports (and some things, as Connor insightfully explores, that it would be a stretch to call sports, namely 'dying', 'flying' and, strangest of all, 'floating').[22]

However, what I want to conclude on is the desperation with which Lucky pleads at how we seem to 'waste and pine' despite 'the strides of physical culture'. Rather than enabling us, or satisfying us, sports make palpable that our bodies and minds are on a downward curve. With the onset of time, we gradually 'waste' while we 'pine' after some fleeting ideal of corporeal wellbeing. Under such conditions, our efforts to keep fit or get fitter can seem deluded. Beckett's use of 'strides' here contains a mocking pun that seeks to disturb any illusions we might have that the passing of our lives always charts an upward trajectory. 'Strides' connotes both the advancement of culture over time, and the physical movements of exercise that the play has a habit of sending up.

In this context, the words 'penicillin' and 'succedanea' jump out as perhaps not such non-sequiturs as they may at first appear. Penicillin we administer to combat potentially deadly and painful bacterial infection. It is, like modern sport, an invention to stave off our own mortality. 'Succedanea' is a somewhat more curious choice. As the *OED* codifies, the now archaic word denotes medicines, frequently of inferior efficacy, that have been substituted for another. More tellingly still, the word also merits an entry on its habitual misuse: many have been misguided in thinking it to mean its opposite, to mean remedy and cure.[23] These words, tucked away in the malcoordinated verbal acrobatics of Lucky's monologue, may make us ponder how the act of living is so often an error-strewn search for some form of relief. The pastimes, sports and games we occupy ourselves with have a tendency to take on the alternately nightmarish or risible air of things which never quite do what we want them to. When the apocalypse comes, it seems, we will be left to inspect the absurdity of those activities that keep us going. And we might, like Vladimir and Estragon, just have to brush any tinges of embarrassment off and keep on at them, even when they do not quite do it for us like they once used to, if they ever really did to begin with.

Notes

1. Brohm, *Sport, a Prison*, 180.
2. Debord, *Society of the Spectacle*, [no page number] aphorisms 62, 63. Italics in the original.
3. Adorno, *The Culture Industry*, 195.
4. See, in particular, Ronay, 'Sport's role as the great distraction'.
5. Beckett, *Waiting for Godot*, 11.
6. See Knowlson, *Damned to Fame*, 61–3, 512, 520, 701.
7. Beckett, *Waiting for Godot*, 14, 18. Italics in the original.
8. Beckett, *Waiting for Godot*, 46, 71.
9. Kenner, *Samuel Beckett*, 123–4.
10. Barthes, *What is Sport,* 37.
11. Beckett, *Molloy*, 17.
12. Quayson, *Aesthetic Nervousness*, 83.
13. Quoted in Associated Press, 'Man runs marathon'.
14. Beckett, *Waiting for Godot*, 27, 30, 43.
15. Connor, *Beckett, Modernism*, 24.
16. Beckett, *Waiting for Godot*, 18.
17. Beckett, *Waiting for Godot*, 64.
18. Beckett, *Waiting for Godot*, 71.
19. Beckett, *Disjecta*, 83.
20. Beckett, *Waiting for Godot*, 24–5.
21. Beckett, *Waiting for Godot*, 42–3.
22. Connor, *Beckett, Modernism*, 17–18.
23. 'succedaneum, n.' Entries 2 and 3. *OED Online*.

Bibliography

Adorno, Theodor. *The Culture Industry*, edited by Jay M. Bernstein and translated by Wes Blomster and others. Abingdon and New York: Routledge, 2007.

Associated Press, 'Man runs marathon on 7-metre balcony during French lockdown', *Guardian*, 21 March 2020. Accessed 17 October 2020. https://www.theguardian.com/world/2020/mar/21/man-runs-marathon-on-7-metre-balcony-during-french-lockdown.

Barthes, Roland. *What is Sport?* Translated by Richard Howard. New Haven, CT and London: Yale University Press, 2007.

Beckett, Samuel. *Disjecta: Miscellaneous writings and a dramatic fragment*, edited by Ruby Cohn. London: John Calder, 2001.

Beckett, Samuel. *Molloy*, translated by Samuel Beckett and Patrick Bowles. In *The Beckett Trilogy: Molloy, Malone Dies, The Unnamable,* 7–162. London: Picador, 1976.

Beckett, Samuel. *Waiting for Godot*. In *The Complete Dramatic Works,* 7–88. London: Faber and Faber, 2006.

Brohm, Jean-Marie. *Sport, a Prison of Measured Time: Essays*, translated by Ian Fraser. London: Inks Links, 1978.

Connor, Steven. *Beckett, Modernism and the Material Imagination*. New York: Cambridge University Press, 2014.

Debord, Guy. *Society of the Spectacle*, translated by Fredy Perlman and John Supak. Detroit, MI: Black & Red, 2016.

Kenner, Hugh. *Samuel Beckett: A critical study*. London: John Calder, 1962.

Knowlson, James. *Damned to Fame: The life of Samuel Beckett*. London: Bloomsbury, 1997.

Lanchester, John. 'Diary: Getting into esports', *London Review of Books* 42, no. 16, 13 August 2020. Accessed 17 October 2020. https://www.lrb.co.uk/the-paper/v42/n16/john-lanchester/diary.

Quayson, Ato. *Aesthetic Nervousness: Disability and the crisis of representation*. New York: Columbia University Press, 2007.

Ronay, Barney. 'Sport's role as the great distraction reluctantly cancelled but it will be back', *Guardian*, 13 March 2020. Accessed 17 October 2020. https://www.theguardian.com/sport/2020/mar/13/sport-great-distraction-reluctantly-cancelled-coronavirus.

'succedaneum, n.' *OED Online*, Oxford: Oxford University Press, September 2020. Accessed 17 October 2020. https://www.oed.com/view/Entry/193288.

16
Screening dislocated despair: projecting the neoliberal left-behinds in *100 Flowers Hidden Deep*

Nashuyuan Serenity Wang

The twenty-first century marks a new chapter in China's advancement into a neoliberalised, modernised era, especially under the state's population relocation schemes and urbanisation programmes for economic uplifting. However, the gap between displaced, marginal communities and urban-centric cultural dominance has become significantly wider. This chapter considers what it is to feel not simply displaced, but dislocated, radically severed from and painfully out of joint with time and space. In my usage, dislocation indicates the state that results when people, spaces and social spheres are excluded from China's recent decades of hyper-development – a consumer-driven narrative and practice espoused by the government with its new social class system geared towards the market economy. Dislocation moves with centrifugal force away from urban-centric spaces and shows inhabitants being pushed to the peripheries of more privileged, cosmopolitan lifestyles and social spheres. Its effects deserve greater attention as they reflect the alternative reality of the country's profound transformation.

During the initial outbreak of Covid-19, I stayed at home back in China, experiencing the lockdown and the feeling of being dislocated from the rest of the world. Being confined to my home gave rise to feelings of isolation and displacement and led me to watch films expressive of dislocation in contemporary Chinese cinema. This chapter explores Chen Kaige's *100*

Flowers Hidden Deep (*bai hua shen chu* 百花深处, 2002), a film that captures the rapidity with which China has changed in recent decades, and discusses how the process of dislocation is physically, culturally and spiritually depicted in cinema. It traces how the film, especially in its cinematography and acoustics, makes sensory appeals to its viewers by simultaneously engendering senses of attachment, disengagement and alienation. This paper also adopts a mode of analysis that problematises the concept of home when a sense of belonging is lost, removed, destroyed or abandoned.

Displacement is to blame for a host of sociological, political, economic, environmental and cultural problems afflicting contemporary China. It has influenced and is still affecting how and where a huge number of people choose to settle, their socio-cultural identity and mental wellbeing, causing both direct and indirect dislocation.[1] The former implies the idea of restricted access to and the disappearance and erosion of any sense of belonging people may have to spaces and resources. It is associated with immediate shifts in geographical and physical status in the short term.[2] The latter comprises economic, socio-cultural and mental aspects. It demonstrates a long-term separation and disempowerment process that engages multiple aspects of societies and nations.[3]

In my view, dislocation describes an inhabitant's loss of a physical sense of belonging to a location; it also spiritually represents their faith in an identity that rejects the colonising impulses of modernisation, whereby global market forces uproot and disintegrate local identities and customs once deeply entwined with particular spaces. Thus, any analysis of dislocated spaces is inevitably multifaceted. It has to acknowledge a person's attachment to, identification with and participation in a sense of home or its loss. At the same time, it must recognise the dysfunctionality of many of the spaces late-capitalist modernisation has generated, such as solitary high-rises in the suburbs and deserted provincial villages. In conjoining an understanding of home as both a physical location and spiritual settlement, the sites of dislocation function as sacred grounds, modulating people's ownership of a specific identity and of attachments to places away from invasive urban penetration.

Yellow earth and dislocation

Chen's films are renowned for their distinct brand of sensorial realism. They are bold visual and acoustic evocations of the China of the past century that critically examine the predicaments of modernity, trace

cultural traditions that have evaporated in recent decades and prompt rational reflections on the causes of such. A trademark technique of Chen's interweaves the contemporary with the past within his films' narratives, sometimes even within single frames. This spatial luxation is not merely nostalgic: it carries a dialectic critique that challenges any fixed perspective on what is represented through the lens of his camera. By superimposing the past on the present and vice versa, Chen's films dislocate us as viewers from any comfortable notion of familiarity with what we are seeing: we are to exist in a state of experiential flux, unable to ground ourselves in any singular time or place.

Many of Chen's films address what he dubs the 'yellow earth' (*huang tu di* 黄土), the boundless incomplete sites of ruins, demolished buildings and abandoned residential areas that are left behind by development-induced displacement, that surrounds Beijing. In his debut film of that name (*Yellow Earth*, 1984), Chen depicts this inhospitable, windswept rural landscape of desolation and the mass of displaced individuals who have settled there. It is a boundless but claustrophobic space, teeming with people paradoxically made vivid by their very listlessness. To watch the film is to feel uncomfortably proximate to and oppressed by the profound struggle of life in the pre-Mao era.

In *Yellow Earth*, land, soil and the tangible earth are prominent visual metaphors. A sacred site for devoted worship and the seedbed of a restorative life philosophy, the land should prove fertile ground for those who settle on it across generations. Yet Chen's film repudiates any naïve inclination to read his characters' relationship to where they have settled as symbiotic. Instead, he confronts us with decline, conflict and upheaval. *Yellow Earth* represents a primitive village as a site of gender struggle and oppressive desire, one thrown into further turmoil by the 'disruptive' arrival of the pseudo-enlightenment brought by the Chinese Communist Party's Liberation Army. Chen interweaves these disparate strands with 'the nation's history . . . that of the peasants . . . of China's spiritual culture over thousands of years' in a disturbingly unsentimental manner.[4] With its depiction of the failure of the Liberation Army to bring salvation to the area in the 1930s, *Yellow Earth* evokes the ageless tragic fate of the rural mass.[5] The sense that this land remains unamenable to the forces of modernisation has persisted from the communist era through to the present. Where contemporary Beijing is representative of neoliberalised China, the yellow soil of the lands that encircle it – as well as their cultural and spiritual significance – has proved stubbornly resistant to the state's advancement.

Born in the years of the Great Leap around the 1950s, Chen experienced the most turbulent periods of twentieth-century Chinese history. His education was obstructed by the disastrous Cultural Revolution; his talent and passion for filmmaking were stymied by the Down to the Countryside Movement of the early 1960s and late 1970s and its relocation of urban youth to rural areas, as well as by his army service. Yet, out of these unpromising circumstances he developed a deep attachment to and affiliation with the land, one that remains palpable throughout his filmography.

Chen's films 'express [his] pain and question a culture which had seemingly destroyed tradition' via his attentive focus on rural subjects, their traditions, superstitions, modes of organising and struggles in *Yellow Earth*; his study of children's education in *King of the Children* (*haizi wang*; 孩子王, 1987); his reflections on the allegorical mourning of a spiritual world that now seems remote in *Life on a String* (*bian zou bian chang*; 边走边唱, 1991); his nostalgic historical reenactments of social, filial and personal dysfunctionality in *Farewell My Concubine* (*bawang bie ji*; 霸王别姬, 1993) and *Temptress Moon* (*feng yue*; 风月, 1996); and his epic-historical reflection on contemporary Chinese society in *The Emperor and the Assassin* (*jingke ci qinwang*; 荆轲刺秦王, 1999).[6] However, circumstances have changed since the 2000s. Most Fifth-Generation directors like Chen began to join the state-endorsed 'migrations' to TV production and to 'take advantage of the vogue of materialism and consumerism in Chinese society to promote a "cinema of attractions"' for reaching out to international audiences and ingratiating mass entertainment due to the shrinking domestic film market.[7]

Produced during this state-backed cultural shift, *100 Flowers Hidden Deep* (hereafter *100 Flowers*) is a seven-minute film, Chen's last. It not only marks a stylistic shift but also evokes Chen's own sense of powerlessness as an ageing director confronted by what appears a forceful and unpreventable change in the Chinese cinematic landscape. The title refers directly to the two political movements identified in China with the Hundred Flowers motif: the initial opening up of political and intellectual debate in 1956, followed by the swift crackdown on dissidents by Mao Zedong during the Hundred Flowers Campaign (1957–9); and then again a similar opening up and subsequent crackdown on cultural and intellectual ideas in the late 1980s which fed into the political protests of 1989.[8]

Set in rapidly developing turn-of-the-millennium Beijing, Mr Feng (literally Mr Madman), played by Feng Yuanzheng, is a denizen of old Beijing who is seemingly suffering from some form of dementia. Wearing

a yellow baseball cap sporting the word 安全 (*anquan*, 'safety') on its brim, this security officer is guarding against loss: the loss of the memory of old Beijing, and the concomitant sense of security that living in a society firmly rooted in its traditions and history brings with it. He asks a removal team to help him to move out of an old alleyway poignantly called 100 Flowers Hidden Deep. But as the film progresses, we discover that his home and the whole neighbourhood have recently been demolished. Chen deploys a set of visual binaries between the real and the imagined: the modernised cityscape and the demolished old Beijing, 'sane' modern Beijingers and the old-fashioned lunatic (who, in this instance, is anything but elderly).

Feng's deep attachment to the rubble of the cityscape has the effect of creating profound nostalgia. Feng summons up an imagined community from the ruins of his past life, one reconstructed from memories which seem to spring from the gnarled roots of an old tree, still standing, but now only the symbolic centre of where his home used to be. The 1990s was the decade when Beijing urbanisation was 'optimizing and enhancing' so that only 'two percent of Beijing people are the city's old citizens'.[9] Modern architecture, which allowed for ever more densely populated urban and commercial centres, invaded the old Beijingers' compounds. In 2000, the government sponsored the building of high-rise residential estates worth 23 billion yuan in Beijing alone.[10] The pressures of the market economy and globalisation have forced Beijing city planners to divide and reconstruct its urban spaces, inevitably leading to the disappearance of others. Chen Kaige's film is a lament for the deracinated communities of Beijing who have suffered semi-enforced removal to solitary high-rises in the suburbs. As one of the film's workmen observes, it is 'the old Beijingers [who] are the ones who get lost'.

The film opens with Feng's own perspective on the changes that have taken place. We drive through cosmopolitan Beijing's cityscape as he names historic and much-loved locations like the Bell Tower. As the van penetrates the core of old Beijing, we enter the ruins of this once culturally prosperous centre of imperial power, around which local people have lived for eight centuries. These are the old *hutong*, the narrow alleyways of traditional Chinese residential areas characteristic of Beijing. The broken-down walls graffitied with 拆 (*chai*, 'for demolition') are visually broken up by shots taken from the van as it negotiates the ditches of building sites, a sharp contrast to the smoothness and fluidity of Beijing's Third Ring Road. The demolition sites are dwarfed by high-rise commercial districts that seem to enclose and swallow them, a visual

binary that emphasises the precarity of Feng's ill-fitting home, which has been erased from the surface of the city and living memory. Where Feng's home used to be is now an empty void.

As the group pulls up there, a set of high-angle shots diminishes the plot and Feng, yet reveals the animated workers around his invisible house. Against the bleakness of the muddy space, the detail with which Feng pictures all the beloved items of his old home is rich and beautiful: the dual-entrance courtyard, the layout of its rooms, an antique lamp, the rosewood wardrobe, and a hand-painted vase we see smash in a single shot from what we assume to be Feng's perspective. Feng retraces how he would move about his now vanished house so naturally that we, as the audience, might begin to question whether its absence is not in fact our minds playing tricks on us. Are we cast by Chen alongside the other inattentive spectators he includes in the scene – the construction workers too intent on erecting the monoliths of neoliberalism – to perceive what should be there? Perhaps less speculatively, what Chen presents to us is a vision of a man driven mad by the dislocation he has suffered, capable now of performing only a hollow simulacrum of a past obliterated by the fast pace of modernity. Despite how depressing our awareness of this may be, Feng remains enthralled by his illusion. His deep, sentimental affection for a place now gone still lingers around the tree, tangibly there where all else has been reduced to rubble.

The removal team participates in some physical theatre in acting out an imaginary mapping of the lost home. They do so as if it were a sacred space or ritual setting. The discovery of an old bell which used to hang on Feng's gate actualises the imaginary space. Its chiming signals the beginning and end of the workers' pantomime of moving Feng out. But it also recalls the imperial past, a distant cousin to the nearby Bell Tower, itself a constant reminder of ancient Beijing. Similarly, Feng's 'orchid hand' gesture when he picks up the bell is a classical move of the Peking Opera, a form of entertainment that was initially the preserve of the imperial family. Feng's prosaic cataloguing of the urban past and present, his geo-mapping of his memories and the way his madness embodies the lost imperial power of Beijing, make him both local historian and spiritual geographer of the city.

The film's colour palette also stresses the sense of dislocation. Feng's outfit – a bleached red shirt, flamboyant red sweatpants and a khaki jacket – merge him with China's yellow earth. The warm rustic colours set Feng in juxtaposition to the cold hue of the modern cityscape. During the credits, we see a colourful three-dimensional animation of the original *hutong* that matches Feng's fantasies of his old home. Beijing's intimate

past momentarily sparkles then is extinguished, leaving us to regret the vicissitudes of life that have resulted in the demise of a place and time now lost to history. The complete composition of the quaint 四合院 (*siheyuan*, a traditional courtyard compound) are frozen in time and can only exist in a state of aethereal suspension in such spaces of dislocation, either above the levelled, now-empty ground or in the memories of Feng, who will remain eternally unawakened from his nostalgia.

Dislocation and the pandemic

Dislocation in *100 Flowers* is communicated through both physical and sensory techniques that unsettle any easy distinction between what is real and what is virtual. In the film's focus on a decentred, vanishing space, reality and illusion are united simultaneously, plotting an escape from urban-centric modernity that entails, for Feng, and perhaps us too, a form of self-exile. Throughout this chapter, I have attempted to convey dislocation as being both an active, conscious choice and an involuntary status. Those people and places that have been dislocated disturb the organisation of the urban-normative core of contemporary China.

Re-watching Chen's films during the national lockdown brought to the fore these themes. On the one hand, lockdown has pushed most Chinese citizens into states of quasi-self-exile, dislocated as we have become from the routines, places and spaces we once thought of as giving contour and shape to our lives. The instruction to voluntarily self-quarantine has instigated an ambiguous and estranging outlook on a modern China now caught in stasis. Never have the four walls of my room provided more shelter; never have they felt more suffocating. We peer through windows, portals, screens, and are haunted by images of a past we once took for granted, one that we are unsure whether we will be able to, should or will want to restore once the most stringent restrictions have been lifted. Films like *100 Flowers* should make us re-evaluate where we go from here. Chen asks us if the impetus to modernise China in the name of neoliberalism that undergirded pre-pandemic life does not in fact dislocate us from a cultural heritage in need of more preservation. Or, are we all now, like Feng, locked into a future that will continue to displace us?

Notes

1. Approximately fifteen million people per year worldwide are forced from their homes to make way for infrastructure construction. See Cernea, 'Reforming the foundations'.
2. For further discussion, see Gellert, 'Mega-projects as displacements'; Cernea, 'Development-induced and conflict-induced IDPs'; Drydyk, 'The centrality of empowerment'; and Oliver-Smith, *Defying Displacement*.
3. See Gellert, 'Mega-projects as displacements'; Kibreab, 'Displacement, host governments' policies'; and OECD, 'Addressing forced displacement'.
4. Zhen, 'After *Yellow Earth*', 32.
5. See Silbergeld, *China into Film*, 15–52.
6. Cornelius and Smith, *New Chinese Cinema*, 3.
7. Zhang, *The Cinema of Feng Xiaogang*, 105.
8. See Solomon, *Mao's Revolution*, 268–71; Goldman, *China's Intellectuals*. 214–31; Han and Hua, *Cries for Democracy*, 3–66.
9. Fang and Yu, *China's New Urbanization*, 288; Broudehoux, *The Making and Selling*, 2.
10. See Yu, 'Redefining the axis of Beijing'.

Filmography

Kaige, Chen (dir.). *100 Flowers Hidden Deep* (*bai hua shen chu*; 百花深处). Shenzhen: Shengkai Film Production, 2002.

Kaige, Chen (dir.). *The Emperor and the Assassin* (*jingke ci qinwang*; 荆轲刺秦王). New York: Sony Pictures Classics, California: Columbia TriStar Home Video, 1999.

Kaige, Chen (dir.). *Farewell My Concubine* (*bawang bie ji*; 霸王别姬). Los Angeles, CA: Miramax Films, 1993.

Kaige, Chen (dir.). *King of the Children* (*haizi wang*; 孩子王). Xi'an: Xi'an Film Studio, 1987.

Kaige, Chen (dir.). *Life on a String* (*bian zou bian chang*; 边走边唱). New York: Kino International, 1991.

Kaige, Chen (dir.). *Temptress Moon* (*feng yue*; 风月). Hong Kong: Tomson Films Co., Ltd., Los Angeles, CA: Miramax Films, 1996.

Kaige, Chen (dir.). *Yellow Earth* (*huang tu di*; 黄土地). Guangxi: Guangxi Film Studio, 1984.

Bibliography

Broudehoux, Anne-Marie. *The Making and Selling of Post-Mao Beijing*. London: Routledge, 2004.

Cernea, Michael M. 'Development-induced and conflict-induced IDPs: Bridging the research divide', *Forced Migration Review* (2006): 25–7. Accessed 10 September 2021. https://www.fmreview.org/brookings/cernea.

Cernea, Michael M. 'Reforming the foundations of involuntary resettlement: Introduction'. In *Can Compensation Prevent Impoverishment? Reforming resettlement through investment and benefit-sharing*, edited by Michael M. Cernea and Hari Mohan Mathur, 1–11. Oxford: Oxford University Press, 2008.

Clark, Paul. 'Two hundred flowers on China's screens'. In *Perspectives on Chinese Cinema*, edited by Chris Berry, 40–61. London: BFI Publishing, 1991.

Cornelius, Sheila and Ian Haydn Smith. *New Chinese Cinema: Challenging representations*. New York: Columbia University Press, 2019.

Drydyk, Jay. 'The centrality of empowerment in development-induced displacement and resettlement: An ethical perspective'. In *Development-Induced Displacement and Resettlement: New perspectives on persisting problems*, edited by Irge Satiroglu and Narae Choi, 97–110. London: Routledge, 2007.

Fang, Chuanglin and Danlin Yu. *China's New Urbanization: Developmental paths, blueprints and patterns*. Basingstoke: Springer, 2016.

Gellert, Paul K. and Barbara D. Lynch. 'Mega-projects as displacements', *International Social Science Journal* 55 (2003): 15–25. https://doi.org/10.1111/1468-2451.5501002.

Goldman, Merle. *China's Intellectuals: Advise and dissent*. Cambridge, MA: Harvard University Press, 1981.

Han, Minzhu and Sheng Hua. *Cries for Democracy: Writings and speeches from the 1989 Chinese democracy movement*. Princeton, NJ: Princeton University Press, 1990.

Kibreab, Gaim. 'Displacement, host governments' policies, and constraints on the construction of sustainable livelihoods', *International Social Science Journal* 55 (2003): 57–67. https://doi.org/10.1111/1468-2451.5501006.

MacFarquhar, Roderick. *The Hundred Flowers*. Paris: The Congress for Cultural Freedom, 1960.

OECD (Organisation for Economic Co-operation and Development). 'Addressing forced displacement through development planning and co-operation: Guidance for donor policy makers and practitioners', *OECD Development Policy Tools* (2017). https://doi.org/10.1787/9789264285590-en.

Oliver-Smith, Anthony. *Defying Displacement: Grassroots resistance and the critique of development*. Austin, TX: University of Texas Press, 2010.

Silbergeld, Jerome. *China into Film: Frames of reference in contemporary Chinese cinema*. London: Reaktion Books, 1999.

Solomon, Richard H. *Mao's Revolution and the Chinese Political Culture*. Oakland, CA: University of California Press, 1971.

Yu, Shuishan. 'Redefining the axis of Beijing: Revolution and nostalgia in the planning of the PRC capital', *Journal of Urban History* 34, no. 4 (2008): 571–608. https://doi.org/10.1177//0096144207313880.

Zhang, Rui. *The Cinema of Feng Xiaogang: Commercialization and censorship in Chinese cinema after 1989*. Hong Kong: Hong Kong University Press, 2008.

Zhen, Ni. 'After *Yellow Earth*', translated by Binbin Fu. In *Film in Contemporary China: Critical debates, 1979–1989*, edited by George Stephen Semsel, Xia Hong and Chen Xihe, 31–8. Santa Barbara, CA: ABC-CLIO, 1993.

17
A digital film for digital times: some lockdown thoughts on *Gravity*
Stephen M. Hart

For Enrique Colina (1944–2020), in memoriam

Has Lockdown 2020 produced new understandings of art? This question was answered for me as a result of re-watching one of my favourite films, *Gravity* (2013; dir. Alfonso Cuarón), during the first lockdown. For example, watching the scene in which Dr Ryan Stone (Sandra Bullock) is hit by a lethal cloud of debris hurtling through space and starts spinning out of control, murmuring: 'I can't breathe, I can't breathe . . .', I suddenly no longer saw this event as one of those inevitable dangers of space travel. Now I saw it as an allegory of dyspnea, or shortness of breath, which is one of the 'hallmark symptoms of Covid-19'.[1] When I listened to Stone and Matt Kowalski (George Clooney) talking about their personal lives during a space walk around the Hubble Space Telescope, as set against a country music soundtrack, I could not help interpreting this scene as a poignant depiction of the distance between our Covid-19 existence and our pre-Covid-19 lives: if only we could go back to how it was before – we would even put up with country music![2]

 I now see the cloud of debris – described by the film's director, Alfonso Cuarón himself, as simply the 'adversity' we all face as human beings – as a metaphor for the virus that came from nowhere and created unimaginable waves of destruction, and I see the (literally) faceless dead

astronaut as epitomising the nameless victims of the disease.[3] When I see Kowalski unhook himself from Stone in order to save her, I see the friends I have lost as a result of coronavirus, particularly the Cuban documentary film-maker Enrique Colina (1944–2020), with whom I worked at EICTV for 10 years. Now, when I hear the conversation between Stone in the Shenzhou spacecraft and Aningaaq, the Inuk fisherman who intercepted her mayday message, I still see the event in terms of black humour, as I did when the film was first released in 2013, but I also re-read it as epitomising the isolation from others experienced during lockdown.[4] When I see Kowalski clambering into the Shenzhou spacecraft (after he has apparently died), and telling Stone she has to carry on, whereas I used to see an example of magical realism, I now cannot help but see an example of the visceral and strangely real dreams that all of us have been having during this pandemic.[5] When Stone steers the Soyuz spacecraft into the Earth's atmosphere, I no longer see this scene as an allegory of new life (the meteorites accompanying the ship as it crashed into the Earth's atmosphere looked suspiciously like spermatozoa searching for the egg) – I now see antibodies destroying the coronavirus. And when Stone finally emerges from the capsule and swims to dry land, I still interpret it as an allegory of the birth of human life, but it now has a new meaning for me – it is what it will be like when we all return to normal and get our feet back on the ground.

Why should a film released in 2013 speak to me about Lockdown 2020? Am I over-reading Cuarón's film, seeing things that are not there? I would not be the first, of course, to see a film as eerily prescient of the current pandemic. As James Bailey puts it, '"Funny how *Contagion* predicted how the world would react to a deadly virus" is, at the moment, not an uncommon online refrain'.[6] After all, *Gravity* would be a good candidate for this type of reading since it has, as one critic has argued, a 'haiku-like storyline', which is highly susceptible to allegorisation.[7]

In this essay, I want to use *Gravity* as a launching-pad for a palimpsestuous reading of Alfonso Cuarón's film that argues that one of the inner layers of the film – stripped back as a result of our experience of the brutality of the coronavirus – somehow speaks to us directly of the experience of lockdown. I will be using the notion of the palimpsest not only according to its dictionary meaning, as a 'writing-material, manuscript, the original writing on which has been effaced to make room for a second', but also per the definition provided by Sarah Dillon: 'a surface phenomenon where, in an illusion of layered depth, otherwise unrelated texts are involved and entangled, intricately interwoven, interrupting and inhabiting each other'.[8] These deeper layers within the text are interpreted according

to Patrick Chamoiseau's notion of the 'memory-trace' (*trace-mémoire*), which functions like 'a kaleidoscopic canvas of space-time superimposition', except that I will be proposing that we can see them also as 'omen-traces' in that they are osmotic with the future.[9]

Emotion, mesmerisation and the brain

To make sure I am not hallucinating new meanings in the text, let us compare my reading with some objective data, that is, the 354 reviews of Cuarón's film on the *Rotten Tomatoes* portal. A common thread that runs through these reviews is that the film is highly realistic. Here's a sample:

> *Gravity* really is the closest 99.99% of us will ever get to being in space, and it was beautiful (Aaron Peterson, *The Hollywood Outsider*, 12 October 2018).

> May be the densest visual experience ever made. The disorientation is physical, visceral – the audience I was with limped out of the cinema grasping at chair arms for balance (Stephen Marche, *Esquire Magazine*, 17 October 2018).

> *Gravity* doesn't so much immerse you in its cinematic experience as it simply takes you there and sets you down among the stars (Richard Propes, *The Independent Critic*, 9 September 2020).[10]

These reviews gesture to those body genre and haptic film theorists who focus on emotion as the crux of any given film.[11] But is it true that the film works exclusively through the emotions, and particularly the emotion of thereness?

In 2015, I attempted to find out how the visceral experience of the filmic medium occurs in the brain by teaming up with Dr Jeremy Skipper, a neuroscientist at University College London, using myself as the guinea pig for the experiment. We had one main lead to guide us – Uri Hasson, a neuroscientist at Harvard University, who had used fMRI data to 'prove' that Alfred Hitchcock's films, as a result of orchestrating the responses of different brain regions, have a 'mesmerizing power' that allows them to 'take control of viewers' minds', in contrast to 'oversimplified or overstated films' that lose 'the grip over the audience'.[12] Jeremy and I wanted to conduct an experiment in which a viewer (myself) would undergo an fMRI scan when watching *Gravity*, in order to find out precisely how and

when the various networks of the brain were stimulated. Unlike Hasson's project, however, our project would be able to identify more precisely the networks stimulated by film while watching a film from beginning to end. Standard pre-processing routines on the data established by the Human Connectome Project (HCP) were to be used.[13] The data would be decomposed into thousands of brain networks using a multivariate temporal blind signal source separation approach, and correlating the data with Neurosynth's publicly available database of more than 3,000 term-based whole brain meta-analyses from over 11,000 studies.[14] We focused on six domains of the brain for investigation: (i) language, (ii) motion, (iii) memory, (iv) spatial cognition, (v) action and (vi) emotion. Before the fMRI scan I predicted how important I thought these domains would be in my reaction to the film, ranking emotion as very high importance, language as high importance, both spatial cognition and action as medium importance, and both motion and memory as very low importance.

The fMRI scan went ahead on 30 October 2015 and the fMRI data was processed and then compared with data gathered from a viewing of Alejandro González Iñárritu's feature film *Birdman* (2015), as well as data produced from a viewing of a TV gameshow, *Are You Smarter Than a Fifth Grader?* The results were as shown in Table 1.

	Gravity	*Birdman*	*Gameshow*
Language	−1.0	−1.5	−1.25
Motion	+0.5	+1.5	+1.2
Memory	+0.2	+0.1	+0.5
Spatial cognition	+1.4	+0.5	−0.1
Action	+0.2	+0.2	+0.75
Emotion	−0.25	−1.25	−1.0

Table 17.1 Brain domain response to three titles viewed during fMRI scanning. Values are relative and not absolute, and they indicate brain activity as plotted for each film in each of the six domains over the whole length of the sample viewed. 0.0 is used as a mean or 'normal' level of activity, and +1.4 indicates very high, above-average activity, and −1.25 indicates a low, below-average activity.

It is important to note that the values shown in Table 1 are not absolute but relative. Expressed visually as a graph, the difference between levels of response in networks associated with language and emotion on the one hand and spatial cognition and motion on the other is stark (see Figure 17.1):

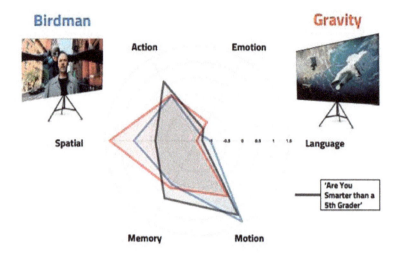

Figure 17.1 Comparison of brainprints of *Birdman*, *Gravity* and *Are You Smarter than a Fifth Grader?* Jeremy Skipper and Stephen Hart, 2017.

The experiment found that the most stimulated regions of the brain were, in descending order, as follows:
1. Spatial cognition
2. Motion
3. Memory
4. Action
5. Emotion
6. Language

The fact that roughly the same order of importance is evident when the relative values of stimulation were calculated for *Birdman* (i.e. spatial cognition and motion high; emotion and language low) suggests that we need to treat with care the research of those body and genre theorists who see emotion as the crux of the filmic medium around which all else converges. The neuroscientific data points to spatial cognition and motion networks, rather than emotion, as the two main conduits through which the sound and image of film have an impact on the mind. This does not mean, of course, that emotivity is not important within a film, just that the main conduits through which film works its magic in the mind are located in the domains of spatial cognition and motion, which, when stimulated effectively, can have that mesmerising power that Hasson identified in successful films, and – we infer – therefore lead to a heightened emotional impact in the viewer's mind.

Digitality as vehicle and message

If, indeed, the vehicles for the success of a given film are spatial cognition and motion, it is interesting to note that the cause of that success in the case of *Gravity* must be traced back to its cinematography. As Cuarón noted, 'you realise all that technology is just a tool for the cinematic expression you want to convey. We explored every single available technology and saw it would not apply, but then you think: "OK, if I combine this with this."' Sandra Bullock, in the same interview, credited the success of the film to the teamwork of cinematographer Emmanuel Lubezki and effects supervisor Tim Webber.[15] A shot-by-shot analysis reveals that, as a result of this digital expertise, the pattern and scale of shots used in *Gravity* produced something unique. In contrast to the medium and close-up shots that are favoured by analogue film, *Gravity* has 18 close-ups, 39 medium close-ups, 37 medium shots, 16 medium long shots, 24 long shots, and 58 very long shots.[16] The first shot of the film, for example, a very long shot lasting 13 minutes and 39 seconds, was beyond the scope of any analogue editor.[17] In its exploration of digitality, *Gravity* moved the centre of gravity from the close-up to the long shot. *Gravity* is not only a digital film, it is a movie that flaunts its own digitality. Some viewers clearly noticed this. As critic Chris Stuckmann noted: 'The CGI is flawless, and the beautiful shot construction is staggering'.[18]

In the final section of this essay, I want to edge towards proposing that digitality in *Gravity* is not just the vehicle of the film's message but part of the message itself. Something of this can be seen if we go back to the representation of the film's eight key events, building the layers that I identified at the beginning of this essay as containing an omen-trace of the future. These are as follows:

1. Stone is hit by a lethal cloud of space debris and murmurs: 'I can't breathe, I can't breathe . . .'
2. Stone and Kowalski chat during a space walk around the Hubble space telescope
3. Stone finds a faceless dead astronaut
4. Kowalski unhooks himself from Stone in order to save her
5. Stone talks to Aningaaq, the Inuk fisherman who has intercepted her mayday message
6. Kowalski clambers into the Shenzhou spacecraft to tell Stone she mustn't give up
7. Stone steers the Soyuz spacecraft into the Earth's atmosphere
8. Stone emerges from the capsule, swims to dry land and stands up.

I note that six of these eight events owe their articulation specifically to digital wizardry (1, 2, 3, 4, 6, and 7), in the sense that they would not have been visually adequate had visual effects not been used, and only two (5 and 8) need no virtuoso digital effects to achieve an adequate and meaningful impact on the viewer. This suggests that the level at which the omen-trace in *Gravity* that speaks to our Covid-19 experience is articulated coincides precisely with the location where its digitality is operationalised. My contention is that Cuarón, rather like Hitchcock many years before, knew precisely what he was doing. The Mexican director's implementation of digitality is shot through with an intense viscerality and emotiveness. Very telling, in my view, is the review by Camilla Long of *The Sunday Times*: 'What makes this by far the best film of the year is not the haiku-like storyline or Stone's heart-stopping scramble . . . but the tears. *Gravity* is one of the most outrageously emotionally manipulative films I have ever seen'.[19]

It is clear that the viscerality of the cinematic experience present in *Gravity*, grudgingly admired by Camilla Long – as focussed on breathlessness, nostalgia for the normal, trauma caused by the onslaught of unprecedented events, the loss of loved ones, isolation, vivid dreams, survivalism and rebirth – owes its power of expression to the virtuoso digitality of the film engineered by Lubezki and Webber. It was this digitality that, as many of the above-quoted reviews suggest, led to the film's extraordinary verisimilitude.[20] As a result of this we can conclude that the level of *Gravity* which contains the memory-trace or, as I have called it, the omen-trace, is found not only in the thematic landscape of the film, which blended with a number of the hallmark experiences of Covid-19, but in the actual medium it was itself using. This should not, perhaps surprise us, since digitality has become an inherently intrinsic part of our post-Covid existence. As one commentator noted during the first lockdown:

> While a significant part of world's population is in lockdown amidst COVID-19 pandemic, the people at home are using connectivity to do more, and to do new things. Earlier people were spending some time on Netflix, YouTube, Amazon Prime & online streaming platforms, but now they are binge-watching, i.e. consuming a lot more content. People are also using the same connectivity to do new things, which they had not imagined before lockdown. For example, online learning classes, virtual fitness sessions, e-business, working from home, and video calls with families and friends. Which means it is not just about staying safely indoors – but also about staying

connected. Reliable and seamless connectivity is turning out to be a necessity, like water and food.[21]

Ironically the palimpsestuous level of *Gravity* containing the seed that would flower in 2020 was encapsulated within its digital turn. Digitality was just waiting to be unlocked from *Gravity*, and Covid-19 was the virus that let the genie out of the bottle.

Notes

1. Fraley, 'What to know'.
2. Editorial, 'Europeans crave normality'.
3. Rose, 'Sandra Bullock: The pain of *Gravity*'.
4. See 'The impact of lockdown'.
5. Katella, 'COVID-19 dreams?'.
6. Bailey, 'The ending'.
7. See Page 3 reviews; https://www.rottentomatoes.com/m/gravity_2013/reviews (consulted on 12/11/2020).
8. *Concise Oxford English Dictionary*, 857; Dillon, 'Palimpsesting', 29.
9. Roca Lizarazu, 'The family tree', 184.
10. Page 1 reviews; https://www.rottentomatoes.com/m/gravity_2013/reviews (consulted on 12/11/2020).
11. See, for example, Williams, 'Film bodies', 2–13; Marks, *The Skin of Film*; and Barker, *The Tactile Eye*.
12. Hasson et al., 'Neurocinematics', 17.
13. See Van Essen et al. 'The WU-Minn human connectome project'.
14. Bordier et al., 'Temporal and spatial independent component analysis'.
15. Rose, 'Sandra Bullock: the pain of *Gravity*'.
16. Hart and Williams, 'Latin American cinema's trojan horse', 427–9.
17. Hart and Williams, 'Latin American cinema's trojan horse', 427.
18. Page 3 reviews; https://www.rottentomatoes.com/m/gravity_2013/reviews (consulted on 12/11/2020).
19. Page 3 reviews; https://www.rottentomatoes.com/m/gravity_2013/reviews (consulted on 12/11/2020).
20. Hart and Williams, 'Latin American cinema's trojan horse', esp. 417–19. The sequence of shots in *Gravity* is listed at pp. 427–9.
21. Nainwal, 'Post COVID-19 era'.

Bibliography

Bailey, Jason. 'The ending of Steven Soderbergh's *Contagion*, revisited', *Vulture*. Accessed 30 January 2020. https://www.vulture.com/2020/01/contagion-movie-ending-coronavirus-and-pandemic-panic.html.

Barker, Jennifer M. *The Tactile Eye: Touch and cinematic experience*. Berkeley, CA: University of California Press, 2009.

Bordier, Cécile, Michel Dojat and Pierre Lafaye de Micheaux. 'Temporal and spatial independent component analysis for fMRI data sets', *Journal of Statistical Software* 44 (2011): 1–24.

Dillon, Sarah. 'Palimpsesting: Reading and writing lives in H. D.'s "Murex: War and Postwar London (circa AD 1916–1926)"', *Critical Survey* 19, no. 1 (2007): 29–39.

Editorial. 'Europeans crave normality but remain patient', *DW* (2020). Accessed 14 November 2020. https://www.dw.com/en/coronavirus-europeans-crave-normality-but-remain-patient/a-53002476.

Fraley, Leilani. 'What to know about COVID-19 and shortness of breath', *Healthline*. Accessed 1 November 2021. https://www.healthline.com/health/coronavirus-shortness-of-breath.

Hart, Stephen M., and Owen Williams. 'Latin American cinema's trojan horse', in *A Companion to Latin American Cinema*, edited by Maria M. Delgado, Stephen M. Hart and Randal Johnson, 408–29. Malden, MA: Wiley-Blackwell, 2017.

Hasson, Uri, Ohad Landesman, Barbara Knappmeyer, Ignacio Vallines, Nava Rubin and David J. Heeger (eds). 'Neurocinematics: The neuroscience of film', *Neurocinematics* 2, no. 1 (2008): 1–26.

Katella, Kathy. 'COVID-19 dreams? Here's what they mean', *Yale Medicine*. Accessed 11 November 2021. https://www.yalemedicine.org/stories/covid-dreams/.

Marks, Laura U. *The Skin of Film: Intercultural cinema, embodiment and the senses*. Durham, NC: Duke University Press, 2000.

Nainwal, Ashish. 'Post COVID-19 era: "digitalized service delivery" a new normal', *Nokia*, 8 May 2020. Accessed 1 November 2021. https://www.nokia.com/blog/post-covid-19-era-digitalized-service-delivery-new-normal/.

Queens' Centre, Queen's University Belfast. 'The impact of lockdown on isolation and loneliness', 22 May 2020. Accessed 14 November 2020. https://www.qub.ac.uk/coronavirus/analysis-commentary/lockdown-isolation-loneliness/.

Roca Lizarazu, Maria. 'The family tree, the web, and the palimpsest: figures of postmemory in Katja Petrowskaja's *Vielleicht Esther* (2014)', *Modern Language Review* 113, no. 1 (2018): 168–89.

Rose, Steve. 'Sandra Bullock: The pain of *Gravity*', *The Guardian*, 18 September 2016. Accessed 14 November 2020. https://www.theguardian.com/film/2014/feb/06/sandra-bullock-pain-gravity-oscars-george-clooney-2014

The Concise Oxford English Dictionary, edited by H. W. Fowler and F. G. Fowler, 4th edn. Oxford: Oxford University Press, 1951.

Van Essen, David C., Stephen M. Smith, Deanna M. Barch, Timothy E. Behrens, Essa Yacoub and Kamil Ugurbil, 'The WU-Minn Human Connectome Project: An overview', *Neuroimage* 80 (2013): 62–79.

Williams, Linda. 'Film bodies: Gender, genre, and excess', *Film Quarterly* 44, no. 4 (1991): 2–13.

18
The Great Plague: London's dreaded visitation, 1665

Justin Hardy

The history of London is one of repetitive and periodic lockdowns, not least during the persistent and endemic bubonic plagues that struck the city between the Middle Ages and the eighteenth century, when an epidemic broke out every 20 years or so. The worst epidemic since the Black Death infamously brought 'London's Dreaded Visitation in the year of our Lord 1665',[1] killing an estimated one-third of the city's population, taking 100,000 souls to their maker. As an historian-filmmaker, I directed a feature-length drama-documentary on *The Great Plague* for Channel 4's season 'A Century of Troubles', which transmitted in 2001, an experience that remained seared on my memory as Covid-19 approached these shores in 2020. The parallels of tardy government response, public hysteria and lockdown memory are so many that they do not require underlining, and so I shall merely tell the tale of a year of another of London's lockdowns through the prism of this single televisual narrative from the past.

We, the production team, had no way of dramatising the infection rates and mortality of so many within a televisual budget, hence we searched for a single primary source that would act as a microcosm for the greater metropolitan experience. This we found in a PhD publication, *London's Dreaded Visitation*, written by a promising young Restoration historian, Justin Champion.[2] He had discovered in the financial records of the parish of St Dunstan in the West – little more than a mile east of UCL's

Bloomsbury campus – a decipherable narrative of one Cock and Key Alley, off Fleet Street, which housed 30 inhabitants, who lived on what he defined in the documentary as 'the margins of society, the scum, but not the base froth as contemporaries would have called them, just clinging to the urban economy'.[3]

Champion identifies a whole society in this alley, and we find our cast for a new sub-genre of primary-sourced dramatised documentaries: William Gurney, who ran the pub and sold vegetables on the side; John Gale the blacksmith, who also ran 'an engine for the quenching of fire'; Thomas Birdwhistle, a scavenger who cleared filth from the streets; Widow Andrews, who lived with a parish orphan named Lawrence Dunstan; and William Penny, the grave-maker, with his wife and three sons, one of whom – Joseph – was paid by the parish to be his apprentice. The man who wrote the accounts book was Henry Dorsett, churchwarden, 'who although recently on poor relief himself, was now raising taxes and donations, and was unwittingly writing the account on which our film was based', our narrator Brenda Blethyn tells us. Champion recognises the hero in the bureaucrat: 'To many he was a boring clerk, recording in meticulous detail, but the incremental bits of data is what life is made of – the padlock to hold a quarantined door fast'.

Bills of mortality were posted every week in each parish and were the first anyone knew of the plague's encroachment. Wherever it came from geographically, it came from Providence, or at least from the East, in 'a most subtle, peculiar, insinuating, venomous, deleterious, exhalation arising from the maturation of the ferment of the faeces of the earth', cites the contemporary physician Nathanael Hodges, played in the film by the then little-known actor Stephen Mangan. The real Hodges wrote a first-hand account of the Great Plague regarded as the best medical record of the epidemic.[4]

The first cases came in the spring, in Covent Garden, half a mile from Cock and Key Alley, so 'the Privy Council did what it always did – locked up the healthy with the sick and marked the door with a red cross', continues Champion. Henry Dorsett knew what it meant – for the accounts book indicated that he had been a recipient of money for his own infection in 1646, almost twenty years earlier. 'Given to Henry Dorsett, for that purpose, 10 shillings', confirms the primary source, with the implication that local communities registered who had survived a prior outbreak, like some kind of health pass.

In early May there were ten cases, and the government responded without hesitation: 'it's not a medical problem, it's a problem of order, controlling the areas of sociability, the playhouses, the pubs – to make

sure the healthy and unhealthy didn't mingle'. The dogs and cats were killed 'with the vapours of disease clinging to their mangy coats', adds Dr Carole Rawcliffe, Emeritus Professor of History at the University of East Anglia (UEA), specialising in medieval diseases including plague and leprosy. The animal killers were paid tuppence a corpse, and killed an estimated forty thousand dogs and eighty thousand cats. Hindsight remains a wonderful thing, knowing as we do now that the rats at the foot of the food-chain presumably multiplied unchecked.

The Book of Plague Orders came out in May: 'a kneejerk response, quarantine, 40 days, issue some food supplies, constables to watch every house'. On 21 May, St Dunstan in the West saw its first casualty, Elizabeth Cherrington, 12 years old. The rich fled, the middling sort too, as doctors and the clergy went with their clients, all avoiding not so much the disease but the poor, 'the carriers of disease and sin'. To break out through the city gates one needed a certificate of health, determined by a degree of literacy, and possibly the possession of a second home. Only one couple were able to leave Cock and Key Alley, John and Elizabeth Davis, but where they went is not recorded.

The Lord Mayor of London, Sir John Lawrence, installed himself in a glass box from which he received petitions. 'The government abdicated responsibility', confirms Champion, somewhat prophetically; 'I dread to think what would happen if a quarter of Londoners of the 21st century were to go down with a mysterious disease in the space of three months'. Money was not handled directly and letters were aired over boiling vinegar, as families policed themselves for tell-tale signs: swellings in the armpits, neck or groin. This did not identify the pneumonic plague variant that was vastly more lethal, made memorable in the 'ring-a-ring of roses' children's lament. The truth is, we still don't know exactly what causes the disease. The film attempts some scientific explanation from an expert at the Ministry of Defence laboratory at Porton Down: in bubonic plague, fleas are the carriers; they feed on rodents, the bloodmeal in their stomachs becomes clogged, and when the flea bites a human it regurgitates the meal into the human victim.

Back in the Alley, on 15 June, Widow Andrews displayed symptoms. She was locked into her small dwelling with the orphan Lawrence beside her: 'Fee to John Gale, the smith. For hasps, hooks and a padlock, and for fitting them on. Three shillings and tuppence.' John Dudley held the key to the padlock. 'It was a society dominated by surveillance. Everybody is watching somebody else.' The Plague Orders produced the previous month allowed for victuals to be brought by a nurse, in the alley's case one Sarah Fletcher, and they paid for searchers to confirm the presence of

plague in the event of death. On 15 July the searchers found the widow dead, with the boy still alive. He was again locked in, and died the next day, presumably alone.

The widow's possessions were sold by brokers and the profits went to the parish to pay for her care, such as it was. 'Disbursed for the widow by Mr Drinkwater, apothecary: quart of sack – one and sixpence, sorrel – tuppence, for bread and ale – sixpence, for the searchers two shillings, for the bearer to drink one shilling, for a coffin one shilling, for the gravemaker one shilling.' Prices rose as expected. Thomas Decker, in 1603, noted that a sheaf of rosemary cost one shilling, which then became six shillings for a pinch. Tobacco was rumoured to have prophylactic powers, and boys at Eton were flogged for refusing to smoke.

By late June, six had died in the alley. William Penny was locked up with his family, while special dispensation was made for his eldest, Joseph, who was required to continue gravedigging duties. In early July the two younger boys succumbed; John was 12, Edward was 8. It was three months later that the Lords, safe in Oxford, debated the plague. They made two proposals: that no member of the Lords should be shut up in their house and no plague hospital should be built 'near to persons of note and quality'. A contemporary noted 'this shutting up would breed a plague if there were none, infection may have killed its thousands, but shutting up have killed its ten thousands'. What was most impressive, according to Champion, was the stoic response of those within the lockeddown city: 'They had amazing self-control, there was an extraordinary dignity in these communities, one can imagine today, this town would be a ruin, there would be riots, but in early modern London, these were selfdisciplined individuals who struggled to make a life.'

Meanwhile, the rumour was that foreign countries were dealing better with the outbreak. Genoa, Florence and Paris were much better equipped with their 'peste houses' (specially built hospitals). Perhaps the Roman Catholic church had better organisation, and funds, for dealing with the sick. But then again, protestant Amsterdam was also better equipped than London, where only five houses were built: all outside the city walls, one in Marylebone village, one in Golden Square. The total number of patients that could be admitted did not rise above 500, adds Stephen Porter, author of *The Great Plague*.[5]

Help was offered by nurses who went to people's homes, for which they received very little thanks, and certainly no collective clapping. They were widely blamed for spreading the disease. Vanessa Harding,[6] who also provides key primary source research into the intricate detail of London's parishes, tells us that there are many contemporary accounts of

nurses being seen as parasites: 'These wretches would strangle their patients and discharge the disease'. But Harding confirms that these accounts were written by men of the middling class, who often attributed to women their own fear. There was concern that the nurses were stealing from their vulnerable patients, displaying 'rooking avarice, being as they were dirty, ugly, unwholesome hags'. This was not a judgement supported by the parish records of St Dunstan. In the alley, Sarah Fletcher was honest enough to declare substantial amounts of money cleared out of a plague victim's house, enough for a month's wages: '27th July, received of nurse Fletcher – £1 and 8 shillings which was left in Goodman Short's trunk in Cock and Key Alley.'

By August, there were 7,000 dead in a week. In St Dunstan, the lists of the dead show legions of names marked with a P in the margin. Harding relates that 'other diseases are running at the same time – many deaths are attributed to diseases quite similar to plague, such as spotted fever'. It was thought that the weekly death toll might be even higher – after all, the numbers were collected by the church, and did not account for Jews, Quakers or other denominations. As well as nurses, there were numbers of plague doctors who roamed the streets, wearing waxed leather coats and leather masks with bird-like beaks containing pomanders of herbs through which to breathe. William Boghurst, a physician who wrote down his reminiscences, talked of prescriptions that included applying a hollowed-out, scalding hot, onion onto a tumour, or a decapitated mastiff dog to a breast.[7] There were rumours that syphilis offered immunity. The consistent thread is that it took one poison to drive out another. Remember President Trump recommending the imbibing of bleach?

By September, Cock and Key Alley had buried 16 of its 30 inhabitants, of whom 7 were children. It was said that across the city, the bells were 'hoarse with tolling'. The ordinary routines of life can be seen to have collapsed. Deaths were recorded sometimes without names, anathema to a society that treated the passing of every soul with utmost respect. In the next-door parish to St Dunstan there is a record: 'paid to the coroner, and expended when he set about the child thrown over the wall into ye churchyard.' Harding explains that this report indicates that an anonymous death was still considered an outrage, even in such straitened times. She found that the child's death prompted an inquiry into how a Christian could be so abandoned. There, sadly, the trail of this abandoned child goes cold. Harding points to the Great Fire of the next year, in which so many records were lost.

Later in September, there was hope for a cure of sorts, in the form of fumigation. It was a mix of vaccination and test and trace. A presumed

'expert' in fumigation, James Angier, was allowed by the Privy Council to experiment with setting fires in the streets, to burn out the pestilence. He began in High Holborn, showering saltpetre, brimstone and amber onto piles of coal placed at a distance of every six houses. It was a monumental undertaking, and it was certainly enormously expensive. The Cock and Key records showed expenditure of £17 for the coal for this corner of a parish alone.[8] The fires burned for three days, until rain fell, and the next night 4,000 died across the capital, including William Penny, who was buried by his son, Joseph. The young apprentice dug seven plague pits, and charged extra for the planks to cover them.

By the winter, the Bills of Mortality showed the numbers of deaths had dropped. John Davis and his wife returned to the alley and can be seen to have been paid to tend to the sick. But then a second wave hit, and there were more deaths in December. In February, the King returned and white crosses were painted over the red. The Editor of the *Intelligencer*, the only London newspaper of the time, reported: 'I do not find this visitation to have taken away in or about the city any person of prime authority and command.'

In Cock and Key Alley, 12 out of 20 houses were afflicted, and 11 of those were shut up. Over half the inhabitants died, a total of 36 men, women and children. Joseph Penny had died in the autumn and his mother Elizabeth, the only surviving member of the Penny family, received from the parish: 'for three shovels and a basket – sold by Henry Dorsett – 4 shillings and 4 pence.'

Three shovels and a basket. The sum total of a life so easily ignored by the editor of the local newspaper. The estimated death toll in London from the Great Plague was 100,000. As of August 2021, the London death total from Covid-19 has been 15,000, and the UK death toll has been 131,000. Coincidentally, Professor Justin Champion died during the pandemic, but not of Covid-19. He passed away, tragically, of complications from a brain tumour, aged 59.

Notes

1. Unless otherwise stated, all quotations are from primary sourced research into the film *The Great Plague* (Channel 4, 2000). The film was produced by Juniper TV and won the first Royal Television Society Award for Best History Film, 2001.
2. Champion, *London's Dreaded Visitation*.
3. Champion, *London's Dreaded Visitation*.
4. Hodges, in Boghurst, *Loimologia*.
5. Porter, *The Great Plague*.
6. Harding, *The Dead and the Living in Paris and London*.
7. Boghurst, *Loimographia*.
8. £17 in 1665 is equivalent to around £3,500 in 2021; see Nye, 'Pounds sterling to dollars'.

Filmography

Hardy, Justin, dir. *The Great Plague*. Juniper Productions for Channel 4, 2000.

Bibliography

Boghurst, William. *Loimographia: An account of the great plague of London in the year 1665, now first printed from the British Museum Sloan MS. 349*. Edited by Joseph Frank Payne. London: Epidemiological Society of London, 1814. Accessed 1 November 2021. https://wellcomecollection.org/works/e4vdp24g/items?canvas=5 .

Champion, Justin. *London's Dreaded Visitation: The social geography of the great plague of London, 1665*. Historical Geography Research Series, University of Edinburgh, 1995.

Hodges, Nathanael, in Boghurst, William. *Loimographia: An account of the great plague of London in the year 1665, now first printed from the British Museum Sloan MS. 349*. Edited by Joseph Frank Payne. London: Epidemiological Society of London, 1814. Accessed 1 November 2021. https://wellcomecollection.org/works/e4vdp24g/items?canvas=5 .

Harding, Vanessa. *The Dead and the Living in Paris and London,* 1500–1670. Cambridge: Cambridge University Press, 2002.

Nye, Eric. 'Pounds sterling to dollars: Historical conversion of currency'. Accessed 1 November 2021. https://www.uwyo.edu/numimage/currency.htm

Porter, Stephen. *The Great Plague*. Stroud: Alan Sutton Publishing, 1999.

19
Lessons for lockdown from Thomas Mann's *The Magic Mountain*

Jennifer Rushworth

Let me be clear from the outset: I am neither a Thomas Mann specialist nor even a Germanist. The reading of Mann's 1924 novel *Der Zauberberg* that I will offer in these pages is based on an encounter with Mann in English, and more specifically Mann in the English translation of John E. Woods (first published in 1996). In the edition I have of that translation, *The Magic Mountain* runs to 853 pages, which gives you an idea of the satisfying weight of the tome in one's hands – but also the daunting prospect of finding time to read it. An ideal lockdown project, then, for people (like myself, at that time) with certain privileges of time, health and quiet.

In lockdown, I turned to Mann for a number of different reasons. Firstly, as intimated, I found myself with an increased amount of time without socialising, commuting or travelling. Secondly, Mann was an obvious choice given my own love of long early twentieth-century novels, in particular Marcel Proust's *In Search of Lost Time*. Thirdly, I was inspired to read Mann by critics, colleagues, friends and family. One of my sisters said that reading this book changed her life; a friend and fellow Proustian, Igor Reyner, spoke in similarly warm terms of the transformative power of the novel. Reading Mann was, as a consequence, a way of feeling close to distant friends and family during lockdown. As Kate Briggs writes, 'Reading the same books as someone else is a way of being together.'[1]

On a similar note, the precise catalyst for my reading was the SELCS (School of European Languages, Culture and Society) Book Club at UCL, which ran from 1 May to 3 July 2020 and was led and conceived by Emily Baker, a colleague in Comparative Literature and Latin American Studies. This lockdown book club was a wonderful collaboration of staff and students and was held online weekly for up to two hours on a Friday afternoon. The student blog posts recording our book choices and discussions can be accessed online.[2] Nominating *The Magic Mountain* as my chosen book for the session on 22 May was a good way to ensure that I read it from cover to cover in a timely manner, although other participants were permitted to read only the first one hundred pages (in other words, the first three chapters of the book), should they prefer.

Finally, my interest in Mann had been piqued by my reading of the twentieth-century French theorist Roland Barthes. Barthes is famous for his essay on 'The death of the author' (1967) and within histories of modern literary theory is often described as progressing from structuralism to post-structuralism. For my part, however, I tend rather to follow the simpler definition of Barthes as – in the words of Neil Badmington – 'first and foremost a *reader*'.[3] In my academic research, I have enjoyed reading authors such as Dante and Proust with Barthes.[4] Reading Mann with Barthes was a logical next step, but also one which involved – for me – quite a different mode of reading: no longer a claim of critical distance but rather an intimate, personal form of reading as identification.

The term *identification* is used by Barthes in a lecture on Proust and Dante from autumn 1978. In this lecture, Barthes begins by defending himself against accusations of pretentiousness for announcing his intention to speak about Proust and himself. He explains that:

> by setting Proust and myself on one and the same line, I am not in the least comparing myself to this great writer but, quite differently, *identifying myself with him*: an association of practice, not of value. Let me explain: in figurative language, in the novel, for instance, it seems to me that one more or less identifies oneself with one of the characters represented; this projection, I believe, is the very wellspring of literature.[5]

Barthes will go on to explain that he identifies with Proust's narrator in that they are both motivated by the desire to write a novel. In the case of *The Magic Mountain*, however, the grounds of identification are less

bound up with writing and meta-literary concerns and more to do with health and environment.

In short, *The Magic Mountain* recounts the story of the protagonist Hans Castorp's seven-year stay in an alpine sanatorium, initially to visit his cousin but eventually as a patient in his own right diagnosed with tuberculosis. Barthes himself spent time – 'more than four years (1942–46), apart from a few short periods of leave' – in various sanatoria as a result of suffering from tuberculosis, and it was here that he read Mann, as well as other authors (in particular, the nineteenth-century French historian Jules Michelet).[6] Though it is not literally a sanatorium, I felt that our lockdown experience was similar to – and might even be identified with – the time spent in sanatoria by Mann's fictional characters and by Barthes in real life. In this contribution I reflect on *The Magic Mountain* through a mode of reading as identification, encouraged by Barthes's example, and with a focus on a few lessons we might take from Mann's novel in light of the Covid-19 pandemic.

Health: no one is 'perfectly healthy'

When Hans Castorp arrives at the International Sanatorium Berghof in the first few pages of *The Magic Mountain*, it is to visit his cousin Joachim Ziemssen (a patient there) for three weeks in the summer, as a sort of holiday before joining the shipbuilding firm Tunder and Wilms 'as an unsalaried engineer-in-training'.[7] In other words, Hans considers himself to be very much an outsider and a temporary visitor. One of the doctors, however, when he meets Hans asks '"You have come as a patient, have you not – if you'll pardon the question?"' (18).

> In answering, [Hans Castorp] said something about three weeks, mentioned his exams, and added that, thank God, he was perfectly healthy.
>
> 'You don't say!' Dr. Krokowski replied, thrusting his head forward at a derisive slant and smiling more broadly. 'In that case you are a phenomenon of greatest medical interest. You see, I've never met a perfectly healthy person before.' (19)

Of course, Dr Krokowski's intuition will prove correct, as Hans's visit gradually extends from three weeks to seven years and is brought to an end not by a return to health but rather by the outbreak of the First World

War, which prompts the patients at the International Sanatorium to return to their national homes.

During his long visit, Hans often finds himself caught amid the heated debates among two friends that he makes while at the sanatorium: on the one hand, Lodovico Settembrini, the Italian freemason who is writing a volume on literature for an encyclopaedia entitled *The Sociology of Suffering*; on the other hand, the Jew-turned-Jesuit Leo Naphta. Having learnt early on from Dr Krokowski to discard the idea of perfect health, one of the debates observed by Hans between Settembrini and Naphta concerns the nature of illness. First, he hears the view of Settembrini:

> illness meant an overemphasis on the physical, sent a person back to his own body, cast him back totally upon it, as it were, detracted from the worthiness and dignity of man to the point of annihilation by reducing man to mere body. Illness, therefore, was inhuman.
>
> Illness was supremely human, Naphta immediately rebutted, because to be human was to be ill. Indeed, man was ill by nature, his illness was what made him human . . . In a word, the more ill a man was the more highly human he was, and the genius of illness was more human than that of health. (550–1)

Whether we agree with Settembrini or Naphta, or indeed with neither, will depend on our own experiences and philosophical position. On the one hand, Naphta's glorification and generalisation of illness is certainly off-putting and unhelpful in practical terms, since it suggests that if illness is universal and natural then it ought to be accepted rather than remedied. On the other hand, Settembrini's identification of illness as inhuman is also potentially a regrettable way to other those who are ill, and his underlying view of human existence is impractically dematerialised and disembodied. It is pleasing, then, that Hans himself manages to stay aloof from both sides, suggesting an alternative middle ground to the stark opposition between two characters whose intellectual sparring will end in a literal duel.

What is certain is that *The Magic Mountain* encourages us, with Hans, to acknowledge our own physical vulnerability. It also offers us, early on, this chilling account of the cough of one of the other sanatorium guests, an Austrian aristocrat:

> It was a cough, apparently – a man's cough, but a cough unlike any that Hans Castorp had ever heard; indeed, compared to it, all other coughs with which he was familiar had been splendid, healthy

expressions of life – a cough devoid of any zest for life or love, which didn't come in spasms, but sounded as if someone were stirring feebly in a terrible mush of decomposing organic material. (14)

This sentence moves from the literal language of straightforward medical diagnosis ('It was a cough') to a more empathetic literary register of analogy and imagination ('as if'). The sound or rhythm of coughing is perhaps mimicked in the syntax here, with its interruptions, negations and drab, exhausted conclusion. Most of all, in this contrast between different types of coughs encountered in different contexts – past and present, in the world versus in the sanatorium – we may find words for some of our own experiences during the pandemic. Like Hans, these experiences include the new ways in which we have learnt to respond with fear and aversion, but hopefully also with some compassion, to anyone who happens to cough in our hearing.

Food: one of the greatest pleasures in life

At the sanatorium, the day is structured by mealtimes, thermometer readings and the obligatory rest cures. It is at mealtimes that the community comes together, with an elaborately structured seating plan where guests meet and tables gain nicknames such as 'the Good Russian Table'. This is Hans's first experience of breakfast:

> he sat down and noted approvingly that early breakfast here was a serious meal.
>
> There were pots of marmalade and honey, bowls of oatmeal and creamed rice, plates of scrambled eggs and cold meats; they had been generous with the butter. Someone lifted the glass bell from a soft Swiss cheese and cut off a piece; what was more, a bowl of fruit, both fresh and dried, stood in the middle of the table. A dining attendant in black and white asked Hans Castorp what he wanted to drink – cocoa, coffee, or tea? (49)

A lovely sense of opulence is created here through the tripartite list of plural nouns (pots, bowls, plates), balanced pairs ('marmalade and honey', etc.), and singular treats (butter, cheese). Other meals – breakfast (distinct from 'early breakfast', described above, and including beer as a drinks option), dinner, tea, and supper – are described in similarly lavish detail.

In his lecture course *How to Live Together*, Barthes also notes the importance of food in *The Magic Mountain*, commenting in a lecture of 30 March 1977 under the point 'conviviality as encounter' that 'the meal-eaten-together is a crypto-erotic scene' and adding shortly thereafter, in relation to the association between food and life, that 'the patients in the sanatorium of *The Magic Mountain*: they're there to save their lives, because they want to be reborn outside of illness. Are served monstrously stodgy foods, are stuffed with food in the hope that it will turn them into new human beings.'[8]

That said, these elaborate meals remind us of the immense privilege of the guests at the Berghof and the way in which their particular experience of sickness relies on and is made possible by the work of others – not only doctors and nurses but also the so-called 'dining attendants' (15), cooks and other staff that ensure the smooth running of the hotel. Lockdown made our relationship to food more fraught, with middle-class stockpiling on the one hand and increased demand at food banks (including from the newly unemployed) on the other. Emerging from lockdown, we were met by two food-related government campaigns, 'Eat Out to Help Out' and the 'Better Health' campaign, which responded to increasing awareness of obesity as a risk factor in the disease. As in Barthes's reading of Mann's novel, food is contradictorily presented both as a means of new life and as a sign of suspicious excess. It is difficult not to envy Mann's characters their menus and appetites, but also difficult not to see their moneyed, luxurious status as both exceptional and problematic. We need to find, like Hans's response to the alienatingly stark debate between Naphta and Settembrini, a middle ground between these extremes.

Time: illness and lockdown change our relationship to time

'What is time?' asks the narrator at the start of the sixth chapter. The first answer given is: 'A secret – insubstantial and omnipotent.' One of the insights of *The Magic Mountain* is quite Bergsonian: the difference between 'clock time' and subjective time.[9] For Bergson, clock time is a quantitative approach to time, which considers time to be regular, identical, divisible, measurable and in this manner inherently spatial and spatialised. Subjective, lived time, in contrast, is qualitative, depending upon emotion and experience, and therefore much more elastic and

flexible, as well as continuous and indivisible. The former is an illusion; the latter is what counts.

At the start of the next chapter the narrator poses a further question about time: 'Can one narrate time – time as such, in and of itself?' (641). One reason for the length of *The Magic Mountain* is that Mann envisages a directly proportional relationship between the experience of time and its narration. The first day at the Berghof, because everything is so new, feels endless to Hans, and perhaps to the reader, since it is narrated over one hundred pages. As his stay is extended, however, the pace picks up, with years passing in very few pages. As the narrator observes relatively early in the novel:

> What people call boredom is actually an abnormal compression of time caused by monotony – uninterrupted uniformity can shrink large spaces of time until the heart falters, terrified to death. When one day is like every other, then all days are like one, and perfect homogeneity would make the longest life seem very short, as if it had flown by in a twinkling. (122)

Lockdown had a similar capacity to render days homogeneous and 'shrink large spaces of time'. For my part, I felt a paradoxical sense of absolute stasis, as if the clocks had stopped in March 2020, versus an anxious sense of lost, irrecuperable time. Time, as it is both lived and narrated, is certainly qualitative, tied to experience and emotion, but we still need regular clock time as a point of comparison against which to register the shock of our different experiences of lived time.

Tentative hope?

I have proposed that *The Magic Mountain* offers us three distinct lessons for lockdown: an acknowledgement of our own vulnerability and lack of perfect health; an appreciation of food and of communal dining in a multilingual community (though these may be desiderata rather than a reality for many during lockdown); a way to make sense of our own changing, subjective experience of time. At the same time, this analysis overlooks ways in which *The Magic Mountain* might resonate in a more traumatic way with our own situation. In addition to the terrible cough cited earlier, these include: doubts about the efficacy of medical treatment in certain cases and for certain diseases; the 'Great Stupor' and 'Great Petulance' (citing later section titles from the novel) that come from being

in one place for too long with more or less the same people; and the tragedy of losing a loved one, which in Hans's case includes eventually his cousin Joachim. As I have also suggested, readers are unlikely to share the privilege of Mann's characters, nor may they be comfortable with such privilege, given the tragic connection between sickness and economic inequality that Covid-19 has highlighted.

If Mann's novel is, from this perspective, politically out of touch, I want to end nonetheless by very briefly considering its potential exemplification of the role of literature in lockdown. To do so, I return first of all to Settembrini's work for the encyclopaedia *The Sociology of Suffering*. As Settembrini explains, '"Literature is … to have its own volume, which is to contain, as solace and advice for those who suffer, a synopsis and short analysis of all masterpieces of world literature dealing with every such conflict"' (293). While we might decry the canonical focus of Settembrini's project and question the notion of 'masterpieces', *The Magic Mountain*, too, might offer us solace and even advice, as I have suggested. Ironically, Settembrini becomes too ill to write this volume, but he does, later in the novel, offer us a glimpse of his underlying principles: '"The courage of self-recognition and expression – that is literature, that is humanity"' (696). In this regard, Settembrini's theory coincides with Barthes's argument (cited above) for identification as 'the very wellspring of literature'.

Mann's positioning of Naphta as an intellectual opponent to Settembrini warns us against taking the latter as the only viable philosophical spokesperson in the novel. Yet I admit to being tempted by Settembrini's defence of literature, both for its varied purposes and understood as a synonym for humanity. Such a conclusion may seem too optimistic, but we might at least draw support from *The Magic Mountain*'s own tentatively hopeful conclusion, which speaks so much to our current situation: 'And out of this worldwide festival of death, this ugly rutting fever that inflames the rainy evening sky all round – will love someday rise up out of this, too?' (854).

Notes

1 Briggs, *This Little Art*, 226.
2 UCL, 'SELCS summer book club'.
3 Badmington, *The Afterlives of Roland Barthes*, 110.
4 See especially Rushworth, *Discourses of Mourning*.
5 Barthes, *The Rustle of Language*, 277 (translation amended).
6 Samoyault, *Barthes*, 113.
7 Mann, *The Magic Mountain*, 41. All subsequent references are to this edition and made in text.

8 Barthes, *How to Live Together*, 109–10.
9 See, in particular, Bergson, *Time and Free Will*.

Bibliography

Badmington, Neil. *The Afterlives of Roland Barthes*. London: Bloomsbury Academic, 2016.
Barthes, Roland. *How to Live Together: Novelistic Simulations of Some Everyday Spaces: Notes for a lecture course and seminar at the Collège de France (1976–1977)*, translated by Kate Briggs, edited by Claude Coste. New York: Columbia University Press, 2013.
Barthes, Roland. *The Rustle of Language*, translated by Richard Howard. Oxford: Basil Blackwell, 1986.
Bergson, Henri. *Time and Free Will: An essay on the immediate data of consciousness*, translated by F. L. Pogson. London: Routledge, 2013.
Briggs, Kate. *This Little Art*. London: Fitzcarraldo, 2017.
Mann, Thomas. *The Magic Mountain: A Novel*, translated by John E. Woods. New York: Everyman's Library, 2005.
Rushworth, Jennifer. *Discourses of Mourning in Dante, Petrarch, and Proust*. Oxford: Oxford University Press, 2016.
Samoyault, Tiphaine. *Barthes: A Biography*, translated by Andrew Brown. Cambridge: Polity, 2017.
UCL. 'SELCS summer book club'. *UCL Blogs*. Accessed 29 April 2022. https://blogs.ucl.ac.uk/selcs-summer-book-club/.

20
The locked room: on reading crime fiction during the Covid-19 pandemic
Jakob Stougaard-Nielsen

'Our seclusion was perfect.'[1]

Lockdown reading habits turn to crime

UK readers doubled the amount of time they spent reading books during the UK government-implemented lockdown.[2] Anxious about catching the virus from other people, confined to our homes and with long lonely hours to fill, more than half of the respondents to a Nielsen Book survey reported that they had turned to books for entertainment, while more than a third noted that they used reading as an escape from the crisis.

While the benefits of recreational reading to the general adult population remain under-studied, research into pre-lockdown reading habits suggests that reading may have a positive effect on self-reported wellbeing in what already was an escalating loneliness epidemic.[3] According to The Reading Agency, readers have reported a wide range of benefits such as 'enjoyment, relaxation and escapism, increasing understanding of self and social identities, empathy, knowledge of other cultures, relatedness, community cohesion and increasing social capital'.[4] Perhaps surprisingly, while reading in modern times is mostly considered

a solitary pursuit, it appears that apart from offering escapist entertainment reading promotes social attachment and interpersonal trust – relations most people have missed during lockdown.[5]

The nation was not only reading more books during lockdown. A Nielsen Book survey also found that two-thirds of readers became more interested in crime fiction.[6] As a genre long associated with pure entertainment and escapism, it is not surprising that crime fiction should attract more lockdown recreational reading. In fact, crime fiction was also pre-lockdown one of the most widely read types of fiction.[7] While the modern form of crime fiction extends back to the nineteenth century, it has probably been the most popular fiction genre at least since the 1940s, when it first became more widely read than any other genre of fiction in the anglophone world and possibly beyond.[8]

Literary scholarship has been pondering why crime fiction has become so dominant across the world and across media. Critical works from the 1980s suggest that crime fiction, first and foremost, provides vital escape and relaxation.[9] Dennis Porter, for instance, called crime fiction a pleasure machine, which helps the reader momentarily escape from 'something frightening' and unwind from the 'unpleasurable effort of work'.[10] Crime fiction, more than any other genre it seems, has an ability to absorb its readers and provide relief from the pressures and anxieties of the everyday. According to Julian Symons, crime fiction's most notable attraction is that it offers the reader a 'reassuring world in which those who tried to disturb the established order were always discovered and punished'.[11] The traditional crime novel conjures a world of threats and fear, yet there is almost always comforting resolution in the end, as the detective gathers up clues and unmasks the guilty. Perhaps readers turned to crime fiction during lockdown not only for respite but also for the reassurance that, in the end, the murderous virus will be contained and life will return to a sense of normalcy.

Critics have judged the crime novel a potent treatment of the crises, terrors and dislocations of modernity more broadly, yet one whose form – like those of all popular genres – must not be blindly trusted. W. H. Auden, for instance, famously claimed that the reassurances of repetitive crime narratives made the genre addictive, like tobacco or alcohol.[12] While literary criticism historically has had an uneasy relationship with popular literary genres, more recently critics have become attuned to the diverse portrayals and critical investigations of societies, borders, law, identities, bodies, technologies and the environment in crime fiction. Indeed, as Mary Evans has recently argued, 'reading fiction about crime is the most vivid account that we have of western societies' various fears

and preoccupations'.[13] Rather than an addictive prophylactic against common tedium, the genre is today considered for the social knowledge it imparts and its ability to 'hook' its readers (to borrow a term recently reinvigorated by Rita Felski) with thrilling and puzzling plots.[14] So, as we have turned to crime fiction during lockdown, does the genre merely distract us from the current crisis or does it perhaps impart useful social knowledge about life in lockdown, and maybe even reading itself?

The locked-room mystery from Poe to Christie

In fact, lockdown itself is a familiar detective fiction trope, as Agatha Christie biographer Laura Thompson reminds us.[15] The figure is central to the frequently revisited subgenres of the locked-room mystery and the related country-house mystery, in which 'various ingenious methods of committing murder in a hermetically sealed environment formed the core'.[16] It appeared first in its generic form in what is generally taken to be the very origin of modern crime fiction in the West, Edgar Allan Poe's 'The Murders in the Rue Morgue'. Reading Poe's detective story during lockdown is an encounter with 'something excessively *outræ*', as first appreciated by the readers of *Graham's Magazine* in 1841. Yet, Poe's 'original' detective story also imparts something strangely familiar to the solitary reader during lockdown as we seek safety in our homes and distraction from our anxieties, distrust state authorities and scavenge piecemeal knowledge about an invisible virus raging brutally and indiscriminately through communities and across borders.

In Poe's story, the master detective Monsieur C. Auguste Dupin forensically examines a Parisian locked-room mystery, where a savage slaughter of mother and daughter, Madame and Mademoiselle L'Espanaye, has taken place. With no apparent motive and no obvious access to the crime scene, the police (and the reader) are left confounded by the circumstances of the crime: the doors to the crime scene are locked from within and the windows nailed shut with no indication as to how an intruder could have entered or left.

To solve the locked-room mystery, Poe has given us a detective whose personal condition resembles a self-imposed lockdown. The narrator, who shares rooms with Dupin in a dilapidated old mansion, prefaces the narrative of detection with a lengthy profile of the detective. Apart from giving us examples of his astonishing deductive skills, he tells us that they did not allow any visitors to their rooms, they had cut off all contact with past acquaintances and ventured outside only at night: their

'seclusion was perfect' and is spent reading and conversing. 'We existed', the narrator explains, 'within ourselves alone'.[17]

Poe's story does, in the end, provide the reader with some reassurance that what at first appeared *outræ*, irrational and exotic has a logical (albeit profoundly strange) explanation. However, it takes a similarly strange detective, one whose isolation and estrangement from others and state authorities is central to solving the mystery – and it takes someone who reads – to see past the common assumption that we should expect a murder to have occurred at the hands of a human perpetrator. As it turns out, no actual murder has been committed as Dupin unveils the killer to be an 'Ourang-Outang of the East Indian Islands'.[18]

A seminal lockdown narrative, Poe's 'The Murders in the Rue Morgue' attaches secluded reading to the ability to solve crime puzzles; yet, it also suggests that 'perfect seclusion' is not as impenetrable to viral infection as it seems. The borders between mindless animal and unsociable reason are not as stable as we might assume: they are both uncannily capable of breaking into and out of locked rooms, infecting the reader with uncertainty in the process.

In the British Golden Age crime mystery, the locked-room trope re-emerged, according to John Scaggs, as 'immensely reassuring for the inter-war reading public' as it reduced an opaque, uncertain world 'to self-contained, enclosed, manageable proportions and dimensions'.[19] Readers will be familiar with the trope from Christie's most successful novels, *Murder on the Orient Express* (1934) and *And Then There Were None* (1939), whose success made Christie one of the world's bestselling and most translated authors of all time.[20]

In fact, there is no more appropriate figure for the attraction of the modern crime novel than *Murder on the Orient Express*. In this lockdown-on-wheels mystery, a murder conspiracy of revenge implicating almost all the passengers unravels as the train is marooned in snow drifts. Certainly, the suspense leading up to the murder in the secluded and confined space of the train and the following puzzle of a 'whodunit' mystery are great 'hooks' that keep the reader turning the pages, absorbed and entertained; however, Christie's mystery may also perform a less obvious function for the modern reader.

The German critic Walter Benjamin wrote the short essay 'Detective Novels, on Tour' (1930)[21] a few years before Christie's novel was published. He asks why people have a preference for reading crime novels during train travel and suggests that the genre offers an 'anaesthetising of one fear by the other', in the way the 'freshly separated pages of the detective novel' helps the traveller distract from and overcome

momentarily the 'anxieties of the journey' itself. To Benjamin the crime novel represented a controlled laboratory environment within which readers could anaesthetise themselves against larger-scale anxieties arising from the pressures, timetables, alienation and loss of direction in an age of modern capitalism.

We may find that the continuing fascination with Christie's *Orient Express* relies on its similar ability to substitute an exotic and inscrutable age of mobility, information, murky morals and unsolvable crimes with one in which plausibility, clarity and personal agency is possible. To decipher this world, a world in which nothing (and nobody) is as it seems, the reader is empowered by the master detective Hercule Poirot to follow clues and eventually unmask the conspirators. In the process, the reader becomes a new conspirator in the absence of state authority as she forms an attachment with the detective (and other imagined readers), trusts his solution to the locked-room puzzle and, like him, is led to sympathise with the passengers' righteous quest for revenge. 'In times of terror', Benjamin writes, 'when everyone is something of a conspirator, everybody will be in the position of having to play detective'.

That Christie turned her readers into conspiring detectives in her locked-room mysteries is perhaps no more obvious than in *And Then There Were None*, where 10 people are invited to an island and murdered one by one, with their hosts – Mr and Mrs U. N. Owen – mysteriously absent or 'unknown'. Christie's lockdown nightmare 'hooks' the island guests and the reader with its suspenseful and sinister accumulating body-count following an innocent nursery rhyme. As no real detective is present on the island, the novel leaves the detection to the reader and the 'victims' themselves, who are gradually overcome with guilt, social isolation and, not least, suspicion of each other as potential killers. Thompson, Christie's biographer, draws out the parallel to our own age of pandemic terror, where we have been led to suspect other people to be lethal carriers of virus.[22] Perhaps the looming threat of war towards the end of the 1930s sent readers looking for a (fictional) fear to anaesthetise another – at least while we are playing detectives the locked-down island dystopia can be contained.

Christie's lockdown crime narratives are centrally about suspicion, a suspicion that is contaminating and includes the reader, a suspicion borne out of and illustrating the deterioration of social trust *and* about the incomprehensible terrors that inevitably turn readers into conspirators and detectives. However, while these lockdown mysteries do indeed serve as containments of unmanageable risks, such as a global pandemic, in a 'self-contained' and 'enclosed' narrative form, they also put the reader

through challenging exercises in the loss and gain of social capital as she negotiates attachments, sympathies and trust with detectives, state authorities, victims and perpetrators.

Lockdown Sweden, crime reading and social trust

As Christie was investigating the locked rooms and country houses of an increasingly fearful interwar Britain, in Sweden the construction of a modern, rational welfare state was well underway. Prime Minister Per Albin Hansson had in 1928 delivered his now famous 'people's-home' speech where his vision for a future welfare society was modelled on the synecdoche of the 'good home'. This home, based on equality, consideration, cooperation, helpfulness and social trust materialised, in the eyes of many, in a near-perfect nation-family in the decades following the Second World War, from which Sweden had emerged comparatively unscathed; however, in the 1960s the comforts of the Social Democratic people's home started to crack, and new uncertainties and anxieties found their way into Mai Sjöwall and Per Wahlöö's socio-critical police novels.

The eighth novel in their classic 'Novel of a Crime' series (1965–75), *Det slutna rummet* (1972, *The Locked Room*, 1973), begins with the police detective Martin Beck left traumatised by a near-lethal gunshot in the previous instalment. He is left out of the police squad's investigation of a bank robbery and is instead given a curious case of a man who was shot dead in his flat, which was found locked from the inside with no trace of a gun at the crime scene. Beck gradually realises that the motif of the locked-room mystery is as much referring to his own personal 'locked room' as to the case. Gripped with an increasing feeling of loneliness, he is, the narrator tells us, 'on his way to becoming a recluse who had no desire for others' company or any real will to break out of his vacuum'.[23] Beck's alienation from his police collective and the wider society, however, initiates a social awakening, as he notices he is by no means alone: 'Observing people all around him, he gained the impression that many of them were in the same predicament he was, though they either didn't realize it or wouldn't admit it to themselves.'[24]

The Locked Room presents an increasingly dystopian Swedish welfare state awash with 'sick, poor, and lonely people, living at best on dog food, who are left uncared for until they waste away and die in their rat-hole tenements'.[25] However, as Beck slowly pieces together the locked-room puzzle he also gradually breaks out of his own isolation when he

meets Rhea Nielsen – the owner of the building where Svärd, the man in the locked room, was murdered. She embodies a more authentic vision of a socially responsible 'people's home', such as when she describes her run-down tenement building as one where the inhabitants 'must feel they belong together and that it's their home'.[26] Rhea, who has an affection for jigsaw puzzles and is an avid reader of crime fiction, provides Beck, who does not read crime novels himself, with the solution to his clue-puzzle, partly by sharing an article with him about the locked-room mystery genre. The article lists different types of locked room cases, including one where a murder is committed with the help of an animal.[27] As Beck falls in love with Rhea, she also brings him out of his own locked room: 'At the same time he was breaking into Svärd's locked room he was also breaking out of his own.'[28]

Sjöwall and Wahlöö's Scandinavian appropriation of the locked-room mystery functions as a vehicle for drawing out the relations between the individual, the social and crime fiction reading. It becomes to some extent a sentimental narrative of the detective's existential, sexual and political awakening and his 'home-coming' in the mother-goddess Rhea's version of a new 'people's home' based on 'old-fashioned' social and moral obligations of cooperation and trust. In Rhea's dilapidated old tenement building, whose function is not that different from Dupin's, one can trust in one's neighbours, and even a stubborn ageing Scandinavian policeman may learn to attach himself to another, to break into and out of his own locked rooms by the aid of crime fiction reading.

Conclusion

The locked-room mystery is a genre of crises. The late modern Scandinavian welfare state has its own literal and figurative 'locked rooms' that threaten the wellbeing of detectives and citizens alike with social alienation and distrust. In late-modern locked-room mysteries by Sjöwall and Wahlöö in the 1970s, and later by Anne Holt and Stieg Larsson in the 2000s, detectives must break out of their own isolation and commit themselves to communal trust and relations with others to solve crimes and enhance their own wellbeing.[29] The detectives must come to realise their own predicament as part of a wider social experience, and to do so they need to become readers, to exercise essential genre and social knowledge rather than traditional forensic abilities.

With the lockdown, we have been forced further into a social condition that Robert Putnam diagnosed as 'bowling alone': a loss of

social networks, interpersonal trust and social capital.[30] We might presume that the increase in solitary reading of crime novels during the pandemic has done little to prevent loneliness and the spreading loss of social capital. Yet as I have argued here, with the example of a seminal crime fiction trope, the locked-room, crime fiction does not only 'treat' the emotions commonly experienced during lockdown: weirdness, tedium, ambient anxiety, dread and the uncertainty created in our lives.[31] These locked-room mysteries also suggest that reading imparts useful social knowledge: it contains otherwise unmanageable risks, exercises social attachments and allows us to conspire with other readers against the personal and social deterioration of our wellbeing and trust.

Notes

1. Poe, 'The murders in the Rue Morgue'.
2. See Nielsen Book, 'Reading increases in lockdown'. See also Reading Agency, 'New survey says reading connects'.
3. According to Demos and the Reading Agency, '[t]here is a significant body of literature associating reading with lower rates of self-reported loneliness'. Hilhorst et al., 'It's no exaggeration', 12.
4. The Reading Agency, 'Literature Review', 4.
5. The Reading Agency, 'Literature Review', 12.
6. Nielsen Book Press Release, n.p.
7. Nilsson, Damrosch and D'haen, *Crime Fiction as World Literature*, 2.
8. Symons, *Bloody Murder*, 11.
9. See Gregoriou, *Deviance*, 49.
10. Porter, *The Pursuit of Crime*, 3.
11. Symons, *Bloody Murder*, 16.
12. Auden, 'The guilty vicarage', 406.
13. Evans, *The Imagination of Evil*, 11.
14. See Felski, *Hooked*.
15. Thompson, 'Lockdown'.
16. Scaggs, *Crime Fiction*, 51–2.
17. Poe, 'The murders in the Rue Morgue', n.p.
18. Poe, 'The murders in the Rue Morgue', n.p.
19. Scaggs, *Crime Fiction*, 52.
20. See UNESCO, 'Index translationum'.
21. Benjamin, 'Detective novels, on tour'.
22. Thompson, 'Lockdown', n.p.
23. Sjöwall and Wahlöö, *The Locked Room*, 156.
24. Sjöwall and Wahlöö, *The Locked Room*, 235.
25. Sjöwall and Wahlöö, *The Locked Room*, 25.
26. Sjöwall and Wahlöö, *The Locked Room*, 174.
27. Rhea gives Beck the article 'Det slutna rummet. En undersökning' ('The locked room – an investigation'), written by one Göran Sundholm. Michael Tapper has noted that this is indeed referring to a real article published in 1971 in *DAST Magazine for Popular Literature*. See Tapper, *Snuten i skymringslandet*, 792.
28. Sjöwall and Wahlöö, *The Locked Room*, 277.
29. See the use of the locked-room mystery in Anne Holt's Christie pastiche *1222* (2007), in which a train is marooned in snow drifts in the Norwegian mountains. The passengers seek refuge in a hotel where a series of murders take place in front of the traumatised wheelchair-using detective Hanne Wilhelmsen. Most famously, the locked-room mystery is used as an exercise

in detection in Stieg Larsson's *The Girl with the Dragon Tattoo* (2005). See my discussion of crime genres and trust capital in Larsson's global bestseller in Stougaard-Nielsen, *Scandinavian Crime Fiction*.
30 Putnam, *Bowling Alone*.
31 Mull, 'What you're feeling is plague dread'.

Bibliography

Auden, W. H. 'The guilty vicarage: Notes on the detective story, by an addict', *Harper's Magazine* (1948): 406–12.

Benjamin, Walter. 'Detective novels, on tour.' First published in the *Frankfurter Zeitung*, 1930; translated by Sam Dolber, Esther Leslie and Sebastian Truskolaski. Verso Books, 29 September 2017. Accessed 1 November 2021. https://www.versobooks.com/blogs/2848-detective-novels-on-tour.

Evans, Mary. *The Imagination of Evil: Detective fiction and the modern world*. London: Bloomsbury, 2011.

Felski, Rita. *Hooked: Art and attachment*. Chicago: University of Chicago Press, 2020.

Gregoriou, Christiana. *Deviance in Contemporary Crime Fiction*. Basingstoke: Palgrave, 2007.

Hilhorst, Sacha, Alan Lockey and Tom Speight. 'It's no exaggeration to say that reading can transform British society. . .'. London: Demos, 2018. Accessed 1 November 2021. https://readingagency.org.uk/news/A%20Society%20of%20Readers%20-%20Formatted%20(3).pdf.

Mull, Amanda. 'What you're feeling is plague dread: During a pandemic, terror and tedium can go hand in hand.' *The Atlantic*, 19 March 2020. Accessed 1 November. https://www.theatlantic.com/health/archive/2020/03/coronavirus-anxiety/608317/.

Nielsen Book. 'Reading increases in lockdown.' 13 May 2020. Accessed 1 November 2021. https://nielsenbook.co.uk/wp-content/uploads/sites/4/2020/05/Press-Release_Covid-Tracker_wave-1-1.pdf.

Nilsson, Louise, David Damrosch and Theo D'haen. *Crime Fiction as World Literature*. London: Bloomsbury, 2017.

Poe, Edgar Allan. 'The murders in the Rue Morgue'. In *The Works of Edgar Allan Poe, The Raven Edition*, Vol. I, Project Gutenberg. Accessed 1 November 2021. https://www.gutenberg.org/files/2147/2147-h/2147-h.htm#chap07.

Porter, Dennis. *The Pursuit of Crime: Art and ideology in detective fiction*. New Haven, CT: Yale University Press, 1981.

Putnam, Robert. *Bowling Alone: The collapse and revival of American community*. New York: Simon & Schuster, 2000.

Reading Agency, 'Literature review: The impact of reading for pleasure and empowerment' (June 2015). Accessed 1 November 2021. https://readingagency.org.uk/news/The%20Impact%20of%20Reading%20for%20Pleasure%20and%20Empowerment.pdf

Scaggs, John. *Crime Fiction*. London: Routledge, 2005.

Sjöwall, Mai and Per Wahlöö. *The Locked Room*, translated by P. Britten Austin. London: Fourth Estate, 2011.

Stougaard-Nielsen, Jakob. *Scandinavian Crime Fiction*. London: Bloomsbury, 2017.

Symons, Julian. *Bloody Murder: From the detective story to the crime novel; a history*. Harmondsworth: Penguin, 1972.

Tapper, Michael. *Snuten i skymringslandet: svenska polisberättelser i roman och film 1965–2010*. Lund: Nordic Academic Press, 2011.

Thompson, Laura. 'Lockdown provides the perfect conditions for a murder – just ask Agatha Christie', *The Guardian*, 10 May 2020. Accessed 1 November 2021. https://www.telegraph.co.uk/books/crime-fiction/lockdown-provides-perfect-conditions-murder-just-ask-agatha/.

UNESCO. 'Index translationum'. Accessed 1 November. http://www.unesco.org/xtrans/bsstatexp.aspx?crit1L=5&nTyp=min&topN=50.

21
The weight of a shrinking world
Florian Mussgnug

We need the weight of the world we fear.[1]

Veteran environmental activist Bill McKibben begins his latest monograph with a contemplation of the diversity of human experience: 'the sum total of culture and commerce and politics; of religion and sports and social life; of dance and music; of dinner and art and cancer and sex and Instagram; of love and loss'.[2] This extraordinary tangle, McKibben asserts, is threatened by the unfolding climate emergency: 'We are putting the human game at risk', he writes, and have already 'changed the board on which the game is played, and in more profound ways than almost anyone now imagines. The habitable planet has literally begun to shrink'.[3] Other environmentalists strike a similar note. David Wallace-Wells, for example, conjures the terrifying vision of a near future marked by cascading environmental catastrophes, collapsing human societies and the violent struggle for survival on an 'uninhabitable Earth'. 'If the next thirty years of industrial activity trace the same arc upward as the last thirty years have', he explains, 'whole regions will become unliveable by any standard we have today'.[4] Biologist Edward O. Wilson, in a similar vein, argues that global environmental catastrophe can only be avoided if one half of the surface of Earth is immediately and permanently designated as a human-free natural reserve.[5] Significantly, this bleak geopolitical forecast has already been dismissed as naïve by Wallace-Wells, who contends, in a spirit of escalating, claustrophobic anxiety, that the fraction of the planet

available to humans 'may be smaller than that, possibly considerably, and not by choice'.[6]

In early April 2020, nearly four billion people – more than half the world's population – were under lockdown. Many were profoundly shaken by this experience of forced immobility and by the dramatic restriction of personal freedom. Mass quarantine delivered a sense of limited possibility that was unfamiliar to most, especially in affluent societies, and that appeared to run counter to basic ideas of human dignity. Since its earliest origins, the human idea of Earth, in its manifold historical and cultural declinations, has been virtually synonymous with mobility and with the progressive 'cultivation' of nature, imagined either in terms of pious stewardship or as ruthless conquest. For twenty-first-century environmentalists, lockdown provided an opportunity to rethink this assumption, and to reject the power-geometry of expansion and growth. In a recent interview, Wallace-Wells has described the pandemic as a 'dry run or dress rehearsal for climate change', which made people aware of ecological entanglement, but which also normalised the prospect of mass death, to a worrying extent:

> In part because of the severity of the disease and the lockdowns it produced, I do think the experience has been eye-opening. In ways that climate change hasn't really managed, Covid-19 has taught us all that we live within nature, no matter how superior we may feel to it or protected against its forces.[7]

As Wallace-Wells points out, lockdown has heightened our sense of vulnerability and our awareness of patterns of global connectivity that threaten much of what we value about humanity and the more-than-human world. Like McKibben's shrinking world, lockdown is both the antithesis of utopian fantasies of global interdependence and a direct consequence of the failure of this vision. The *shrinking world* – a trope that was once positively associated with globalisation – has come to denote both the reality of lockdown and a tragically plausible worst-case scenario: a planet where many regions have become unhospitable to human populations. While Wilson imagines a pristine natural world without human interference – not unlike the counterfactual 'world without us' described by journalist Alan Weisman – McKibben and Wallace-Wells turn their attention to the most harrowing consequences of anthropogenic climate change: rising sea levels, heat waves and droughts, ocean acidification, deep sea warming, plastic pollution and so on.[8]

What has become of globalisation? Transnational networks of communication and exchange have failed to give rise to more egalitarian global maps. More than twenty years after their first articulation, optimistic forecasts of a 'borderless world', by Anthony Giddens, Manuel Castells and others, stand in sharp contrast with everyday experiences of state violence, involuntary migration and forced immobility, especially among those who are construed as aliens on the grounds of their class, race, ethnicity, gender or nationality.[9] The rapid, global spread of digital information technology has not empowered democratic resistance to powerful actors – government bodies and corporate multinationals – but has enabled these actors to reach more widely and directly into the lives of others, where they control access to information and mould and manipulate habits and preferences. Similarly, territorial authority is not abolished but profoundly transformed by the emergence of new geographies of power. According to geographer John Allen, the *intensive* reach of political and corporate agents cannot be fully mapped 'in terms of lines of connection etched on a flat surface across measurable spans of the globe'.[10] Traditional accounts of institutional power were informed by the idea that authority radiates from a stable centre – a political capital, the headquarters of a business corporation, or an entire 'global city' – and is exercised outwards and downwardly, within the limits of a clearly defined territory. This familiar way of thinking about space, as Allen explains, appears increasingly out of sync with social and technological innovation:

> The measured times and distances of the modern era no longer quite capture the felt experience of being on the receiving end of a so-called 'distant' corporate or financial power, or the intensive reach that states can have over the lives of migrants far removed from territorial borders.[11]

Dystopian fiction provides a significant observatory for these trends, and has inspired transformative practices of political and cultural intervention.[12] This role derives from the genre's characteristic attention to spatial boundaries: islands, journeys, walls and similar spatial and temporal barriers have long functioned as effective generic markers.[13] Since Thomas More, utopian and dystopian worlds have been imagined as either physically remote or distant in time, even where their political critique is concrete and specific. As I have argued elsewhere, capitalist globalisation inhibited this attention to spatial and temporal distance.[14] Canonical utopian literature, according to Darko Suvin's influential

definition, aspired to hold up a 'shocking mirror' to the author's society; it employed strategies of cognitive estrangement to invite critical analysis.[15] This political and aesthetic practice, as Italo Calvino has remarked, requires us to imagine utopia and dystopia as isolated, self-sufficient and static domains: *'L'Utopia sente il bisogno d'opporre una sua compattezza e permanenza al mondo ch'essa rifiuta e che si mostra altrettanto compatto e pervicace.'* ('Utopia feels the need for compactness and permanence in opposing the world it rejects, a world that presents an equally refractory front.')[16]

The utopian imagination, as Calvino notes with considerable prescience, is threatened by the cultural logic of globalisation. It cannot be easily reconciled with global capitalism's widespread sense of flux, shifting social and geopolitical conditions and blurred horizons of possibility. But that situation appears to be changing. Where lockdown arrested or transformed the convergence of spatial and temporal structures – where it has interrupted the exponential growth in air travel or triggered the proliferation of new communication networks – shrinking-world discourse has inspired new forms of utopian and dystopian speculation. My contribution explores this idea and investigates lockdown culture as a dynamic site of social and political activism. I will focus on speculative fiction, a genre that has become closely associated with the anxious expectation of political and environmental catastrophe.[17]

Lockdown anxieties in a post-holocenic world

My chapter focuses on a set of dystopian novels by the British author and comic artist M. R. Carey, which exemplifies the growing importance of apocalyptic literature and film in contemporary popular culture. This allows me to make two related points. First, speculative fiction has emerged, since the turn of the millennium, as a vital tool for reflection on the unpredictability and interconnectedness of post-holocenic societies and ecologies. Secondly, in the context of the Covid-19 pandemic, it accounts for the specific anxieties that we now associate with lockdown culture, and which psychosocial theorist Lisa Baraitser has described as the 'impossible situation' of solitary being: 'It entails living the impossibility of continuing to exist indefinitely, but without social or physical contact with other people or living creatures . . . under conditions of permanent surveillance'.[18]

M. R. Carey's best-selling dystopian thriller, *The Girl with All the Gifts* (2014), and its prequel *The Boy on the Bridge* (2017), are set in

Britain, some 20 years after a global catastrophe known as the Breakdown.[19] Humanity has been nearly wiped out by a fast-spreading fungal infection. Some survivors have founded Beacon, a brutally repressive city state hosted in a high-security military base, while other, smaller groups live in violent, marauding gangs, the so-called 'junkers'. Both communities are constantly threatened by the infected, also referred to as 'hungries'. These only seemingly humanoid creatures have lost most of their mental powers and feed on the flesh of uninfected animals, including healthy humans, whom they can smell from a great distance. Melanie, the child protagonist of *Girl*, grows up in a tightly guarded military outpost; she has learned from her teacher, Miss Justineau, that 'there are lots of hungries still out there. If they get your scent they'll follow you for a hundred miles, and when they catch you they'll eat you' (*Girl*, 3).

Carey's description of the *ophiocordyceps unilateralis* fungal infection is reminiscent of post-Romero zombie culture, and provides immediate genre recognition.[20] Melanie lives in a world of never-ending threats and risks, where each individual carries responsibility for the survival of the human species. Her enemies, the 'hungries', are characteristically atrocious and predictably repulsive. Like the near-ubiquitous zombies of twenty-first-century popular culture, they resemble rotting human corpses, but behave like exorbitantly aggressive automata, marked by a complete loss of agency, control or consciousness. Carey's similarly predictable human characters can be read as a self-conscious homage to the generic conventions of apocalypse fiction: Caroline Caldwell (*Girl*) and Alan Fournier (*Boy*) are quintessentially evil scientists; Sergeant Eddie Parks (*Girl*) and Lieutenant Daniel McQueen (*Boy*) embody masculinist fantasies of regenerative violence and heroic virility; psychologist Helen Justineau (*Girl*) and biologist Samrina Khan (*Boy*) appear in the positive role of the nurturing and self-sacrificing mother and are, for good measure, the only explicitly non-white characters in the two novels.[21] There is, however, an unexpected twist: Melanie is not fully human. Rather, she forms part of a small group of highly intelligent 'hungry children' who do not suffer the negative effects of the mind-controlling fungus. Indeed, it is Melanie who stages the group's escape from the 'school' (a high-security underground lab for experiments on 'second-generation hungries') and who finally decides – in a twist that closely resembles the surprise ending of Richard Mathewson's Cold War-era vampire thriller *I Am Legend* (1954) – to save only her beloved teacher, Miss Justineau, from the rapid and definitive spread of the pathogen.

Early reviews of *Girl* focused on Carey's ability to subvert the hackneyed conventions of the zombie thriller and to breathe new life into a popular, but frustratingly repetitive, genre.[22] While some critics have paid attention to the historical origins of the zombie figures, others have engaged specifically with the 'hungry girl' Melanie, whose depiction has been hailed as a critique of anthropocentric humanism.[23] More interestingly, James McFarland reads the 'consumptive and contagious' excesses of homicidal violence in zombie fiction as a nihilistic explosion of vitality, aimed at the tragic 'alienation from ritualized death' in late capitalist societies.[24] But is this claim borne out by Carey's novels? Despite the many violent deaths in both stories, Carey appears surprisingly uninterested in gory detail, and more drawn towards the repetitive, daily practices dictated by military hierarchy, scientific protocol and the need to survive in a hostile world. Melanie, for example, is frequently described as sitting passively in her small prison cell, in a manacled wheelchair, as she awaits the armed guards who will take her to 'class'. Similarly, Stephen Greaves, the autistic boy hero of Carey's prequel, spends his days scribbling notes in the suffocating space of an airlock that is supposed to protect from contagion. Such passages, as Theodore Martin has shown, are characteristic of the monotonous tempo of recent post-apocalypse fiction.[25] But Carey's repeated insistence on quotidian routines also draws the reader's attention to the increasingly claustrophobic, oppressive and vulnerable spaces of human life on a planet that is less and less hospitable to *Homo sapiens*.

The world seen from within

As Roger Luckhurst has explained, outbreak stories are not simply an allegory of the dangers of capitalist globalisation. Rather, they must be read as a *literalisation* of contemporary risk factors and therefore as a 'peculiar new form of social realism':

> What the zombie outbreak narrative really reveals – as do all epidemics – is the shape of our networks and risky attachments, our sense of an incredibly fragile global ecology . . . Medicalized, viral zombie hordes offer us a figure of a properly globalized interconnection.[26]

Carey's novels are aware of this interpretative context. *Boy*, in particular, mocks modern narratives of scientific and social progress and the idea of

a heroic human conquest of nature. The novel begins with a seemingly celebratory description of Rosie, a mobile lab fitted into a small bus and patriotically named after the English biochemist and crystallographer Rosalind Franklin.[27] Three years after the first wave of infections, when 'the freefalling societies of the developed world hit what they mistakenly thought was bottom', this vehicle is refurbished by the Department of Defence, and becomes part of a secret government plan to stop the pandemic and to reclaim British national territory from the 'hungries' (*Girl*, 47). Rosie is 'unveiled with as much fanfare as could be mustered' and becomes the new physical home to the government's 'great big save-the-human-race think tank . . . the biggest deal in a rapidly shrinking world' (*Girl*, 47–8). Khan, who is recruited to join the expedition, muses that 'Rosie is an awesome thing to behold, a land leviathan'. But her sense of admiration quickly fades when she considers the lab's claustrophobic quarters: 'a single shower and a single latrine, with a rota that's rigorously maintained. The only private space is in the bunks, which are tiered three-high like a Tokyo coffin hotel' (*Boy*, 4).

Carey's poignant insistence on the discrepancy between nationalist rhetoric and post-apocalyptic reality becomes further apparent when Khan reveals that it has taken the expedition seven weeks to cross southern England, from Beacon to the abandoned city of Luton, where they stop to loot 'the precious bounty of Boots the Chemist' (*Boy*, 8):

> Finally, after a hundred false starts, the Rosalind Franklin begins her northward journey – from Beacon on the south coast of England all the way to the wilds of the Scottish Highlands. There aren't many who think she'll make it that far, but they wave her off with bands and garlands all the same. They cheer the bare possibility.[28]

Carey's description of Rosie's departure evokes the typically modernist theatre of the adventure story, with its characteristic emphasis on physical discipline, endurance and virility. But the setting of *Boy* works against this pathos. Underground prison cells, poorly furbished labs and oppressive military barracks are premonitions of an increasingly unsupportive world that is literally shrinking. Unlike the vast, abandoned spaces conjured in traditional post-apocalyptic fiction, Carey's claustrophobic interiors contain no utopian promise of redemption or hope for a new social contract. This is especially evident from the implausible, but cinematically allusive ending of *Girl*, in which Justineau awakes only to find herself locked in the hermetically sealed, coffin-like space of the now abandoned Rosalind Franklin, staring through a small window at a world where

ophiocordyceps has become airborne, where the disease has infected all remaining humans and has made her, literally, the last woman.

Carey's political attention to shrinking worlds is emblematic of a wider rethinking of planetary space, which affects not only literature and literary criticism, but also the transdisciplinary field of the environmental humanities. As this analysis has shown, shrinking-world discourse marks an important shift in our understanding of responsibility and care. As Denis Cosgrove points out, the Western imagination has long focused on visions of Earth as a world perceived *from without*: a representational practice that culminated in mid-twentieth-century photographs of the blue planet suspended over abyssal darkness.[29] This visual paradigm conveyed a deceptive sense of human detachment from nature, even when it was employed to signal the vulnerability of ecosystems. According to Michael Cronin, 'as the images of the globe proliferate, often ironically to mobilize ecological awareness, the danger is that these images themselves distort our relationship to our physical and cultural environment by continually situating us at a distance, by abstracting and subtracting us from our local attachments and responsibilities'.[30] In times of lockdown, the increasingly influential new paradigm of the shrinking world holds the power to contrast this stance of detached spectatorship. It can shift our attention away from the world-as-globe and towards the matrix of lived experience.

Notes

1. Berlant and Stewart, *The Hundreds*, 22.
2. McKibben, *Falter*, 8.
3. McKibben, *Falter*, 15, 22.
4. Wallace-Wells, *The Uninhabitable Earth*, 15.
5. See Wilson, *Half-Earth*.
6. Wallace-Wells, *The Uninhabitable Earth*, 15.
7. Wallace-Wells and Eptakili, 'It is worse, much worse'.
8. Weisman, *The World Without Us*.
9. See Giddens, *The Consequences of Modernity*; Castells, *The Information Age*.
10. Allen, *Topologies of Power*, 18.
11. Allen, *Topologies of Power*, 2.
12. See Haraway, *Staying with the Trouble*.
13. See Jameson, 'Of islands and trenches'.
14. Mussgnug, 'Utopian / World / Literature'.
15. Suvin, *Metamorphoses of Science Fiction*, 57.
16. Calvino, 'Per Fourier 3', 307. The translation is Patrick Creagh's: Calvino, 'On Fourier III', 246.
17. See especially Heise, *Imagining Extinction*, 202–37.
18. Baraitser, *Enduring Time*, 118.
19. Carey, *The Girl with All the Gifts*; *The Boy on the Bridge*. Carey also wrote the screenplay for the 2016 film adaptation of *Girl*, which was directed by Colm McCarthy. My discussion here will focus on the two novels, which I will henceforth abbreviate as *Girl* and *Boy*.
20. See Lauro, *Zombie Theory*.

21 Colm McCarthy inverts this aspect of the novel when he casts the Black British actress Sennia Nanua in the role of 'dead pale' Melanie (Carey, *Girl*, 169).
22 Smythe, '*The Girl With All the Gifts*'; Kermode 'Provocative and imaginative'; Slagman, 'Die wollen nur essen'.
23 Heise-von der Lippe, 'Zombie fictions'; Hale and Dolgoy, 'Humanity in a posthuman world'.
24 McFarland, 'Philosophy of the living dead', 58.
25 'The post-apocalyptic genre is uneventful, repetitive, pedantic, and generic; for these reasons it is uniquely poised to offer an exhaustive and exhausting record of the monotonous details of modern work.' (Martin, *Contemporary Drift*, 164).
26 Luckhurst, *Zombies*, 183.
27 The name Rosalind Franklin was also given to a robotic rover that was meant to take part in the ExoMars programme led by the European Space Agency (ESA) and the Russian Roscosmos State Corporation. The name was chosen by ESA without any intentional reference to Carey's novels. The mission was scheduled to launch in July 2020, but was subsequently postponed to 2022. Because of the 2022 Russian invasion of Ukraine, the programme has now been indefinitely suspended.
28 Carey, *Boy*, 3.
29 Cosgrove, *Apollo's Eye*, 235–68.
30 Cronin, *The Expanding World*, 25–6.

Bibliography

Allen, John. *Topologies of Power: Beyond territory and networks*. New York and London: Routledge, 2016.
Baraitser, Lisa. *Enduring Time*. London: Bloomsbury, 2017.
Berlant, Lauren and Kathleen Stewart. *The Hundreds*. Durham, NC, and London: Duke University Press, 2019.
Calvino, Italo. 'On Fourier, III: Envoi: A utopia of fine dust'. In *The Literature Machine: Essays*, translated by Patrick Creagh, 213–55. London: Secker and Warburg, 1987.
Calvino, Italo. 'Per Fourier 3. Commiato. Utopia pulviscolare'. In *Saggi 1945–1985*, edited by Mario Barenghi, vol. 1, 306–14. Milan: Mondadori, 1995.
Carey, M. R. *The Girl with All the Gifts*. London: Orbit, 2014.
Carey, M. R. *The Boy on the Bridge*. London: Orbit, 2017.
Castells, Manuel. *The Information Age: Economy, society and culture*, 3 vols. Oxford: Blackwell, 1996–8.
Cosgrove, Denis. *Apollo's Eye: A cartographic genealogy of the Earth in the Western imagination*. Baltimore, MD: Johns Hopkins University Press, 2001.
Cronin, Michael. *The Expanding World: Towards a politics of microspection*. Winchester and Washington, DC: Zero Books, 2012.
Giddens, Anthony. *The Consequences of Modernity*. Stanford, CA: Stanford University Press, 1990.
Hale, Kimberly H. and Erin A. Dolgoy. 'Humanity in a posthuman world: M. R. Carey's *The Girl with All the Gifts*', *Utopian Studies* 29, no. 3 (2018), 343–61. https://doi.org/10.5325/utopianstudies.29.3.0343.
Haraway, Donna J. *Staying with the Trouble: Making kin in the Chthulucene*. Durham, NC, and London: Duke University Press, 2016.
Heise, Ursula K. *Imagining Extinction: The cultural meaning of endangered species*. Chicago: University of Chicago Press, 2016.
Heise-von der Lippe, Anya. 'Zombie fictions'. In *The Palgrave Handbook to Horror Literature*, edited by Kevin Corstorphine and Laura R. Kremmel, 219–32. London: Palgrave, 2018.
Jameson, Fredric. 'Of islands and trenches: Naturalization and the production of utopian discourse', *Diacritics* 7 (June 1977), 2–21. https://doi.org/10.2307/465017.
Kermode, Mark. 'Provocative and imaginative', *Guardian*, 25 September 2016. Accessed 30 September 2021. https://www.theguardian.com/film/2016/sep/25/the-girl-with-all-the-gifts-review-glenn-close-gemma-arterton.
Lauro, Sarah J. (ed.). *Zombie Theory: A reader*. Minneapolis, MN: University of Minnesota Press, 2017.

Luckhurst, Roger. *Zombies: A cultural history*. London: Reaktion Books, 2015.

Martin, Theodore. *Contemporary Drift: Genre, historicism and the problem of the present*. New York: Columbia University Press, 2017.

McFarland, James. 'Philosophy of the living dead: At the origin of the zombie-image', *Cultural Critique* 90 (2015), 22–63. https://doi.org/10.5749/culturalcritique.90.2015.0022.

McKibben, Bill. *Falter: Has the human game begun to play itself out?* London: Wildfire, 2019.

Mussgnug, Florian. 'Utopian / World / Literature'. In *The Good Place: Comparative perspectives on utopia*, edited by Florian Mussgnug and Matthew Reza, 1–14. Oxford: Peter Lang, 2014.

Slagman, Tim. 'Die wollen nur essen', *Der Spiegel*, 7 February 2017. Accessed 30 September 2021. https://www.spiegel.de/kultur/kino/zombiefilm-the-girl-with-all-the-gifts-filmkritik-a-1133459.html.

Smythe, James. '*The Girl With All the Gifts* by M R Carey', *Guardian*, 15 January 2014. Accessed 30 September 2021. https://www.theguardian.com/books/2014/jan/15/girl-with-gifts-mr-carey-review.

Suvin, Darko. *Metamorphoses of Science Fiction: On the poetics and history of a literary genre*. New Haven, CT: Yale University Press, 1979.

Wallace-Wells, David. *The Uninhabitable Earth: A story of the future*. London: Penguin, 2019.

Wallace-Wells, David and Tassoula Ephtakili. 'It is worse, much worse, than you think', *Ekathimerini*, 28 September 2020. Accessed 10 October 2020. https://www.ekathimerini.com/society/257409/david-wallace-wells-it-is-worse-much-worse-than-you-think/.

Weisman, Alan. *The World Without Us*. London: Virgin Books, 2007.

Wilson, Edward O. *Half-Earth: Our planet's fight for life*. New York: W. W. Norton, 2016.

22
A voice-mail lyric for a discipline in crisis: on Ben Lerner's 'The Media'
Matthew James Holman

In the 20 April 2020 print issue of *The New Yorker,* Ben Lerner published the prose poem 'The Media'. Curiously categorised by the magazine as short fiction, it was written a month or so before the Covid-19 pandemic forced New York to close but has peculiar – and, I will argue, collectively affirmative – resonances for the (unevenly) shared experience of lockdown.[1] Literary works that feel somehow representative of living through a particular crisis in history sometimes go unnoticed during their own time; others feel ready to be analysed now. This is one of those poems.

'The Media' was published at a time when our liberties were pared back and mass deaths felt inevitable; many reached for the solace of what Lyndsey Stonebridge has characterised as 'the moral clarity of good writing'.[2] There was reassurance to be found in twentieth-century novels like Albert Camus's *The Plague* (1947), or Ingeborg Bachmann's *Malina* (1971). For Stonebridge, Bachmann is among the few who 'describ[e] modern history from the perspective of those ... who suffer it.'[3]

In these canonical texts the plague is often treated as a metaphor for being human, invariably standing in as a version of something else: the existential prerogative of going on living as we are dying, the spread of fascist ideology or the contagions of patriarchal or class injustice. The plague operates here within an allegorical nervous system of infection, transmission and mutual interdependence. An anxious reading public

was reminded that such plague has always been with us, will always be with us, and that it is a condition of being alive.

But what did it actually feel like this time around? Were we too close, and do we remain too close, to treat this experience metaphorically? Is this a flaw of our present abilities to imagine the world beyond the pandemic? Surely there are several significant differences, indeed several significant privileges, in separating the specifics of an experience of lockdown from the broader experience of living through the plague. What were our lived methods of communication and working practice during lockdown, and how might that shape literary form and representation?

I wrestled with these questions after listening to a recording of 'The Media' during the lockdown of spring 2020, in a field on Walthamstow Marshes. The isolation enforced as a security measure against Covid-19 in mid-March might have post-dated Lerner's composition, but the unnamed, external crises that haunt the poem and its mode of composition allow Lerner to offer powerful consolations to the affective experience of being *locked down*.

'What does a normal day feel like to you?' asks Ben, the speaker, who sits by Grand Army Plaza on the northern corner of Prospect Park in Brooklyn, and notes that the 'they' of the municipal authorities have 'shut off' the fountain 'until the spring, when it will again give sensuous expression to our freedom'.[4] Reading this during a period when access to public space was severely restricted, it was clear that those spaces have become contested ground in which our relative 'freedoms' meant more than the liberty to exercise within those spaces, but were conditioned above all by the degree of our economic independence and by the dimensions of the places in which we lived.[5] For many, the free access to public space never mattered more. Much hangs here on the transition into a more hopeful season at a time when the adverb 'again' offers some sense of a return to normalcy, or whatever our freedoms felt like before the crisis.

Narrated by 'Ben', 'The Media' begins by self-reflexively 'recording this prose poem on my phone' while walking through the Long Meadow of Prospect Park: 'that's my job', Ben says, 'as old as soldiery, the hills, the soldered hills where current flows, green current'.[6] The poem navigates the formation of complex geometries in nature, and then interweaves philosophical reflections on the conditions of work, the aftermath of a friend's overdose and the micro-aesthetics of line and form in the natural world: rivulets of silence on glass, dendritic patterns in frozen ponds, and lightning captured in hard plastic. The title itself offers a plurality of

meanings: in my view 'The Media' is less about the information overload caused by clickbait and catastrophe headlines than about an iPhone 6 with a badly cracked screen, the ancient recording technologies of poetry and, most explicitly, the entomological name for the fourth vein of an insect's wing.

Nature is at once a reprieve, a leap into a timeless space of beauty and mathematical purity, as well as the driving force of the poem's energy – if only the self-conscious poet could capture it – which is buzzing all around us. It is as though the crisis has cleared time for us to notice it. The poem oscillates between the world of nature, Ben passing the time assembling cut flowers with his daughters, and the harsh contours of the wires and metallic structures of technology: 'polished steel gives way to painted water'.[7] The streets are so emptied of people that Ben observes 'racoons . . . descending from their nests in foreclosed attics to roam the streets of Kensington', a residential neighbourhood of Brooklyn where he has recently moved.[8]

Throughout the poem the future is part-suspended as 'to come'; holding the promise of restoring fragments of family life and the friend's recovery from substance abuse. Yet so many of the images of what life will be like *again* are warped realities. If 'The Media' shares anything with those great plague novels, it is that crisis and the suspension of normal life for the present are non-negotiable facts of temporal experience. As Ben puts it later, the poem and the moment appear to be both 'signifying nothing but holding a place'.[9] Seasons are therefore important for Ben to make sense of order and cyclical continuity. In one of his more desperate and lonely moments, he reflects on the epistemological impossibility of knowing whether others can feel pain but eventually resolves that he does 'recognize what philosophers call "pain behaviour" among my loved ones when the seasons change'.[10] A reference to Ludwig Wittgenstein's idea that pain is learned and defined by our affective emotional networks *out there* and not only *in here*, Ben asks how if pain is shared and defined in part by our desire to comfort and reassure, then the bonds of emotional interconnectivity are perhaps most keenly felt when life is reduced to the immediate family. Pain is amplified the more those around us notice it in us.

'The Media' narrates being locked down in a deliberative state of crisis: its story, if it has one, is the hour or so spent exercising daily in semi-deserted public parks; the back-and-forth of leaving voicemails to friends and support networks after hours. It is this, intimately linked to what Lerner has called the recent 'voice-mail genre' of the lyric poem, that registers the act of 'calling' as both an experience and a poetic message; the call that is made but remains unanswered. This reflection on the lyric mode is expressed in the subject and tenor of the poem, too: in the case of the friend, whose constant precarity is anxiously rehearsed by Ben, and

perhaps for us all as we feel our lives have been put on indefinite pause. The figure of Ben makes repeated claims on the stunted experiences of his day, while punctuating that imagined course of the poem with promises and commitments by making calls and leaving voicemails. These calls are made into the future and not returned, lyric snapshots of their own.

This is an exaggerated lyric poem, in which the poet speaks *in propria persona* and the external world – of the apostrophised addressee and the reader – is mediated by the poet's subjectivity. During a period of enforced social distance, in which the opportunities for intimacy are physically forbidden beyond technological platforms, the lyric becomes an intensified medium for connection. That is not to say that it should be privileged over, or indeed separated from, other forms of communication we have used, teenagers and grandparents alike, over the past few months. Indeed, it seems to be part of the internal logic of the poem to scrutinise the mediation of lyrical address in a voicemail, a text message, a phone call or a poem. It is not even about the medium: more so 'the ancient impossible desire to get it all down somehow', reflected Lerner in an accompanying interview to *The New Yorker* article, 'whether the medium is pen and paper or voice mail':

> Language always involves time travel: when you leave a message through any medium, you are no longer identical to the person who left it – you are older than the 'I' who wrote 'I'm writing you,' the 'I' who said 'I'm calling you' – but the message takes on a life of its own, becomes a fragment of another present renewed by a recipient in whatever near or distant future; it's a little linguistic miracle … [11]

In whatever form it takes, each iteration of the lyrical expression is troubled, and each time actualised, by temporal succession. The collective subject who reads the lyric, ear pressed against the wall of the poet's faux-solitary room of subjective expression, is each time different and therefore begins again the life of the poem. If there is something to give hope to the medium, Lerner writes, it is this.

'I am resolved to admire all elaborate silvery pathways,' writes Ben, 'no matter where I find them, that's why I'm calling'.[12] This is an absurd statement to make to a friend in a voicemail message, but that's the point; the speaker moves freely between the language of the poem and technological communication, collapsing the distance and distinctions between the two, while simultaneously referring to the ancient vocation of 'poetic calling' across time and space. This trope of 'calling' has been a persistent concern of the American lyric in recent years and recalls Peter

Gizzi's gorgeous poem 'It Was Raining in Delft', which itself plays on the scheduling of the telephone call and then immediately the 'calling' of pilgrimage or spiritual vocation:

> I will call in an hour where you are sleeping. I've been walking for 7 hrs on yr name day.
> Dead, I'm calling you now.[13]

Like Gizzi, who also acknowledges these engagements with various forms of communication technology in the long history of the lyric, Lerner enables the work of the poem to self-reflexively speak to the labour of its composition. Throughout 'The Media', Ben reflects on the daily grind of writing and the fraught, often embarrassed positioning of his work in the economy of what he does while his daughters are at school.[14] In a moment of self-reflection on the process of composing the lyric, which elsewhere is described as 'realigning and interlocking barbules', Ben writes to the persistent 'you' of the address:

> ... how you've rearranged the stresses to sponsor feelings in advance of the collective subject who might feel them, good work if you can get it, and you can't, nobody can, that's why the discipline is in crisis.[15]

The careful play of possible meanings, from the 'stress' of recognising pain behaviour in others, to mediating where the stress falls in the poem; the act of sponsorship, as though at once a patron of sincere emotion and the observant supporter of the friend in recovery – all of these textures affirm the debilitative pressure the poet works under to craft his poem. At times the work feels arduously put together and the poem appears to be making a defence of writing not as leisure but as a legitimate category of labour, even during a crisis, while at the same time struggling to properly code the meaning of that labour for his daughters, or for himself.

Of course, the 'discipline' that Ben refers to is our own. The academy. The line on 'good work if you can get it' chimes with Jason Brennan's self-help book for anxious and misguided early career academics that bears that title and was published in May 2020. Lerner has himself distinguished between the crises of the 'humanities and most social sciences' in institutions on account of 'enrolment', and the same goes for 'magazines ... [a]nd so many things we care about'.[16] Lerner may be a well-published and celebrated poet, but like pretty much every other literary labourer he is employed by a university (in his case, Brooklyn College). One of the most

haunting, humorous moments of the poem comes early on when Ben remembers when he interviewed for 'this position', bringing on a nightmarish vision: after 'the usual pleasantries, the chairperson requested that [he] sing'.[17] The setting is particularly anxiety-inducing: a Hyatt hotel room with 'migraine carpet', in which he finds himself wearing one of his great-grandfather's 'Regency trimmed velvet tailcoat[s]' from 'more than two hundred years ago, when people still got dressed up for air travel'.[18]

The poem is always mediating what it means to be together and yet apart, being connected to what he calls 'a spirit' – again that word – who is 'at work in the world, or was, and that making it visible is the artist's task, or was'.[19] Lacking the power to animate the world, he finds meaning in situating work in an operative present whereby old guarantees of meaning are at once scrutinised and left in play for a possible revision after the holding pattern of the present moment.

By the end of the poem, Ben has finally managed to put his children 'down' to sleep and in so doing protected them from overhearing the difficult conversation – the quiet trauma that is the reason for the voice-mail calls – with the interlocutor on the overdose of a mutual friend. In bed, he sees through the blinds 'the blue tip of the neighbor's vape pen signalling in the dark' while he waits for the call to be returned, and starts 'clicking on things' in bed, as we all do now, including 'a review by a man named Baskin, who says I have no feelings and hate art'.[20] This review by Jon Baskin is entitled 'On the Hatred of Literature', and in it he argues that Lerner is a product of the anti-subjectivity of 'New Historicism' that dominated liberal arts programmes in the US at the time when he was an undergraduate. Baskin's central grievance is with Lerner's 2016 book *The Hatred of Poetry* on the grounds that Lerner 'confuses the incapacity to suspend disbelief – the unwillingness to enter into the artwork's imaginative world – for a mark of intellectual sophistication'.[21]

In some ways, 'The Media' is a rebuttal to Baskin and those that Lerner believes have misread his approach to poetics. In so doing, the poem expresses an excess of the imaginative world of the artwork or the lyric poem, and any incapacity to 'suspend belief' is here expressed as faith in the ways that we can find semblances of meaning when all shared beliefs on the nature of what life is like have been suspended. If 'The Media' really tells us anything about the experience of lockdown, about the experience of life less paused than further thrown into debilitating precarities of where we live and how we work, then it is that art – for a moment at least – can be 'signifying nothing but holding a place' for what might yet be, once the fountains are switched back on, in all their sensuous freedom.

Notes

1. I refer to the speaker of the prose-poem as 'Ben'. This should not be read as an affect of over-familiarisation but as consistent with *The New Yorker*'s generic categorisation of 'The Media' as short fiction and Ben as a character: one strongly resembling Ben Lerner himself, but not *him*.
2. Stonebridge, 'The plague novel'.
3. Stonebridge, 'The plague novel'.
4. Lerner, 'The Media'.
5. A curiosity to note is that the fountain in question, the Bailey Fountain, later became a site of several protests and emancipatory demonstrations over the course of 2020, including for the Black Lives Matter movement – given that Grand Army Plaza is linked to the representation of the Union Army's victory in the American Civil War – and after the Presidential election of Joe Biden.
6. Lerner, 'The Media'.
7. Lerner, 'The Media'.
8. Lerner, 'The Media'. This image resonates with the recent work of Josh Smith, a contemporary figurative painter also based in New York, whose phantasmagoric streetscapes of half-deserted avenues with the lights on inside the buildings were shown simultaneously as *Josh Smith: Spectre* at David Zwirner's London and New York galleries in September and October 2020.
9. Lerner, 'The Media'.
10. Lerner, 'The Media'.
11. Lerner, in Cressida Leyshon, 'Ben Lerner on the voice-mail genre'.
12. Lerner, 'The Media'.
13. Gizzi, 'It Was Raining in Delft'.
14. In one particularly evocative expression, Lerner writes on the uncomfortable desire to use the work of the imagination, his work, to charm his daughters and affect how they see him – although that too ends in self-effacement: 'I want to say that I enchant the ferryman with my playing so that lost pets may return, that the magnet tiles arrange themselves into complex hexagonal structures at my song, but they know I'm not the musical one, that I describe the music of others, capture it in hard plastic.' Lerner, 'The Media'.
15. Lerner, 'The Media'.
16. Lerner, in Leyshon, 'Ben Lerner on the voice-mail genre'.
17. Lerner, 'The Media'.
18. Lerner, 'The Media'.
19. Lerner, 'The Media'.
20. Lerner, 'The Media'.
21. Baskin, 'On the hatred of literature'.

Bibliography

Baskin, Jon. 'On the hatred of literature', *The Point Magazine*, 26 January 2020. Accessed 6 July 2020. https://thepointmag.com/letter/on-the-hatred-of-literature.

Gizzi, Peter. 'It Was Raining in Delft'. In *Sky Burial: New and selected poems*, 64. Manchester: Carcanet, 2020.

Lerner, Ben. *The Hatred of Poetry*. London: Fitzcarraldo Editions, 2016.

Lerner, Ben. 'The Media', *The New Yorker*, 13 April 2020. Accessed 2 May 2020. https://www.newyorker.com/magazine/2020/04/20/the-media.

Leyshon, Cressida. 'Ben Lerner on the voice-mail genre', *The New Yorker*, 13 April 2020. Accessed 2 May 2020. https://www.newyorker.com/books/this-week-in-fiction/ben-lerner-04-20-20.

Stonebridge, Lyndsey. 'The plague novel you need to read is by Bachmann not Camus', *Psyche*, 3 August 2020. Accessed 5 August 2020. https://psyche.co/ideas/the-plague-novel-you-need-to-read-is-by-bachmann-not-camus.

23
20,000 leagues under confinement
Patrick M. Bray

Confinement has a way of exacerbating our desire for comfort. Toilet paper, crisps, binge-watching Netflix, pyjamas. These are apparently what make us feel most ourselves. Not just 'safe' (what Giorgio Agamben calls 'bare life') but protected.[1] A video conference call in a necktie and shorts, while sipping a gin and tonic and calling it soda. 'Safe' comforts within the walls of the home resemble emotional barricades defending us from the chaos outside, no matter how dangerous or foreign. Yet relying on the 'safe' may keep us from facing our fears.

Living in London, I had planned to spend April and then the summer back in the US with my 10-year-old son, before the world stopped and the planes were grounded. Given that he was swamped with online homework from his teachers, I took the opportunity to help him out a few hours a day on video chat. It was a way to give us something to talk about besides the scary virus or, perhaps worse, Nerf guns, Legos and Minecraft. It was also a way to take him out of his comfort zone. But reading the dull-as-dust made-for-children books suggested by his teachers, ones that mirror what adult authors think 10-year-olds look and think like, made the prospect of video chats less pleasant; for me at least they were outside of my comfort zone. I lighted upon the idea of reading to him a book from my London flat. As a scholar of French, my collection of Marcel Proust, mystery novels, cookbooks and dictionaries didn't seem quite appropriate. By chance, I found an English copy of Jules Verne's *20,000 Leagues under the Sea* (1869–70), which I had recently rediscovered in a box of books I had read when I was my son's age. Maybe this could be a way to sneak in

some history, geography, maths, science, politics and French (as was the publisher Hetzel's original intention with the *Voyages extraordinaires* series)?

Luckily, he fell for it. Or fell into it. It probably helped that I skipped the endless pages about categories of fish, which bored both of us and were fairly embarrassing when I couldn't pronounce the Latin names (*Cypræa Madagascariensis* is particularly hard over Zoom). It helped motivate him too when I teased him about reading it in French if he stopped paying attention. The long arc of the story, 350 dense pages as opposed to the 40 pages of the books he is usually assigned, meant that our conversations after each chapter could focus on little details or our own experiences of travelling to the places described. Or what we would do with Captain Nemo's fortune, or how we might try to escape, like the harpooner Ned Land.

Perhaps unconsciously, I had picked the book, too, because, like most of Jules Verne's novels, the narrator describes a paradox of travelling the world from a confined, comfortable place. As the critic Roland Barthes argued, Verne's main novelistic invention was to '[g]age space by time, ceaselessly conjoin these two categories, risk both of them on the same throw of the dice or on the same always successful sudden impulse'.[2] Barthes criticises the tendency of Verne's characters to have a bourgeois desire for comfort and for imperialistic domination of the world, but I think he misses the deep irony of Verne's prose that questions these very tendencies. What ends up being considered essential or fantastically desired – comforting – to a nineteenth-century Frenchman projecting onto his young and not-so-young readers turns out to be quite instructive. Toilet paper or other 'bare life' necessities are never mentioned. Nemo takes with him in his underwater palace a huge library and art treasures, and feasts on the finest fish, while smoking sea-weed cigars. In *From the Earth to the Moon* (made famous by Georges Méliès' film adaptation), the space travellers bring in their bullet-shaped rocket ship a hunting dog, artwork and whiskey. Seeing the world from the comfort of your bourgeois living room, which Barthes saw as obviously colonialist, also reflects I would argue our experience of reading, especially as a child. When you are confined to your bedroom, books become your portal onto the world. Conversely, as we get older, a book can bring us back to the feeling of our first childhood adventures in reading.[3]

There was another, more troubling aspect, to reading Verne's masterpiece to my son as Covid-19 rages around the world. The outside environment in Verne's stories is always hostile, in a very non-politically-correct way – savages (whether gun-toting Americans after the Civil War

or South Sea cannibals), dangerous animals (giant squid, tigers) and the natural elements (lack of food or air, rough seas) add the necessary touch of adventure with the not-terribly-serious menace of death (what can really happen to a first-person narrator with 200 pages left in the book?). Still, leaving the comfort of the vessel (whether submarine, or our own bedroom) always appears frightening. Best to put on a mask to explore the ocean deeps. And practise social distancing with the natives when on land. Verne's formula usually involves some combination of a scientist (Aronnax, Professor Lidenbrock), a faithful servant (Conseil, Passepartout) and a brilliant misanthrope with a heart of gold (Captain Nemo, Phileas Fogg). A sort of Willy Wonka offering champagne instead of chocolate. Distrustful of humanity, Verne's misanthrope is nevertheless in solidarity with the oppressed, though he keeps his distance. The characters are happy in an octopus's garden, no one there to tell them what to do. At the end of most of Verne's novels, the adventurous group ends where they started, joining society again, happy to be home and leave behind the vessel (always in tatters). And the adults seem just a bit more grown up, enriched by knowledge and adventure. Life returns to normal.

A mere two months after the last chapter of *20,000 Leagues under the Sea* was published in serialised form, 'normal' was put on hold as France underwent the disaster of the Franco-Prussian War. Paris was under siege for months in 1870–1, brutally cut off from the rest of the world. Even the mail had to be sent via hot-air balloon, and hungry well-to-do Parisians paid for exotic animal meat from the zoo, straight out of a Verne novel. After months of siege, when rebels in the city refused to accept the newly formed Third Republic's truce with the Prussians, they declared Paris to be a self-governing Commune on 18 March 1871. (Exactly 149 years to the day later, the French Prime Minister would declare all public places closed to slow the contagion of Covid-19.) For two brief months after the Commune was declared, Parisians began to dream of a better world, and to make that dream into a reality.[4] Paris enacted the separation of church and state, the abolition of child labour, the abolition of interest on debts, rent moratoriums, citizenship for foreign residents, factories run by workers, equal pay for women, and civil unions, among countless other measures. Paris, isolated from France and the rest of the world in a militarised quarantine, nevertheless became a beacon of liberty and progress. These progressive ideals were crushed at the end of May 1871, when the French Third Republic, with the aid of the Prussians, invaded Paris from Versailles and killed between ten thousand and twenty thousand Parisians in a single week. The bubble of siege,

confinement and then progressive idealism was burst, and the new normal of incremental capitalist republicanism reinstated at gunpoint.

Moved by the principles of the Commune, 16-year-old poet Arthur Rimbaud wrote his famous letter of the 'Seer' calling for a 'long, immense, and reasoned derangement of all the senses'.[5] While we do not know for certain whether he was able to make it to Paris during the Commune, the young Rimbaud wrote over the summer of 1871 one of the masterpieces of nineteenth-century poetry, 'The Drunken Boat', inspired by the recent defeat of the Communards and by Rimbaud's passion for Verne's *20,000 Leagues under the Sea*. Rimbaud, still a child barely older than my own son, having at that point seen the ocean only through the fictional portholes of Verne's *Nautilus*, wrote of the dreams and nightmares of politics, adventure and childhood fantasy: 'A child crouching full of sadness, releases / A boat as fragile as a butterfly in May.'[6]

Nearly a century and a half later, when the entire world finds itself under siege from what many politicians unfortunately describe as an invisible viral enemy, the causes the Communards fought for have largely been accepted. It may even seem incredible that so many were willing to kill thousands of their countrymen to curtail such basic human rights. We are used to thinking of conservatism as a nostalgic mindset, whereas the left unsentimentally plans for a utopian future. And yet, history books and collective memory erase the leftist struggles and victories of the past. With every political spring, whether 1871 or 1968, or perhaps 2020, the basic ideas of equality and decent living conditions for all appear to be forever new and completely radical.

For those of us lucky enough to be in our comfortable domestic vessels, social distancing and occasionally risking our lives to go out and interact with the world, this is a time to reflect on our natural and our built habitat, how we see it and how we must change it. Confinement itself doesn't feel particularly strange. It can in fact be very comfortable, for the modern-day bourgeois, except that the health and wellbeing of the elite few very much depends upon the health and wellbeing of the 'deplorable' *demos* – underpaid cooks, housekeepers, Uber drivers can spread the disease to their rich employers. The initial shock of imposed loneliness gives way to a deeper shock, the idea that our salvation relies on the paradox of a solidarity of seclusion. For our own selfish needs, we urgently have to find housing for the homeless. We have to ensure running water for those whom we tell to wash their hands several times a day (in Detroit, several thousand homes still lack access to water, though will we do the same for the millions without clean water in poorer countries?).[7]

Low-wage workers in the gig economy must be guaranteed an income so as not to risk their health (and public health) by continuing to work.

Through the portholes of our lockdown abodes, the lives we were living when we were nominally free appear suddenly outlandish, our politics and our worldviews completely ill-adapted. Confinement invites us to return to that space we lived in as kids, when we used to read, and when the world was an unsettling place of desire and danger, only intelligible, we thought, to adults.

Whenever the risk of Covid-19 has been contained, will we want to return to the way things were? As Aronnax says when his companions plan an escape from the submarine: 'What a sad day I passed, between the desire to regain the possession of my freedom and the regret of abandoning this marvellous *Nautilus* . . . My novel would fall out of my hands after only the first volume, my dream interrupted at the most beautiful moment!'[8] But confinement, like childhood, dreams and revolution, is only passing. Confined, we nevertheless voyage around our unequal world, where we see that, no matter how distant we are in space, time or economic means, we are connected; the danger of this virus shows that the health of the most privileged on the planet is tied to the health of even the least privileged. Nemo understood it: 'I am still, and until my last breath I shall be, a countryman of the oppressed'.[9]

And my son understands it too, in his way, when he says, 'When it's all done, what's the next book we can read together?'

Notes

1. See Agamben, *Where Are We Now,* in particular pp. 17–18; and 38–42.
2. Barthes, *Mythologies,* 102. My translation.
3. We can think of Proust's essay 'Journées de lecture' ('On reading'), in which he defines reading as a solitary practice, especially in childhood, where the reader enters into a mysterious communication with other people in time and space. Proust, *On Reading*.
4. See Ross, *Communal Luxury*.
5. Rimbaud, *Œuvres complètes*, 250. My translation.
6. Rimbaud, *Œuvres complètes*, 66–7. My translation.
7. Lakhani, 'Detroit suspends water shutoffs'.
8. Verne, *Vingt mille lieues*, 393–4. My translation.
9. Verne, *Vingt mille lieues*, 332. My translation.

Bibliography

Agamben, Giorgio. *Where Are We Now? The epidemic as politics*, translated by Valeria Dani. London: Eris, 2021.
Barthes, Roland. *Mythologies. Édition illustrée*, edited by Jacqueline Guittard. Paris: Seuil, 2010.

Bray, Patrick M. 'Conceptualizing the novel map: Nineteenth-century French literary cartography'. In *Literature and Cartography*, edited by Anders Engberg-Pedersen, 279–98. Cambridge, MA: MIT Press, 2017.

Lakhani, Nina. 'Detroit suspends water shutoffs over Covid-19 fears', *The Guardian*, 12 March 2020. Accessed 21 September 2021. https://www.theguardian.com/us-news/2020/mar/12/detroit-water-shutoffs-unpaid-bills-coronavirus.

Proust, Marcel. *On Reading*, translated by William Burford and edited by Jean Autret. New York: Macmillan, 1971.

Rimbaud, Arthur. *Œuvres complètes*, edited by André Guyaux and Aurélia Cervoni. Paris: Gallimard, 2009.

Ross, Kristin. *Communal Luxury: The political imaginary of the Paris Commune*. New York: Verso, 2016.

Verne, Jules. *Vingt mille lieues sous les mers*. Paris: Le Livre de Poche, 1990.

Whidden, Seth. *Rimbaud*. London: Reaktion Books, 2018.

24
Reflections on *Guixiu/Kaishu* literary cultures in East Asia

Tzu-yu Lin

Introduction

In March 2020, British Prime Minister Boris Johnson announced that schools and childcare services in England were to be closed and encouraged people to work from home whenever possible to stop the spread of the deadly coronavirus. As the mother of an energetic three-year-old boy, my experience of working from home during the first few months of the pandemic was extremely challenging, and in some ways even traumatic. I was reading papers on Eileen Chang, having hoped to study her cross-cultural experience and its influence on her self-translation. I was soon fascinated by her resistance to the Chinese feudal system and the metaphorical significance of confined domestic spaces in her work. The balcony, for example, becomes a liminal space where the indoor meets the outdoor, and where Chang could breathe the air of freedom.[1] I must admit that, as a feminist literary scholar, I had never considered myself a fan of *Guixiu/Kaishu* literature, which has been considered a subgenre with limited scope in the category of women's literature in Sinophone countries. Over months of staying home, with limited opportunity for outdoor activities, I longed for some kind of spiritual consolation – and this was why I revisited *Guixiu/Kaishu* literature, a genre that is out of favour in a time when freedom of mobility is possible for most East Asian women.

The term 閨秀 ('Guixiu' or 'Kaishu'), literally denotes a well-bred lady from a wealthy family, and also refers to a woman with artistic, musical and/or literary talent. At its origins, *Guixiu/Kaishu* literature had no negative associations of regressive domesticity; rather, *Guixiu/ Kaishu* writers adopted a liberated outlook. This was the case in early twentieth-century Japan, when a group of intellectual women – Hiratsuka Raicho[2] (1886–1971), Yasumochi Yoshiko (1885–1947), Mozume Kazuko (1888–1979), Kiuchi Teiko (1887–1919) and Nakano Hatsuko (1886–1983) – set up one of the earliest Japanese feminist journals, *Seito*, also known as *Bluestocking*.[3] They were inspired by the prominent Japanese male writer, translator and scholar Ikuta Choko (1882–1936), who established the Kaishu Literary Society. For women writers of the time, *Seito* offered a platform to foster their talents and have their work published. Like the *keishu sakka* (lady writers)[4] in the Meiji era (1868–1912), Hiratsuka and her fellow editors had been born into affluent and privileged families, and therefore were educated at a higher level than was typical in Japan. Regrettably, *joryu bungaku* (women's literature) has since, as Joan E. Ericson points out, 'been bracketed off into a separate sphere',[5] and even today most Japanese bookshops still shelve *joryu bungaku* separately rather than in the section for the *bungaku* (literature) produced exclusively by male authors.[6] Despite the huge diversity of women's writing in Japan, *joryu bungaku* seems not to be able to escape the presumption of inferiority and exclusion from the category of 'proper literature'.

In China, the term *Guixiu* writers first appeared in the 1920s during the years of the May Fourth Movement, and referred generally to women's writers, before it came to be used to denote especially those who emerged in the 1940s and 1950s.[7] The *Guixiu* writers are considered to have inherited the gentle lyric tradition of Chinese literary culture, and to have developed a specific style of feminine Chinese writing.[8] Nevertheless, *Guixiu* literature, according to Mei-tzu Tsai, became a negative term in the 1950s and 1960s, when the Communist Party had taken control of the country, as *Guixiu* refers only to a writer belonging to a particular social class.[9] Therefore, once a woman writer had been called a *Guixiu* writer, it would suggest that she is lacking social consciousness concerning the outside world, unaware of the pains and suffering of people in lower socio-economic classes.[10]

Situated in between Chinese and Japanese cultures, Taiwanese literature has inherited the literary traditions of both countries. The term 閨秀 *(Guixiu/Kaishu)* therefore has multiple meanings and layers of

complexity in Taiwan, which is home to both Sinophone *Guixiu* and Japanophone *Kaishu* writers. However, literary criticism has not fully explored this literature by including those works written in Japanese. Until now, the category of 閨秀 literature in Taiwan has mainly referred to the works of writers born into privileged expatriate families from mainland China who had received an elite education, either in China or in post-war Taiwan. Emerging in the 1980s, *Guixiu* writers, whose lyrical style follows the Chinese literary traditions and rhetoric, made a significant contribution to forming Taiwan's mainstream literary sphere at a time when the Chinese nationalist regime was being destabilised by Taiwanese nativism on the island. Consequently, Taiwanese nativist feminist critics, such as Chiu Kuei-fen, Lu Cheng-hui and Yu Cheng-yi, contend that this group of *Guixiu* writers, through their superficial and shallow descriptions on themes relating to 'womanly issues', were merely serving patriarchal Chinese nationalism, and that they monopolised the limited opportunities for 'grassroots' writers born in Taiwan. But in fact, the dispute over *Guixiu* literature is not confined to the purported superficiality for which it has often been criticised. The tension between Chinese *Guixiu* and Taiwanese feminists, I argue, is a proxy for the war between Chinese nationalism and Taiwanese nativism. This might be why Yang Chian-he (1921–2011) and Ku-Yen Bi-hsia (1914–2000), who were also from privileged and affluent families, and highly educated, but whose political ideology was aligned with that of the nativist feminist critics, have never been recognised or maligned as '閨秀 writers'.

As Taiwanese scholar Fan Ming-ju observes, *Guixiu* literature is now a negative term when referring generally to women's writing.[11] Yu also argues that *Guixiu* has been used to ridicule a supposed lack of depth and of self-awareness in women's writing.[12] Even the author Chou Feng-ling is herself aware that, these days, the term is no longer a descriptor for a privileged woman writer, but an insult.[13] So, it is not surprising that, as Yu describes, there was an opportunity for women writers such as Chou Feng-ling, Su Wei-chen and Chian Chen to evolve from *Guixiu* writers to feminist writers, and to prove that a 'liberated Guixiu' could still contribute to the literary culture of the 1990s.[14] As Yu points out, literary works by Chou, Su and Chian have eagerly turned away from *Guixiu* style, leaving their past behind to seek approval from feminist critics and readers, and because of this shift they have outshone other *Guixiu* writers.[15] Like their male counterparts, women writers will change their writing styles when they feel it necessary, but I would argue it is unnecessary to diverge from *Guixiu* style as outdated or as something inferior to feminism – these literary works do, after all, assemble different facets and different periods

of contemporary Taiwanese women's writing, where Chinese *Guixiu* culture and a modified version of Western feminism converge.

Unlike works by male writers, which have been considered full of diversity, women's writing in terms of *Guixiu/Kaishu* has long been considered dull, unimaginative and incapable of competition with their male counterparts' work.[16] However, when we investigate the historical background of *Guixiu/Kaishu* cultures in East Asia, as I will further discuss below, it appears highly likely that criticism of *Guixiu/Kaishu* literature has been shaped by the terms and conditions of feudal systems.

Historical context of Guixiu and Kaishu cultures in East Asia

In the societies of the pan-Chinese cultural zone in the Qing Dynasty (1636–1912), physical immobility was commonplace for women due to the custom of binding the feet of young girls. Therefore, women's mobility beyond the domestic space in traditional Chinese societies was restricted not only by social conventions, but by their physical conditions. In addition to the East Asian tradition of 'sitting the month' (postpartum confinement),[17] the foot-binding custom was also practised in Chinese immigrant communities in Taiwan. Until the early twentieth century, there was a tradition of selecting daughters-in-law by foot size.[18] Marriage, at the time, was believed to be the only path for women, so families that could afford to hire servants for household labour would have their girls' feet bound when they were as young as five years old, hoping to negotiate a good marriage contract when they reached their teenage years.[19]

From the Meiji restoration onward, Japan came to be influenced significantly by the West. Since then, girls and young women have been admitted to schools and enrolled in physical education classes. However, the purpose of introducing Westernised education was not to liberate women, but to serve a conservative goal: preparing them to be good wives and wise mothers with up-to-date knowledge. The restrictions on women's lives remained obvious in all aspects of Japanese culture. For example, in Japanese, a married woman is called 'Oku-san'. 'Oku' means 'interior space', and 'Oku-san' can be translated literally as 'the lady of the house'.[20]

On the other hand, although in Meiji Japan (1868–1912) the government had already set out to transform the country, meaning that, for the first time, young privileged upper-class women such as Hiratsuka

Raicho could enter higher education,[21] it was not until the 1910s that a limited number of girls' public schools were established in colonial Taiwan.[22] For these young girls who gave up home schooling to attend public schools, school attendance meant they needed to commute, go on field trips and participate in physical education classes, which prompted them to depart from traditional conventions such as foot binding and confinement in the home.[23] Chinese communities in Taiwan underwent huge changes during the Japanese colonial period (1895–1945), when the modernised and Westernised practices of Japanese colonial culture first confronted conventional Chinese culture in Taiwan. The banning of foot binding, as a practice of de-Sinicisation, was one of the most important policies in colonial Taiwan. After 50 years of colonisation, the inhumane tradition of foot binding was finally uprooted completely. However, the mobility of young Taiwanese women was not unrestricted – they were still not allowed to travel freely beyond home and school.[24] Therefore, with educated women granted only this limited mobility, it is not surprising that their literary works put great emphasis on narrating experiences of marriage, wifehood, childcare responsibilities, domesticity and women's experiences of school life.

Under such restricting social conventions, how can it be fair to criticise *Guixiu/Kaishu* literature as limited in its scope? How can it be fair that these authors have been criticised for not writing about colourful lives spent travelling around Japan, China and other countries as their male counterparts were able to do? Indeed, the subject matter of *Guixiu/Kaishu* literature has its limitations, but this simply reflects the fact of the inequality between genders and nothing more.

However, it does not necessarily mean that under such limiting conditions great literature cannot be created.[25] Japanese woman writer Takahashi Takako (1932–2013), for example, features in her literature women who struggle against domestic roles and expectations, manifesting a new feminist viewpoint that contributed significantly to women's liberation and social transformation in 1970s Japan.[26] Other women writers such as Hikari Agata (1943–1992) and Tsushima Yuko (1947–2016) redefined the meaning of family by investigating women's experiences and those of their children, chronicling the effects of divorce and broken relationships.[27] Yoshimoto Banana (born 1964) even uses domestic space as metaphor to tackle the issue of transgenderism and further expand the notion of family. Taiwanese woman writer Huang Bao-tao (dates unknown) elaborates on bonds between family members to tackle complex issues such as Japanese colonialism and the patriarchy of traditional Chinese/Taiwanese societies. Ku-Yen Bi-hsia, in her banned

novella *Stream* (1942), presents the difficulties of a well-educated mother in answering her daughter's queries about the racism of Japanese classmates. The themes mentioned above were all ground-breaking at the time when these authors composed their literature.

Literary metaphors in *Guixiu/Kaishu* literature

As discussed above, family, child rearing, marriage, domestic space and the private sphere have commonly been used as literary metaphors in *Guixiu/Kaishu* literature. Interestingly, even in works categorised as feminist writing, as Yu points out, these topics play central roles in threading the storylines, while only the linguistic style has changed: from conservative to radical, from implicit to explicit and from traditional narrative modes that deploy confined structures to streams of consciousness.[28]

Despite domestic spaces having long been gendered female and stereotyped to link women with their traditional role in the care and maintenance of the home, the representation of domestic space in literature gives scope for educated career women or feminist writers to deal with gender inequality and women's developing consciousness of gender difference.[29] Among these domestic spaces, the kitchen is one of the most vital – as although male writers also deal with the topics of cooking, food and food history, they seem to care little about the space of the kitchen.[30] This is evident not only in their literary works, but also in the fact that the male-dominant literary sphere, as Tsai suggests, pays little attention to literary works about kitchen space when selecting women's literature for inclusion in literary canons such as the two-volume *Essays by Taiwanese Women over the Fifty Years* (2006). Literature on the kitchen has wrongly been thought of as unimaginative, unhelpful to women's developing self-consciousness, outdated and inessential to modern societies.[31] Tsai lists the examples of Chian Chen's 'Sensational Kitchen' (2003) and 'Miancha' (1989) and Xi Murong's 'The Lius' Fried Sauce Noodles' (2003) in arguing that writing about kitchen spaces can still express women's sexual desire and deal with complicated issues, such as conversations between different social classes and the struggles of being both a career woman and a mother.[32]

The metaphors of domestic spaces have also driven women writers' creativity in diverse literary productions since Meiji Japan. The complicated and alienating effects of domestic duties and responsibilities on the female characters' senses of identity and their social relationships

(familial and beyond) have been extensively explored.[33] The story 'Her Daily Life' (1921) by Tamura Toshiko (1884–1945), for example, portrays the conflict between women's careers and their household duties at home. The protagonist Masako rejects her motherly duties and the traditional conventions shaping women's lives in order to pursue her own vocation of artistic and professional writing. It is clear that the struggles between domestic roles and women's independence still haunted female writers in Tamura's time. Takahashi Takako (1932–2013) explores the dark side of domesticity in her story 'Congruent Figures' (1982). As feminism in Japan evolves over time, the domestic space has been reconciled with female self-awareness and autonomy.[34] Tsushima Yuko (1947–2016), for example, revisits domestic space and motherly duties from a female-centred perspective where she echoes the idea, proposed by feminists in the 1970s, that 'the rejection of patriarchy need not entail the rejection of motherhood'.[35] In telling the story of an atypical family and using one of the most important sites in the home, Yoshimoto Banana's *Kitchen* (1988) brilliantly challenges the traditional concepts of home, parenthood and stereotyped gender roles within the family. For Yoshimoto, the kitchen is not just the site and symbol of an ideal notion of the family – it can be the heart of a home, where the home can be recreated through a process of self-identification and even by a non-traditional cast of characters of family members, including friends and a newly transitioned transgender family member who used to be the protagonist's father.

In writing from women's perspectives, *Guixiu/Kaishu* literature has long been criticised for focusing on 'womanly issues', such as childcare, marriage and narratives taking place in domestic spaces. The eminent Taiwanese author and critic Chung Chao-cheng claims that *Guixiu/Kaishu* literature merely spins around trivial household incidents happening around these women writers, and nothing is to be found in their literature beyond their own (boring) life experiences.[36] In fact, as argued above, *Guixiu/Kaishu* literature has redefined what should be considered as vital to literature, by focusing on subject matter that has long been ignored by patriarchal authors or critics. It would be a shame if the literary metaphors of 'womanly topics' used by the *Guixiu/Kaishu* writers to create a new experience of enlightenment continued to be construed only as 'trivial household incidents'.

Artistic activities and creativity in the domestic space: past, now and future

Home and domestic environments have long been stereotypically associated with women writers – but, as discussed above, artistic works focusing on domestic issues are neither inferior to nor less challenging to create than those concerning activities exterior to the home. During the Covid-19 pandemic, when home schooling has become widespread and only limited opportunities for social exchange are available, it is more vital than ever for writers and artists to rethink the ways in which domestic environments and activities can be important resources for literature and the arts. As discussed in this chapter, these experiences of restricted mobility are comparable to what the *Guixiu/Kaishu* experienced in the late nineteenth century and the first half of the twentieth century. After months of 'lockdown' in our homes, it is time for us to reconsider criticisms of women's writing, which has been unjustly discriminated against as secondary to the 'proper literature' of male authors whose life experiences exterior to the home have been much more vibrant than women's.

As explored above, women's literature has represented homes as multi-layered spaces of unbearable obligation, self-realisation, sexual desire and loneliness, and as wretched prisons of domestic violence. These spaces are impossible to live in simply on women's own terms, by excluding the strong involvement of men, husbands and fathers, who are also interlopers in such potentially inspiring spaces. By illuminating the historical context and reception of *Guixiu/Kaishu* literary cultures in East Asia, this chapter intends not only to revisit this literary tradition from a sympathetic perspective, but also to call attention to the breaking of the strict division of gender roles in literary works before the time of Covid-19, where the man or husband was supposed to act mainly in the public sphere, and the woman or wife was to create the warm and nurturing atmosphere that defined the home. By revisiting our ideas of how domesticity and the home should be, and by appreciating the artistic value of women's literary works focusing on the home, we – as human beings surviving in this brave new world – can continue to create a whole new form and value system for literary art for generations to come.

Notes

1. Chang, 'Chinese life and fashions', 54.
2. The Japanese and Chinese names in this chapter are given with family names first, then given names.
3. The magazine was launched in 1911. The name 'bluestocking' originated from the nickname for the eighteenth-century English women's salon. 青踏 (Seito), a term rendering 'bluestocking' into Chinese characters, 'marked a kinship with contemporary Western use of the term as a pejorative for intellectual women' according to Bardsley ('Seito and the resurgence of writing by women', 93).
4. A term derived from Chinese, denoting women of good breeding and significant talent. *Keishu sakka* has been seen as synonymous with 'women writers' in Japan (Copeland, 'Meiji women writers', 70).
5. Ericson, *Be a Woman*, 23–5.
6. Orbaugh, 'Gender, family, and sexualities', 49.
7. Tsai, 'Study on the historical derivation', 67.
8. Tsai, 'Study on the historical derivation', 67.
9. Tsai, 'Study on the historical derivation'.
10. Tsai, 'Study on the historical derivation', 2.
11. Fan, *Women, Roses of Different Colours*, 134–6.
12. Yu, 'From Kuei-hsiu literature to feminist writing', 144.
13. Yu, 'From Kuei-hsiu literature to feminist writing', 144.
14. Yu, 'From Kuei-hsiu literature to feminist writing'.
15. Yu, 'From Kuei-hsiu literature to feminist writing', 154.
16. Copeland, 'Meiji women writers', 72.
17. In East Asia, women must stay indoors for a month after they give birth to a child, and some are not even allowed to leave their beds.
18. Hung, *Kindai Taiwan Josei-shi*, 44.
19. Hung, *Kindai Taiwan Josei-shi*, 65.
20. Hiratsuka, *In the Beginning, Woman Was the Sun*, 244.
21. Hiratsuka, *In the Beginning, Woman Was the Sun*, viii.
22. Hung, *Kindai Taiwan Josei-shi*, 114.
23. Hung, *Kindai Taiwan Josei-shi*, 126–8.
24. Hung, *Kindai Taiwan Josei-shi*, 128.
25. Lin, 'The invisibility of Japanophone Taiwanese women's writing', 142.
26. Seaman, 'Inner pieces', 56.
27. Seaman, 'Inner pieces'.
28. Yu, 'From Kuei-hsiu literature to feminist writing', 159–64.
29. Seaman, 'Inner pieces', 65; Tsai, 'Space of happiness', 346.
30. Tsai, 'Space of happiness', 346.
31. Tsai, 'Space of happiness', 347.
32. Tsai, 'Space of happiness', 344–8.
33. Seaman, 'Inner pieces', 55–6.
34. Seaman, 'Inner pieces'.
35. Seaman, 'Inner pieces', 59. Ueno, 'Collapse of "Japanese mothers"', 257.
36. Chung, *Lecture Series on Taiwanese Literature*, 197.

Bibliography

Bardsley, Jan. 'Seito and the resurgence of writing by women'. In *The Columbia Companion to Modern East Asian Literature*, edited by Joshua Mostow, Kirk A. Denton, Bruce Fulton and Sharalyn Orbaugh, 93–8. New York: Columbia University Press, 2003.

Chang, Eileen. 'Chinese life and fashions', *The XXth Century* 4 (January 1943): 54–61.

Chen, Fang-ming and Chang Jui-feng 陳芳明、張瑞芬, (eds). 五十年來台灣女性散文. 選文篇 [*Essays by Taiwanese Women over the Fifty Years*], 60–3. Taipei: Rye Field Publishing, 2006.

Chian, Chen 簡娟. '麵茶' [Miancha]. 下午茶 [*Afternoon Tea*]. Taipei: Tayen, 1989.

Chian, Chen 簡娟. '肉慾廚房' [Sensational kitchen]. In 台灣飲食文選 I [*Taiwanese Food in Literature I*], edited by Chiao Tung, 245–6. Taipei: Fish & Fish, 2003.

Chiu, Kuei-fen 邱貴芬. 日據以來台灣女作家小說選讀 (下) [*Taiwanese Fictions by Women Writers Since the Japanese Colonial Rule II*]. Taipei: Fembooks, 2001.

Chung, Chao-chen 鍾肇政. 台灣文學看法十講 [*Lecture Series on Taiwanese Literature*]. Taipei: Chien-wei, 2000.

Copeland, Rebecca. 'Meiji women writers'. In *The Columbia Companion to Modern East Asian Literature*, edited by Joshua Mostow, Kirk A. Denton, Bruce Fulton and Sharalyn Orbaugh, 69–73. New York: Columbia University Press, 2003.

Ericson, Joan E. *Be a Woman: Hayashi Fumiko and modern Japanese women's literature*. Honolulu, HI: University of Hawai'i Press, 1997.

Fan, Ming-ju 范銘如. 女人, 是變色的玫瑰 [*Women, Roses of Different Colours*]. Taipei: Chien-hsing, 2003.

Hartley, Barbara. 'Feminism and Japanese literature'. In *The Routledge Handbook of Modern Japanese Literature*, edited by Rachael Hutchinson and Leith Morton, 82–94. London: Routledge, 2016.

Hiratsuka, Raicho. *In the Beginning, Woman Was the Sun*, translated by Teruko Craig. New York: Columbia University Press, 2006.

Hung, Yuru 洪郁如. 近代台灣女性史: 日治時期新女性の誕生 [*Kindai Taiwan Josei-shi: Nihon no Shokuminchi Tochi to 'Shin Josei' no Tanjo*]. Taipei: National Taiwan University Press, 2017.

Ku-Yen, Bi-hsia 辜顏碧霞. 流 [*Stream*], translated by Chen-jui Chiu. Taipei: Grassroots, 1999.

Lin, Tzu-yu. 'The invisibility of Japanophone Taiwanese women's writing and its translation'. In *Feminism(s) and/in Translation*, edited by José Santaemilia, 137–46. Granada: Comares, 2020.

Lu, Cheng-hui 呂正惠. '分裂的鄉土, 虛浮的文化—八〇年代的台灣文學' [Divided soil, culture of vanity: Taiwanese literature in the 1980s]. In 戰後台灣文學經驗 [*Postwar Taiwanese Literary Experience*], 129–35. Taipei: Hsindi, 1995.

Orbaugh, Sharalyn. 'Gender, family, and sexualities in modern literature'. In *The Columbia Companion to Modern East Asian Literature*, edited by Joshua Mostow, Kirk A. Denton, Bruce Fulton and Sharalyn Orbaugh, 43–51. New York: Columbia University Press, 2003.

Seaman, Amanda C. 'Inner pieces: Isolation, inclusion, and interiority in modern women's fiction'. In *Routledge Handbook of Modern Japanese Literature*, edited by Rachael Hutchinson and Leith Morton, 55–66. London: Routledge, 2016.

Takahashi, Takako. 'Congruent figures', translated by Noriko Lippit and Kyoko Selden. In *Japanese Women Writers: Twentieth-Century Short Fiction*, 168–93. Armonk, NY: M. E. Sharpe Inc., 1991.

Tamura, Toshiko. 'Her Daily Life', translated by Kyoko Selden. In *More Stories by Japanese Women Writers: An Anthology*, edited by Noriko Lippit and Kyoko Selden, 9–25. Armonk, NY: M. E. Sharpe Inc., 2011.

Tsai, Mei-tzu 蔡玫姿. '閨秀風格小說歷時衍生與文學體制研究' [Study on the historical derivation (ramifications) of Kuei-hsiu literature and the interactions within the overall literature framework]. Unpublished PhD thesis. Hsinchu: National Tsing Hua University, 2005.

Tsai, Mei-tzu 蔡玫姿. '幸福空間、區隔女人、才女禁區—初論1960年後廚房空間的性別議題' [Space of happiness, segregation of women, forbidden zone for women of intellect: A gender study of the kitchen space in post-1960s Taiwanese literature], 東海中文學報 [*Tunghai Journal of Chinese Literature*] 21 (2009): 337–70. https://doi.org/10.29726/TJCL.200907.0014.

Ueno, Chizuko. 'Collapse of "Japanese mothers"'. In *Contemporary Japanese Thought*, edited by Richard Calichman, 246–62. New York: Columbia University Press, 2005.

Xi, Murong 席慕容. '劉家炸醬麵' [The Lius' Fried Sauce Noodles]. In 台灣飲食文選 *II [Taiwanese Food in Literature II]*, edited by Chiao Tung, 55–66. Taipei: Fish & Fish, 2003.

Yoshimoto, Banana. *Kitchen*, translated by Megan Backus. New York: Grove Press, 1993.

Yu, Chen-yi 余貞誼. '閨秀文學到女性主義書寫: 以場域觀點論周芬伶' [From Kuei-hsiu literature to feminist writing: An analysis of Chou Fen-ling from the perspective of Bourdieu's field theory], 台灣文學研究學報 [*Journal of Taiwan Literary Studies*] 21 (2015): 131–72. https://doi.org/10.6458/JTLS.

25
At home: Vaughan Williams' 'The Water Mill' and new meanings of 'quotidian'

Annika Lindskog

Ralph Vaughan Williams is a composer whose musical output is often connected with the outdoors, specific geographies and the English landscape in general. In his complete oeuvre there are some 80 songs, often setting significant poets: some of the better known song-cycles, like *Songs of Travel* (R. L. Stevenson, 1904) and *On Wenlock Edge* (A. E. Housman, selections from *A Shropshire Lad*, 1909) exemplify both traits. These songs, together with a not insignificant part of Vaughan Williams' work in general, often seem to connect human life on both an individual and collective level with the landscape(s) and localities which surround us and in which we live, as places in which we develop our own senses of being and work out our interaction with the world at large (often with nationally collective resonances).

'The Water Mill', however, is set indoors, relates only to one specific family and details no obvious development, either narratively or psychologically; nor can the poet be said to belong to a contemporary list of highly relevant or significant writers. Fredegond Shove (1889–1949) seems in fact only to have been published once, in the fourth anthology of 'Georgian' poetry (1918–19) in a series curated by Edward Marsh; Banfield branded this 'the least incisive' of the anthologies.[1] Shove was a family relation of Vaughan Williams, and in what (little) mention there is in the literature on the set of four songs to texts of hers to which 'The

Water Mill' belongs,[2] this fact is usually allowed to occasion some speculation as to Vaughan Williams' motivation for engaging with it.

'The Water Mill' was first performed in a concert in London on 27 March 1925, almost exactly 95 years before the first UK lockdown in 2020. Its text describes the setting of a working mill, and the daily business of its occupants (human as well as animal, and even inanimate). There is a mill, 'an ancient one', and the miller's house 'joined with it'; swallows flit in and out, the cat plays in the loft. There is a clock, which strikes the hour; the miller's wife and his eldest girl see to chores, and the children play after school, barefoot by a twilit pool. At the end there are supper, needle-work, thoughts of the future; a moon shining gold and a lamp shining buff.

One very apt description of the song (indeed one of very few) calls it 'a Dutch painting in music'.[3] This is evocatively relevant. The content of the poem has the air of describing an interior portrait of family life (despite starting outside) and a musical setting with partly statically repetitive characteristics appears to be providing an effective 'framing' of this tableau (despite the narrative time-span across a full day). The setting is strophic in the sense that it breaks down into six sections, which use similar melodic and harmonic ideas. These are closely enough related to be conceived of as verses, but none is exactly the same as any other (thereby technically making the setting through-composed, despite its strophic appearance). It is loosely structured as AABBA(B), as the first two verses follow a similar shape, verses three and four take a slightly varied (but again shared) form, before verse five returns to the A format, and the final sixth starts as a B-variant but ends up developing into a coda using characteristics from both the A and B parts. All verses also vary in length, between 12 and 18 bars, as does the length of the transfers between the sections, and neither melodic shape nor harmonic progression is precisely identical in any of the verses. The song is in fact full of constant variations, yet there is enough shared material across the sections – particularly in recurring leading notes, harmonic ideas and melodic shapes – for it to be perceived of cohesively. This is helped by one of the song's most noticeable characteristics: the shape of the piano accompaniment. As Schubert set his 'Gretchen am Spinnrade' to the steady rhythm of the spinning wheel itself (which breaks off only when Gretchen imagines the kiss from Faust), Vaughan Williams in his piano accompaniment evokes the turning of the millwheel (see Figure 25.1). Although not as constant in its repetitive imitation as Schubert's 'Spinnrade', the accompaniment nevertheless flows consistently throughout, sometimes meandering more river-like, sometimes running

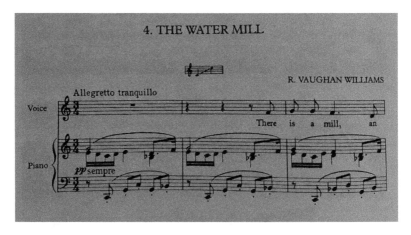

Figure 25.1 Bars 1–3 from 'The Water Mill' by Ralph Vaughan Williams (1872–1958), words by Fredegond Shove (1889–1949), from 'Four Poems by Fredegond Shove'. © Oxford University Press 1925. Reproduced by permission. All rights reserved.

a number of spins together in longer loops, and sometimes responding directly to the narrative focus, but never breaking off its rhythmical underpinning of the constancy of the song.

Quotidian

In a masterclass a few years ago, the keyword for this song was suggested to be 'quotidian'.[4] Its narratively strophic structure, mundane topical material and lack of dramatic drive provide few clues for how to perform it, at least in a way that makes it engage, rather than sound like an inventory of interior detail. It seemed then that 'quotidian' represented a range of limitations only: a sort of pedestrian steadiness, devoid of development or multiple perspectives, and lacking in emotional range – apt, perhaps, for the unremarkable every-day, but poetically and artistically less exciting. Technically, and from a performative perspective, however, it is at the same time rather un-'quotidian'. Although its fluidity and easily grasped sectionality make it appear straightforward and steady, the constantly turning mill wheel, together with the myriad subtle variations, in fact require a substantial degree of balance, dexterity and speed from the performers.[5]

In addition, both singer and pianist need to be alert to instantaneous changes of mood, character and rhythm, as the music constantly responds

to the textual narrative. The closer we look at this song, the more life we discover. 'The Water Mill' teems with details and experiences to relate in time to the rhythm the wheel's motion sets. And, as it revels in imagery, textures and sound, it fundamentally challenges our perception of 'quotidian'. The song opens, as above, by establishing location both in text ('There is a mill') and in the music (the millwheel figure). In the first verse, the narrative gaze approaches the mill, taking in its appearance ('brown with rain and dry with sun'), and noting the miller's house 'joined with it'. We will eventually go inside, but first the song observes its surroundings. There are swallows flitting 'to and fro, in and out, round the windows all about'. Although the millwheel is not explicitly mentioned until the next verse, the music anticipates it here by letting the swallows turn in half-circles, indicating an intimate connectivity between the surrounding nature and the driving engine of the millstead. Verse two then introduces the millwheel itself, its seminal role echoed in the prominent, driving quaver figures in the piano, as it 'whirrs' and the water 'roars', out of the 'dark arch by the door'. Here too, however, the mechanics of the wheel are softened by the tactility of the surrounding nature, as 'the willows toss their silver heads' and the phloxes 'smell sweet in the rain': the last phrase semi-melancholically word-painted through a harmonic shift (a C-major chord in an A-major passage allows 'sweet' on a C to sound 'flattened', a little wistful).

Harmonic qualities and contours are indeed an essential part of how the song adds layers of interpretation to the text. It starts and finishes resolutely in C major, and any excursion away from that key is always followed by an eventual return. In between, however, it plays consistently with shifting harmonic ideas and variations of scales. The end of the first bar of the piece, already, uses a flattened 7th to turn the wheel over – a B♭, where a B would have been the C-major scale-relative option. This suggests use of modality, i.e. employment of scales other than the 'standard' major and minor ones. The tonality therefore becomes somewhat slippery, not entirely predictable, though all the while the repeated figures in the piano and shapes of the vocal line (also taking much of its form from turning, circular patterns), together with the repeated returns to the home key tonality, give an overall sense of stability. The song also manages to shift between various key positions at different points without losing that stability: verse three moves to a minor (the C major parallel key, so still quite closely related), while verse four starts in D major (related to the previous A minor as its subdominant, and anticipated in the previous verse as such, but now quite far away from C

major). Yet each time it does, it eventually finds its way back to C major and its innate security in the home key.

These harmonic fluctuations are part of the score's sensitivity to the text, but also part of its own playfulness. The two middle verses, those in contrasting keys, focus on the feline and inanimate inhabitants: the cat and the clock respectively. The mill cat is a tabby, 'as lean as a healthy cat can be' (a particularly pleasing phrase to sing). Here the piano breaks off its millwheel figures, and while the left hand 'walks' the song forward (rhythmically regular step-wise figures tend to create this effect – or is it perhaps the cat?) under the right-hand chords, both parts emphasise smooth legato lines, in which the cat gently plays 'in the loft, where the sunbeams stroke', and 'beetles choke in the floury dust'. The end of the verse links the cat's playing back to the setting as it returns the accompaniment to the millwheel, which for four bars suddenly 'goes round' very intensely, but quietly, in a dreamlike F# major – the most outlying chord in the entire piece – while the miller's wife 'sleeps fast and sound'. The song is here interlinking the space itself with those who inhabit it, while suggesting temporal juxtapositions between play and rest.

It might be argued that this is the first actual glimpse we get of the mill's (human) inhabitants. But as the initial gaze focused on 'the miller's house', the existence of its occupants has been established all along. What is missing is only a direct focus on them: instead they have been described through the surroundings they inhabit. In verse four we move inside the house, and encounter a clock. In strikingly imitative sound-painting, the piano marks out the ticking seconds, inserting occasional flurries of the wheel, and towards the end chimes the hour, 'when shadows drowse or showers make the windows white'. The inside-out perspective here is a new angle, and the ethereal poetic quality of the reflection seemingly a contrast to the workmanlike, almost plodding, characteristic the clock first seems to display. It is the eternal qualities of the clock, or rather of time, that are being emphasised here, however, and the duality of time as both a marker of our condition as productive beings, on the one hand, and as an intangible, precious commodity which we cannot control on the other. 'Loud and sweet, in rain and sun, the clock strikes', therefore. While the text brings closure as 'the work is done', the millwheel has other ideas, and restarts on the very next beat.

Thus, and in accordance with that constant movement of time, verse five brings us back to the everyday reality (back in C major), as the wife and the eldest daughter 'clean and cook, while the mill wheel whirls'. The children go off to school and come back and play at dusk by the twilit

pool, 'barefoot, barehead, till the day is dead', and their mother 'calls them into bed'. The children's play occasions a new rhythm: the piano elongates its quavers into triplets, which gives a whole new rhythmical texture, separating the young from the household chores and the task of the mill. The location of the pool brings back the flowing semi-quavers briefly, but when the children go in to bed it is again to the triplets, setting the children's world at a slight tilt to the adult one.

By the final verse, verse six, we have somehow lived through the day at the water mill, and at last, supper stands on 'the clean-scrubbed board'. The tactility of the everyday detail is foregrounded as the roaming gaze takes in the closing of the day, and after the wistful young men (long arpeggios in the accompaniment; high, long notes in the voice) have visited, for 'his daughter's sake', and she 'drives her needle and pins her stuff' while not knowing what future to choose and the piano waits her out, the day eventually stills into an end of moonlight and lamplight. Above gazes the moon, with the perspective of longevity; below, the lamp lights the moment, the instant, reflecting both the passing day and the approaching repose of the night-time in its encompassing buff circle of light. The mill wheel keeps turning, now at ease in the C major key it has stopped trying to make escapades from, climbing softly at the end into the lighter spheres of sleep and dream.

Home

Far from equating 'quotidian' with the mundane, unremarkable or dull, the song, I have come to see, is a revelling in moments, of those myriad and texturally varied instances that make up our daily lives, defined and reflected against the places where we exist. It is the dust and the slanted sunrays and the changing seasons and the chores and the feel of the physicality of our surroundings and, when we remember, the air that fills them.

The gentle, steady, circular motions of the piano carry us forward, set the time and motion the day on, while reminding us of the relationship between our work, our home and our existence. The vocal line interlinks the separate parts of the day, the indoors and outdoors, the family and the children and the visitors, the work and play and dreaming. The harmonic variations permeate the atmosphere of this being, flashing colours amongst the steady rhythm of the day and the translucent tangibility of the homestead.

By the 1920s, there were relatively few working water mills left in England. Although some had survived up to the Great War, alternative sources of power, together with the displacing of millstones by steel roller mills, eventually caused the inexorable decline of both wind and water mills. The world evoked in 'The Water Mill' therefore was already at the song's conception a past setting on which the song looked back, potentially perceived (nostalgically) as containing qualities preferential to those of contemporary circumstances. Banfield, in his investigation into English song in this period, also identifies the interwar ambience as 'primarily one of lyrical retreat', and defines one major direction of Georgian poetry (to which Shove belongs) as a 'retreat to the country' (208). To point up one example of topical focus, he quotes Ivor Gurney, to Banfield the Georgian composer *par excellence*: 'There are not many things that make worthy art. They are, Nature, Home Life (with which is mixed up Firelight in Winter, joy of companionship etc.)'.[6]

'The Water Mill' seems to encompass all of these at the core of its expression (if we let the evening lamp stand in for the firelight). Any charge of 'simplicity' made against this tableau would, however, need to consider that the 'simplicity' consists mainly of shorter distances between our needs and how we respond to them, and perhaps of greater transparency about the roles we inhabit and how we achieve them. In the daily routines of the mill life, there are, simply, fewer miles to traverse between the constitutional parts, and less distraction from noises off.

And this is where 'The Water Mill' starts to resonate beyond the heyday of life lived out in a long-gone past, and beyond the interwar period in the first half of the last century (although we might want to be alive to parallels in levels of circumstantial challenges). 'Auch kleine Dinge können uns entzücken', to cite Paul Heyse (and Hugo Wolf), and in 'The Water Mill', it is these 'small things' that fill the rooms and the lives contained within them, and which are the main charge for the song-setting to explore and engage with.

'Home' has, during the years of the pandemic, taken on a different significance, as it has become more central to our daily lives, and a greater part of how we define ourselves. In 'The Water Mill', this inter-agency between home and our various roles – as workers, homemakers, cooks, parents, children, friends, cat owners – is articulated in a relationship between the dwellers and the dwelling itself, the shape of the building and the nuances of its textures. The song is therefore neither nostalgic escapism, nor in any actual sense 'quotidian': rather, it is engaged in the business of an inquisitive and perceptive exploration of the multi-layered

spatial and temporal architectures in which we live and work and grow (and still dream).

It is not 'easier' to be at home. The repeated rhythms that constitute the driving force of the millwheel, and which the piano illustrates, require constant application to keep steady, while the ever-changing surroundings cause shifts needing to be accommodated. It is a spatially restrictive existence, lacking the vivaciousness of further-flung exploration, and contained within daily cycles and repeated chores. Yet within that space, through which the gentle circling of the voice and the repeated motions of the piano are spinning continuous threads, there are to be found nuances, textures, sounds and smells: the wafts of phloxes and flitting of swallows, the tactility of cats' paws, the freedom of barefoot children, the contentment of the dinner table and the peace of the evening. The compassionate but colourful exposition of the day's cycle in 'The Water Mill' is thus nothing but a celebration of the core of our lives, and our homes.

Notes

1. Banfield, *Sensibility and English Song*, 209.
2. *Four Poems by Fredegond Shove* (1925). 'The Water Mill' is generally regarded as the most successful song in the set, together with 'The New Ghost'; only 'The Water Mill' seems to have lived on in the repertoire, then and now.
3. Hold, *Parry to Finzi*, 118.
4. For Margaret Humphrey Clark, at the Abingdon Summer School for Solo Singers, August 2017.
5. Baritone Roderick Williams and Iain Burnside's recording for Naxos (2005) is one of the faster examples. Williams' ability to let the words pour out over the driving force of the turning wheel is sheer technical brilliance, and belies the effort required. It could be added, however, that in Vaughan Williams' personal papers, there are several letters in which he complains that 'The Water Mill' 'is always taken too fast'.
6. Banfield, *Sensibility and English Song*, 212.

Bibliography

Banfield, Stephen. *Sensibility and English Song*. Cambridge: Cambridge University Press, 1985.
Hold, Trevor. *Parry to Finzi: Twenty English song-composers*. Woodbridge: Boydell & Brewer, 2002.
Vaughan Williams, Ralph. 'The Water Mill', from *Four Poems by Fredegond Shove* (London: Oxford University Press, 1925).

26
The habit of freedom
Naomi Siderfin

> *But, you may say, we asked you to speak about lockdown cultures – what has that got to do with a room of one's own? I will try to explain.*[1]

The fog is still real. It is as if I am holding two conch shells to my ears and the sea is flowing between them, sifting through sand and amplifying every grain. Sound bouncing off the Velux windowpane above my head, St Peter's Primary School is on break as I start to assemble the fragments in October. It's good to hear the cacophony of voices, all, it seems, screaming at once. The silence of the spring term was uncanny. Then the planes had ceased altogether, bringing to attention a more detailed metropolitan soundscape. I recall lying in bed listening to the newly audible as the hours slip away in March 2020; hearing Radio 3 comment 'The world has become quite still'.[2] I shiver uncontrollably then throw off the duvet as my body heat rises higher and higher. Twenty-two days of fever and extraordinary dreams. No cough. Obediently, I do not call the overburdened NHS. The thermometer is broken and there are none to be had in March: thermometers, eggs, flour, toilet roll. We are so excited by the idea of an *actual* national emergency, that we collectively ensure that it is real.

In Covid convalescence, I re-read the seminal text of first-wave feminism: 'A Room of One's Own', penned by Virginia Woolf in 1928. Mercifully short and suitable for concentration levels compromised by ill health, home schooling and precarious livelihood. I am well rewarded. Woolf's published text, developed from two papers

delivered at Cambridge University to the women of the Arts Society of Newnham College and One Damn Thing After Another (ODTAA) of Girton College. On her subject of 'Women and Fiction', she offers 'an opinion upon one minor point – a woman must have money and a room of her own if she is to write fiction . . .'.[3] Woolf's critical contribution was to articulate the conditions necessary for creativity – financial independence, space and time – in explanation for the historic dearth of women writers: freedoms that men of her class and across history take for granted. As part of this powerful exposition of barriers to creativity, Woolf creates the fictional character of Shakespeare's sister, who also has talent and ambition to write poetry and plays, but who meets her fate in the big city, is impregnated and left to die in poverty – offered neither time nor money. Woolf remains prophetic, as she urges her audience of academic women to creatively prepare the way for the female poet who has never had the opportunity to express herself. Referring to her own invention, she writes of Shakespeare's sister:

> She died young – alas, she never wrote a word. She lies buried where the omnibuses now stop, opposite the Elephant and Castle. Now my belief is that this poet who never wrote a word and was buried at the cross-roads still lives. She lives in you and me, and in many other women who are not here tonight for they are washing up the dishes and putting the children to bed. But she lives; for great poets do not die; they are continuing presences; they need only the opportunity to walk among us in the flesh.[4]

Woolf ponders 'what effect poverty has on the mind', thinks of the economic disparity between the sexes 'how unpleasant it is to be locked out; and . . . how it is worse perhaps to be locked in'.[5] Her analysis places emphasis on the power of the collective and holds good for a more intersectional reading. The unnatural suspension into which we were all plunged by pandemic lockdown, and the restrictions placed on man, woman, non-binary person and child alike (regardless of postcode), not only threw a harsh spotlight onto social inequalities but had a curiously levelling impact upon individuals and institutions equally.

It is disabling when the space between one's ears is dominated by a low-level hum and the sensation that one might be underwater and when the physical vibration envelops arms and legs. The effect is to push one into the third person.

Lying on the low and narrow wall of the flowerbed in her small outdoor space in April, head in a lavender bush, she absorbs the unseasonable warmth of the sun, letting it fall full on her face as if to burn away the viral traces. Too weak to move out of its rays, she lies for several hours, listening to the anxious flapping of a wood pigeon whose nest above her head is hidden, deep in overgrown ivy. The bird swoops in and settles. She peers up, to see from the barely visible tail feathers that the mother is doing her duty. The excitable trilling of smaller birds attracted by apple blossom and the invisible insect life supported by the tree overlays hammering from two streets away where builders, unable to Work From Home, are making the most of the pause, getting ahead of themselves with empty roads and free parking. The scream of a woman losing it dovetails with the wail of her offspring as conjugal partner responds with ugly words that fall like a pickaxe. The atmosphere is warmed by the gospel choir crooning from a transistor radio on the other side of the fence, intercut by comfortable patois as her neighbour catches up with a sister on WhatsApp between London and the Caribbean.

Waiting in limbo, those of us responsible for the provision of cultural spaces and programmes have been exercised – as artists and curators – to think our way through the short and long-term future of the public 'exhibition': a convention whereby a critical mass gathers together for a sensory and intellectual experience. 'For masterpieces are not single and solitary births; they are the outcome of many years of thinking in common, of thinking by the body of the people, so that the experience of the mass is behind the single voice.'[6] Almost one hundred years later, Woolf's analysis of the key barriers to creativity – time and money – remains not only pertinent to the issue of artists and exhibition, but to my own writing exercise. To develop a thought in word, sound or image requires time – generally significant amounts of time – and time is costly. And just as I write these words in November, the key turns in the front door and my Young Person arrives home from school demanding to be accompanied to an optician appointment.

The wind picks up, leaves start to fall on her and blossom drifts across the paving. Her face screams with irritation as she peers up through the foliage through one eye, entire head swollen in allergic reaction – to blossom? Or is her body furiously rebuffing malicious attack by an unseen but violently experienced microbe? She reads that urticaria is a symptom for 25 per cent of Italian Covid-19 patients. Reggae starts up from the flats. A big sound that bounces off the opposite block, resonating around the small park beyond the concrete garden wall that protects her privacy as she lies on a bright and folded

patchwork blanket, knitted by a late aunt, softening stone beneath a weakened body untactfully described as 'wizened' by a colleague on Microsoft Teams. She notes the courtesy with which the sound system is switched off after forty minutes. Faraway vibration, seashell on ear, amplified: a distant tingle between inner ear and brain. Now the external itch – a persistent invitation to scratch.

The pandemic curtails the exhibition we open in March. The day after it opens, I am raging with fever. An international project scheduled for May is cancelled, along with the income it brings. Any possibility of vital revenue from cafe or events is cancelled indefinitely. Emergency public funding will ensure that we do not have to close the gallery permanently. As I emerge from illness, I knock out the first funding application, influenced by my recent reading. A fraction of the budgeted overhead sum for survival is earmarked for art itself. We make a proposal for lockdown and beyond, that draws on versatile creative capital – the minds and bodies of artists – to provide a new type of cultural experience. 'National lockdown triggers an experimental broadcasting project . . . to embrace the new conceptual spaces currently being carved out in the collective unconscious: "Lock up your libraries if you like; but there is no lock, no bolt that you can set upon the freedom of my mind." Virginia Woolf, A Room of One's Own, 1928.'[7]

The scrape and tinkle of steel on earth and stone as a bed is dug on the other side, 2 metres from her head, in May. A little moan of fatigue from next door and the spade falls. Leaves shush one against another in lazy wind currents; a passing song; a laugh; slam; buzz; whistle; the tropical echo of parakeets venturing beyond their migrant habitat in Nunhead Cemetery. A car horn is chased by the swooping of ambulance sirens racing to Kings College Hospital. A dog yaps. A man coughs. 'Girls and boys come out to play, The moon doth shine as bright as day . . .' Ice cream is selling well from the van in lockdown. Who still remembers the quaint words of the nursery rhyme tune? 'Come with a good will or not at all.'

Our lockdown proposal is to build a structure to bridge virtual platforms and physical space. For the first commission in the series, live closed-circuit television footage is streamed from the physical site to the digital realm with superimposed art interventions:

> The cameras record weather patterns, changing light levels throughout the day and the ambient sounds of the site. Resident cat, Untitled, roams the yard space, fed by human friends on a daily lockdown rota … The digital object … holds the liminal space between tentative, physical visits and the online realm in which so many of us have become immersed since Covid19 hit the world as we knew it.[8]

The published rhetoric is realised, but the human fallout is significant. To create a live-stream platform with dated gallery technology demands phenomenal energy, creativity – and time. In the absence of money, a camera is propped on a pile of books to record the digital image of one computer screen, in turn recording nine CCTV cameras positioned around the gallery spaces (see Figure 26.1). This image is sent from the gallery in Vauxhall to a flat in Parsons Green where one artist (Simon Tyszko) labours night and day to connect the creaking technology. When he desists in exhaustion, another (A. D. Crawforth) takes over in Walworth. A kids' online gaming channel is commandeered, and the live stream maintained throughout August and into a second lockdown. Time and money: the two are not remotely concomitant. Audio and video artworks continue to stream across the nine screens, incorporating opaque loops of news footage marking an unjust killing, a fatal explosion and the symbolic toppling of a Bristol slave trader.

Back to school in September and new boots. Lockdown economy discounts mean new boots for me too: Cuban heels and artful crumpled leather. I chance upon a neighbour who laughs at my ballet-dancer stance with turned out toes. I've pulled those heavily elasticated Chelsea boots onto the wrong feet and in my ongoing state of disconnection have not noticed all day. She looks incredulous, no doubt wondering whether my distraction is permanent. A question for me too.

Figure 26.1 Simon Tyszko and A. D. Crawforth, *B_T1 Freedom of the Mind* (2020). Screen grab ('a ghost of an image'). Beaconsfield, London.[9]

It feels incumbent to verify this deleterious state of affairs. I sit near the lifts on a nineteenth-century wooden bench bridging old and new wings of St Thomas' hospital in October, waiting not more than twenty minutes for a blood test. As I sit, I become aware of birdsong and as I sit longer, aware that it is a continuous loop: *déjà vu*. Here is evidence of a personal legacy. In 1996 we had already reconsidered the gallery-based exhibition and found it wanting. *Disorders: art from dawn to dawn*[10] was a curatorial project of my youth, inspired by artist and cultural critic Suzi Gablik's challenge to modernism and her call for a socially engaged 're-enchantment of art'.[11] Following a long negotiation, we obtained permission to commission thirteen artists to perform or install time-sensitive artworks, for a duration of 24 hours, in specific public spaces of the hospital neighbouring our gallery space (Figure 26.2). *Disorders* reflected on the circularity of time and mortality in an institution that never sleeps, and so we as artists did not sleep either. In 1996 'David Cunningham installed a work in all four lifts which leave the main lobby and travel the six storeys of the hospital. Intermixed tapes of insects and birdsong from a diversity of environments created an ambiguous, artificial

Figure 26.2 Anne Bean, 'Peace in Rest', installation view. *Disorders*, St Thomas' Hospital, London, 15–16 August 1996, produced by Beaconsfield. Photo Robin Chaphekar.

soundscape.'[12] The last time I paused in this corridor space 24 years ago, I was on a continuous curatorial circulation of the ground floor, checking on an artist recording all patients, staff and visitors passing from one wing to another over the twenty-four hours, by attaching a Polaroid photograph of their feet to the wall.[13]

The Black nurse calls me 'Ma'am'. I close my eyes. 'Tiny prick', she murmurs. When I reopen the syringe is full of blood. 'That was efficient!' I smile, having felt nothing more than the tiny prick. I thank her and wish her a good day. She bids me goodbye, again with the respectful salute 'Ma'am' (as in pram). I am not the Queen. I ponder on the legacy of British colonialism expressed in contemporary institutions as I leave the blood test centre.

I wander down the memory lane of South Wing's corridor lined with Doulton ceramic murals, fired in 1896, depicting English nursery rhymes. Exactly 100 years later, the Pre-Raphaelite figure of Dick Whittington provided the inspiration for John Carson's 1996 embodiment of 'A candy-coloured clown they call the sandman',[14] a wandering presence in the corridors, linking one artist's project to another with fragments of song and text. 'What drives you?' Carson asked me when we collided at 4:00 a.m.: 'Fear of failure', I replied; like the junior doctors, almost sleepwalking with fatigue. I meant failure as an artist to follow through an idea to its most complete realisation. Unlisted, a soundwork by us, the artist-curators of the project,[15] was installed at the furthest end of the corridor in a broom cupboard. As curators of the project it seemed indelicate to profile our own work, but as artists we were compelled to make a contribution and were given late permission to locate a sonic piece in this obscure location: 'Muffled knocking noises, wind blowing and metallic vibrations hinted at a disturbing narrative from a Victorian gothic novel . . . overlaying uncertain sounds . . . much in the way that the hospital has transformed itself from Victorian Institution into a hi-tec medical service for the next century',[16] Jenni Walwin later wrote. Nobody but this essayist, commissioned by the London Arts Board to draw attention to an upsurge in interdisciplinary collaborative practice during the 1990s, noticed our piece in the remote storeroom, but its inclusion seems vindicated in 2020. To work creatively in forgotten corners, in one's bedroom, or even in captivity, is to discover freedom through restriction: 'I am talking of the common life which is the real-life and not of the little separate lives which we live as individuals . . . if we have the habit of freedom and the courage to write exactly what we think . . . then the opportunity will come . . . to work, even in poverty and obscurity, is worth while.'[17]

I grab 10 minutes to write at the North Wing coffee shop, grateful to smell the roast beans and appreciating my post-Covid recovery of taste.

Gazing through the modern wing's generous glass front across the river towards the Palace of Westminster, past Naum Gabo's stainless steel, constructivist fountain, around which sculpture Anne Bean performed on 15 August 1996, I imagine again the artist projecting the image of her own face onto the Houses of Parliament's Big Ben at midnight, connecting Augustus Pugin's Gothic Revival clocktower with Gabo's modernism and our own collective contemporary expression.[18] I dwell in the clues that have already been laid as to how we might proceed without galleries. Twenty-four hours, twenty-four years ago. I remember a dancer strapped in a fabric stretcher, suspended high upon the outer entrance wall, her upstretched arms a living crucifix, alluding to the Lady with the Lamp.[19] Florence Nightingale founded the first professional nursing school in the world, was decorated and honoured in her lifetime and never married. As I scrawl down thoughts in my notebook I recall Virginia Woolf bringing St Thomas' most celebrated founder-figure into her argument: 'And as Miss Nightingale was so vehemently to complain, – "women never have an half hour . . . that they can call their own"'.[20] I reflect on how far women have been able to advance their creativity since Woolf was writing in 1928, and yet how we still cannot escape the 'triple shift',[21] or the procreational demands of our bodies. I remind myself that Woolf draws on Coleridge to argue that 'a great mind is androgynous',[22] that bitterness must be overcome 'for anything written with that conscious bias is doomed to death . . . There must be freedom and there must be peace.'[23]

I leave the hospital to pick up a bus on Westminster Bridge. As I look back from the top deck of the number 12, my last view is of Big Ben, Naum Gabo and in the foreground, next to the sign for the Nightingale Museum, a human-scale three-dimensional tribute in artificial flowers: heart symbol followed by the letters 'NHS'. We sit every other seat. The half-empty bus sweeps quickly through the daily regenerating Elephant and Castle, past unregulated construction workers who never stopped going to work, who had no choice but to scoff at the notion that they might maintain 2 metres' distance between each of them. Peering down for Shakespeare's sister, I see a thin figure lying on their side, head on arm along a narrow bench, face turned towards the watery October sun, sore feet bare, with battered shoes slipped off on the pavement.

At 7:00 a.m. in November, dressed for sixth form, my daughter appears: 'Here's your tea'. 'Migraine', I whisper. 'Can you stop being ill? It's getting on everybody's nerves, including your own!' 'Florence Nightingale never fully recovered from Crimea fever, although she lived to ninety.'

I look up through the glass and a cloud moves in my direction. I become absorbed in its candy floss drift through my window of Payne's grey. It has some sort of visual correlation with the state of my brain: a thought with indeterminate boundaries moves swiftly through and out the other side of the picture plane, lost in an instant. Sea still rushes through sand nine months later. A handbell rings and the screaming cuts off – immediately. A few desultory voices and then the sound of a council lawn mower. Doorbell. Delivery. Silence. Plane. Sound comes in waves. Another, deeper vibration flying lower and nearer. The airline industry is picking up again. I feel the ozone thickening. Must remember to call for antibody results. Girls and boys back out to play. Lunchtime. Screams. LBC Radio reports that some children have forgotten how to hold a pencil or sit up straight. Scream. My loft-bed-workroom is an echo chamber in real life. Ready for yet another sleepless kip. Handbell. Chanting. Someone is being bullied. This time the cacophony subsides gradually, dampening down as they file back into the classroom to learn again how to manipulate a pencil and balance themselves erect on a chair. Some of their small hands are beginning to resemble fins; five fingers morphing into the one essential digit necessary to swipe a screen. And Boots the Optician diagnoses astigmatism forming in my daughter's eyes – a widespread phenomenon this year, she tells me, since the young have had little choice but to gaze at digital blue light since March.

The white nurse at St Thomas' vaccination tent calls me 'ma'am' (as in jam). Must be a colourblind NHS thing. March 2021, almost exactly one year later, AstraZeneca plunges my body back to sub-zero temperatures, like immersion in the North Sea. A seasoned voyager by now, I am not fazed as I wait for the inevitable ascent back up to Torremolinos.

Notes

1. Woolf, *Room*, 5: opening phrases cited verbatim, bar the subject.
2. 'Late Junction' hosted by Verity Sharp, 27 March 2020, BBC Radio 3.
3. Woolf, *Room*, 5–6.
4. Woolf, *Room*, 111–12.
5. Woolf, *Room*, 25–6.
6. Woolf, *Room*, 66.
7. Beaconsfield application to the Arts Council Emergency Response Fund, submitted 10 April 2020.
8. Beaconsfield, 'Beacon_Transitions', *B_T1 Simon Tyszko & A .D. Crawforth, Freedom of the Mind*.
9. Steyerl, 'In defense of the poor image', 1.
10. *Disorders: Art from dawn to dawn*, St Thomas' Hospital, London, 15–16 August 1996. Kirsty Alexander & Paul Burwell, Anne Bean, John Carson, Sarah Cole, David Cunningham, Bruce Gilchrist, Matthias Jackisch, Michal Klega, Rona Lee, Alastair Maclennan, Guillaume Paris, Sonia Zelic. Curated by Nosepaint. Produced by Beaconsfield.
11. Gablik, *The Reenchantment of Art*.

12 Walwin, *Low Tide,* 47.
13 Sonia Zelic, 'Sleep Walking'(1996). Duvet, polaroid photographs, video. Part of *Disorders*, St Thomas' Hospital, London, 15–16 August, 1996. The polaroid series 'Sleep Walking' was acquired for the hospital art collection and is permanently sited in the Sleep Research Centre. Long before GDPR and digital photography, protocol suggested that it would be insensitive to photograph people's faces as the artist originally proposed, so we compromised with their feet and, as is often the case, the tightening of the brief produced a more compelling piece.
14 Roy Orbison, *In Dreams*. Monument Records, 1963. Cited by John Carson in his performance for *Disorders*, St Thomas' Hospital, London, 15–16 August, 1996.
15 Naomi Siderfin and David Crawforth are founding co-directors of Beaconsfield and have collaborated as artists and curators since 1991: first as Nosepaint and later as Beaconsfield ArtWorks or BAW.
16 Walwin, *Low Tide*, 47.
17 Woolf, *Room*, 112.
18 Anne Bean, 'Peace in Rest' (1996). Performance and video projections as part of *Disorders*, St Thomas' Hospital, London, 15–16 August. Bean projected a sleeping face/death mask onto the Houses of Parliament and a turning globe on the clock face of Big Ben. The 'clock' installed around Naum Gabo's fountain in the hospital garden was the size of Big Ben's face.
19 Kirsty Alexander and Paul Burwell, *A Twenty-four Hour Performance with Several Parts*, sculptural danceworks with three performers as part of *Disorders*, St Thomas' Hospital, London, 15–16 August 1996.
20 Woolf, *Room*, 67.
21 The triple shift of paid, domestic and emotional labour experienced by women was theorised by Duncombe and Marsden, '"Workaholics" and "whingeing women"'.
22 Woolf, *Room*, 97.
23 Woolf, *Room*, 103.

Bibliography

Beaconsfield. 'Beacon_Transitions: B_T1 – Simon Tyszko & A. D. Crawforth'. *Freedom of the Mind*, 9 July 2020. Accessed 7 September 2021. https://beaconsfield.ltd.uk/projects/beacon_transitions/.

Duncombe, Jean, and Dennis Marsden. '"Workaholics" and "whingeing women": Theorising intimacy and emotion work – the last frontier of gender inequality?'. *Sociological Review* 43.1 (1995), 150–69.

Gablik, Suzi. *The Reenchantment of Art*. London: Thames and Hudson, 1991.

Krauss, Rosalind. *A Voyage on the North Sea: Art in the age of the post-medium condition*. London: Thames and Hudson, 2000.

McGarvey, Darren. *Poverty Safari: Understanding the anger of Britain's underclass*. Basingstoke: Pan Macmillan, 2017.

Steyerl, Hito. 'In defense of the poor image'. *e-flux*, 10 (November 2009). Accessed 10 June 2017. https://www.e-flux.com/journal/10/61362/in-defense-of-the-poor-image/.

Walwin, Jenni. *Low Tide*. London: Black Dog Publishing, 1997.

Woolf, Virginia. *A Room of One's Own*. Harmondsworth: Penguin Books, 1928.

27
Pandemic dreaming
Adelais Mills

I dreamt all our masks became part of our physical faces. No one had mouths or noses anymore.[1]

By March 2020, the time of the (first) lockdowns in Europe, a new phenomenon had been named online: #pandemicdreams. The online platforms teemed with accounts of dreams in which alter-selves negotiated the terrors of the virus: bare shelves, hydroxychloroquine poisoning, the struggle to breathe. In the same month, Erin Gravely began the digital archive 'i dream of covid' (presumably an ironic allusion to the NBC fantasy sitcom *I Dream of Jeannie*) with an invitation to contributors to submit any nocturnal creation that reflected on the conditions of its production in a global crisis. Gravely's project can be located in a line of modern dream-catching efforts that centre on historically significant events – from the collection of 9/11 dreams, to the archiving of 'atomic dreams', through to the gathering of dreams from survivors in the wake of the Holocaust.[2] The creators of 'i dream of covid' trace the genealogy for their project further back, citing a book long out of print called *The Third Reich of Dreams* (1968 [1966]). Compiled in Berlin during the late 1930s by writer Charlotte Beradt, the book is a collection of dreams testifying to life lived in the shadow of Nazism. The 'About' page for the 'i dream of covid' project references Beradt's book as a spur to Gravely's aspiration to document the impression left on dreaming by contemporary events: '*The Third Reich of Dreams* tracked the effect that authoritarianism

and terror in Nazi Germany had on the nation's dreamers ... I was curious to know how the anxieties of the moment would translate to our dreams'.[3]

It seems the fate of *The Third Reich of Dreams* to be at once belated and timely. It was not until 1966 – after the trial of Adolf Eichmann had ignited interest beyond Jewish communities in the events of the Holocaust – that Beradt, with the help of Hannah Arendt, was able to publish her book of dreams. Even then, there is little evidence to indicate that it was read outside of small psychoanalytic circles. But in November 2019, Beradt's dream book was revived for a second time when it appeared in a *New Yorker* piece published on the cusp of the outbreak of the virus in China.[4] Mireille Juchau's discussion of *The Third Reich of Dreams* is set in the context of her concerns about the authoritarian caste of then-president Donald Trump's government; Covid-19 was as yet barely on the West's horizon. As the pandemic took off, though, Beradt's book became ever more germane to the time.

There is in the first place a correspondence between the extensive impact of the Nazi regime on everyday existence and the far-reaching effects of the virus. The claim made by the viral paradigm upon our inter- and intra-subjective interactions is – as once was that of the Nazi *Weltanschauung* – so all-embracing that much of life in the global north seems to have been affected, including dreams. Secondly, and more importantly for my purposes, *The Third Reich of Dreams* attends to the way in which common socio-historical experience informs dreaming, as well as to how dreams might, by turns, re-inform this register of experience. Juchau's initial attraction to the book is due to this unusual conjugation of the socio-political and the oneiric; I think it is also mainly for this quality that *The Third Reich of Dreams*, under the auspices of social media, was lifted free of Juchau's article, of its yoke to the Trump presidency, to become – along with Daniel Defoe's *Journal of a Plague Year* (1722) and Albert Camus's *The Plague* (1947) – a title to conjure with. By the spring of 2020, Beradt's dream book had 'gone viral' as a means of framing the outbreak of #pandemicdreams.

It is in part the purpose of the present essay to show that Beradt's dream collection caught the contemporary imagination because it aims to preserve the value of the dream to the world beyond the dreamer; in so doing it challenges the reigning psychoanalytically informed dream discourse. In fact, *The Third Reich of Dreams* is not just a collection, but a critique of the theory offered by Freud in his seminal text *The Interpretation of Dreams* (1900) – a book which has, for more than a century since its publication, remained the most prominent (at least amongst Western countries) secular explanatory framework for dreams. One of the key

ideas Freud presents in this book is that dreams represent 'a particular *form* of thinking'.[5] In the crucible of sleep, the thinking-in-language that happens when one is conscious undergoes, by virtue of regression and repression, a sea change. Language-bound thought is transmuted by a process Freud calls the 'dream-work' into the rich visual imagery synonymous with dreaming.[6] Often, so thorough-going is this transformation that the dream-image retains only the most tenuous of connections to the originary thought.

It is worth noting – particularly in relation to Beradt's frustration with Freudian dream theory, presumably for its socio-political quietism – that Freud employs a political analogy to explain the principle behind the distortion the dream-work effects. Freud suggests that the dream-thought is to the dreamer's conscious like the 'political writer who has disagreeable truths to tell those in authority'.[7] This is to say that dream-work produces something akin to allegory, written for the purpose of smuggling out a message from a state under repression. The aim of dream interpretation, Freud proposes, is to decipher this communication. The upshot of this is that no matter how strange and absorbing the immediate 'given' of the dream, the process of interpretation involves treating this material as a screen, glancingly looked at on the way to retrieving the obscured dream-thought. Freud's interpreter of dreams aspires, writes Charles Stewart, to 'the undoing of the dream-work, the unravelling of the disguise, the translation of the manifest content of the dream hallucination back into the thoughts which lie behind it'.[8]

There are a number of elements in this account that offer resistance if one is trying to appreciate the 'exteriorising' orientation of a dream that appears to refer to an event like the current pandemic. One consequence of Freud's theory is that the image is, to a degree, treated as an epiphenomenon or an excrescence of the dream-work. In the aftermath of the dream, the visual image remains relevant in that the dreamer's associations to it may lead to the thought concealed by the dream-work; besides this, however, the value of this manifest content has largely been exhausted.

Many of the dreams archived on the 'i dream of covid' site are littered with the paraphernalia of Covid-19: masks, hand sanitiser, swabs. In one, teleconferencing technology appears to have consumed the three-dimensionality of people's heads:

> I was walking down a busy city street … But as I looked at the faces of all the people I passed, their heads were all computer screen images, still talking and emoting but flat and distant.[9]

In another, the envelope of personal space implied by the term 'social distancing' becomes terribly concrete as the dreamer, isolated in an actual 'bubble', 'suffocat[es] in total silence'.[10] Were these dreams to be treated by Freud in *The Interpretation*, it is unlikely that ephemera such as Zoom would be permitted to remain coupled to the immediate pandemic context; instead, Freud would set store by the dreamer's associations to the Zoom element as a way of probing its status as a proxy or deputy for some other thing altogether, perhaps entirely unrelated to the socio-historical frame.

This method of association tends to have the effect of draining any collective import dream imagery may initially carry. This is because associations favour the dreamer's personal history. If the hypothesis is that the dream-image disguises a thought or wish pertaining to a singular unconscious then all material – including 'fragments and residues' lifted from a shared socio-political milieu – must be searched for the *unique* feelings, fantasies and desires invested there.[11] As Pick and Roper point out, '[e]lements in Freud's dreams were drawn from and identifiable within nineteenth-century German culture and history, sometimes specifically within *fin-de-siècle* Vienna'.[12] Nonetheless, in his analyses, Freud finds reasons for the appearance of these elements that have little to do with *fin-de-siècle* Vienna. In his most overtly political dream, for instance, called the 'Revolutionary Dream', Freud places himself at a university student gathering where the real-life politician Count Thun (or a conservative predecessor, Count Taaffe) is belittling German nationalism. After becoming angry at the minister, Freud flees the meeting, retreating through the halls of a university. The final scene takes place at a railway station where Freud finds himself on the platform in the company of an elderly blind man. Freud holds a urinal for the man, conscious that the ticket collector will look the other way. In his lengthy analysis of the dream, Freud refrains from expanding on much, if any, of the dream's political valence. He brings his analysis to focus on the final scene, identifying the old man as his father. The dream, he hypothesises, is the expression of a wish to revenge himself on the father who had, when Freud was a boy, dismissed him with the words, 'This boy will come to nothing'.

To dream, then, of a contemporary politician, or of living in a structure of hoarded loo roll, or falling towers, or nuclear winter is not necessarily (according to this approach) to be haunted by socio-historical experience; rather, it is for the dreamer to have lit upon the remains of the day as a means for expressing dreads and desires that press for hallucinatory satisfaction in the dream state.[13] This 'privatisation' of the

dream makes it tricky to imagine there could be such a thing as a dream shared. But dreams that occur at the level of the collective do seem to be a phenomenon of historical events. Beradt points out that '[h]alf a dozen times, I came across a virtually identical experience: "I dreamt it was forbidden to dream, but I did anyway."'[14] This phenomenon calls for a framework that can hold a space for dreams that emerge between minds.

There is a further reason why the Freudian method eclipses a dream's possible salience to the world beyond the interiorised subject – because the method tends to identify the time-signature of the dream-thought with the dreamer's earliest years. Dream material is understood to bely fantasies and fears of an infantile nature. In this way, 'fragments and residues' borrowed from our viral present would be deprived not only of their communality but also of their contemporaneity. In her preface to *The Third Reich of Dreams*, Beradt expresses her belief that the dreams she has collected 'could only have sprung from man's paradoxical existence under a twentieth century totalitarian regime, and most of them nowhere but under the Hitler dictatorship in Germany'.[15] A classical psychoanalytic reading of such dreams would imaginably, however, place these timely testaments in the service of the (personal) past. In *The Interpretation*, Freud writes of the dreamer's long-dead wishes that they are 'not dead in our sense of the word but only like the shades in the *Odyssey*, which awoke to some sort of life as soon as they had tasted blood'.[16] Here, the dream-thought takes on the guise of an Odyssean shade; the events of daily life are to this shade the blood that awakes it, the dream a 'sort of life'. The idea that this simile moves to capture is that the dream-image – regardless of how timely – is the vehicle for thoughts of a profoundly old tenor.

The influence of Freud's dream theory – its elevation of the latent over the manifest, the personal over the social, the past over the present – does not make it straightforward to view the dream as an expression of the 'political unconscious', a symbolic response to common material conditions.[17] This may in part be why commentators have not been able to offer much by way of an imaginative response to today's pandemic dreams. At UCL's 'Lockdown Dreams' project, housed within the university's Psychoanalysis Unit, researchers have chosen to focus on the unusual 'vividness' of dreams in this period. The project thereby avoids addressing head-on the question of how to frame the meaningfulness of any dream material that seems to refer to the virus or the conditions it has brought about.[18] In the media, meanwhile, analysts interviewed on the phenomenon of pandemic dreams have tended to take a classical approach by describing the pandemic as a medium for the expression of

endogenous forces in the psyche.[19] In its way, each response isolates the same lack in contemporary dream discourse: the means to speak to and therefore preserve dimensions of dreams that invite some framing other than the idea that they represent a wish for oneself in the past tense. Here lies the attraction of Beradt's book: in her preface and authorial commentary, Beradt not only criticises Freud's dream theory for its tacit bracketing of the dream's relationship to the socio-historical realm but looks for ways to pursue this relationship.

In her wish for there to be an alternative way to interpret the dream, Beradt is at times unwarrantedly dismissive of Freud's ideas. In one place, for instance, she rules out altogether the possibility that the dreams in her collection are the products of intra-psychic turmoil. These dreams, she writes, are *not* the artefacts of 'conflicts arising in their authors' private realm'.[20] Beradt wants to deny that the dreams in her book draw on private, concealed reservoirs of meaning in order to focus the interpreter's attention on the manifest dream-image. She writes of her dreams that here '[t]here is no façade to conceal associations'.[21] There is no reason why, however, a plurality of dream discourses should not coexist to illuminate a single dream diversely. Nonetheless, by elevating the dream-image, in all its potential timeliness and commonality, Beradt is able to treat the dreams in her collection as complementary to sociological projects like Wilhelm Reich's *The Mass Psychology of Fascism* (1933) or Arendt's *The Origins of Totalitarianism* (1951). These dreams take on value as veracious fictions – testimony to the hardly articulable conditions of life under Nazism. For instance, with regard to one young woman's dream series – a series that occurred after the 1935 race laws had come into force – Beradt writes that oneiric experience offers 'new insight into a situation that has already been illuminated from other angles [sociological, historical, philosophical]'.[22] In these dreams, the young woman experiences powerful feelings of shame and hatred for her Jewish mother, feelings that are painfully at odds with the love that predominates between them in waking life. Beradt puts daughterly ambivalence to one side here, suggesting that the series discloses the impossibility of withstanding the corrosive effects of an ideology that assaults one from all directions: the 'outside encroachments … that make it too difficult for him [mankind] to love his neighbor, even the one dearest to him'.[23]

The sensitivity Beradt promotes to the given of the dream-image means that dreams felt to be in some sense 'historical' are accorded the status of a type of evidence. At the same time, Beradt's work contains a more radical proposition: that the 'historical dream' has the capacity to disclose facets of our common state in reality unheeded. Beradt writes

that the most intriguing of the dreams in her collection are those that stem from the advent of the Nazi regime but that betray insights into its deadly ends. Recalling Freud's idea that the dream is a '*form* of thinking', Beradt invites readers to view such dreams as forms of knowing. One can hear in this invitation a harking back to the prophetic, externally derived dream of which Defoe writes when he imagines London's dreamers – in the days and weeks before the arrival of the plague – warned by 'voices' 'to be gone, for that there would be such a Plague in *London*, so that the Living would not be able to bury the Dead'.[24]

Beradt gives a contemporary take on the derivation of such insinuating dreams. Amusingly, she leans on Freud's notion of the truth-denying, repressive tendency of the conscious mind to frame these dreams that appear to know where the dreamer knows not. They are, she suggests, the result of a lapse in the domination of consciousness (the basic orientation of which Lacan describes as desiring not to know) – a lull allowing knowledge otherwise barred to well-up in the dream-state in the form of an image. These images become, in essence, insights into life's social fabric gleaned during waking life from barely discernible 'symptoms' in this structure – they represent what Christopher Bollas has called the 'unthought known', knowledge one simultaneously possesses and cannot possess.[25]

Putting to one side Beradt's in-the-end somewhat equivocal relationship to Freud's dream theory, her book's appeal to the moment is precisely its effort to turn the dream towards 'now' – whether the now of Nazi Germany or of the contemporary pandemic. Where Freud described the way in which dreams spoke of the past, and Defoe's was an age in which dreams were a medium through which the future could be sounded, Beradt calls attention to the dream's dialogue with the present. In the 'i dream of covid' archive, one dream – reminiscent of Freud's dream of the Botanical Monograph – gestures to the emergence of a post-human time in the present moment of lockdown cultures:

> I discovered a mushroom that sort of resembled an orchid in size & shape, and after some research, I learned that this was a rare type of mushroom commonly referred to as the 'Apocalypse Mushroom'. It only grows in cities and other highly-populated areas when there are no humans around to disturb its growth. The last time the streets were empty enough that it could be seen growing was on 9/11.[26]

It is a strangely hopeful dream – if not for us humans.

My thanks to David Hillman, for his suggestions and his company since March 2020.

Notes

1. 'Faces', in Gravely, *i dream of covid*.
2. See Hartmann and Tyler, 'A systematic change'; for atomic dreams, see Sergeant, 'Dreams in the nuclear age'; for references to the dreams of Holocaust survivors, see Koselleck, *Futures Past*.
3. See 'About – This Site', *i dream of covid*.
4. Juchau, 'How dreams change'. The November publication of Juchau's article was, in turn, a second go-round for the piece. The republication coincided with a fresh out-break of Trumpian pandemonium.
5. Freud, 'Interpretation', 506, fn. 2.
6. Freud, 'Interpretation', 178.
7. Freud, 'Interpretation', 142.
8. Stewart, 'Dreaming and historical consciousness'. I am grateful to Professor Stewart for generously providing me with an earlier draft of the manuscript for his book *Dreaming and Historical Consciousness in Island Greece* (Chicago: University of Chicago Press, 2012) when I was unable to access the published book during the UK lockdown of March 2020.
9. 'Screens', in Gravely, *i dream of covid*.
10. 'Bubbles', in Gravely, *i dream of covid*.
11. Freud, 'Interpretation', 81.
12. Pick, 'Introduction', *Dreams and History*, 2.
13. Freud, 'Interpretation', 81.
14. Beradt, *The Third Reich of Dreams*, 45
15. Beradt, *The Third Reich of Dreams*, 15.
16. Freud, 'Interpretation', 249.
17. Jameson, *The Political Unconscious*.
18. After I drafted this essay, the 'Lockdown Dreams' research team hosted a webinar during which they highlighted the difficulty of discussing historically inflected dream content with Freud's paradigm in mind. A recording of the webinar, 'Learning from Lockdown Dreams', can be found at https://www.lockdowndreams.com/media.
19. In *The Guardian* of 23 April 2020, psychotherapist Philippa Perry answers a question about pandemic dreaming with reference to Freud-inspired ideas of 'processing': '"Normally our dreams are processing ancient memories, or things that have just happened," she says. "We have so much more to process right now in terms of experience and feelings."' See Noor, 'So you've been having weird dreams during lockdown, too?'.
20. Beradt, *The Third Reich of Dreams*, 15.
21. Beradt, *The Third Reich of Dreams*, 15.
22. Beradt, *The Third Reich of Dreams*, 68.
23. Beradt, *The Third Reich of Dreams*, 68.
24. Defoe, *A Journal of the Plague Year*, 23.
25. Bollas, *The Shadow of the Object*.
26. 'Apocalypse Mushroom', in Gravely, *i dream of covid*.

Bibliography

Beradt, Charlotte. *The Third Reich of Dreams*, trans. Adriane Gottwald. Chicago: Quadrangle, 1966.
Bollas, Christopher. *The Shadow of the Object: Psychoanalysis of the unthought known*. New York: Columbia University Press, 1987.
Defoe, Daniel. *A Journal of the Plague Year*, edited by Cynthia Wall. London: Penguin, 2003.

Freud, Sigmund. 'The interpretation of dreams'. In *The Standard Edition of the Complete Psychological Works of Sigmund Freud*, Vol. 4, edited by James Strachey and Anna Freud, translated by James Strachey. London: Vintage Classics, 2001.

Gravely, Erin. *i dream of covid*. Accessed 1 November 2021. https://www.idreamofcovid.com.

Hartmann, Ernest and Tyler Brezler. 'A systematic change in dreams after 9/11/01', *Sleep* 31, no. 2 (2008): 213–18. https://doi.org/10.1093/sleep/31.2.213.

Jameson, Fredric. *The Political Unconscious: Narrative as a social symbolic act*. London: Methuen, 1981.

Juchau, Mireille. 'How dreams change under authoritarianism'. *The New Yorker*. Accessed 1 November 2021. https://www.newyorker.com/books/second-read/how-dreams-change-under-authoritarianism.

Koselleck, Reinhart. *Futures Past: On the semantics of historical time*, trans. Keith Tribe. Cambridge, MA: Massachusetts Institute of Technology Press, 1985.

Noor, Poppy. 'So you've been having weird dreams during lockdown, too?', *The Guardian*, 23 April 2020. Accessed 1 November 2021. https://www.theguardian.com/lifeandstyle/2020/apr/23/coronavirus-dreams-what-could-they-mean.

Pick, Daniel and Liz Allison. 'Learning from lockdown dreams', *Lockdown Dreams*. Accessed 9 November 2021. https://www.lockdowndreams.com/media.

Pick, Daniel and Lyndal Roper. 'Introduction'. In *Dreams and History: The interpretation of dreams from ancient Greece to modern psychoanalysis*, edited by Daniel Pick and Lyndal Roper. Routledge: London and New York, 2004.

Sergeant, Larry. 'Dreams in the nuclear age', *Journal of Humanistic Psychology* 24, no. 3 (1984): 142–56. https://doi.org/10.1177/0022167884243010.

Stewart, Charles. 'Dreaming and historical consciousness in island Greece'. Unpublished manuscript.

28
In pursuit of blandness: on re-reading Jullien's *In Praise of Blandness* during lockdown

Emily Furnell

Against a backdrop of major global disruption, the predominant texture of many of our days has been one of incongruous blandness. As I write this, in the UK over 150,000 people have died due to Covid-19 or related complications,[1] and the murder of several people of colour in America has sparked a succession of conflicting demonstrations around the world. The pandemic has brought to the surface underlying issues of racial and economic inequality and injustice etched into the body politic of Western late capitalism. Yet, for those of us privileged enough to be able to adhere to national mandates, or quarantine ourselves in relative isolation, the unrest we confront every time we check social media feeds or news outlets jars with the inertia of our locked-down existences. The four walls in which we have been confined do not offer us what we are used to. Severed from those routines with which we used to structure our lives, time is distorted and becomes a shapeless, indistinct mass. We exist in states of suspended animation, disquieted by the conflict between our impatience for things to happen or circumstances to change, and our fears of what tragic consequences such may have.

I first read François Jullien's *In Praise of Blandness* (2004) several years ago, as a moment of reflection in my artistic practice at a time in which I felt myself stuck. Through mining into ancient Chinese philosophical thought and aesthetics, Jullien seeks to revise our

understanding of blandness as a quality to be avoided. Drawing on its inclusion as a central tenet of Confucianism, Daoism and Buddhism, Jullien argues that we should foster blandness, and the 'harmony' those traditions suggest it attests to,[2] which can be used as a remedy to the disaffection for how neoliberal societies have structured themselves in the twenty-first century.

From a Western (largely capitalist) perspective, reactions to blandness may likely be uninterest, or rather boredom. Culturally, we loathe boredom; not merely its tedium but its incompatibility with our contemporary experiential proclivities: our consumerist demands for the new, the different or the out of the ordinary. Paul B. Preciado has termed ours a pharmacopornographic era, one in which we vary the monotony of our existence by micro-dosing on the thrills digitalised consumer culture purports to offer.[3] Boredom provides the impetus for much of our fevered activity. It is, to use Georges Teyssot's expression, a 'luxurious disease' suffered by the subjects of late-capitalist economies, whereby an abundance of variety only serves to highlight the emptiness and homogeneity of the majority of cultural production.[4]

Blandness has been incorporated into the very architecture and infrastructure of late capitalism to ensure we remain keen participants. Tom McDonough suggests that Western life today is spent largely in spaces with which we maintain only a 'contractual relation'.[5] We occupy the anonymous spaces of airports, hotels and bus stops with the sole purpose of accessing the next planned activity. Blandness in this context is persistently instrumentalised as an obstacle to overcome in order to move towards our imagined goals. Rather than the opposite of the glut of desire-fulfilment neoliberalism offers us, blandness is an integral feature; the tedium it inspires designed to divert us from redressing economic inequalities and exploitative labour practices.

Lockdown has also been framed similarly. Governments have been eager to present national and local lockdowns as only temporary hiatuses to a neoliberal status quo. In the UK, then Foreign Secretary Dominic Raab warned the British to prepare themselves for a 'new normal' on 26 April 2020, prior to the first-wave lockdown restrictions being eased.[6] By 17 July 2020, Boris Johnson claimed there would be a 'significant return to normality' by Christmas.[7] After a further 80,000 Covid-related deaths, Johnson announced a 'roadmap' out of lockdown on 22 February 2021, the end point of which he would later claim to be motivated by the nation's desire 'to go back to a world that is as close to the status quo, ante-Covid, as possible.'[8]

In the meantime, we have had to exercise patience in being limited to our homes, a state of affairs we have been repeatedly told we will soon inevitably fatigue of.[9] Buying into the British government's rhetoric, to limit potential damage to the economy, lockdown is to be experienced restlessly. When our work allows, we should make of our home a workspace, our productivity undeterred by the new sets of constraints we find ourselves operating under. Our experience of such, though, should not be satisfying. Rather, we should feel, as Zadie Smith says, the indignancy of not being able to manage the 'real limitations' of our time according to a 'real schedule'.[10] Cynically put, lockdown should not make us reflect on correctives to late-capitalist reality and its discontents; it should make us long for those self-same ways of being that it has cut us off from.

Beyond attempts to realise radical change to neoliberalism's systemic inequalities, we might find an act of minor consolation in a reassessment of our response to blandness. In a passage characteristic of *In Praise of Blandness*, Jullien writes that an impetus to satisfy our desires to excess can be likened to a meal we have prepared in which the prime ingredient saturates all other flavours. In only ever reflecting a sole ingredient, the meal has no future potential. Its taste palette cannot develop and becomes clouded and tedious. All individual flavours 'disappoint even as they attract', satisfying our tastes only during the moment of consumption.[11] A succession of fast-paced experiences that quickly satisfy our desires or affirm our most ill-founded thoughts do not stem hunger, but instead leave us starving for more of the same. It is blandness, Jullien posits, that offers us the heavy meal.

When no individual flavour fights for dominance, categorising taste becomes impossible and leaves more to relish. This prevents it from being reduced to a single disappointing experience that we had expected much more from and presents the possibility of a richness that derives from all combined flavours. In 1189, Zhu Xi wrote *The Great Learning*, which has since become a staple of Chinese philosophy. With the spirit of blandness, the text outlines the need for ongoing and lifelong study in order to understand the principle that draws together all the elements of any given circumstance. Only after one has 'pause[d] to understand' can knowledge be actioned appropriately.[12]

If we classify something as bland or ordinary, we are no longer in a suitable condition to examine it since we are partisan to the social norms that have taught us to strive for productivity against reflection and contemplation. Instead of encouraging reactive behaviour (the breeding ground of nepotism, incompetence and complacency), what we require is

patient thought. Jullien explains that blandness is that which 'appears to the eyes of those who look farthest into the distance . . . beyond the narrow confines of the individual's point of view'.[13] The pursuit of blandness is difficult and forces us to re-evaluate, sometimes morally, what is truly of significance. Blandness can help us remove ourselves from a narrow-minded perspective that is all-encompassing and instead teaches us compassion, and the ability to relate objectively to others. Carefully sifting through its subtle gradations can prove restorative to critical faculties that have become desensitised by the hyperactive machinations of global capital.

Notes

1. UK Government, 'Deaths in the UK'.
2. Jullien, *In Praise of Blandness*, 125.
3. Preciado, 'Learning from the virus'.
4. Teyssot, 'Boredom and bedroom', 50.
5. McDonough, 'Introduction', 12.
6. Merrick, 'Public must accept tough restrictions'.
7. Stewart and Murphy, 'Boris Johnson's plan for "return to normality"'.
8. Morton, 'Prime Minister upbeat'.
9. For commentary on this, see, for instance, Wood, 'Government delayed lockdown', and Fancourt, 'Opinion: People started breaking Covid rules'.
10. Smith, *Intimations*, 23.
11. Jullien, *In Praise of Blandness*, 42.
12. Quoted in Sterckx, *Chinese Thought*, 219.
13. Jullien, *In Praise of Blandness*, 53.

Bibliography

Fancourt, Daisy. 'Opinion: People started breaking Covid rules when they saw those with privilege ignore them', *UCL: Institute of Epidemiology & Health Care*, 21 January 2021. Accessed 9 September 2021. https://www.ucl.ac.uk/epidemiology-health-care/news/2021/jan/opinion-people-started-breaking-covid-rules-when-they-saw-those-privilege-ignore-them.

Jullien, François. *In Praise of Blandness: Proceeding from Chinese thought and aesthetics*, translated by Paula M. Versano. New York: Zone Books, 2008.

McDonough, Tom. 'Introduction: An aesthetics of impoverishment'. In *Boredom: Documents of contemporary art*, edited by Tom McDonough, 12–23. Cambridge, MA: MIT Press/London: Whitechapel Gallery, 2017.

Merrick, Rob. 'Public must accept tough lockdown restrictions as "new normal" for many months, Dominic Raab says', *Independent*, 26 April 2020. Accessed 23 August 2021. https://www.independent.co.uk/news/uk/politics/coronavirus-lockdown-restrictions-uk-new-normal-dominic-raab-a9484416.html.

Morton, Becky. 'Covid: Boris Johnson upbeat about easing lockdown in England on 19 July', *BBC News*, 1 July 2021. Accessed 23 August 2021. https://www.bbc.co.uk/news/uk-57681216.

Preciado, Paul B. 'Learning from the virus', translated by Molly Stevens. *Artforum*, May–June 2020. Accessed 23 August 2021. https://www.artforum.com/print/202005/paul-b-preciado-82823.

Smith, Zadie. *Intimations: Six essays*. London: Penguin, 2020.

Sterckx, Roel. *Chinese Thought: From Confucius to Cook Ding*. London: Penguin, 2019.

Stewart, Heather and Simon Murphy. 'Boris Johnson's plan for "return to normality" met with scepticism', *The Guardian*, 17 July 2020. Accessed 23 August 2021. https://www.theguardian.com/politics/2020/jul/17/boris-johnson-plan-for-return-to-normality-met-with-scepticism-coronavirus.

Teyssot, Georges. 'Boredom and bedroom: The suppression of the habitual', translated by Catherine Seavitt, *Assemblage* 41, no. 30, (August 1996): 44–61. https://doi.org/10.2307/3171457.

UK Government. 'Deaths in the UK – Coronavirus in the UK'. Accessed 23 August 2021. https://coronavirus.data.gov.uk/details/deaths.

Wood, Vincent. 'Government delayed lockdown over fears of "behavioural fatigue" – but their own scientists don't agree it exists', *Independent*, 30 July 2020. Accessed 9 September 2021. https://www.independent.co.uk/news/uk/home-news/coronavirus-behavioural-fatigue-uk-lockdown-delay-science-chris-witty-robert-west-a9644971.html.

29
Blinded lights: going viral during the Covid-19 pandemic

Sarah Moore

An alarm sounds. A firefighter, helmeted, iridescent visor down, looks up from their desktop and jogs out of an office. Another stops sweeping a nondescript storage area. The same goes for others, interrupted from lifting weights, making a cup of tea and sitting on the toilet. The camera lingers on a poster that reads 'KEEP YOUR DISTANCE', before the door it is stuck to is opened, one of the jogging firefighters enters and tears (of all things) a fax out of a machine, reading 'URGENT: BLINDING LIGHTS CHALLENGE'. The jogging firefighters, now hands on hips, enter a forecourt, assume suitably socially distanced positions in front of two fire engines, blue lights flashing, and begin, as a synth-pop beat kicks in, to dance in synchrony.[1]

Countless variations on this theme can be found on the social media platform TikTok, an app that allows its users to upload videos, generally of them dancing, backed by a music track of their choice. The majority date from the first weeks of the UK's first national lockdown in response to the Covid-19 pandemic. They feature different groups of 'key workers' – those deemed necessary to the running of the UK during the pandemic, and therefore exempt from stay-at-home orders – performing choreographed routines to the single 'Blinding Lights' by The Weeknd (Abel Makkonen Tesfaye) (first released in November 2019). The dancers were taking part in the #blindinglightschallenge, which went viral – an idiom that now feels naïve, hardly something worth celebrating. Nurses,

care workers, supermarket attendants, warehouse workers and (easily forgotten) zookeepers swung their arms, hopped on the spot or gyrated their hips, all while nightclubs, bars, gyms and community centres were closed until further notice. The song itself only adds to the disconcerting effect these videos may have on us, its retro-synthwave orchestration a throwback to the 1980s, a decade marred by the incipient HIV/AIDS crisis, and its lyrics ('I've been on my own for long enough'; 'Sin City's cold and empty') holding eerie premonitions of the parameters of life under lockdown.[2]

Internet usage reached unprecedented levels during lockdown. In June 2020, Ofcom reported that adults spent a record-breaking average of four hours and two minutes a day online. Twice as many people were using video calls as before the pandemic, and one in three preferred to watch online streaming platforms rather than traditional television.[3] Techspot reported in May 2020 that there had been over 315 million downloads of TikTok in the first three months of 2020, increasing from 187 million in the same period the previous year.[4] In comparison to other digital media services, TikTok usage is now comparable in the US to Netflix. In the UK, the platform had 12.9 million adult users in April 2020, up from 5.4 million in January 2020.[5] The popularity of TikTok has only increased since, with 87 million downloads worldwide in June 2020 and a further 62 million downloads in January 2021.[6]

How people have used the platform during the pandemic, though, is less easily quantifiable. Watching videos from the #blindinglightschallenge, we are ostensibly witness to an attempt from indispensable elements of the nation's workforce to manufacture a sense of community spirit in a state of emergency. We, as viewers, are to rally around their pretence of cheer, the simple pleasure of dancing in unison, and take heart that even those tasked with being on the frontline of combating Covid-19 could muster the energy to do something uplifting. Yet, it is unlikely many watched these routines in late March and early April without an attendant sense of creeping dread, a foreknowledge that the government had dithered over locking the nation down, and that the first wave death toll would – as turned out to be the case – be high.

These videos also lead us down a peculiar hall of mirrors that make us question the expectations of modern labour and, in turn, how we prefer to spend our leisure time. Workers no longer at work, furloughed, made redundant or barred from their offices, watched other workers, still at work and dressed for such, perform routines we would more readily associate with downtime and time off. All to promote the necessity of the work they do. Many of those ordered to stay at home also took part in the

viral craze. With little to do, time to fill, or no line manager able to monitor how they were keeping to their working hours, people turned instead to the endorphin rush of bopping up and down in front of a smartphone.

Sianne Ngai has provocatively argued that one of the aesthetics that defines late capitalist labour is what she terms 'the zany': 'zaniness is essentially the experience of an agent confronted by – and endangered by – too many things coming at her at once'.[7] The precarity of modern labour (underpaid, overworked, tied to temporary or zero-hour contracts and perpetually on the verge of dismissal) impels workers to put on an exaggerated show of affect, a hyperactive performance of jollity and cheer that barely disguises the compromised positions their employers force them to adopt. There is an overlap here with social media, a form whose use has become increasingly predicated on converting what we do in our leisure time into monetary gain. TikTok is only the latest platform to have spawned social media influencers able to make a living off the content they upload.[8] Either suddenly divested of purpose or with purpose brought into sharp focus, lockdown saw people manically competing for the attention of others in a flail of animated limbs, all while Covid-19 made a sense of our own and others' mortality uncomfortably proximate. Maria Stepanova has critiqued our time's incessant drive to self-memorialisation, reading how digital culture's imperative that we capture our lives in pictures, video or bitesize text works against itself:

> We get a vague sense of the vast mass from social media, where thousands of mediocre pictures are posted, pinned like butterflies with 'tags'. For these images the future is just one more cemetery, a huge archive of human bodies we know nothing about for the most part, except that they existed.[9]

Instead of memorialisation, what is uploaded is quickly lost, subsumed in the waves of similar material added to these platforms in vast quantities by myriad users every second.

Covid-19 appears to have accelerated shifts already in train in the ways we mediate our behaviour, whether occupationally or in our free time. Attending meetings, birthday parties, weddings and funerals via video-link is no longer alien to us. That said, lockdown has also ensnared us more tightly in the distortions of social media, its presentation of performances often veiling or untethered from the bleak, atomised reality we have been existing in. We have videos of nurses dancing in wards at our fingertips; few see them pumping the lungs of those afflicted by Covid-19 in inadequate PPE. We should pay closer attention to the uptick

in social media usage during the pandemic, and the type of content it for the most part platforms, to try to unpick the curiously delusional state many have descended into, fearful, isolated and unable to grasp the seriousness of the virus and the dangers it poses. An aversion to inspecting this dark mirror on our behaviour may blindside us once again the next time another catastrophe befalls us.

Notes

1. @emergency_cheshire, 'Loving what Lymm Fire station have done'.
2. The Weeknd, 'Blinding Lights'. Canada and United States: XO and Republic, 2019.
3. Ofcom, 'UK's internet surges'.
4. Potoroaca, 'TikTok revenue surged'.
5. Ofcom, 'UK's internet surges'.
6. Doyle, 'TikTok statistics'.
7. Ngai, *Our Aesthetic Categories*, 183.
8. Shaw, 'Does being "TikTok famous"'.
9. Stepanova, *In Memory of Memory*, 77.

Bibliography

@emergency_cheshire, 'Loving what Lymm Fire station have done', tiktok.com, 14 April 2020. Accessed 7 October 2021. https://vm.tiktok.com/ZM81gFnuk/.

Doyle, Brandon. 'TikTok statistics – updated June 2021', *Wallaroo*, 14 June 2021. Accessed 13 September 2021. https://wallaroomedia.com/blog/social-media/tiktok-statistics/.

Ngai, Sianne. *Our Aesthetic Categories: Zany, cute, interesting*. Cambridge, MA and London: Harvard University Press, 2012.

Ofcom. 'UK's internet surges to record levels', *Ofcom*, 24 June 2020. Accessed 13 September 2021. https://www.ofcom.org.uk/about-ofcom/latest/media/media-releases/2020/uk-internet-use-surges.

Potoroaca, Adrian. 'TikTok revenue surged during the lockdown, setting new record in April', *Techspot*, 26 May 2020. Accessed 13 September 2021. https://www.techspot.com/news/85379-tiktok-revenue-surged-during-lockdown-setting-new-record.html.

Shaw, Dougal. 'Does being "TikTok famous" actually make you money?', *BBC News*, 12 March 2021. Accessed 13 September 2021. https://www.bbc.co.uk/news/business-50987803.

Stepanova, Maria. *In Memory of Memory*, translated by Sasha Dugdale. London: Fitzcarraldo Editions, 2021.

30
Morphologies of agents of the pandemic
Social Morphologies Research Group (SMRU)

Posted 25 December 2020

Admin – I don't believe in the sombrero, herd immunity or eating out to help out. I did clap but now that is over it seems like it never happened. I want to know why my life has a different shape to it now. That is why I started this blog. Why is it I miss people less and less? And culture, what is that? About a month ago, as a joke, I googled 'LOCKDOWN CULTURE' and found out about the Social Morphologies Research Unit (SMRU). I am not sure if they are real, a spoof or a diagram cult. If the latter, I have been well groomed, for I think their diagrams help me understand what has happened to me. I screen-grabbed eight disparate schemas before their diagrams were mysteriously scrubbed from the internet. They are presented below.

'Pandemic Stack: Agents Visible & Invisible to the Eye'

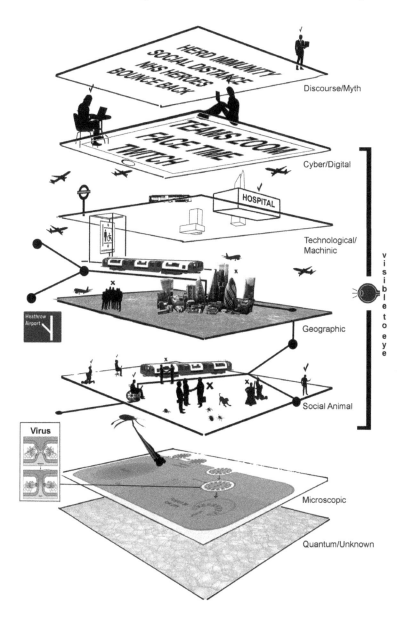

Figure 30.1 'Pandemic Stack: Agents Visible & Invisible to the Eye'. David Burrows, 2020.

'Pandemic Timeline: Covid-19 UK From First Case to Lockdown'

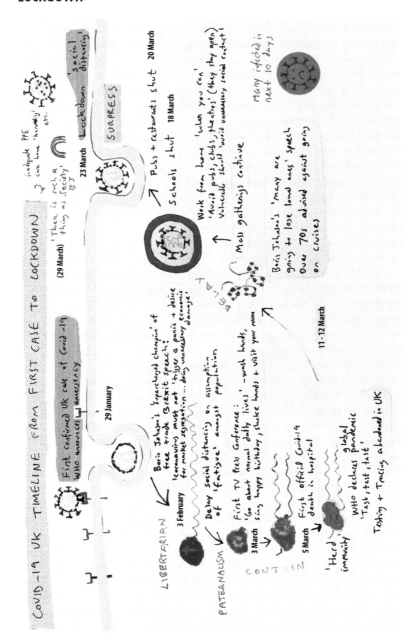

Figure 30.2 'Pandemic Timeline: Covid-19 UK From First Case to Lockdown'. Dean Kenning, 2020.

'Covid-State Triangle'

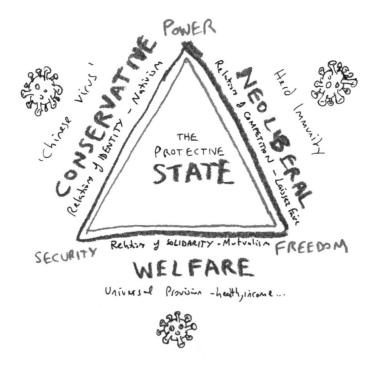

Figure 30.3 'Covid-State Triangle'. Dean Kenning, 2020.

'Social Distance Diagram'

'Social distancing' is an oxymoron so powerful in its meaning-effacing effects that it likely qualifies as what anthropologist Clifford Geertz called a 'core symbol'.[1] Anthropologists have always been drawn to oxymorons of this kind, as hints that forms of life beyond what one might take for granted are possible. Twins are birds, Nuer people told English colonial anthropologist E. E. Evans-Pritchard in Sudan in the 1930s, and, in some sense, they meant it.[2] Peccaries are human, people in Amazonia say, and they mean it too.[3] But what do they mean? Another anthropologist, Roy Wagner, suggests that, far from glossing 'apparently irrational beliefs', these apparent oxymorons are powerful because they invent new

meanings by contorting conventional categories into new and unexpected shapes, with startling effects. Nuer people 'knew' perfectly well that twins are humans, just like indigenous people in South America 'know' a peccary is a boar-like creature. For reasons that are important to them, however, they want to explore the possibility that, differently considered, twins or peccaries may reveal themselves as something more than what is already known of them.

Wagner's technical term for these acts of invention is 'obviation', and his signature diagram of how obviation works is a fractal triangle. In *Lethal Speech* he shows that meaning does not, as is often assumed, operate by stringing together conventional concepts (in other words, we know what twins and birds are, so let's now 'claim' that twins are birds).[4] Rather, conventional concepts are only able to say something (other than the trivial) when they are effaced, distorted, shifted, twisted, exhausted – in short, 'killed' – in the very act of being used. I did this just now: conventionally understood, 'meanings' cannot be 'killed', so proposing that they are killed does just that: it kills the (conventional) meaning of meaning by allowing the concept of killing to interfere with the term (to flow into it analogically), and in that way to invent it afresh.

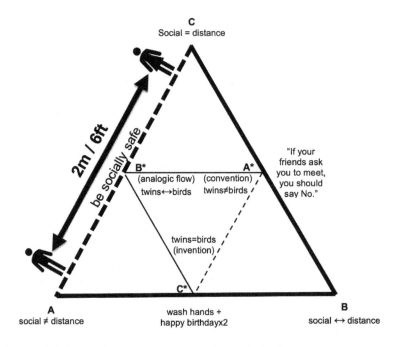

Figure 30.4 'Social Distance Diagram'. Martin Holbraad, 2020.

And so it is with 'social distancing'. Social relationships are not conventionally measured in feet and metres. But the oxymoron stuck. As with the myths and rituals through which twins that are birds and human peccaries come to pass, conventional distinctions (between social and spatial) are eroded for 'social distancing' to gain traction. Category mistakes (working on conceptual borderlands to shift them) became the modus operandi of the state. That initial, ostensibly sensible (if a little obsessive) injunction, 'wash your hands', became conjoined with a seemingly quaint (but, I suggest, deeply significant) incursion into sociability: sing 'Happy birthday' twice, to measure out the 20 seconds required. The UK Prime Minister's iconic speech on 23 March 2020 deepened the conceptual entwinement of the spatial and the social. The critical injunction, 'you must stay at home', is literally brought home with the exhortation to 'say No' to friends proposing meet-ups, to prevent 'the virus spreading between households'.[5] And as with twins that are birds, the effects of the state's drive towards spatialised sociality, transfigured in the image of two humans measuring their 'social distance' at 2 metres or 6 feet, have indeed been startling. The story of lockdown in 2020 could be told as a mass struggle with the consequences of this arresting conceptual possibility: that social relations might be recast in (and as) measurements of spatial proximity and distance.

'Semiotics of Covid-19'

Figure 30.5 'Semiotics of Covid-19'. Kelly Fagan Robinson, 2020.

This diagram (Figure 30.5) reflects on the government's visual communications and how they have reshaped meaning for our home and family over the course of the Covid-19 pandemic. The images here are an archive, weaving together a drawing by Miranda Robinson (aged 9) of the view from her window during lockdown, the bored doodles of escaping stickmen by Elliott Robinson (aged 12), 'the Curve' produced by the Office of National Statistics (ONS), and an image of the children themselves. It is a schema registering the ways that telic, hegemonic image-making directs different meanings.

Against a backdrop of political polarity, endemic inequality and uncertain futures, living with the pandemic replaced 'everyday living' at the precipice of a new kind of meaning-making. Over the pandemic's relentless course, there has been a sense of place-marking, charting things in anticipation of a moment when 'we' can look back and determine what was right, wrong, heroic or cowardly. Specifically, in our home peopled by two adults and two children, the shapes emerging from the ONS began to serve as a way of proving the presence and promise of science, and as a way of punctuating our own muted and mutual isolation hidden behind our windows. I knew and we discussed repeatedly the ways that the numbers behind 'the Curve' were always temporally scattered. It was perfectly clear that the pandemic's markers – of infections, of deaths, of people – did not represent what occurred on a given day, only what was accounted for in that moment; increases in community and nursing home deaths would go unwitnessed, folded in much later and without further acknowledgement.

Recent information availability has yielded rapid, drastic change in the ways that humans connect with one another. Semiotician Gunther Kress has distilled this transformation down to a single concept: '[r]epresentational and communicational practices are constantly altered, modified, as is all of culture, in line with and as an effect of social changes'.[6] This requires a reorientation of linguistic ideologies, reflecting the fact that '[electronic] forms of communication can now make aspects of any specific "where" into features encountered everywhere, with an unspoken and urgent requirement for it to be made sense of "there"'.[7] The pandemic's ongoing discourse is similarly polytemporal; communications by government officials mobilise related multimodalities eschewing simple binary oppositions of 'today' and the 'past', registering instead lived realities of 'locked-down' bodies and fuzzy numbers.

At a time lived via adrenaline and abstraction, numbers communicated visually by diagrams can appear – and for our family have been – something to cling to. Conceptualisations of 'the visual turn' are useful to think about during the pandemic, as image-making itself emerges as a social practice

that is at least as important as the messages these images convey.[8] As Sperber and Wilson's approach to communicative cognition states: 'communication is a process involving two information-processing devices'; the message received by the listener may or may not be the message intended by the teller.[9] The gap between message-maker and receiver is bridged using inference, reliant on teller and receiver having enough in common and a willingness to build understanding. With the everyday filtered by the numerical schemas of the ONS, our ability to cognitively 'leap' to understanding is thus at the core of both meaning-making and the 'we' that is constructed and delimited by common understanding.

'Breach & Clear: Pandemic'

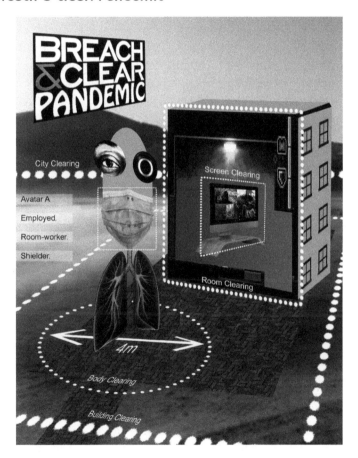

Figure 30.6 'Breach & Clear: Pandemic'. David Burrows, made in discussion with John Cussans, 2020.

Breach & Clear, released in 2014, is an action role-playing video game requiring strategy to control an armed unit that must breach an area of a city where dissenting organisations are located, and clear (kill) all inside. The sequel, *Breach & Clear: Deadline rebirth*, was released in 2016, adding infectious zombies. The unit has to: 1. clear a cave where the zombie horde dwells; 2. find patient zero; 3. join or eradicate lawless cults in the city; and 4. choose whether to defend family (stay home and save kin) or travel to Washington D.C. with patient zero's biological sample (complete essential work for the nation). In 2020 (in another universe) the game was hacked and released clandestinely as *Breach & Clear: Pandemic*. In this version, zombies were replaced by a virus and militaristic fantasies gave way to maintaining clearings that the virus and other (potentially infected) avatars try to breach.

The terms 'clearing' and 'dwelling' used in the hacked game are taken from 'The Elmauer rede: Rules for the human zoo' (1999) by Peter Sloterdijk, who controversially argues that contemporary societies are produced by breeding self-taming or self-domesticating humans, who think they are no longer animals as they dwell in clearings – in houses in cities – and maintain domestic boundaries.[10] It is this idea that *Breach & Clear: Pandemic* makes diagrammatic (see Figure 30.6), by creating a post-human zoo: avatars survive through maintaining clearings both physical and cyber. Domestic clearings are so marked: a city (circle) accommodates buildings (squares) with rooms (squares) in which avatars sit before screens (squares) presenting avatars (in more squares). Movement in this open-world game involves maintaining a 2-metre clearing (circle) free from others. The game has individually controllable avatars – A, B and C – that are unequal in resources and must be kept safe. A has a laptop and can work from their room but must 'shield' from contagion. B has a tablet and an essential job, and must leave their room to work and support an extended family, including parents that, like A, are extra-vulnerable to the virus. C has a mobile phone and no job, and relies on charity. A player must decide when and if their avatars should: 1. leave their rooms; 2. stay home and safeguard their kin or travel to undertake essential work for the nation; and 3. join or oppose dissenting groups that believe clearing measures are either a. unaffordable, b. unnecessary, or c. curtailing liberty and dissent.

Here are the real challenges of *Breach & Clear: Pandemic*, not self-preservation but decisions about consent and dissent – are you for (self-)policing or for breaching clearing measures for the sake of liberty, fraternity and equality (and economy)? *Breach & Clear: Pandemic* marks these choices through twisted reference to Jacques Rancière's concept of

dissensus, which marks a difference between the operations of politics (democracy and equality) and the police (regulation of the sensible in the Polis or city).[11] Rancière suggests that, today in European democracies, consensus is attained through 'the reduction of politics to police' operations.[12] In playing *Breach & Clear: Pandemic*, liberals of all stripes must quickly confront and adapt to complex biological and political problems or risk fatal consequences.

'Aspirational Horror'

Home alone on the sofa I am toxic. Spent jets of exhaled steam accumulate in a miasma that lingers around my body, respiratory droplets of my bodily fluids no longer contained by my skin are ejected from my orifices in these warm swampy cloudbursts. Contagions dribble out of my pores and run down the outside of my body, stream down my skin, run over my hands and drip off my fingers. They pour out of my eyes and down my face. My breath is hot and wet with aerosol saliva and a tropical humidity dredged from deep inside my body, from the damp regions of my respiratory tract. It condenses and streams down the uninsulated windows, pooling on the sill and drooling down onto the carpet. In this slow creeping eversion, my outside is gradually being mediated by my inside, my unruly body revealing its terrifying and embarrassing interior.

Reza Negarestani describes radical paranoia as a departure from an openness to the outside, as a withdrawal from the dynamic vigour of the environment, a closure that enables a survival that is 'disobedient to vitalistic ambitions' – to the social and the libidinal.[13] This contestation of a dual orientation toward inside and outside (both socially and individually) is compounded by a confrontation with all that is abject – the dirt, the muck that deprives the idealised humanistic solidity of the body of its definitive boundaries, complicating the difference between inside and outside, between solidity and diffusion.

With an implicit directionality and tendency toward unpredictable movement, bodily fluids appear to have an agency of their own that require the management of their potential for both containment and gushing release, with or against one's will. As these fluids cross the somatic boundary they transform into an ambiguous and unassimilable composite, that upsets the social and individual order, confusing identities and the edges of things.[14] Such abjection emerges at the point where the inside is turned to the outside, an eversion that leaves the body psychically coated in vectors of contagion.

Bodily fluids retain a cathexis and value of the body even after their apparent total ejection, extending the corporeal schema in expected ways across space and time.[15] This understanding of saliva as ostensibly a detachable body part is central to the functioning of folk magic, well documented from witch trials of the late Middle Ages in Europe – contagious magic as a 'secret sympathy' transmitted through a kind of invisible ether.[16] Saliva is a potent material – once contained within the corporeal schema it can never fully be separated from the body again. Bury your fingernails, burn your hair, wipe away your spit.

In medieval Europe, in the time of the Black Death, contagion was believed to pass eye to eye with a glance. The vulnerable jellies of eyeballs so exposed to the outside are ready receptacles for contaminants that no amount of tears can wash away. Nearly seven centuries later it is not transmission through the evil eye that we dread, but proximate wet breath and touch.[17]

Figure 30.7 'Aspirational Horror'. Text and image by Lucy A. Sames and Melanie Jackson, 2020.

Figure 30.7 is a speculative diagram of a corporeal schema open to multifarious readings of insides and outsides, as anatomy or as cartography, but either way, certainly as a sigil for drawing down, with hot and unusual optimism, a more moist and pleasant future.

'Aurora 01'

Figure 30.8 'Aurora 01'. Mary Yacoob, 2020.

I began lockdown in late March 2020 by charting imaginary constellations. By schematising cosmic spatial relations, our imaginary space can expand even as the physical space of our social interactions contract.

The diagram in Figure 30.8 shows the drawing Aurora 01, an artistic response to a diagram of solar winds, a theme connected to the cyanotype printing process which was used to create the work. Ultraviolet sunlight triggers chemical reactions in specially coated paper, giving rise to the deep Prussian blue of 'blueprints'. The technique was invented by the astronomer Sir John Herschel to reproduce diagrams and notes. The drawing is composed of halos, streams of energy and flashes of light, with the sun depicted as a rotating ball of electricity and the Earth as a portal. The source diagram was rotated ninety degrees clockwise to evoke a composition inspired by the works of the artist Hilma af Klint, a pioneer of abstraction who manifested her conceptions of her spiritual place in the universe by deploying what are commonly thought of as scientific graphic forms such as diagrams, geometrical and biomorphic visualisations and complex symbolic systems. The Earth's magnetic fields protect us from the radiation of solar winds, and in doing so, get compressed and elongated by the velocity of plasma and particles. This puts us in mind of both bodily and interstellar protective systems against the hostile forces of nature, and the miraculous and precarious nature of human existence within cosmological space-time. As particles pass through the Earth's magnetic shield, they collide with oxygen and nitrogen atoms and molecules, triggering the spectacular light displays in the sky known as auroras, named after the Roman goddess of dawn.

Admin – *Aurora 01* is an optimistic end, fitting for my last blog entry. I am going to take a break from screen-life. I am going outside more and every night, to look at the heavens. Each night I feel less of an urge to go inside, despite the cold. Tonight, the moon is waxing gibbous.

Comments disabled.

Notes

1. Geertz, 'Thick description', 17.
2. Evans-Pritchard, 'A problem of Nuer religious thought', 1954.
3. Viveiros de Castro, 'The relative native'.
4. Wagner, *Lethal Speech*; see also Holbraad and Pedersen, *The Ontological Turn*, 69–109.
5. See Prime Minister's Office and Johnson, 'Prime Minister's statement on coronavirus', for a transcript.
6. Kress, *Multimodality*, 7.

7 Kress, *Multimodality*, 7.
8 Jewitt, *The Routledge Handbook of Multimodal Analysis*.
9 Sperber and Wilson, 'Précis of *Relevance*', 697.
10 For a translation, see Sloterdijk, 'The Elmauer rede'.
11 Rancière, *Dissensus*, 37–42.
12 Rancière, *Dissensus*, 42.
13 Negarestani, *Cyclonopedia*, 219.
14 Kristeva, *Powers of Horror*, 4.
15 Grosz, *Volatile Bodies*, 81.
16 Frazer, *The Golden Bough*, 16.
17 Jackson, *Spekyng Rybawdy*.

Bibliography

Breach & Clear. Cary, NC: Mighty Rabbit Studios, 2014.
Breach & Clear: Deadline rebirth. Cary, NC: Mighty Rabbit Studios and Gun Media, 2016.
Evans-Pritchard, E. E. 'A problem of Nuer religious thought', *Sociologus Neue Folge / New Series* 4, no. 1 (1954): 23–42.
Frazer, James George. *The Golden Bough*. London: MacMillan Press, 1978.
Geertz, Clifford. 'Thick description: Toward an interpretive theory of culture', in *The Interpretation of Cultures: Selected essays*, 3–30. New York: Basic Books, 1973.
Grosz, Elizabeth. *Volatile Bodies: Toward a corporeal feminism*. Bloomington, IN: Indiana University Press, 1994.
Holbraad, Martin and Morten Axel Pedersen. *The Ontological Turn: An anthropological exposition*. Cambridge: Cambridge University Press, 2017.
Jackson, Melanie. *Spekyng Rybawdy*. London: Procreate Project, 2020.
Jewitt, Carey. *The Routledge Handbook of Multimodal Analysis*. New York: Routledge, 2009.
Kress, Gunther. *Multimodality: A social semiotic approach to contemporary communication*. London: Routledge, 2010.
Kristeva, Julia. *Powers of Horror: An essay on abjection*. New York: Columbia University Press, 1982.
Negarestani, Reza. *Cyclonopedia: Complicity with anonymous materials*. Melbourne: re.press, 2008.
Prime Minister's Office and Boris Johnson, 'Prime Minister's statement on coronavirus (COVID-19)', 23 March 2020. Accessed 7 October 2021. https://www.gov.uk/government/speeches/pm-address-to-the-nation-on-coronavirus-23-march-2020.
Rancière, Jacques. *Dissensus: On politics and aesthetics*, edited and translated by Steven Corcoran. London: Bloomsbury, 2010.
Sloterdijk, Peter. 'The Elmauer rede: Rules for the human zoo: A response to the *Letter on Humanism*', translated by Mary V. Rorty, *Environment and Planning D: Society and Space* 27 (2009): 12–28. https://doi.org/10.1068/dst3.
Sperber, Dan and Deirdre Wilson. 'Précis of *Relevance: Communication and cognition*', *Behavioral and Brain Sciences* 10, no. 4 (Winter 1987): 697–754. https://doi.org/10.1017/S0140525X00055345.
Viveiros de Castro, Eduardo. 'The relative native', *HAU: Journal of Ethnographic Theory* 3, no. 3 (2013): 473–502. https://doi.org/10.14318/hau3.3.032.
Wagner, Roy. *Lethal Speech: Daribi myth as symbolic obviation*. Ithaca, NY: Cornell University Press, 1978.

31
Wildfire
Jon Thomson and Alison Craighead

April 2020

During a lull in the meeting I drop myself into Minecraft. I find myself sitting in a Lego garden on a farm with a colourful windmill some way up the hill behind my right shoulder. This sparks a brief diversion as the three of us sort through the baffling library of pictures you can deploy if you would rather nobody sees what is really behind you.

We sit in front of our computer screens jumping from place to place. There is Ben's head and shoulders floating in Outer Space, and now Julie is sat in every bland hotel room I have ever forgotten.

As we each sit in our own physical confinement, in our own homes, in different parts of the world, we teleport our way through the corporate imagination of whoever it was who compiled these images for the conferencing software that we have been told to use by our employers for the duration of pandemic lockdown.

A scribbled note is pushed into my view and I snap back into my house on a hill in the highlands of Scotland in late spring, where my partner Ali is silently mouthing their scribbled message at me. I lift one side of the headphones away from my left ear dispelling the patch of workplace that has been mapped onto the kitchen table for the last hour or so.

> *There's a wildfire out on the heather. Keep looking for smoke through the trees at the back in case we have to leave*

A fire engine passes by. Julie jumps to an Italian palazzo. Ben is on a sweeping coral sand beach. I reposition my headphones and continue the meeting without knowing why, and Ali runs outside to better understand what is going on.

*

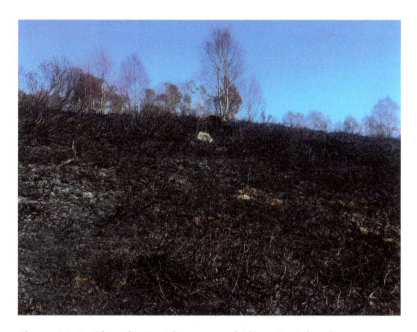

Figure 31.1 Photo by Jon Thomson and Alison Craighead.

Two days later I see the helicopter rising into the air having scooped water from the loch below ready to be dumped onto the wildfires. The flames have been sprawling unpredictably across the land, branching and multiplying as they are blown to the west across dead bracken and heather.

That first night we lay in bed with the blinds open, watching a thin line of flame describe the hill line through the trees. All the signs are good. We have an overnight bag ready, but we know we will probably be OK. The wind is blowing away from us, but the anxiety remains in parallel to the pandemic. As the virus blazes across the planet, we are all staying home, if we can, in our attempt to slow its crossing.

My laptop starts chirping, an insult to the birds outside. The ringtone is calling me to my next meeting where we can be alone together.

32
Poems from *Gospel Oak*
Sharon Morris

Preface

I have selected these six poems from my collection of poetry *Gospel Oak* (Enitharmon Press, 2013), in response to the invitation to revisit past texts, theories or a corpus familiar to us.[1] These poems revisit texts from the Communist Manifesto, Plotinus, Blake, Constable, Keats and the plural authors of the folk song, 'Ring, a ring o'roses' that emerged from a range of cultural influences.

 The title of the collection cites 'Gospel Oak' as the name of the north London borough that edges Hampstead Heath; the train station on the Silverlink line carrying atomic waste; the oak as locus of the gospel reading to mark the beating of the parish boundary; the boundary eroded by the River Fleet channelled underground, its geological sediment turned to the charnel pits of Waterloo, quarries of gravel littered by the retreating great western river.

 To walk over Hampstead Heath becomes an act of intertextuality, reading the past in the traces of rock, its geomorphology – the way water runs orange with the rust of Chaleybeate; the grass changes colour with the legacy of rain belying the porosity of rock; the ancient oaks of Hampstead Heath remnant of the Ice Age and a Mesolithic midden, still visible, are the texts of prehistory, expanding our life-time incommensurate.

Looking for the location where Constable, 'skying', documented clouds with a meticulous quest for knowledge; where Keats walked reflecting on the meaning of democracy, the value of truth, beauty and the purpose of art; the Commons of Hampstead Heath hosting the rights of the dispossessed to gather and graze before the acts of enclosure; I stand outside the home of Rabindranath Tagore in the Vale of Health, where in 1603 they came to escape the plague.

The wealthiest homes discretely arrayed the other side of the Heath from the housing estate; the view from here of the city and its bounded histories; the sky open to its vulnerability, materialist history and the infamous trade of people; the tallest building, the Shard, affording us an island glimpse of the North Sea; I walk these other streets with their blue plaques to Orwell, Marx and Lenin.

And I think of the role of vision; the visionary Blake walking from Lambeth to his 'Dante Woods' of the Heath Extension. How his image of God creating the world with a compass, emerging from measurement, points beyond the commensurate to the creation of space from nothingness; the way, perhaps, Keats's negative capability points to potential.

The poem proposes a thinking through, a working through of image, image conceptualised as a constellation of the sensory and the idea; I am seeking to release Freud's overdetermination without reduction to metaphor and metonymy.

As if throwing Plotinus into reverse, to revisit that fragment made divisible from the infinite continuum will make clear not only the present as echo of the past, but how poetry may become prophetic in its imminent evocation; I am trying to find that hope.

A ring, a ring o'roses

A rash of red bites
from fleas carried
on the backs of rats, living
in the sewers
of London; rivers red
with fly-blown meat
and rotting carcasses,
 the bubonic Fleet
open to the air, piss
and shit oozing
down the walls:

we are the plagued,
locked in our houses
by doctors clothed
in vinegar-soaked
robes, long-beaked
masks filled with
bergamot oil,
bearing pouches
of sweet-scented
herbs.
Burn us —

The view from Parliament Hill

Paddington Basin: Carmine, Monsoon, Battleship, Cucumber.
Battersea's vision of a Green Bird; Lambeth's Three Sisters.

Constant revolutionising of production,

City of London: Walkie Talkie/Pint, Helter Skelter/Pinnacle,
Heron Tower, Cheesegrater, Tower 42, Gherkin.

uninterrupted disturbance of all social conditions,

Shadowing St. Paul's: the Stealth Bomber, Vortex,
Rothschild's Sky Pavilion, groundscraper engine block for UBS.

everlasting uncertainty and agitation …

South of the river: Shard, Quill, Strata, Razor/Isengard,
Boomerang, Doon Street Tower.

All fixed, fast-frozen relations … are swept away …

Isle of Dogs: Canary Wharf, Tower 42, Riverside South,
One Canada Square, the FSA, the Pride.

All that is solid melts into air, all that is holy is profaned …[2]

Chorus

In this choiring, the soul looks upon the wellspring of Life – each scent of thorn separate, discriminate – froth of white flowers – hawthorn/quickthorn/whitethorn/blackthorn, May – Bend down – to the wash of blue, bluebell, Spanish/English (paler, more scented, prefiguring death) – to the lily, wood anemone, lesser/greater celandine, pink purslane, campion, violet/dog-violet, primrose/butter-rose (pink-eyed/thrum-eyed), cuckoopint/arum/lord and lady/Adam and Eve/bobbin/wake Robbin (spathe sheathed around spadix) – to the honey-sweet yellow anther, the pungent leaf of/stalk of ramson/wild garlic – the damp earth warm, well-lit before the canopy of leaf, sun after rain each twig and branch glassy – Look up through the cut buds/catkins, to new leaves – each blade velvet-bloom/shiny, serrated/smooth, holly/ilex – oval/boat/lobed – alder, beech/wild service, sycamore, maple, lime, London plane – pure//hybrid oak, common/uncommon, pedunculate/sessile, English/durmast, Turkey, American red, cork//Lucombe – squint through the screen of set/array – compound leaflets alternate/paired opposing – mountain ash, false acacia/common ash – palmate chestnut horse/sweet, framing the light, dappling the sun – overlapping hands concealing blue, white/grey scudding clouds – Skying a mackerel sky, what individuates the haeccity of cloud? – pileus, pannus, velum, incus, mamma, virga, tuba, fumulus —— be dazzled by the effects of light in air – halo, mock sun/sun-dog/parhelion, arc, corona, iris, glory – Listen to the volary, aggregation, roost, mess, leach, drove, aerie, rout, flew of birds – How many notes, mother? – lowing/bellowing of bullfinches, chime/family/herd of wrens, cloud/keg/merl of blackbirds, hermitage/mutation/rash of thrushes – calls of alarm/defence/attraction/mating/birth – contusion/mischief/ tiding/charm/tribe/murder of magpies – a *cri de coeur* – call and answer/hunger – chatter/clutter/hosting/murmuration/cloud/filth/scourge/congregation of starlings – too numerous to count, wing-beats imperceptible – charm/chirm/chirp of goldfinches, red-faced, wresting seeds from pine cones – jays/parakeets escaped from a circus – one pair of kestrels soaring, *kee kee, kee kee, kee kee, kee* – descant – veridical to that vernal sky – Hum of traffic in the distance – a woman strolls by learning a score by heart.[3]

Constable the nubilous skying

View from Hampstead Heath looking towards Harrow.
August 1821 5 p.m. very fine bright & wind after rain slightly
in the morning.

Study of clouds at Hampstead. 11th *Sept. 1821. RA. 10 to 11.*
Morning under the sun – Clouds silvery grey, on warm ground Sultry.
Light wind to the SW fine all day – but rain in the night following.

Hampstead Heath, Sun Setting over Harrow. 12th Sept. 1921.
… while making this sketch I observed the Moon rising very beautifully …
due east over the heavy clouds from which the late showers had fallen.
Wind Gentle … increasing from the North West.

The Road to the Spaniards, Hampstead, July 1822 looking NE 3pm
[previous to] a thunder squall wind N West.

Cloud Study. August, 27th*. 1822 at 11 a.m. … o'clock noon*
looking Eastward large silvery clouds… wind Gentle at S West.

London from Hampstead with a Double Rainbow, 1831, between 6
and 7 o clock Evenings June.

This, the first diagram of a double rainbow, shows
the precise angles of primary and secondary bow,

its spectrum inverted, noting that the height depends
upon time of day and year

and that a rainbow cannot be seen obliquely
as a viewer must always keep the sun

over the shoulder: *a mild arch of promise …*
Flashing brief splendour through the clouds awhile.[4]

A grand democracy of Forest Trees

instead of being a wide heath of Furse and Briars,
with here and there a remote Oak or Pine…

a grand democracy of Forest Trees

this was Keats's vision for humanity:

our inner citadels open to each other
like flowers opening their leaves,

passive and receptive; without dispute
or assertion but whispering, the way

he would have whispered in Fanny's ear,
as they walked across the Heath

and surely rested here at Bird Bridge,
its iron-rich stream a deep rust;

we sit now observing the nuthatch
and tree-creeper spiral the birch,

a rat hurry over the bank where Keats,
the apothecary, would have searched

for coltsfoot, bogbean, sphagnum moss,
lungwort, wanting to do some good.[5]

Wylde's farmhouse

It's still here, Old Wylde's farmhouse,
remarkably unchanged since the time Blake
used to stay with Linnell and his family
during his late years, when he worked
on engravings for the *Divine Comedy*;
walking from Lambeth through the city
to this wood he called 'the Dante Wood',
often leaving late at night in darkness,

no moon, no shadows, no distinction,
only in my mind, pitiless fear; one of his
last images, *God creating the universe*, a man
with a pair of compasses, measuring,
dividing the absolute into infinity and
finitude, and therefore creating space.[6]

Notes

1. Morris, *Gospel Oak*. With permission from Enitharmon Press. 'Chorus' reprinted here with permission from *Poetry Review*.
2. Lines from Marx and Engels, 'Manifesto of the Communist Party'.
3. Quotation from Plotinus, *The Enneads*, VI, 9.1.
4. Constable's notes made on the reverse of his paintings and drawings in collections at the V&A and British Museum.
5. Keats, 'Letter to John Hamilton Reynolds'.
6. Blake, Illustrations for Dante's *Divine Comedy*; Blake, *God Creating the Universe*.

Bibliography

Blake, William. *God Creating the Universe / The Ancient of Days*. Frontispiece to *Europe a Prophecy*. 1794.

Blake, William. Illustrations to Dante's *Divine Comedy*. 1824.

Keats, John, 'Letter to John Hamilton Reynolds', Hampstead, 19 February 1818. In *Letters of John Keats to His Family and Friends*, edited by Sidney Colvin, 73–5. Cambridge: Cambridge University Press, 2011.

Marx, Karl and Friedrich Engels. 'Manifesto of the Communist Party'. In *Marx/Engels Selected Works*, vol. 1, translated by Samuel Moore and Friedrich Engels, 14–21. Moscow: Progress Publishers, 1969.

Morris, Sharon. *Gospel Oak*. London: Enitharmon Press, 2013.

Plotinus. *The Enneads*, translated by John Dillon and Stephen MacKenna. London: Penguin, 1991.

33
I have a studio (visit), therefore I exist

Alice Channer, Anne Hardy, Karin Ruggaber and Carey Young

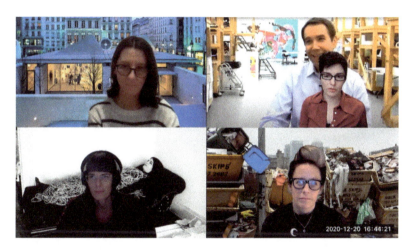

Figure 33.1 Two-by-two grid view of the authors on a video call, December 2020. Karin Ruggaber in front of a photograph of Atelier Brancusi, © Michel Dénance 2022, courtesy Renzo Piano Building Workshop and Atelier Brancusi, accessed 10 Sept 2021, http://www.rpbw.com/project/reconstruction-of-the-atelier-brancusi); Carey Young in front of a still from Tate Shots video 'Jeff Koons', © Tate and Jeff Koons 2009, accessed 19 December 2020, https://www.youtube.com/watch?v=XTnPq0uIUds ; Alice Channer, 'Studio Visit, Nov 28th 2020', in front of a photograph of Eva Hess; see https://liverpoolbiennial2021.com/programme/alice-channer-studio-visit/; Anne Hardy in front of a photograph of her 'outdoor studio', © Anne Hardy, 2020.

Introduction

The artist studio is a special, personal and mythic place, traditionally considered essential to an artist's creativity as well as their production. Studio visits by exhibition curators, collectors and arts patrons are a long-established method for arts professionals to visit an artist's workspace in order to gain insight and understanding about an artist's practice, and to nurture relationships which might develop into future opportunities such as new projects, exhibitions or sales.

During the Covid-19 lockdown from March 2020 in the UK, art galleries and institutions internationally turned their then-current exhibitions and archives into a mass of digitised and streamed content. Included within this generous and marketing-minded outpouring was a noticeable trend – the online 'studio visit', often featuring well-known artists, in which viewers were given an informal video tour of the artist's workspace, usually including an introduction by the artist to their recent or new work-in-progress. Many of these videos have been archived permanently online. A signifier of privileged institutional access to some of the world's best-known artists, online studio visits proved a popular and influential trend at a moment when the public seemed hungry for cultural insights into the Covid-19 pandemic.

In this discussion from December 2020 four London-based artists, Alice Channer, Anne Hardy, Karin Ruggaber and Carey Young, reflect on online studio visits within a wider artistic context.

Discussion

Carey Young (C.Y.): We thought of doing this discussion after each having watched many online studio visits during lockdown. This was especially in relation to the first few months of the pandemic, where art institutions and commercial galleries were pumping out these studio visit videos, regularly emailing their enormous mailing lists with new content. It was a phenomenon, maybe a response to the shock of the pandemic and an urgency of feeling that one – in this case galleries – had to *do something*. What felt essential and urgent? Was art still even being made? People were thinking about what life was, or should be about, and galleries were thinking that culture – and no doubt themselves – had to be in the mix somehow. Beyond the awfulness of the virus, the terrifying death rates, economic statistics and many instances of basic failure of

government, it wasn't just a simple matter of survival, was it? Millions, no doubt billions of people were unable to work. In the UK many were furloughed and stuck at home. Many people were bored, and of course there's a lot of art-interested people around. Galleries were closed to visitors, but felt compelled to generate and circulate cultural content which reflected on the pandemic and platformed their connection to certain artists. This seemed to manifest an unstated message of 'we're keeping going, and artists are still making'.

Anne Hardy (A.H.): At one point in that early lockdown period people were saying to me, 'As an artist, you have this special ability during a pandemic to continue to make your artistic work. This is your unique situation'. This implied that art and artists' material conditions were somehow completely separate from the rest of the world, which was experiencing this catastrophic event. Nobody really knew what the consequences were going to be at that point, whether in terms of health or economically, or practically. There was an assumption that artists would just carry on, and that they would immediately respond to the pandemic, process it and output artworks for everybody else to get to grips with. This came across as on the one hand an extraordinary faith in the power of art, but on the other hand, complete ignorance about how most artists function in the world and how they support themselves.

Karin Ruggaber (K.R.): But you could also only 'carry on' if you had your studio close by, because otherwise it was sort of illegal, wasn't it? It divided artists that had a studio in or near their home or that they owned, and artists that didn't have access.

Alice Channer (A.C.): Most artists got a worse deal than commercial tenants in terms of the kind of breaks that commercial tenants got from their rent, or the kind of help that the UK government might have provided to keep those businesses going. While there was some small state support available to artists, it was nothing in comparison to what functioning businesses were given in order to continue functioning.

C.Y.: Don't you think that it's also a kind of micro-aggression, because it was also implying that artists have got some psychopathic ability to ignore trauma. The rest of the world is going through this terrible circumstance, and everyone was in a state of shock, and yet somehow artists are like these little productive elves that are going off to their studio and happily either responding to the pandemic as if they didn't

already have work in progress, or that we were just somehow carrying on. I honestly find that insulting!

A.C.: The idea of artists having time to think is actually quite threatening because that might be the point at which we decided something quite radical about what our conditions might be. The idea that we might just carry on, and because of that not be able to process or draw conclusions from this pandemic experience, serves quite a few interests.

A.H.: That's a really interesting point. A specialist in AI development once told me that with AI taking over many types of work, the biggest fear of governments was not that they wouldn't be able to give people income, but the fact that people would not have anything to do, and therefore they would have time to think. They then might decide to rethink the system that they're contained within – exactly as you said, Alice. The pandemic threw a lot of those assumptions into sharp relief in the arts, as it has done elsewhere. It also made it clear through some of the earlier studio visit videos, in which some institutions and artists were putting out charming, engaging, high-production videos about their work, while at the same time other artists were losing their studios and maybe their homes, let alone friends or family members. It's a great extreme. At some points you feel that because you're part of this artistic community, there's a greater awareness of social and economic conditions, often a more left-leaning dimension. But what revealed itself at the beginning of the pandemic was how all these different fragments had no understanding of the other ones. I guess this is like the world in general. It became very visible.

C.Y.: The Covid period gave different visibility to some artists that started online art schools during the pandemic where they gave specific training, feedback, or developed a digital platform enabling art sales. It was all over Instagram. Some artists and curators became very visible, as if they started their own mini institutions. This gave them a currency, their work became better known because they developed a community around it. Is it marketing? Absolutely. I'm sure it also benefited many people. It was definitely generous. Those people took on a lot of work, no question, but it was a 'thing'. And I was thinking, wow, I'm not doing any of that. I don't have time, I have a child to look after, home schooling, an art school teaching job: but one also felt like the art world hierarchies were a little re-ordered – if only temporarily, perhaps.

K.R.: It was hard to know how to fit into that, and whether one should even try to.

A.H.: There were different levels of intimacy and engagement. They're an extension of what's been happening over the last 10 years with social media. The possibility to create a group of like-minded people that stretches across geographical boundaries can be so empowering and enriching. Concurrently, where's the line between marketing and everything else? I've certainly benefited from being able to listen to the proliferation of online talks and lectures, but at the same time, as an individual speaker providing content, this is often requested as unpaid labour.

K.R.: Art organisations needed to 'show off' the artists they are exhibiting or otherwise working with in order for them to be able to show themselves, and to demonstrate the idea that they could just keep going.

C.Y.: Did any of you have an online studio visit since lockdown started? As well as watching many online studio visits, I had remote meetings with curators about projects, and did some remote talks where I showed my work, but so far I haven't had an online studio visit as such.

K.R.: Neither have I.

A.H.: I did an online studio visit conversation with a curator, and online talks which included a studio visit element.

A.C.: I've done the same, and I also taught art students remotely from my studio, which became a kind of studio visit.
 Additionally, I made a studio visit video for a recent group show. I staged 'images' for the camera involving materials from my work, rather than an actual view of my workspace. It's like making my work: it's completely constructed. Other artists have done that historically, like the image of Eva Hesse which you can see behind me (Figure 33.1, lower left-hand quadrant). This was taken by the fashion photographer Hermann Landshoff at the end of the Sixties. The images are very knowing. Hesse has a playful but also sly look in her eye. It's artificial, strange and quite complex. She's posing with her sculptural materials, but lying on a chaise longue. I prefer such an explicitly synthetic scenario to everything that is often assumed about the authenticity of the artist's studio, which is still really seductive and has often been exploited in the studio visit videos that we're discussing.

K.R.: The way you speak about it sounds as if you can also use these opportunities to introduce yourself artistically, to do new things that you wouldn't be able to in an offline studio visit. Rather than just orchestrating it, you can play with it in an interesting way. You are *performing* the studio. We're doing it in this conversation as well. We're not showing our workspaces, but are using certain images as our Zoom backgrounds, which relate to what we want to discuss, and maybe to our artistic work. This would never have been possible before. For example, I chose an image of the Atelier Brancusi by the architect Renzo Piano (Figure 33.1, upper left-hand quadrant) – it's a reproduction of the exact layout of Constantin Brancusi's works as they had been displayed in his original studio. It's artist studio as historic site.

A.H.: When people ask to make a video about you and your practice, then you have to think, what is your studio? What is your working practice? This image behind me is from a crazy-looking street in East London in which people deposit waste goods in skips (Figure 33.1, lower right-hand quadrant). I spend a lot of time outside in places like this, to get inspiration for my work and to gather materials I might use in a piece. Through the process of thinking about this, I realised, how do I show somebody else what it is that I consider to be my studio? Places like this East End street are actually my studio as well, because that's where I get materials from, and think about what I'm doing with my work.

C.Y.: Aside from studios, there might be many other places where artists make their work, and those places might be practically or psychologically important. I know I have some. There have been periods where I've been travelling a lot and I've had a really productive time, artistically speaking, in a train or hotel room – all I needed was my laptop. So when a curator asks for a studio visit, I always think, you are welcome to visit my home office-type space where I make my work, but it's not going be particularly exciting in terms of the reveal of the room itself. Since my work is mostly video, photography, performance and text, we'd sit around a screen to discuss it – we could actually meet anywhere, as long as we can have an in-depth conversation. I think the studio visit, and the studio itself is a kind of a fetish, especially for curators and collectors. But not necessarily for artists, who may be 'post studio' in terms of a more digital way of making.

K.R.: When you make something, and then you're also asked to talk about it at the same time – I can never do that. It feels really complicated,

because they're actually two different hats. You're not only making work, or an exhibition, but you're also being asked to show and discuss it at the same time. It's really complicated, and this whole expectation of Zoom is a new thing. It's never enough for an artist to just *make* something. Apparently, people can never really just take something in, they have to be told *how* to take it in at the same time. They want to see behind the scenes as well as seeing the work.

C.Y.: That's the core of this whole discussion, the idea of 'behind the scenes' and the private domain of artistic making, and what one puts into the public domain. As soon as you let people into the private stuff – that might be one's private thoughts about the work or 'here's how the work looks when it's half finished' – you bring the public domain right into your personal space. There is a tricky negotiation about what one reveals and what one doesn't, and also whether one is ready to reveal it. When it's a new artistic work, it's very hard to have insight into it in the same way as you would six months or a year later. You need to generate enough critical distance.

A.H.: It's an ironic thing that, as you were saying, you have to somehow interpret, re-present or re-perform the content and inspiration in another way. That becomes the background, or the 'behind the scenes' of your work. But because of marketing deadlines you're often required to do that around three months before the final work is presented to the public. So, you don't really know what the finished piece is yet either, but the 'studio visit' film will come out at the same time as that show or project opens. And so, as an artist, you have to be careful with how much you reveal. It has to arrive at something that you'll be okay with being referenced online for the rest of your life. Especially now that everything stays online forever.

A.C.: In relation to this, I don't feel like there is a private, authentic space or place in my studio or in myself that I have to protect, or that can somehow be revealed. I just accept it as all artificial. When I got to that point, it became incredibly liberating. I realised, okay, if I do these films, then I have to control them and think of them as completely artificial. My work doesn't come from the point of view of having an authentic self to express. My studio is not a point of origin for work. But there are ways that I can ask my materials to speak to a digital screen for a Zoom studio visit. Then I am interested. I think there's an opportunity to experiment like that in this context. And especially now, when lockdown and being so

removed from our former lives has given us a feeling a lack of touch and a lack of reality, a lack of texture.

C.Y.: One thing we haven't talked about is the filming style used in studio visit videos. Before the pandemic, a camera crew would be hired to film artists. But in lockdown, online studio visits were almost always filmed by the artists themselves, often using a phone. That gave them a domestic, democratic, amateur quality. What does this give to the online studio visit? In my view it's something new.

A.H.: If a film crew is used, they have power in numbers and professionalism, and have already decided how you and your work will be 'framed' – often without talking to you first. You have to be disciplined about taking control and directing things to suit key themes in your work by saying 'this is the way we're doing it'. Whereas when you're filming yourself with your own laptop or phone, you can construct this yourself.

C.Y.: Filming yourself gives a kind of authenticity, doesn't it? The kind of home-made aesthetic, or an equality between the artist and everyone else, rather than artists always being seen as separate and different. If an artist is filming studio visit material on their phone then it's just an Instagram mode of operating, it's selfie culture. This is actually an equaliser. I imagine that this might have helped viewers connect with the artists that they see within online studio visits.

A.C.: It can also be utterly alienating – an artist moving around a vast studio that's actually the size of a sports hall.

C.Y.: Yes, there is definitely a size issue. Some online studio visit videos included an aspect of peacocking – the artist wordlessly implying *look at my resources, my wealth, my assistants* . . .

The image behind me is a screengrab from an online studio visit with Jeff Koons which was created before the pandemic (Figure 33.1, upper right-hand quadrant). Watching this video you feel like you're in the *machine*. He's in a vast warehouse space talking about several major bodies of work destined for different commissions and museums, and there's 20 assistants beavering away in the background. You immediately sense considerable cultural and economic capital.

A.C.: Again, it comes back to authenticity. When a studio visit film is used to suggest authenticity, but actually signifies privilege, it's obvious straight away.

There was recently a studio visit video on a major commercial gallery website which featured a single shot moving through the artist's studio. The artist is surrounded by assistants welding huge metal sculptures. The film had a documentary style, but with a glamour which undercut any assumed authenticity. I was willing to let the artist get away with it though – I thought it was incredible. I guess it all depends who the video is aimed at: who buys into which kinds of authenticity.

C.Y.: But we're also talking about a level of construction and fiction. As an artist, you can decide what's in the background of your Zoom studio visit. It's different to how a newsreader reads the news from home: because it's lockdown, they can't travel to a TV studio, so they've arranged their lounge, and the broadcaster sent over some lights so they can light it relatively well. It's different for an artist: a case of 'do I really include all the mess of my real workspace?' In essence, do I create a fiction where my chaotic real working stuff isn't in the background of the shot, and instead there's plants and piles of books, which maybe look nicer? In all such preparation, there's little idea of my artistic work. Even though an online talk is supposedly all about what the artist says and the images that they are going to show of their work, by controlling what is in the background the artist is extending their work or creating an aura around it. You could and perhaps should create a total fiction, actually.

This is also true of Hollywood films about artists, and arts documentaries. The wider cultural image that they propagate is of the artist roaming their vast studio like some caged animal, and then occasionally throwing paint at the wall, or instructing their myriad assistants. It's the Romantic cultural trope of the artistic genius. Always a man, and most likely a 'bad boy' in one way or another.

These templates run deep in the art world as well, even if arts professionals such as curators are highly educated about the breadth of artistic identity and practice. It affects collector and journalist mindsets too – the idea of artistic success being expressed through a large studio with lots of assistants pumping out work. There is a bias. These professionals still judge you, if you have a small or domestic workspace. This may include many women artists, or artists of colour, who historically have been excluded from gallery representation, shows and other professional opportunities to generate income and renown. They may not be able to afford a rented studio space, which often costs as much as, or

more than a mortgage, or it may not be worth it for any artist who works in a 'post studio' way, such as with performance or moving image. That kind of work does not sell as much, and may have a lower sale value, so the economics are totally different to a medium like painting, which can often sell for far more, and has a much more developed and large-scale market. Inherited wealth is also a factor – some artists have family assistance or an inheritance to help them exist as an artist and maintain a studio, so the large studio may simply signify that kind of privilege, rather than career success – and this is never discussed. Personally, I have used the cost savings of not paying studio rent to help fund many of my recent works, it's offered a vital kind of liberty. Not having a workspace outside my home has actually helped me create my work.

A.H.: Maybe there's a feeling that if you go to the artist's studio, you will actually inhabit the nucleus of the work, that you'll be inside it somehow. That's where people want to go. I always feel like with my work, that's kind of the opposite. It only exists when it's installed, so that's when you can be inside it. If you come to my studio, you just get lots of fragments.

A.C.: I do think stories about how objects – and I include art within this – are made are really interesting because generally we're quite divorced from that. If you come to my studio, you won't see anything being made there. It's rare for something to be finished there. And it's still a taboo often to discuss how an artwork is made. This is hidden a lot of the time.

K.R.: A studio definitely doesn't tell you everything.

C.Y.: If you think about, for example, Francis Bacon, there are famous photographs of his studio, which was an incredible mess, paint everywhere on the walls and knee deep in papers and trash. In relation to the work, it doesn't matter! Looking at the work in a museum is much more important and interesting. What does the mess of his studio actually show you about or tell you about Bacon's work? I don't think it says much that you wouldn't get from looking at the work itself. The work is the thing. We can see the passion, the brilliance in the work itself. The fact he had a kitchen, a filthy studio, is beside the point.

K.R.: Bacon's studio has been recreated piece by piece in a museum, which is another weird level of this discussion. The fakery of recreating a painter's studio. Unbelievable.

C.Y.: With all this, people try to psychoanalyse an artist through images, and now through videos of their workspace or home. It creates a narrative, an origin myth.

34
Inventory

Jayne Parker

At the start of lockdown, the magnolia tree in my garden was in full bloom. For several years I collected every petal that fell from the magnolia tree, laying them out to dry in rows on kitchen towel. The tree has long since grown too big for this to be a manageable task.

Magnolia buds and petals are the subject of an ongoing series of individual stone carvings, films, photograms and photographs. During the year of lockdown, I reflected on the series of photograms, made by laying out the petals in rows on light-sensitive photographic paper and exposing them to light in the darkroom. They act as an inventory of each year's fallen flowers. As an image, this resonates with the tally of days spent in lockdown and the effect of the pandemic on our lives.

The photographs were made by placing newly fallen petals directly in the negative holder of the enlarger, thus using the petal as a negative. No photograms or analogue photographs were made in 2020 as the Slade darkrooms were closed. Although I was unable to add to the photographic series of magnolia petals, I continued stone carving.

Lockdown coincided with spring, the blooming of the magnolia tree and the call for contributions to *Lockdown Cultures*. There is no fixed meaning to the photographs in this series other than being what they are and made in the way described. I hope that they hold something of the beauty and loss of spring and life.

Figures 34.1a and (opposite) b 'Inventory 1–2', photograms from series, 2017 to the present, Jayne Parker.

Figure 34.2 'Haphazard', photogram from series, 2017 to the present, Jayne Parker.

Figure 34.3a 'Magnolia Petals', photograph from series, 2017 to the present, Jayne Parker.

Figure 34.3b 'Magnolia Petals', photograph from series, 2017 to the present, Jayne Parker.

Figure 34.3c 'Magnolia Petals', photograph from series, 2017 to the present, Jayne Parker.

Figure 34.3d 'Magnolia Petals', photograph from series, 2017 to the present, Jayne Parker.

35
After a long time or a short time
Elisabeth S. Clark

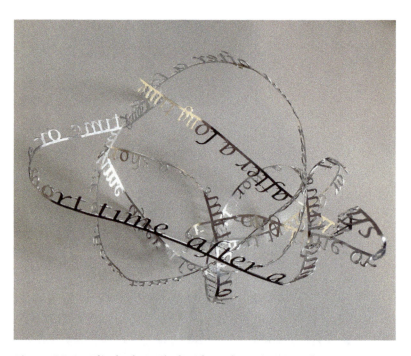

Figure 35.1 Elisabeth S. Clark, *After a long time or a short time*, 2020. Reproduced courtesy of the artist and Galerie Dohyang Lee.

My interdisciplinary art practice is engaged in translation processes of both a physical and a linguistic nature, encouraging a sensitive perception of our environment and the spaces we occupy.

My material poetics proposes a visual, sensual and imaginative experience that reconsiders the materiality of language itself as well as the expression it elicits. In this way, language reaches beyond itself to see, to think and feel.

After a long time or a short time (Figure 35.1) presents a time-tangled sculpture that continues a series of temporal works which observe our fragile and fragmentary perceptions of time and memory.

Bridging sculpture and writing, my gesture also wishes to map and ponder an *interior geography*.

Covid-19 and its attendant lockdown opened a parenthetical interlude for creativity, reflection and introspection. By giving materiality to this interval, my practice seeks to materialise the impermanent, the unsayable and the subjective. I also wish to give form to formlessness, inciting a sense of thought itself exposed within my work.

36
When the roof blew off
Joe Cain

I grew up on the edge of a hurricane zone. Each season we followed news about storms developing far off at sea. I grew up knowing about danger and risk. I grew up knowing the importance of preparation and escape. Where's the nearest high ground? Is our store of drinking water fresh? Which walls are solid and which likely to buckle? News reports about storm paths decided whether we committed their names to memory or

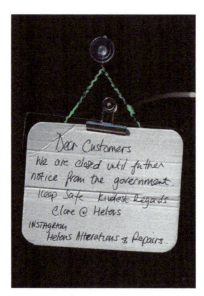

Figures 36.1–18 All images by Joe Cain, Hove, UK, 2020.

quietly left this job for those down the line. Most years, calamity lived in abstraction. We rehearsed our drills as if actors on imaginary stages.

Hurricanes take a long time to build. Once assembled, they can change character with little warning. A category three might grow quickly into a category five. A track north might shift fast to a track west. Calamities due for one county over might suddenly arrive at our own very tiny, very frightened doorstep. I grew up in a hurricane zone. I was taught to keep an eye on the weather and to expect sudden changes.

I remember the shock and disbelief on neighbours' faces the morning after one specific night before, when a category four headed up our bay. I remember the darkest noon I'd ever seen. I remember the water pouring so thick from the sky it seemed we had been thrown into a lake. And I remember the sharp-edged howling of wind above our basement refuge. 'If the roof goes', my mother said, 'get under the stairs and hold tight'.

Covid-19 closures

The hurricane that was Covid-19's first arrival in the UK reminded me of those storms from my youth. We watched Covid-19 come from far away. We committed new names to memory. We spoke about preparation and escape, mostly as abstraction and in the mood of theatrical pretence. Those conversations about washing hands and keeping our distance and skipping the commute were all conveyed through soft-spoken disbelief. It was never going to arrive. Not here. Not today. Not us. It just didn't seem possible.

Arrive, it surely did. Three turned into five before most of us understood there was a storm overhead. I remember when the roof blew off. I remember begging friends to get under the stairs and hold on tight. I grew up in a hurricane zone. I was taught to keep an eye on the weather and to expect sudden changes.

The British government imposed sweeping restrictions on trade and movement near the end of March 2020. I spent this first lockdown period in Hove, an English seaside town 100 kilometres south of central London, with a population of approximately 110,000. I followed national instructions restricting movement, keeping mainly indoors and avoiding interaction outside a small family bubble.

Shutterbug

Government instruction encouraged one brief period each day for outdoor exercise. I used these opportunities mainly to walk the streets of my town. At street view, Hove felt empty. I found myself drawn into that emptiness, fascinated with the wreckage this hurricane had left. I remember the absence of motion, the quiet and the overwhelming feeling of vacancy.

I carried a camera on these walks. At first, I had no specific purpose in mind. My gaze quickly fixed on one image recurring in endless variety: signs in shop fronts with messages of explanation and disbelief. It would be trite to say I noticed an endless variety of 'closed' signs when so many shops were, in fact, closed. I was seeing more. I came to think most shops were registering absence with more than mere status updates; sometimes, considerably more.

Photographs accompanying this essay (Figures 36.1–18) sample from a collection of over 350 images taken on the streets of Hove during the first national lockdown in Spring 2020. In some cases, I photographed systematically along the length of an entire street. In other cases, I selected for variety and visual aesthetic. A larger sample from this collection has been published online in conjunction with this volume. The full collection has been printed and offered for archival deposit.[1]

While on these walks, I thought a great deal about the act of creation experienced by each person making these signs. In some cases, pen was put hurriedly to paper, with seemingly little planning and with emotions unknown. In other cases, something seems to have kept the writer at their notice adding more words, prolonging connection, and avoiding a lifting of pen that began a walk into the unknown. When storms approached my childhood town, shutters went down and boards went up. The last few panels always seemed the hardest. Fixing those in place meant preparations were complete, and they'd have to hold whatever nature had in store.

Reading the signs

Studied as a whole, this collection of images from Hove in 2020 offers a resource about communication. I have organised this sample to demonstrate some of the strongest themes I observed. Crucial to their interpretation is the timeline of lockdown cultures in England in Spring

2020. These photographs capture the fleeting moment of locking down and boarding up. It's the moment of realisation that the Covid-19 hurricane was indeed overhead, and the roof was about to go.

Theme 1. Urgency: These signs show improvisation and rapidity. The images capture the moment of decision about closure. On most days, a simple 'closed' sign would do. For some reason, that was not enough for this day. The qualifications merit attention: 'until further notice', 'for the duration', and the like.

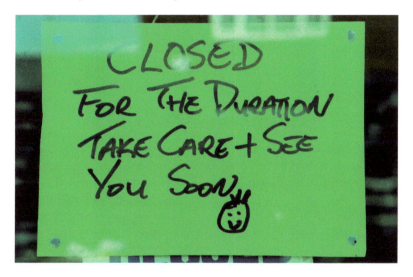

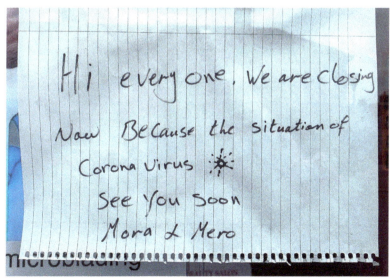

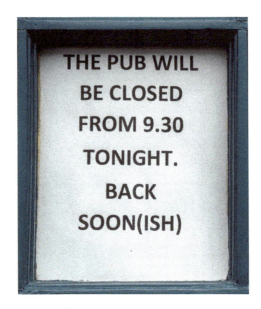

Theme 2. Preamble: Closure in a moment such as the pandemic hardly needed justification, especially after government mandates directed action. Still, many shop fronts found reason to preface their closure notices with emotive appeals and apology: 'with heavy heart', 'difficult decision', and the like. Notices with this theme sometimes extended explanations to express fear, dismay, dread and sometimes anger.

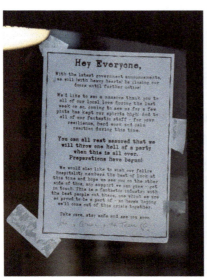
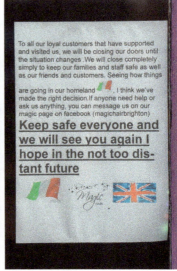

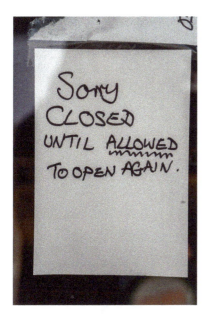 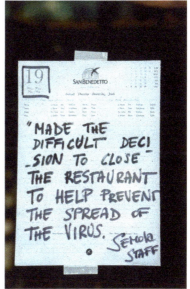

Theme 3. Resilience: Closure meant an immediate stoppage in trade for businesses. The threat to cashflow and livelihood created, for many, seemingly insurmountable difficulties. Some of the images collected under 'urgency' and 'preamble' convey the kind of dread associated with closing a business under conditions that seemed indefinite and complete. A variety of closure signs expressed resilience and determination, asserting grip as a virtue: holding on and holding fast.

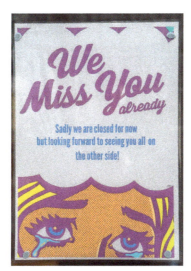

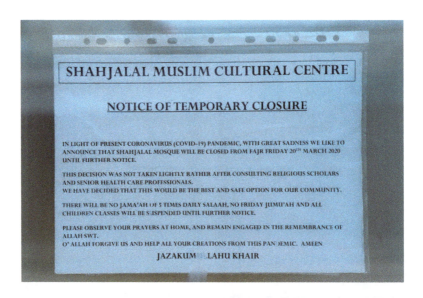
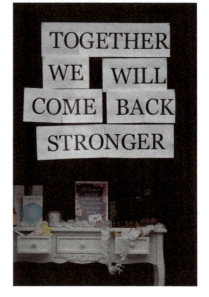

Theme 4. Shared humanity: Closure signs sometimes invoked ideals of community and cooperation. Others used this setting to assert the importance of treasured values and aspirations. These frequently came in the form of reminders about prioritisation and prescriptions to behave in ways we might idealise in calmer times as virtuous or good.

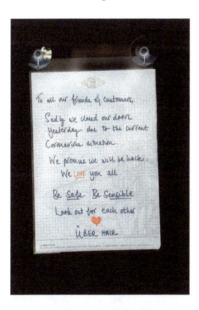

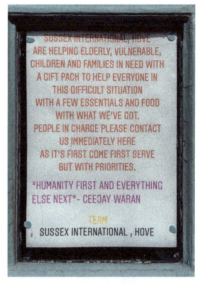

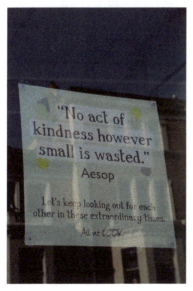

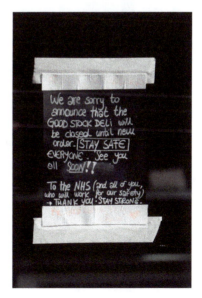

Theme 5. Humour: Humour tightens social bonds and offers a means for ventilation. Humour was rare in closure signs in March 2020. It became more common later in the closure timeline.

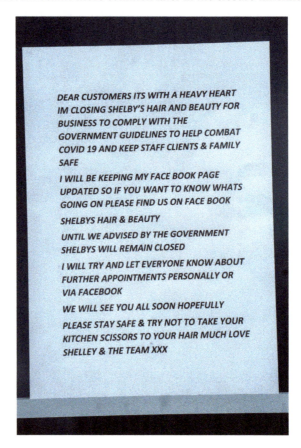

A curious absence in Hove was appeal to nationalist mythologies associated with times of crisis. I saw no appeals to Dunkirk, Blitz or Armada as comparable instances of resolve and community. Possibly, it was absent generally. Equally possible, an absence in Hove reveals sampling bias of several kinds.

Evolution

Signage evolved over the lockdown timeline. The images in this sample focused on the moment of first mass closure near the end of March 2020. For all intents and purposes, some premises thereafter seemed abandoned

for months, with no change to posted notices. This appeared to be the case for approximately one-third of commercial premises in Hove.

For other premises, themes in the initial wave of closures disappeared and other types of communications arose. Reports of burglaries and vandalism, which rose sharply early in lockdown, led to a rapid change of notices to assert that valuables had been removed and that premises were being monitored. This applied most frequently to retailers of high-value goods, restaurants and pubs. Contact details appeared on storefront signs to guide those needing urgent communication with responsible parties. The change was so common as to seem guided, perhaps by police or council instruction. Stores previously receiving donations, such as charity shops, typically posted requests to avoid depositing goods at the premises and informing donors of alternative locations for deposit.

Second, many businesses pivoted to online engagement. When replaced quickly, initial notices were commonly replaced with information about social media channels and digital commerce. For example, 'Follow us on . . .' or 'You can still purchase goods through . . .'. Other notices provided instructions for remote availability, typically from estate agents, solicitors, consultants and gyms. These were present only on a small number of premises at the point of closure, but they grew in frequency quickly during April and May 2020.

Third, storefronts that adapted to new closure rules and re-opened frequently posted notices to steer customers toward safer behaviours and to identify restrictions imposed within the establishment. For example, 'Only two customers at any one time', or 'Masks must be worn'. Typically, these were part of extensive new signage instore to manage customer behaviour.

One location; one moment

Studied as a whole, this collection of images supports a study of communication during a particular moment of the complex, multi-layered timeline of lockdown cultures and periods of mass action.

These images most clearly document communication during one type of extreme anxiety. Though specific expressions varied, they clustered into cumulative themes. Analysis of those themes helps understand how people in this one location and this one time conceptualised the challenges of pandemic closure at the point of initiation. It speaks to the 'locking down' bit of lockdown.

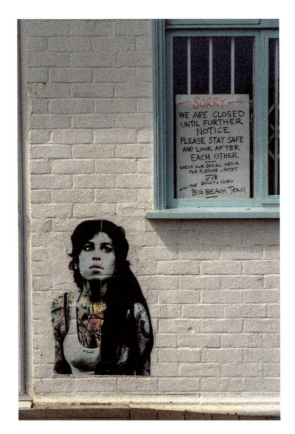

Comparable examples of this type of communicating are not difficult to find. One example leads me back to storms from my childhood, to messages painted on protective boards: 'bring it on' or 'tougher than you' or 'prayer good; plywood better' or 'close gate after leaving'. Those signs changed, too, over the timeline of a storm. I remember after one particularly rough storm passed, and we children were let loose again into the neighbourhood. Quick to sprout were signs of triumph, tragedy and recovery. Now, as then, it is hard to communicate the joy I felt when seeing posted on the door of a local favourite shop the simple message, 'open as usual; regular business hours'.

Notes

1 This larger sample and information about archival deposit is available from the digital resource http://profjoecain.net/lockdown.

Index

academic work 2, 7, 9, 62
access and accessibility 119
Adorno, Theodor 137
affinities 63–4
Agamben, Giorgio 205
Agata, Hikari 215
aid 94
AIDS 133
Allen, John 190
Amazon (company) 62
Amin, Tayyab 51
Amsterdam 166
Angier, James 166
anthropocentrism 193
anthropology 125–6
Arendt. Hannah 241, 245
art, magic of 118–19
artforms 66
the arts, government support for 52
Arts Council 50
arts and crafts movement 119
arts and humanities scholarship 2–6, 10, 22, 39, 47–8
astigmatism 238
astroturfing 15–18
asymptomatic carriers 83
Auden, W. H. 180
'Aurora 01' image 269–70
Australia 53
avatars 266

Babylon 72
Bachmann, Ingeborg 198
Badminton, Neil 171
Bailey, James 155
Banana, Yoshimoto 215, 217
Banfield, Stephen 228
Baraitser, Lisa 191
'bare life' 205
Barthes, Roland 138, 171–2,175, 177, 206
Baskin, Jon 203
Baudrillard, Jean 120
'Beacon' 192
Beckett, Samuel 7, 138–41
Beijing 147–51
belonging, sense of 146
Benjamin, Walter 118–20, 182–3

Beradt, Charlotte 9, 240–6
Berger, John 120
Berlin Wall 45
Bi-hsia, Ku-Yen 213–16
Bills of Mortality 166
biopolitics 61–2
Bjorneboe, Jens 7, 79–82, 85–6
Black Death 268
Black Lives Matter 18
Blake, William 275, 279
blandness 249–52
Bluestocking (journal) 212
bodily fluids 267–8
Boghurst, William 167
Bollas, Christopher 246
boredom 250
The Boy on the Bridge 191–4
brain domain response 157
brainprints 158
Breach & Clear (video games) 265–7
Brennan, Jason 202
Brexit 17
Briggs, Kate 170
Brohm, Jean-Marie 137
Brome, Richard 34
Brunt, Shelley 53
Bullock, Sandra 159

California 12
Calvino, Italo 191
Cambridge Analytica 16, 18
Camillus 105–9
Camus, Albert 198, 241
The Canterbury Tales 112
capitalism, global 191
Capitol Building, storming of (2001) 16
Caplice, Richard 70
carers and careers 62
Carey, M. R. 8, 191–5
Carson, John 236
Cash, Rosanne 32
Castells, Manuel 190
Catilinarian Conspiracy 98
Cayari, Christopher 54
Chamoiseau, Patrick 155–6
Champion, Justin 8, 163–8
Chang, Eileen 211

Chao-cheng, Chung 217
Chaucer, Geoffrey 112
Chian, Chen 213
Chian-he, Yang 213
China 8, 16, 145–8, 151, 211–13, 249–51
Choko, Ikuta 212
Christie, Agatha 182–4
Cicero 7, 97–8, 106
 attitudes to games and to intellectual pursuits 99
 and Roman amenities 99
 speeches to the people 99
 writings on philosophy and politics 99–102
civil rights movement (US, 1960s) 14
civium coniunctio 106–7
Cixous, Hélène 65
climate change 188–9
Cohen, August 93
Cold War 192
Coleridge, Samuel Taylor 237
Colina, Enrique 155
collective experience 10–11
colonialism 215
common experience as distinct from disconnected feelings 1–2
Communards 208
communication, definition of 264
'community', use of the word 25–6
community interests 107
Condell, Henry 34
confinement 205–9, 211
connectedness and connectivity 115, 160
Connor, Steven 139, 142
Constable, John 275, 278
contagion 69, 268
Contagion (film) 155
contamination 69–71, 74
contributors to the present book 5
coping mechanisms 94, 101
Cosgrove, Denis 195
Covid-19 pandemic 1–11, 16–17, 23–4, 32–3, 38–9, 45–7, 49, 58–61, 65, 68, 75, 79–83, 86, 93–5, 97, 103–5, 108–9, 115, 121, 132, 137–8, 145, 154–5, 160–1, 163, 172, 181, 189–91, 206–9, 211, 218, 228, 230–3, 236, 240–5, 249, 255–7, 273, 282, 301, 303
 death toll 108, 168
 semiotics of 263–4
 timeline 260
 UK response to 105, 108
 vulnerability to 23
Crawforth, A.D. 234
creative and cultural industries 6
crime, reading about 179–82
crime writing, Golden Age of 182
Cronin, Michael 195
Cuarón, Alfonso 8, 154–6, 159–60
Cultural Recovery Fund 52
Cunningham, David 235
cyborgs 6, 58–66
 definition of 59

Dante Aligheri 171
Davies, Karen 51–2
Davyd, Mark 49–50
Debord, Guy 137
Decker, Thomas 166
decolonial option 39–42, 45–6
Defoe, Daniel 115, 246
denialism 85
Derrida, Jacques 127
devotio ritual 107–8
diagrams communicating numbers 264
digital divides 115
digitality 159–61
digitised objects and digital spaces 119–20
Dillon, Sarah 155
disabilities, access for people with 58
disease 7
disinformation and misinformation 16, 85
dislocation 145–6, 151
Distant Together 53
diversity of human experience 188
do-it-yourself (DIY) music 50–5
 health of networks 51
domestic space, artistic activities and creativity in 218
Donne, John 112
Dorsett, Henry 164, 166
'Down to the Countryside' Movement 148
drag kings 126–33
dreams, theory and interpretation of 240–6

education 115, 117, 120
 of girls 214–15
 marketisation of 120
 Westernised 214
Eichhorn, Kate 54
Eichmann, Adolf 241
emotions 157–60
The Emperor and the Assassin 148
'end of the world as we know it' 38
enemy aliens 89–92
environmental catastrophe 188, 191
epidemiology 73, 80
Ericson, Joan E. 212
Eurocentrism 38
Evans, Mary 180–1
Evans-Pritchard, E. E. 261
extended families 74

Facebook 6, 12–18, 117
Falk, Dan 30–1
Farewell My Concubine 148
Felski, Rita 181
femininity 60
feminism 58, 212–17
Feng-ling, Chou 213
Ferri, Giuliana 61
festivals 51
fiction, speculative 191
films 155
Finkel, Irving 71
First World War 172–3
Fleet, River 274
Fletcher, Sarah 167
Florence 166
Floyd, George 18, 132
fMRI scans 156–7
food 174–5
foot-binding 214–15

forest trees 279
Foucauldian fandom 126
Foucault, Michel 17, 61, 124–6, 129–30, 133
framing, academic xiv, 3
France 129, 132–3
Franco-Prussian War 207
Franklin, Benjamin 68
Franklin, Rosalind 194
freelance practitioners 50
Freud, Sigmund 241–6
Fukuyama, Francis 38
fumigation 167–8
funeral practices 107
future prospects 50, 65–6

Gablik, Suzi 235
Gabo, Naum 237
Geertz, Clifford 261
gender roles 218
Genoa 166
Germans living in Britain 89–95
Giddens, Anthony 190
gig-going 54
The Girl with All the Gifts 191–3
'Give me liberty, or give me death' 12–14
Gizzi, Peter 201–2
global financial crisis (2008) 3
globalisation 189–93
Goethe, J.W. von 63–4
Goffman, Erving 112
González, Alejandro 157
Gormley, Antony 119
Gospel Oak 274
Graeber, David 130
Graham's Magazine 181
grassroots spaces 52, 55
Gravely, Erin 240
Gravity (film) 154–61
'growth' mindset 65
Guixiu/Kaishu literature 211–18
 historical context of 214–16
 metaphors in 216–17
Gullace, Nicoletta 92
Gurney, Ivor 228

humanities thinking 3; *see also* arts and humanities
Hampstead Heath 274–5
handwashing 69, 79–86
 discovery and rediscovery of 80–2
Haraway, Donna 6, 58–66
Harbou, Thea von 59
Harding, Vanessa 166–7
Hardman, Saidiya 60
Hasidic communities 6, 22–7
Hasidic Yiddish 23–5
Hasson, Uri 156–7
Heller, Agnes 127
Heminge, John 34
Henry, Patrick 12–14, 17
Henry V (play) 35
herd immunity 17
heterogeneity of the present book 5
Herschel, Sir John 270
Heyse, Paul 228
Hirst, Damien 119

history 7–8
Hitchcock, Alfred 156, 160
Hitler, Adolf 244
Hodges, Nathanael 164
Holt, Anne 185
home, concept of 146, 150, 184, 218, 251
Houghton, Steph 137–8
Housman, A.E. 222
Hove 303–4, 310
Human Connectome Project (HCP) 157
human-free natural reserves 188–9
human rights 208
humanities, the 46–7
 diversity of themes, styles and objects of study in 5
 scholarship in 4
100 Flowers Hidden Deep 145–8, 151
'hungries' 192, 194
Huntington Beach 13
hurricanes 302–5
 themes relating to 305, 311
hygiene 71–4, 79–80
hypothesis-testing 85

illness, nature of 173
image-making 264–5
imagined communities 149
Internet usage 255
internment 91–2

Jackson, Mary 59
Jameson, Frederic 36
Japan 212–16
joryu bungaku 212
Johnson, Boris 30, 211, 250, 263
Jones, Chris 32–3
Jones, Ellis 54
Juchau, Mireille 241
Jullien, François 9, 249–52
'junkers' 192

Kaige, Chen 8, 145–51
Kane, Harry 137–8
Kant, Immanuel 117
Keats, John 275
Kenner, Hugh 138
key workers 254–6
King of the Children 148
King Lear (play) 31–6
Kings College Hospital 233
kingship 130–1
Kipling, Rudyard 112
Kiryas Tosh 24, 27
kitchen literature 216
knowledge production 7
Kress, Gunther 264

Lacan, Jacques 246
Lang, Fritz 59
Larsson, Stieg 185
La Vidange, Judas and Jésus 131
Lawrence, Sir John 165
learning, social nature of 120
leprosy 111–12
Lerner, Ben 198–203
Lerner, Ben 9

INDEX **315**

LGBT (lesbian, gay, bisexual or transgender) people 62–3, 133
liberalism 14, 16
Liberation Army 147
libertarianism 14–18
Life on a String 148
linguistics 22
live streaming and live tweeting 50, 53–5, 118, 234
Livy 103–9
lockdowns 51–5, 59, 62–6, 92–5, 102, 121, 132, 137–41, 145, 154–5, 160, 163, 170, 175–7, 179–81, 184–5, 189–93, 198–9, 209, 218, 231–4, 240, 249–51, 254–6, 263, 282, 292, 301, 304–5, 310–11
 in a post-holocenic world 191–3
 and reading habits 179
'locked room' mysteries 181, 183, 186
London 163, 167–8
Long, Camilla 160
long- and short-term considerations 300–1
Lubezki, Emmanuel 159
Luckhurst, Roger 193

McCarthy, Bonnie 30
McDonough, Tom 250
McFarland, James 193
McKay, George 50
McKibben, Bill 188–9
MacLean, Nancy 14
The Magic Mountain 172–7
magnolia petals 292
 pictures of 293–9
Maheke, Paul 40, 45
Malek, Natalia 41
Malina, Debra 85
Mann, Thomas 8, 170–1, 175–7
Mao Zedong 148
Marsh, Edward 222
Martin, Nick 30
Martin, Theodore 193
massive open online courses (MOOCs) 115
Mathewson, Richard 192
Mbembe, Achille 17
meaning, sense of 3
'The Media' (prose poem) 198–203
Méliès, Georges 206
Mercer, Robert 16
Mesopotamia 68–9, 72–4
miasma 69, 81
Michelet, Jules 172
Mignolo, Walter 39, 43
migrant crisis' 132
Minecraft (game) 272
Ming-ju, Fan 213
Molloy (play) 139
Moloney, Isobel 51
Monnigan, Annie 92
moral theory 107
More, Thomas 190
Morris, William 119
moving images 120
Mügge, Maximillian 90, 93
Music Venue Trust 52

Nancy, Jean-Luc 64
National Health Service (NHS) 238
National Theatre 117
nationalism 213
nativism 213
naturalisation 90, 93
Nazism and Nazi regime 241, 245–6
Negarestani, Reza 267
Nelligan, Kat 53
neoliberalism and neoliberalisation 14–15, 18, 147, 250–1
neuroscientific data points 158
Neurosynth 157
New History of Sexuality 124, 126, 130, 133
Newton, Isaac 31
Ngai, Sianne 256
Nielsen Book Surveys 179–80
Nightingale, Florence 237
Nochomovitz, Elisha 139
normalcy, sense of 180
Noschke, Richard 91–2

Obamacare 15
'obviation' 262
Office for National Statistics (ONS) 264, 266
Old Wylde's farmhouse 279–80
O'Neill, Stephen 35
online communities 54
ostracism 91–3
outbreak stories 193
'outsiders' 59

pandemics 51–2, 55, 68, 97, 155; see also Covid-19
Paris 130, 132, 166, 207
Parliament Hill 276
Peking Opera 150
penicillin 142
personal reflections 9
photography, use of 292
photography, use of 304–5
Pick, Daniel 243
plague and plague-time 30–5, 115, 163, 167, 198–9, 246
Poe, Edgar Allen 181–2
poetry 9–10, 34, 198–203, 231, 274–5
 hatred of 203
policing 18
political themes 6
Pollack-Pelzner, Daniel 30
Polybius 107
Pompidou Centre and Museum 124–7, 132
populism 47
Porter, Dennis 180
Porter, Stephen 166
postmodernism 36
Preciado, Paul B. 8, 61, 63, 125–8, 132, 250
priorities 108–9
privatisation of the dream 243–4
productivity 6–7, 31–3
Proust, Marcel 170–1
public goods 15
Pugin, Augustus 237
Putnam, Robert 185–6

quarantine 71, 111–12, 121, 249
 mass form of 189
 militarised 207
Quayson, Ato 139
queer thought and politics 127, 129, 132–3
questions long neglected 3
Quijano, Anibal 39

Raab, Dominic 250
racism 17–18, 216
Raicho, Hiratsuka 214–15
Rancière, Jacques 266–7
Rawcliffe, Carole 165
Reading Agency 179
readings
 benefits from 179, 186
 textual 8
recognition 117
Reich, Wilhelm 245
religious observance 106, 108
republican institutions 106–9
republicanism 129
return to normal life after the pandemic 2
Reyner, Igor 170
Rimbaud, Arthur 208
Robinson, Elliott 264
Robinson, Miranda 264
Rodak, Wojtek 40–3, 47
Roman society 109
Rome, sack of (390 BCE) 103
Rome, sack of 7
Roper, Lyndal 243
Rosenbaum, Lisa 85
Roued-Cunlife, Henriette 50

Sahlins, Marshall 130
St Thomas' hospital 235, 237
Scaggs, John 182
scepticism 85
Schubert, Franz 223
seafood 99
Seito (journal) 212
self-quarantine 151
Semmelweis, Ignaz Philipp (and *Semmelweis* (play)) 7, 69, 79–86
Semon, Sir Felix 89–93
Shakespeare, William 6–7, 30–5
 how he wrote his plays 34–5
 wealth of 34
the Shard 275
shop closures 304–11
Shove, Fredegond 222
'shrinking world' discourses 195
Shurpu text 69
signage 304–12
Sjöwall, Mai 184–5
Skipper, Jeremy 156
slavery 14, 60
Sloterdijk, Peter 266
smell associated with infection 82–3
Smith, Zadie 251
social capital 183–6
social conventions 215
social distancing 50–4, 68, 71–4, 83, 89, 121, 207–8, 243, 261–3
social isolation and cohesion 92–5

social media 3, 35, 50–4, 115, 241, 249, 256–7
somathèque, the 126
songs 226–7
Southampton, 3rd Earl of 34
sovereignty 130
Spanish flu 89
Sperber, Dan 265
Spinalonga 7, 111–12
sport 137–42
'spring', political 208
Stamford Hill 23–4
Stamp Acts 14, 16
Stepanova, Maria 256
Stevenson, R.L. 222
Stewart, Charles 241
stigma 112–13
stoic response 166
Stonebridge, Lyndsey 198
strophic settings 223
'struggle of the orders' 106
Stuckmann, Chris 159
studios, artists' (and studio visits) 282
'Succedane' 142
surveillance 63, 165
Suvin, Darko 190–1
Sweden 184
Symons, Julian 180

Tagore, Rabindranath 275
Taiwan 212–15
Takako, Takahashi 215, 217
Tea Party movement 15–16
technical reproduction 121
Temptress Moon 148
Teyssot, Georges 250
theatre, experience of 118
theatre closures 33–4
Thomas, Anna B. 93
Thompson, Laura 181, 183
Thun, Count 243
Tiktok 9, 254–6
time 175–6
Tlostanova, Madina 39, 42–3
Tokarczuk, Olga 7, 38
Torr, Diane 127
Toshiko, Tamura 217
Tour de France 138
touring 52
translation studies 22
Trump, Donald 16, 167, 241
trust 85
Tsai, Mei-tzu 212, 216
Twitter 32, 35
Tyszko, Simon 234

United States 6
universities 2, 120
University College London (UCL) 2, 23, 63, 171, 244
University and College Union 31
utopian literature 190–1

vaccine hesitancy 85
values, system of 107
Vandenberg, Femke 54
van Haaren, Suzette 120

Vaughan Williams, Ralph 9, 222–4
Venus and Adonis 33–4
Verne, Jules 8, 205–8
video 40–7
video-conferencing 59, 62
violence, domestic 62
virtual meetings 115
virtual spaces 49
visual responses 9–11

Wagner, Roy 261–2
Wahlöö, Per 184–5
Waiting for Godot (play) 138–42
Waldron, Janice I. 54
Wallace-Wells, David 188–9
Walwin, Jenni 236
'The Water Mill' 222–5, 228–9
Webber, Tim 159
Wei-chen, Su 213
Weisan, Alan 189
welfare state provision 185
wildfire 272
Wilson, Deirdre 265
Wilson, Edward O. 188–9

Witching Waves 53
Wittgenstein, Ludwig 200
Wolf, Hugo 228
women, position of 214–17
women writers 216–18, 231, 237
Woods, John E. 170
Woolf, Virginia 9, 230–3, 237
working from home 211
World Health Hygiene 80
World Health Organisation (WHO) 80, 121
worldviews 209
writing style, changes in 213

xenophobia 92

'yellow earth' 147
Yiddsh language 23–5
Yiddish translation of Covid-19 information 22–7
Yuko, Tsushima 215, 217

Zhu Xi 251
zombie culture 192–3, 266
Zoom 243